FRANTZ FANON

Frantz Fanon was a fearless critic of colonialism and a key figure in Algeria's struggle for independence. Since his untimely death in 1961, Fanon's intellectual reputation has grown on the strength of works such as *Black Skin, White Masks* and *The Wretched of the Earth*, with their incisive insights into issues of race and colonialism. *Frantz Fanon: Critical perspectives* addresses Fanon's extraordinary, often controversial writings, and examines the ways in which his work can shed light on contemporary issues in cultural politics.

In the opening section, 'Re-reading Fanon's Legacy', contributors examine Fanon's commitment to the Algerian revolution and address debates concerning gender and sexual politics. The second section places Fanon's work in the context of contemporary debates in cultural studies, asking how Fanon's work might both contribute to and remake contemporary cultural studies. Finally contributors turn to the question of how Fanon's legacy could influence future political and intellectual thought, imagining what future cultural work that builds on Fanon's crucial insights might look like. Embracing feminist theory, cultural studies and postcolonialism, *Frantz Fanon: Critical perspectives* offers new directions for cultural and political thought in the postcolonial era.

Anthony C. Alessandrini is a doctoral candidate in English and Women's Studies at Rutgers University.

FRANTZ FANON

Critical perspectives

Edited by
Anthony C. Alessandrini

London and New York

First published 1999
by Routledge
11 New Fetter Lane, London EC4P 4EE

Simultaneously published in the USA and Canada
by Routledge
29 West 35th Street, New York, NY 10001

Typeset in Galliard by Routledge
Printed and bound in Great Britain by TJ International Ltd,
Padstow, Cornwall

British Library Cataloguing in Publication Data
A catalogue record for this book is available from the British Library

Library of Congress Cataloguing in Publication Data
A catalogue record for this book has been requested

ISBN 0–415–18975–6 (hbk)
ISBN 0–415–18976–4 (pbk)

CONTENTS

CONTRIBUTORS

Anthony C. Alessandrini is a PhD candidate in Literatures in English and Women's Studies at Rutgers University, New Brunswick. He has published articles on postcolonial literature and feminist and Marxist theory. He is currently completing a dissertation entitled "*Bombay* in Iselin: Culture, Capital, and Citizens between South Asia and the South Asian Diaspora."

Michael Azar is currently completing a work on the intellectual debate on the Algerian War, *In the Name of the Spirit, Representations of a War: Albert Camus, Jean-Paul Sartre, and Frantz Fanon*, and has also written the introduction to the Swedish translation of Fanon's *Peau noir, masques blancs* (*Svart Hud, Vita Masker*). He teaches philosophy and the history of ideas at the Department of the History of Ideas and Science, University of Gothenburg, Sweden.

Rey Chow is Professor of English and Comparative Literature at the University of California, Irvine. She is the author of *Woman and Chinese Modernity*, *Writing Diaspora: Tactics of Intervention in Contemporary Cultural Studies*, and *Primitive Passions: Visuality, Sexuality, Ethnography, and Contemporary Chinese Cinema* (winner of the 1995 James Russell Lowell Prize). Her latest book is *Ethics After Idealism: Theory–Culture–Ethnicity–Reading*.

T. Denean Sharpley-Whiting is Associate Professor of French and African-American Studies at Purdue University, Indiana. She is the author of *Black Venus: Sexualized Savages, Primal Fears, and Primitive Narratives in French* and *Frantz Fanon: Conflicts and Feminisms*, and co-editor of *Fanon: A Critical Reader* and *Spoils of War: Women of Color, Cultures, and Revolutions*.

Terry Goldie is Professor of English at York University. He is the author of *Fear and Temptation: The Image of the Indigene in Canadian, Australian and New Zealand Literatures*, and has co-edited *An Anthology of Canadian Native Literature in English* and *Canada: Theoretical Discourse*. He is completing a book entitled *Homotextual Possibilities in Canadian Fiction*.

John Mowitt is Professor of Cultural Studies and Comparative Literature at the University of Minnesota. He is the author of *Text: The Genealogy of an Antidisciplinary Object* and the forthcoming *Percussion: Drumming, Beating, Striking*. He has published widely on film theory and cultural studies and politics, including the influential essay "Algerian Nation: Fanon's Fetish."

Nigel Gibson is assistant director of the Institute of African Studies at Columbia University, New York, where he also teaches. He is the author of the forthcoming study *Frantz Fanon*, and editor of *Fanon and Fanonism*.

E. San Juan, Jr. is Professor of Ethnic Studies at Bowling Green State University, Ohio. He is the author of many books, including *Racial Formations/Critical Transformations*, *Hegemony and Strategies of Transgression*, *Rizal: In Our Time*, and *From Exile to Diaspora: Versions of the Filipino Experience in the United States*. His most recent book is *Beyond Postcolonial Theory*.

E. Ann Kaplan is Professor of English and Comparative Literature and Director of the Humanities Institute at the State University of New York at Stony Brook. She is the author of *Women and Film*, *Rocking Around the Clock*, *Motherhood and Representation*, and *Looking for the Other: Feminism, Film, and the Imperial Gaze*. A revised and expanded version of her 1978 book *Women in Film Noir* was published in 1998. She is currently editing a volume on feminism and film for Oxford University Press.

Neil Lazarus is Professor of English and Modern Culture and Media at Brown University, Rhode Island. He is the author of *Resistance in Postcolonial African Fiction* and of a number of influential articles on postcolonial theory and literature, cultural studies, and modernity and postmodernity. His most recent book is *Nationalism and Cultural Practice in the Postcolonial World*.

Kobena Mercer has taught in the History of Consciousness Program at the University of California at Santa Cruz, and is currently Visiting Professor of Africana Studies at New York University. He has written and lectured widely on the cultural politics of race, identity, and representation, and is the author of *Welcome to the Jungle: New Positions in Black Cultural Studies*. He is currently working on a book tentatively titled *The Black Body in Visual Culture*.

Gwen Bergner is Assistant Professor of English at West Virginia University. She is the author of several articles on race, representation, and psychoanalysis, including "Who Is That Masked Woman? Or, The Role of Gender in Fanon's *Black Skin, White Masks*" (in *PMLA*) and "Myths of the Masculine Subject: The Oedipus Complex and Douglass's 1845 *Narrative*" (in *The Psychoanalysis of Race*).

Samira Kawash is Assistant Professor of English at Rutgers University, New Brunswick, where she teaches twentieth century literary and cultural studies and theory. She is the author of *Dislocating the Color Line: Identity, Hybridity, and Singularity in African-American Narrative.*

Françoise Vergès teaches colonial and postcolonial studies at Sussex University, England. She is the author of *Monsters and Revolutionaries: Colonial Family Romance and Metissage*, and has published essays on Fanon in *Fanon: A Critical Reader*, *The Fact of Blackness: Frantz Fanon and Visual Representation*, and *Critical Inquiry*. She is currently editing a book with Isaac Julien and Mark Nash about the making of the film *Frantz Fanon: Black Skin, White Mask.*

ACKNOWLEDGMENTS

My first thanks must go to Bruce Robbins, who has supported this project at every stage. Thanks also to the Social Text collective, whose comments on an early proposal for this collection helped me to concentrate on sharpening its political edge.

I would like to thank all those people, here at Rutgers and elsewhere, with whom I have had the opportunity of discussing Fanon's work (often electronically or by other virtual means): Abena Busia, Elaine Chang, Judy Chen, Suching Chen, Kanishka Chowdhury, Joan Copjec, Debra Curtis, Marianne DeKoven, Jillana Enteen, Ruth Wilson Gilmore, Lewis R. Gordon, Sondra Gutman, Stephanie Hartman, Barbara Holler, Isaac Julien, Jonathan Kahana, Cora Kaplan, Rajender Kaur, Samira Kawash, Rustom Kozain, Amitava Kumar, Rick Lee, Lisa Lynch, Gitanjali Maharaj, John McClure, Ankhi Mukherjee, Rika Nakamura, Nicole Nolan, Peter Osborne, Thomas Ponniah, Sangeeta Ray, Julian Samuel, Louisa Schein, S. Shankar, Bruce Simon, Kate Stanton, Alex Weheliye, Deborah Wyrick, Sandra Young, and the students in my Colonial and Postcolonial Theory, Cultural Studies, and Exposition and Argument classes. In many cases, they may not even remember that such conversations took place, but all of these people have helped this book develop. Thanks also to the audiences at the versions of the panels "Frantz Fanon and/as Cultural Studies" held at the Modern Language Association and the Northeast Modern Language Association, and to Lewis Gordon, Mark Rifkin, and Stacey Takacs, who took part in the discussions.

I owe a great debt of thanks to Rebecca Barden and Alistair Daniel at Routledge, for their expertise, enthusiasm, and patience in working on this book through its various stages.

A different set of thanks is due to Donna Bender, without whose help this book would not have been possible. Thanks to my family, especially my mother and sister, for their support, and to Jill Marie Caporlingua, who put up with it.

Versions of the following essays have appeared previously:

Rey Chow: in the *UTS Review* 1, 1 (1995) and as a chapter in *Ethics after Idealism: Theory–Culture–Ethnicity–Reading* (Bloomington: Indiana University Press, 1998).

T. Denean Sharpley-Whiting: as a chapter in *Frantz Fanon: Conflicts and Feminisms* (Lanham, MD: Rowman & Littlefield, 1998).

Neil Lazarus: in *Research in African Literatures* 24 (1993) and as a chapter in *Nationalism and Cultural Practice in the Postcolonial World* (New York: Oxford University Press, 1999).

Kobena Mercer: in *Mirage: Enigmas of Race, Difference and Desire*, ed. R. Farr (London: Institute of Contemporary Arts, 1995).

1

INTRODUCTION

Fanon studies, cultural studies, cultural politics

Anthony C. Alessandrini

> What is the prognosis?...The prognosis is in the hands of those who are willing to get rid of the worm-eaten roots of the structure.
>
> Frantz Fanon, *Black Skin, White Masks*

> Come, then, comrades, the European game has finally ended; we must find something different...we must grow a new skin, we must develop new thinking, and try to set afoot a new man.
>
> Frantz Fanon, *The Wretched of the Earth*

In December 1997, I chaired a panel with the title "Frantz Fanon and/as Cultural Studies" at the Modern Language Association in Toronto, where versions of several of the essays in this collection were first presented. In the question and answer period that followed, a member of the audience asked the panelists to address the way Fanon's work had been "appropriated" by contemporary theorists. This question continued to haunt me long after the session had ended. The word "appropriation" was obviously meant to carry a negative connotation, as it does, for example, in Cedric Robinson's essay "The Appropriation of Frantz Fanon" (1993). But, I wondered, must we assume that every appropriation is a *mis*appropriation? To put the case in the strongest possible terms: can there today be anything other than various kinds of appropriations of Fanon's work, appropriations which would need to be judged individually to determine their accuracy, their usefulness, and their political valences? This question is at the heart of this book.

I am, of course, intentionally overstating the case. I certainly do not want to be understood as suggesting that any and all interpretations and uses of Fanon's work are equal or interchangeable. This is not an invitation to an easy, unthinking pluralism. What I am suggesting is that if Fanon's legacy, which I consider to be absolutely crucial, is to have any meaning for us today, it will be only insofar as we are able to apply his work – with all of its insights and all of its limitations – to the pressing issues of contemporary cultural politics.

Not all of the contributors to this volume would agree with this suggestion. In his essay, for example, Nigel Gibson declares that he will "use Fanon to

1

polemicize against invented 'Fanons,' " and that he is "neither embarrassed at declaring my Fanon to be more authentic than others, nor concerned that 'my Fanon' radically disturbs the political claims of cultural studies in the US." This is not the only disagreement that will be found in these pages. The field of Fanon studies, whose contours I will attempt to map in this introduction, has been the site of a variety of theoretical, methodological, and political disagreements. By attempting to contain several diverse sets of arguments about Fanon's work – arguments that critique the limitations of Fanon's work as well as attempting to extend his legacy – this volume attempts to generate the kinds of critical conversations that will allow these debates to move forward in a more productive manner.

For those readers encountering Fanon for the first time, some biographical information may be in order.[1] Frantz Fanon was born in Martinique on July 20, 1925, and grew up in Fort-de-France, the island's capital. The Fanons were a middle-class family who belonged to the island's emerging black bourgeoisie: Fanon's father worked as a government official while his mother kept a shop. Because of this, the Fanon children were among the very small percentage of blacks who were able to be educated at the *lycée*.

The experience of receiving a French colonial education affected Fanon deeply: his teacher and mentor, Aimé Césaire, described his own experience of Martinican education as one which "associated in our minds the word France and the word liberty, and that bound us to France by every fiber of our hearts and every power of our minds" (quoted in Hall 1995: 10). Fanon himself later wrote: "The black schoolboy in the Antilles, who in his lessons is forever talking about 'our ancestors, the Gauls,' identifies himself with the explorer, the bringer of civilization, the white man who carries truth to savages – an all-white truth" (1967: 147). Spurred by such feelings, Fanon in 1944 joined the Free French Army and left for the European front. Two years later, having been wounded in battle and having received the *Croix de Guerre* for bravery, Fanon returned to Martinique. But his first experience of French racism, which he would later chronicle so eloquently in *Peau noire, masques blancs* (*Black Skin, White Masks*), had changed him irrevocably.

Fanon wrote the essays that constituted that book while studying medicine at the University of Lyons (he had returned to France, with the original intention of studying dentistry on a scholarship for veterans, in 1947). He defended his medical thesis in 1951, and was admitted to a residence program in psychiatry at the Hôpital de Saint-Alban.[2] After completing his examinations, Fanon wrote to Léopold Sédar Senghor to enquire about the possibility of working in Senegal. But since he received no response, Fanon eventually accepted the opportunity to work in Algeria. In November 1953 he arrived in Algiers as the *chef de service* of the Blida-Joinville Hospital, the largest psychiatric hospital in Algeria.

While working at Blida-Joinville, Fanon introduced a number of innovative programs, many of which bore the influence of François Tosquelles, his mentor

2

at the Hôpital de Saint-Alban; he also wrote and co-wrote many articles on the practice and theory of psychiatry (see bibliography). While stories of Fanon arriving in Algiers as a mythic liberator, "unchaining men and women" who had been tied to their beds (Gendzier 1973: 76), have come to be challenged by those who worked with Fanon at Blida-Joinville (see Vergès 1996a: 48–9; Julien 1995), he was undoubtedly responsible for initiating radical changes in the practice of colonial psychiatry in Algeria.

But it was precisely the problem of practicing psychiatry in a *colonial* situation that began to have its effect upon Fanon. The struggle for national liberation in Algeria had become more conspicuous, partly because French repression had become more brutal since the end of World War II. Fanon had, of course, already experienced the effects of French racism, but in Algeria this experience took on new kinds of meanings. After a period of treating both Algerians fighting for independence and French police officers, the tortured and the torturers (documented in the case studies collected in "Colonial War and Mental Disorders," in *The Wretched of the Earth* (1963: 249–310)[3]), Fanon came to the realization that "[i]t was an absurd gamble to undertake…to bring into existence a certain number of values, when the lawlessness, the inequality, the multi-daily murder of man were raised to the status of legislative principles." "The social structure in Algeria," he concluded, "was hostile to any attempt to put the individual back where he belonged" (1988: 53).

In the summer of 1956 Fanon resigned from his post at Blida-Joinville, writing in his "Letter to the Resident Minister" (later published in *Pour la Révolution Africaine*):

> For nearly three years I have placed myself wholly at the service of this country and of the men who inhabit it. I have spared neither my efforts nor my enthusiasm.
>
> But what can a man's enthusiasm and devotion achieve if everyday reality is a tissue of lies, of cowardice, of contempt for man?…
>
> If psychiatry is the medical technique that aims to enable man no longer to be a stranger to his environment, I owe it to myself to affirm that the Arab, permanently an alien in his own country, lives in a state of absolute depersonalization.…
>
> For many months my conscience has been the seat of unpardonable debates. And their conclusion is the determination not to despair of man, in other words, of myself.
>
> (1988: 52–4)[4]

In January 1957, Fanon, who by this time was working with the Front de Libération Nationale (FLN), received a letter of expulsion from the French government and a warning to leave Algeria within forty-eight hours. As Fanon's reputation as a revolutionary theorist grew over the next four years, he would become the target of assassination attempts by French Algerian settlers and one

of the most wanted persons of the French secret police. He survived several attempts on his life, including one in which his jeep was blown up by a land mine near the border of Algeria and Tunisia, leaving him with twelve fractured spinal vertebrae.

After being expelled from Algeria, Fanon arrived at the FLN headquarters in Tunis and served in a number of capacities, becoming editor of the movement's newspaper, *El Moudjahid*, working as a doctor in FLN health centers, and acting as ambassador to several African nations. He also lectured at the University of Tunis. It was during this time that Fanon wrote *L'An V de la Révolution Algérienne* (translated as *A Dying Colonialism*), a sociological study of the Algerian liberation struggle. Written from within the struggle with a manifesto-like intensity, it received enough attention in France for the government to ban the book and prohibit further printing of it six months after its publication.

Shortly afterwards, while traveling in Mali as an FLN representative, Fanon suddenly became ill. By December 1960 it became apparent that he was suffering from leukemia. He was taken to Moscow for treatments, but the disease worsened. Soviet doctors eventually suggested that Fanon travel to the United States, where he could receive the most advanced treatment. Instead, while the disease was in remission, Fanon returned to Tunis. Writing from what he realized was his deathbed, Fanon produced in a period of ten weeks his last and most famous book, *Les Damnés de la Terre* (*The Wretched of the Earth*). Finally, despite his disgust at the idea of dying in what he called "that nation of lynchers," he agreed to travel to Washington, DC, for treatment. Persistent rumors have suggested that the CIA arranged for him to be left alone in a hotel room for eight days so that he could be interrogated rather than admitting him immediately to a hospital. In any event, by the time he finally entered the hospital, it was too late. Fanon died on December 6, 1961, at the age of 36. His body was taken to Tunisia, then smuggled across the border to Algeria, where he was buried in an FLN cemetery with full military honors.

It was not long after his death that debates over Fanon's work began in earnest. Those that followed most closely upon his death involved his engagements with revolutionary Marxism; particularly controversial were his opinions (or, in many cases, what were *seen* as his opinions) on violence, the need to rethink class struggles in the colonial situation, and the relative revolutionary potential of colonized agricultural workers and the proletariat.[5] As Immanuel Wallerstein has suggested, the aspects of Fanon's work that "shocked the most, and were meant to shock the most" were those that posited the need for a total, violent break with colonialism (1979: 253). The popular image that began to arise was Fanon as a prophet of violence, a figure who was denounced by Marxist critics like Jack Woddis (1972) and liberal critics like Hannah Arendt (1969) and Lewis Coser (1970), but had a particular kind of value for leaders of the Black Panther Party in the US such as Huey Newton and Bobby Seale (see Sutton 1971).

The editors of *Fanon: A Critical Reader*, an important recent anthology, have suggested that Fanon studies can be divided into five stages (Gordon *et al.* 1996: 5–8). The first stage consisted of applications of and reactions to his work, which would include the sorts of critical debates I have already suggested, as well as the applications of his work in practice by revolutionary thinkers such as Fidel Castro, Che Guevara, Huey Newton, and Paulo Freire. The second stage was primarily biographical, featuring work by David Caute (1970), Peter Geismar (1971), and Irene Gendzier (1973). The editors identify the third stage as "one of intense research on Fanon's significance in political theory"; they mention the work of Hussein Adam, Emmanuel Hansen, and Renate Zahar (one might also include here the work of L.A. Jinadu (1986)). Things get a bit more worrisome, according to this account, when the fourth stage is reached, since it "is linked to the ascent of postmodern cultural and postcolonial studies in the academy." The diverse list of theorists said to inhabit this stage, "which is still under way," include Edward Said, Homi Bhabha, Abdul JanMohamed, Gayatri Chakravorty Spivak, Benita Parry, Henry Louis Gates, Jr., and Cedric Robinson (this list seems to come from a review essay on "Critical Fanonism" by Gates (1991)). The editors complain that this stage is marked by a literary–critical bias and by a tendency to attack Fanon "under a number of fashionable political designations." But fortunately (in their view) there has been a fifth and final stage, one which "consists in engagements with the thought of Fanon for the development of original work across the entire sphere of human studies," inaugurated by Hussein Bulhan (1985) and continued in the work of Tsenay Serequeberhan (1994), Lewis R. Gordon (1995), and Ato Sekyi-Otu (1996). Not surprisingly, the editors declare their book to be "squarely rooted" in this fifth and final stage.

This version of the development of Fanon studies is a compelling one. While I would have to disagree with its explicitly teleological bent – the editors suggest that "each stage represents...an ongoing dialectical process" (1996: 7) – what is particularly important about their account is that it forces us to rethink the assertion that Fanon's work has enjoyed a "resurgence" in recent years. This has become a critical commonplace among many contemporary theorists, especially those working in cultural studies, who invoke Fanon's work. Instead, this account suggests that Fanon's work has, since at least the time of his death, been applied and interpreted in a variety of different locations for a variety of different reasons.

But what this account misses, in my view, is the fact that significant disagreements and debates have marked every stage of Fanon studies. Elsewhere, I have suggested that the editors of *Fanon: A Critical Reader* suppress the internal tensions within the discipline they identify (interchangeably) as "postcolonial" or "postmodern" cultural studies, a suppression which is all too typical of sweeping dismissals of this field (Alessandrini 1997). What I want to point out here is the way in which these sorts of internal tensions have always existed in Fanon studies, and the striking parallels between the kinds of debates

that have gone on during its various stages. Almost thirty-five years ago, for example, Aristide and Vera Zolberg identified what they saw as "The Americanization of Frantz Fanon" (1966), a move very similar to that of many critics today (including several in this collection) who point to the increasing appropriation of Fanon's work by American cultural studies. Similarly, by 1970 Tony Martin already felt the need to "rescue Fanon from his critics," a mission which has today been taken up again by a number of critics, most recently Nigel Gibson (1998; 1999; see also his essay in this volume). And the essays in this collection by Gibson and Neil Lazarus return to a number of the issues raised by Fanon's Marxist readers in the 1960s and 1970s, issues having to do with race and class in the post-colonial context.

This is not to suggest that there have not been important breaks and disjunctures in Fanon studies. The one which has been the most crucial for cultural studies work – and, as many of the essays in this volume suggest, has certainly been the most controversial – has been the re-reading of Fanon's body of work by Homi Bhabha. First initiated in several essays in the early 1980s, and begun in earnest in "Remembering Fanon: Self, Psyche and the Colonial Condition," his foreword to the British edition of *Black Skin, White Masks* (1986), Bhabha's readings introduce a Fanon who "may yearn for the total transformation of Man and Society, but...speaks most effectively from the uncertain interstices of historical change: from the area of ambivalence between race and sexuality; out of an unresolved contradiction between culture and class; from deep within the struggle of psychic representation and social reality" (Bhabha 1994: 113). In his comments on Bhabha's readings of Fanon – comments which are both critical and appreciative – Stuart Hall has suggested that

> Bhabha's real argument...is that Fanon constantly and implicitly poses issues and raises questions in ways which cannot be adequately addressed within the conceptual framework into which he seeks often to resolve them; and that a more satisfactory and complex "logic" is often implicitly threaded through the interstices of his text, which he does not always follow through but which we can discover by reading him "against the grain." In short, Bhabha produces a *symptomatic reading* of Fanon's text.
>
> (Hall 1996: 25)

Bhabha's work has inspired a variety of passionate responses. A number of contributors will, in the pages that follow, address Bhabha's work.[6] Rather than a full-fledged analysis of my own, I would like to contribute one or two comments about the context in which Bhabha's work might be placed, as a way to think about the significance of this work within the field of Fanon studies more generally. Critics have often suggested that Bhabha's readings are "the most elaborated that have been produced in the field of poststructuralism," and further, that they proffer Fanon himself as "a premature poststructuralist"

(Gates 1991: 459–60; Parry 1987: 31). This then becomes a way to link Bhabha to what E. San Juan, Jr., in his essay in this volume, calls "American cultural studies," which is said to be "inspired by the poststructuralist gurus Derrida, Foucault, and Lyotard." That Bhabha does indeed set out to produce a particular reading of Fanon, that "he regrets aloud those moments in Fanon that cannot be reconciled to the poststructuralist critique of identity" (Gates 1991: 459) – especially those moments when Fanon declares his commitment to a new humanism, inspired by his existentialist Marxist leanings – and that he as a result often reads Fanon front to back, moving from *The Wretched of the Earth* to *Black Skin, White Masks*, Bhabha's favored text, is undeniable. One question, of course, is what sort of work the term "poststructuralist" is being called upon to do here: for example, doesn't Bhabha's commitment to Lacan speak more of a particular kind of *structuralism*?

But the more important point is the one raised in passing by John Mowitt in his contribution to this volume, when he suggests that critics generally fail to emphasize "the frankly tactical character of Bhabha's reading." Bhabha's reading of Fanon, I would suggest, arises from his strategic engagement with *British* cultural studies of the 1970s and 1980s – more specifically, Black British cultural studies. For example, the opening lines of Bhabha's foreword to *Black Skin, White Masks* explicitly challenge the English left's failure to engage with Fanon's work:

> In the popular memory of English socialism the mention of Frantz Fanon stirs a dim, deceiving echo. *Black Skin, White Masks, The Wretched of the Earth, Toward the African Revolution* – these memorable titles reverberate in the self-righteous rhetoric of "resistance" whenever the English left gathers, in its narrow church or its Trotskyist camps, to deplore the immiseration of the colonized world....The ritual respect accorded to the name of Fanon, the currency of his titles in the common language of liberation, are part of the ceremony of a polite, English refusal.
>
> (Bhabha 1994: 112)

Similarly, critics usually take as Bhabha's conclusion the suggestion that "Fanon opens up a margin of interrogation that causes a subversive slippage of identity and authority" and that "it is for this reason – above all else – in the twenty-fifth anniversary of his death, that we should turn to Fanon" (1994: 122). But Bhabha in fact concludes by returning to the specific context of Black British cultural politics:

> In Britain, today, as a range of culturally and racially marginalized groups readily assume the mask of the Black not to deny their diversity but to audaciously announce the important artifice of cultural identity and its difference, the need for Fanon becomes urgent. As political

groups from different directions gather under the banner of the Black, not to homogenize their oppression but to make of it a common cause, a public image of the identity of otherness, the need for Fanon becomes urgent. Urgent, in order to remind us of that crucial engagement between mask and identity, image and identification, from which comes the lasting tension of our freedom and the lasting impression of ourselves as others.

(Bhabha 1994: 122)[7]

There is a way, then, in which Bhabha must be read beside other critiques emanating from within the Black British left in the 1980s, work by critics such as Stuart Hall, Paul Gilroy, and Hazel Carby. And if it is indeed true that such work has come to be appropriated in particular ways by American cultural studies practitioners – ways which have been charted by Hall, as Mowitt points out in his essay – the point is to be aware of how Bhabha's version of Fanon has circulated in this different set of locations, and with what results.

One of the issues which Bhabha very consciously sidesteps in "Remembering Fanon" has to do with Fanon's gender and sexual politics. He takes at face value the line proffered by Fanon in *Black Skin, White Masks* about the "woman of color" – "I know nothing about her" (1967: 179–80) – a line which, as feminist critics have pointed out, is in fact belied by Fanon's comments in the earlier chapter of the same book, "The Woman of Color and the White Man."[8] I would suggest that the most important recent work on Fanon has been that which has examined the intersections between his theorization of race and colonialism and issues of gender and sexuality in his writings, and has gone on to question the consequent limitations, dangers, and possibilities of applying his work to cultural politics today.[9] *Black Skin, White Masks* has of course been a crucial text for these critics, but so has Fanon's essay "Algeria Unveiled," in *A Dying Colonialism*, where he considers the strategic potential embedded in the choice Algerian women make about whether or not to wear the veil. The more general issue of what bell hooks has identified as Fanon's "homophilia" – which, as she and François Vergès suggest, has to do with Fanon's disavowal of the "motherly" influence of the Antilles in favor of a homophilic connection with Algerian male revolutionaries (hooks 1996; Vergès 1997) – has also been raised, often in reference to the relentless masculinism of passages like this famous one from *The Wretched of the Earth*:

The look that the native turns on the settler's town is a look of lust, a look of envy; it expresses his dreams of possession – all manner of possession: to sit at the settler's table, to sleep in the settler's bed, *with his wife if possible. The colonized man is an envious man.*

(Fanon 1963: 39; emphasis added).

Isaac Julien's film *Frantz Fanon: Black Skin, White Mask* (1995), which directly addresses Fanon's sexual politics, has also been a crucial part of this re-examination within Fanon studies.

The essays in this volume by Rey Chow, T. Denean Sharpley-Whiting, Terry Goldie, E. San Juan, Jr., E. Ann Kaplan, Kobena Mercer, Gwen Bergner, and Françoise Vergès all address questions of gender and sexuality in Fanon's work. Especially important are the attempts by Mercer and Goldie to address Fanon's work, which has been so crucial to the development of postcolonial theory, from within queer theory: in Mercer's case, to "situate a contemporary re-reading of Fanon in relation to sexual politics as the Achilles heel of black liberation," as he has put it elsewhere (1996: 116); in Goldie's case, to interrogate the status of a figure "who has developed into a focus of hagiography" in postcolonial theory (a structurally similar position to that of Foucault in queer theory), but also to attempt to turn many of Fanon's observations to apply to the oppression of gay men. Goldie's reading of Fanon's account of sharing a bed with an Algerian liberation fighter as "a bonding moment which made him a part of the Algerian revolution" relates directly to the emphasis on Fanon's homophilia argued by feminist critics like hooks and Vergès.

The critical conversation between the feminist readings of Fanon offered in these pages by Chow and Sharpley-Whiting is also worth noting. Neither of the essays fall into the too-easy practice of critiquing Fanon for denying the agency of women, particularly women of color. Indeed, Chow suggests that those critics who take Fanon's "I know nothing about her" at face value

> avoid having to deal with its most important aspect – its self-contradiction – which is a clear indication of Fanon's troubled views about colored female sexuality. By the same gesture, they also avoid having to examine closely the disturbing manner in which Fanon does, in fact, give the woman of color agency.

The problem, for Chow, is that Fanon can only imagine that the agency gained by women of color through their sexuality would make them potential traitors to the postcolonial community, rather than seeing them as potentially "equal, indeed *avant garde*, partners in the production of a future community." Sharpley-Whiting also takes issue with feminist critiques that suggest that Fanon does not grant women of color any agency; in her re-reading of Fanon's critique of Mayotte Capécia in *Black Skin, White Masks*, she suggests that some feminist critics "deny Capécia's agency, or at least circumscribe her autonomy and agency, more than Fanon ever could." In Sharpley-Whiting's reading, Capécia's characters, rather than being simply forced into certain types of behavior by the structure of their racist colonial society, instead engage in particular kinds of actions determined by what she calls their "blackfemmephobia," which they have internalized. Both these critics, then, take the important step beyond simply searching for women's agency (or the

lack thereof) in Fanon's texts, and initiate the process of distinguishing between particular *kinds* of agency – keeping in mind that not every granting of agency is necessarily liberating.

The divergence between these two readings of Fanon's gender politics suggests an important goal of this collection: to contain some of the important disagreements that mark the field of Fanon studies today. Two recent anthologies dealing with Fanon's work might be taken as representative of a split in this field. *The Fact of Blackness: Frantz Fanon and Visual Representation* (Read 1996) concentrates on the ways in which visual artists – particularly Black British artists – have worked with Fanon. On the other hand, *Fanon: A Critical Reader* (1996), to which I have already alluded, concentrates on a sustained re-reading of Fanon's work as a whole. Both books are valuable resources, as the many references to them in the pages that follow suggest. But it is fair to say that there is an unresolved schism between the two books. *The Fact of Blackness* contains essays which more often than not work to critique the limitations of Fanon's work, while the majority of the contributors to *Fanon: A Critical Reader* take a protective attitude towards Fanon, seeking to guard or defend him against such critiques. While the former is a work that comes out of a cultural studies framework and reveals the tendency of such work to privilege *Black Skin, White Masks*, the editors of the latter announce their hostility to cultural studies and favor a more dialectical reading of Fanon which privileges his later work.

The goal of the present volume, which I believe should be the goal of Fanon studies itself at the moment, is to bring together both sets of arguments. More importantly, the task is to generate the kinds of critical conversations that will allow these debates to move forward in a more productive manner. That is, rather than be satisfied with what might be identified as a "for or against" attitude towards Fanon's legacy, the point of this collection is to consider what this legacy might contribute to future cultural, political, and intellectual work.

The three sections of this book represent, not three stages, but rather three sets of approaches to this project. "Re-Reading Fanon's Legacy" contains work which re-examines Fanon's body of work, not as a hermeneutic exercise, but rather to outline the sorts of engagements that must be made with this work if we are to both keep Fanon's significant contributions to cultural politics in play and simultaneously go beyond these contributions. "Fanon and/as Cultural Studies" places Fanon in the context of debates in contemporary cultural studies, especially media studies (Mowitt) and film theory (Kaplan). This section contains divergent attitudes towards Fanon and cultural studies, including John Mowitt's attempt to take up the challenge "to proceed as though Fanon and cultural studies were, if not one and the same, in some sense interchangeable"; Nigel Gibson's intentional "misreading" of the title as "Fanon and/or Cultural Studies"; E. San Juan's revision of it to Fanon *versus* cultural studies; and E. Ann Kaplan's insertion of Fanon's work into the renewed interest in trauma that she observes in contemporary cultural studies.

The final section, "Finding Something Different: Fanon and the Future of Cultural Politics," continues many of the analyses found in the first two sections but goes further, striving to imagine what future cultural work that builds on Fanon's insights might look like: it includes Neil Lazarus's examination of questions of nationalism and representation in postcolonial theory; Kobena Mercer's exploration of postcolonial visual artists whose work has been influenced by Fanon; Gwen Bergner's consideration of the role psychoanalysis might play in contemporary African-American theory and politics; Samira Kawash's reading of Fanon's "spectral violence of decolonization" as that which makes possible the opening of history "to an otherwise that cannot be given in advance, but that is always, like justice, to come"; and François Vergès' analysis of the politics of reparation in Fanon's work and in contemporary French post-slavery communities today.

If this introduction has been intended as a way into Fanon's work, my hope is to also introduce readers to the idea of carrying this work forward into the future. So I will end with three points of my own about Fanon and the future of cultural politics. The first has to do with a concern that future work should not get caught up in the question of whether Fanon's texts are being given sufficient respect in the academy today. This is connected to my concern that some liberal critics have found it all too easy to reduce Fanon's legacy to the question of "recognition," in the most limited sense. This is apparent, for example, in Charles Taylor's "The Politics of Recognition," which tries to make a case for Fanon as a prophet of the sort of multiculturalism which maintains that "recognition forges identity," and thus that the solution to questions of social oppression lies in reform of curricula – allowing for the inclusion of women, minorities, etc. (the "etc." is a staple of such suggestions) (Taylor 1994: 97). But to reduce Fanon's work to a request for this type of recognition is to obscure the fact that when Fanon writes about the life-and-death struggle of master and slave, it is real life and death that are at stake; when he protests against the social construction of blackness, against racism's "epidermal schema" (1967: 112), it is with the understanding that such constructions have the power to kill. The emphasis on the violent struggle for freedom, the awareness, as Lewis R. Gordon puts it, that "one cannot give the Other his freedom, only his liberty" (1995: 69), is central to Fanon's legacy. The kind of cultural and political work that will continue to be inspired by this legacy needs to maintain this sense of urgency.

But this brings me to another concern, one which is the flip side of the first: that Fanon's legacy will be reduced to an incitement to violence under all circumstances.[10] In a review of *The Fact of Blackness*, Julian J. Samuel suggests that the anthology has little to offer those who wish for a new interpretation of Fanon's work because it ignores the question of violence. While I think this misrepresents the book, I do agree with Samuel's point that "it is impossible to discuss Fanon without discussing the many violence-laden Algerias today"

(1997: 64). But it does not necessarily follow that Fanon's message is, as Samuel suggests, "Violence is the only thing the masters listen to. Nothing else."

Ato Sekyi-Otu's Gramscian reading of Fanon in his book *Fanon's Dialectic of Experience* (1996) is particularly important in this context. As Sekyi-Otu argues, "Concerning Violence," the opening chapter of *The Wretched of the Earth* and the text most frequently cited by those who consider Fanon to be primarily a theorist of violence, addresses a colonial situation where no civil or political sphere exists. In such a situation, violence is in fact the only response. Fanon is thus suggesting "with the most classical of political philosophers that where there is no public space, there is no political relationship, only violence, 'violence in a state of nature' " (Sekyi-Otu 1996: 86–7). But such a model is hardly transferable to every political situation. For one thing, "the masters" are not always the same sets of people, as Fanon points out later in *The Wretched of the Earth*: "everything seemed to be so simple before: the bad people were on one side, and the good on the other" (1963: 145). What needs to be stressed, against a tendency to read "Concerning Violence" as the major argument of *The Wretched of the Earth* (or indeed of Fanon's entire body of work), is that this chapter is meaningless except when read together with the later chapters "Spontaneity: Its Strengths and Weaknesses" and "The Misadventures of National Consciousness."

The question of producing a contextualized reading of Fanon brings me to my final point, which has to do with the persistent division between *Black Skin, White Masks* and *The Wretched of the Earth* – a division that continues to proliferate in Fanon studies. In readings that valorize Fanon's later work his earlier text is often characterized as one which, in Cedric Robinson's words, never quite manages to "slough off its petit-bourgeois stink" (1993: 82). On the other hand, as I've suggested about Bhabha's reading of Fanon, the opposite has also occurred: a tendency to read backwards from *The Wretched of the Earth* to *Black Skin, White Masks*, and a consequent tendency to privilege the latter over the former.

I want to suggest that a particularly powerful way to read these two texts together, in order to consider their potential for contributing to the future of cultural politics, is to use them to remember Fanon's precarious position within the Algerian Revolution. This is a point that can be lost when one reads *The Wretched of the Earth*, or indeed the essays collected in *A Dying Colonialism* or *Toward the African Revolution*, since Fanon's rhetoric in these texts increasingly becomes that of a dying man who has earned his way into a revolutionary movement through his courageous actions. But the passage that might make us reconsider Fanon's position toward the Algerian Revolution, and the lesson this position holds for us today, comes from the conclusion of *Black Skin, White Masks*:

> It is obvious – and I will never weary of repeating this – that the quest
> for disalienation by a doctor of medicine born in Guadeloupe can be

understood only by recognizing motivations basically different from those of a black laborer building the port facilities in Abidjan.

(1967: 223)[11]

This quote is often used to defend Fanon against the charge leveled by some Marxist critics, which is that he simply replaces the analysis of class with that of race, and is thus able to ignore his own class position (this is the burden of Robinson's attack on Fanon's early work). But what also comes through in this passage is Fanon's discomfort in recognizing the different forms of alienation experienced by himself and by the black colonial proletariat, and the resulting, undeniable space between them. It is this discomfort that needs to be kept in mind as we read Fanon's later work. *The Wretched of the Earth*, read in such a way, becomes an incredibly enabling model of the way an intellectual can put herself or himself at the service of a political struggle which is not "organically" hers or his. The disavowal of the Antilles which Vergès finds in Fanon's work is undoubtedly there – although it must be stressed that it is a disavowal motivated, at least to some extent, by the political circumstances of Martinique. But also present in Fanon's relationship to the Algerian Revolution is an attempt at affiliation, in Edward Said's sense (1983: 18–21). It is from this disjunction between the Antilles, France, and Algeria that Fanon's struggle to establish what I have elsewhere called a "transnational humanism" arises (Alessandrini 1998). And it is as a result of this disjunction that we can identify a Fanon who is more cosmopolitan than we might imagine at first glance. Discovering this Fanon means occasionally reading against the grain, for there is certainly also the Fanon for whom "cosmopolitan identification...serves as the thin, abstract, undesirable antithesis to a red-blooded, politically engaged nationalism" (Robbins 1998: 4, 15 n. 16). But this is, we must remember, the position of a theorist and practitioner who could never be entirely certain of his own connection to that "red-blooded" nationalism. It is also precisely the sort of complexity we might expect from a Fanon who, in Stuart Hall's words, "is bound to unsettle us from whichever direction we read him" (1996: 35). It is this Fanon who challenged us, with his dying words, to "find something different." I can think of no better challenge for cultural politics today.

NOTES

1 See the bibliography for a more complete list of biographical sources. For recent, brief biographical sketches of Fanon, see Gordon, Sharpley-Whiting, and White (1996: 1–5) and David Macey (1997: 69–76). Deborah Wyrick (1998) provides an accessible and thorough introduction to Fanon's life and work.

2 Fanon's training and practice, as Françoise Vergès has pointed out, was as a psychiatrist, not a psychoanalyst. While Fanon's work certainly is influenced by and deals with psychoanalytic theory – as, for example, in his engagements with Lacan, Mannoni, and Adler in *Black Skin, White Masks* – Vergès's point is an important one: "The desire to see Fanon *as a psychoanalyst* (which he never was) has often led postcolonial critics to ignore that, *as a psychiatrist*, he tried to redefine the goal and

practice of psychiatry from within" (1996b: 85; see also 1996a; 1997). See also Hortense Spillers's remarks on Fanon's ambivalent attitude towards psychoanalysis:

> While Fanon offers our clearest link to psychoanalysis in the African/third world field, there is sufficient enough doubt concerning the efficacy of psychoanalysis, implied in some of his writings, that he appears to withdraw with the left hand what he has proffered with the right.
>
> (1996: 89)

3 See the essays in this volume by Samira Kawash, E. Ann Kaplan, and Gwen Bergner for more on these case studies.
4 See the essay by Michael Azar in this volume for more on this passage.
5 See for example Collotti-Pischel (1962); Nghe (1963); Armah (1967); Marton (1969); Staniland (1969); Martin (1970); Zolberg (1970); Woddis (1972); Worsley (1972); Beckett (1973); Perinbam (1973); Clegg (1979). Wallerstein (1979) provides an excellent overview of these debates.
6 Readers might also consult, for various reactions to Bhabha's readings of Fanon: Parry (1987; 1994); Young (1990); Gates (1991); Mowitt (1992); Robinson (1993); Fuss (1994); Bergner (1995); Gordon (1995); Julien (1995); Gordon *et al.* (1996); Read (1996); Sekyi-Otu (1996); Moore-Gilbert (1997); Vergès (1997); Gibson (1998; 1999); San Juan (1998); Sharpley-Whiting (1998); Wyrick (1998).
7 In Bhabha's most recent reading of what he calls "the emergency of the (insurgent) everyday" in Fanon's work, a similar concern with strategies of cultural politics can be discerned (1996: 188).
8 I agree with Spillers that this throwaway line, "with its riff on Freud and 'female sexuality,' " actually comes off in the context of Fanon's argument as "rather playful" (Spillers 1996: 95). When it is juxtaposed with Fanon's other comments on gender, however, it cannot help but be taken rather more seriously – a point of which Spillers is also aware.
9 See, for a start, Decker (1990); Lazreg (1990); Zimra (1990); Doane (1991); Dollimore (1991); Ismail (1991); Andrade (1993); Edelman (1994); Fuss (1994); Moi (1994); Bergner (1995); Schwartz (1995); Elia (1996); hooks (1996); Mercer (1996); Moore-Gilbert (1996); Sekyi-Otu (1996); Sharpley-Whiting (1996; 1998); Spillers (1987; 1996); Young (1996); Vergès (1996a; 1996b; 1997); Kaplan (1997); Sandoval (1997).
10 Samira Kawash's essay in this volume is a particularly important example of the sort of work which addresses the issue of violence in Fanon's work with the required nuance.
11 Neil Lazarus also addresses this passage in his essay in this volume.

REFERENCES

Alessandrini, A.C. (1997) "Fanon and the Post-Colonial Future," *Jouvert* 1, 2 (online).
—— (1998) "Humanism in Question: Fanon and Said," in S. Ray and H. Schwartz (eds) *A Companion to Postcolonial Studies*, Cambridge, MA: Blackwell.
Andrade, S. (1993) "The Nigger of the Narcissist: History, Sexuality, and Intertextuality in Maryse Condé's *Heremakhonon*," *Callaloo* 16,1: 219–31.
Arendt, H. (1969) *On Violence*, New York: Harcourt Brace Jovanovich.
Armah, A.K. (1967) "African Socialism: Utopian or Scientific?" *Présence Africaine* 64, 4: 6–30.
Beckett, P.A. (1973) "Algeria vs. Fanon: The Theory of Revolutionary Decolonization and the Algerian Experience," *Western Political Quarterly* 26, 1: 5–27.

Bergner, G. (1995) "Who Is That Masked Woman? or, The Role of Gender in Fanon's *Black Skin, White Masks,*" *PMLA* 110, 1: 75–88.

Bhabha, H.K. (1994) "Remembering Fanon: Self, Psyche and the Colonial Condition," in P. Williams and L. Chrisman (eds) *Colonial Discourse and Post-Colonial Theory: A Reader,* New York: Columbia University Press.

—— (1996) "Day by Day...with Frantz Fanon," in A. Read (ed.) *The Fact of Blackness: Frantz Fanon and Visual Representation,* Seattle: Bay Press.

Bulhan, H.A. (1985) *Frantz Fanon and the Psychology of Oppression,* New York: Plenum.

Caute, D. (1970) *Frantz Fanon,* New York: Viking.

Clegg, I. (1979) "Workers and Managers in Algeria," in R. Cohen, P.C.W. Gutkind, and P. Brazier (eds) *Peasants and Proletarians: The Struggles of Third World Workers,* New York: Monthly Review Press.

Collotti-Pischel, E. (1962) " 'Fanonismo' e 'Questione Coloniale,' " *Problemi del Socialismo* 5: 843–64.

Coser, L. (1970) "Fanon and Debray: Theorists after the Third World," in I. Howe (ed.) *Beyond the New Left,* New York: McCall.

Decker, J.L. (1990) "Terrorism (Un)Veiled: Frantz Fanon and the Women of Algeria," *Cultural Critique* 17: 177–98.

Doane, M.A. (1991) "Dark Continents: Epistemologies of Racial and Sexual Difference in Psychoanalysis and the Cinema," in *Femmes Fatales: Feminism, Film Theory, Psychoanalysis,* New York: Routledge.

Dollimore, J. (1991) *Sexual Dissidence: Augustine to Wilde, Freud to Foucault,* New York: Oxford University Press.

Edelman L. (1994) "The Part for the (W)Hole: Baldwin, Homophobia, and the Fantasmatics of 'Race,' " in *Homographesis: Essays in Gay Literary and Cultural Theory,* New York: Routledge.

Elia, N. (1996) "Violent Women: Surging into Forbidden Quarters," in L.R. Gordon, T.D. Sharpley-Whiting, and R.T. White (eds) *Fanon: A Critical Reader,* Cambridge, MA: Blackwell.

Fanon, F. (1963) *The Wretched of the Earth,* trans. C. Farrington, New York: Grove.

—— (1965) *A Dying Colonialism,* trans. H. Chevalier, New York: Grove.

—— (1967) *Black Skin, White Masks,* trans. C.L. Markmann, New York: Grove.

—— (1988) *Toward the African Revolution,* trans. H. Chevalier, New York: Grove.

Fuss, D. (1994) "Interior Colonies: Frantz Fanon and the Politics of Identification," diacritics 24, 2–3: 215–27; reprinted in *Identification Papers,* New York: Routledge, 1995.

Gates, H.L. (1991) "Critical Fanonism," *Critical Inquiry* 17, 3: 457–70.

Geismar, P. (1971) *Fanon: The Revolutionary as Prophet,* New York: Grove.

Gendzier, I.L. (1973) *Frantz Fanon: A Critical Study,* New York: Grove.

Gibson, N. (1998) *Frantz Fanon,* New York: Polity Press.

—— (ed.) (1999) *Fanon and Fanonism,* Atlantic Highlands, NJ: Humanities Press.

Gordon, L.R. (1995) *Fanon and the Crisis of European Man: An Essay on Philosophy and the Human Sciences,* New York: Routledge.

Gordon, L.R., Sharpley-Whiting, T.D., and White, R.T. (eds) (1996) *Fanon: A Critical Reader,* Cambridge, MA: Blackwell.

Hall, S. (1995) "Negotiating Caribbean Identities," *New Left Review* 209: 3–14.

—— (1996) "The After-life of Frantz Fanon," in A. Read (ed.) *The Fact of Blackness: Frantz Fanon and Visual Representation,* Seattle: Bay Press.

hooks, b. (1996) "Feminism as a Persistent Critique of History: What's Love Got to Do with It?" in A. Read (ed.) *The Fact of Blackness: Frantz Fanon and Visual Representation*, Seattle: Bay.

Ismail, Q. (1991) "Boys Will Be Boys: Gender and National Agency in Frantz Fanon and the Liberation Tigers of Tamil Eelam," *South Asia Bulletin* 11, 1: 79–83.

Jinadu, L.A. (1986) *Fanon: In Search of the African Revolution*, London: KPI.

Julien, I. (1995) *Frantz Fanon: Black Skin, White Mask*, Normal Film.

Kaplan, E.A. (1997) *Looking for the Other: Feminism, Film, and the Imperial Gaze*, New York: Routledge.

Lazreg, M. (1990) "Feminism and Difference: The Perils of Writing as a Woman on Women in Algeria," in M. Hirsch and E.F. Keller (eds) *Conflicts in Feminism*, New York: Routledge.

Macey, D. (1997) "Fort-de-France," *Granta* 59 (*France: The Outsider*): 61–76.

Martin, T. (1970) "Rescuing Fanon from the Critics," *African Studies Review* 13, 3: 381–99.

Marton, I. (1969) *Tereszmek a Hardmadik Vilagban: Leopold Sedar Senghor, Aimé Césaire es Frantz Fanon*, Budapest: Kossuth Konyvkiado.

Mercer, K. (1996) "Decolonization and Disappointment: Reading Fanon's Sexual Politics," in A. Read (ed.) *The Fact of Blackness: Frantz Fanon and Visual Representation*, Seattle: Bay Press.

Moi, T. (1994) *Simone de Beauvoir: The Making of an Intellectual Woman*, Cambridge, MA: Blackwell.

Moore-Gilbert, B. (1996) "Frantz Fanon: En-gendering Nationalist Discourse," *Women: A Cultural Review* 7, 2: 125–35.

—— (1997) *Postcolonial Theory: Contexts, Practices, Politics*, New York: Verso.

Mowitt, J. (1992) "Algerian Nation: Fanon's Fetish," *Cultural Critique* 22: 165–86.

Nghe, N. (1963) "Frantz Fanon et le Problème de L'Indépendence," *La Pensée* 107: 23–36.

Parry, B. (1987) "Problems in Current Theories of Colonial Discourse," *Oxford Literary Review* 9, 1–2: 27–58.

—— (1994) "Resistance Theory/Theorizing Resistance, or Two Cheers for Nativism," in F. Barker, P. Hulme, and M. Iversen (eds) *Colonial Discourse/Postcolonial Theory*, Manchester: Manchester University Press.

Perinbam, M. (1973) "Fanon and the Revolutionary Peasantry: The Algerian Case," *Journal of Modern African Studies* 11, 3: 440–2.

Read, A. (ed.) (1996) *The Fact of Blackness: Frantz Fanon and Visual Representation*, Seattle: Bay Press.

Robbins, B. (1998) "Introduction Part I: Actually Existing Cosmopolitanism," in P. Cheah and B. Robbins (eds) *Cosmopolitics: Thinking and Feeling Beyond the Nation*, Minneapolis: University of Minnesota Press.

Robinson, C. (1993) "The Appropriation of Frantz Fanon," *Race & Class* 35, 1: 79–91.

Said, E.W. (1983) *The World, the Text, and the Critic*, Cambridge, MA: Harvard University Press.

Samuel, J.J. (1997) "Ignoring the Role of Violence in Fanon: Playing with the Bones of a Hero," *Fuse Magazine* (May): 63–4.

Sandoval, C. (1997) "Theorizing White Consciousness for a Post-Empire World: Barthes, Fanon, and the Rhetoric of Love," in R. Frankenberg (ed.) *Displacing Whiteness: Essays in Social and Cultural Criticism*, Durham, NC: Duke University Press.

San Juan, E. (1998) *Beyond Postcolonial Theory*, New York: St. Martin's.

Schwartz, S. (1995) "Fanon's Revolutionary Women," *UTS Review* 1, 2: 197–201.

Sekyi-Otu, A. (1996) *Fanon's Dialectic of Experience*, Cambridge, MA: Harvard University Press.

Serequeberhan, T. (1994) *The Hermeneutics of African Philosophy*, New York: Routledge.

Sharpley-Whiting, T.D. (1996) "Anti-Black Femininity and Mixed-Race Identity: Engaging Fanon to Reread Capécia," in L.R. Gordon, T.D. Sharpley-Whiting, and R.T. White (eds)*Fanon: A Critical Reader*, Cambridge, MA: Blackwell.

—— (1998) *Frantz Fanon: Conflicts and Feminisms*, Lanham, MD: Rowman and Littlefield.

Spillers, H. (1987) "Mama's Baby, Papa's Maybe: An American Grammar Book," *diacritics* 17, 2: 65–82.

—— (1996) " 'All the Things You Could Be by Now If Sigmund Freud's Wife Was Your Mother': Psychoanalysis and Race," *Boundary 2* 23, 3: 75–142.

Staniland, M. (1969) "Frantz Fanon and the African Political Class," *African Affairs* 68, 270: 4–25.

Sutton, H. (1971) "Fanon," *Saturday Review of Literature* 17 July: 16–19, 59–61.

Taylor, C. (1994) "The Politics of Recognition," in D.T. Goldberg (ed.) *Multiculturalism: A Critical Reader*, Cambridge, MA: Blackwell.

Vergès, F. (1996a) "Chains of Madness, Chains of Colonialism: Fanon and Freedom," in A. Read (ed.) *The Fact of Blackness: Frantz Fanon and Visual Representation*, Seattle: Bay Press.

—— (1996b) "To Cure and to Free: The Fanonian Project of 'Decolonized Psychiatry,' " in L.R. Gordon, T.D. Sharpley-Whiting, and R.T. White (eds) *Fanon: A Critical Reader*, Cambridge, MA: Blackwell.

—— (1997) "Creole Skin, Black Mask: Fanon and Disavowal," *Critical Inquiry* 23, 3: 578–95.

Wallerstein, I.M. (1979) "Fanon and the Revolutionary Class," in *The Capitalist World-Economy*, New York: Cambridge University Press.

Woddis, J. (1972) "Fanon and Classes in Africa," in *New Theories of Revolution*, New York: International Publishers.

Worsley, P. (1972) "Fanon and the 'Lumpenproletariat,' " in R. Miliband and J. Savile (eds) *Socialist Register*, London: Merlin Press.

Wyrick, D. (1998) *Fanon for Beginners*, New York: Writers and Readers.

Young, L. (1996) "Missing Persons: Fantasizing Black Women in *Black Skin, White Masks*," in A. Read (ed.) *The Fact of Blackness: Frantz Fanon and Visual Representation*, Seattle: Bay Press.

Young, R. (1990) *White Mythologies: Writing History and the West*, New York: Routledge.

Zimra, C. (1990) "Righting the Calabash: Writing History in the Female Francophone Narrative," in C.B. Davies and E.S. Fido (eds) *Out of the Kumbla: Caribbean Women and Literature*, Trenton, NJ: Africa World Press.

Zolberg, A.R. (1970) "Frantz Fanon," in *The New Left: Six Critical Essays*, New York: Library Press.

Zolberg, A.R. and Zolberg, V.B. (1966) "The Americanization of Frantz Fanon," *Public Interest* 9.

Part I

RE-READING FANON'S LEGACY

2

IN THE NAME OF ALGERIA

Frantz Fanon and the Algerian Revolution

Michael Azar

Let us consider this remarkable passage from *The Wretched of the Earth*:

> The West saw itself as a spiritual adventure. It is in the name of the spirit, in the name of the spirit of Europe, that Europe has made her encroachments, that she has justified her crimes and legitimized the slavery in which she holds four-fifths of humanity. Yes, the European spirit has strange roots.
>
> (Fanon 1967: 252; 1991: 373)

Fanon emphasizes the dialectical movement of the spirit: on the one hand it is exposed as a mere "European spirit," as a false universalism based on "strange roots," and accordingly a disaster for the majority of humanity; on the other, through the subtle distinction between the spirit and its strictly European embodiment implicit throughout Fanon's work, the spirit itself is rehabilitated as a living force still in the service of a new humanism. The very moment the spirit is detached from its European formation we must therefore interrogate Fanon as to what kind of new spirit he invokes to replace the old one. Who are the "we" designated by Fanon as capable of transcending the "strange roots" of European humanism? Who are the "comrades" chosen to "turn over a new leaf," to "work out new concepts" and, as he writes in the concluding line, to try to "set afoot a new Man"?

The movement of the spirit is, more precisely, a condition of possibility for Fanon's invocation of a new humanism. It warrants the "both...and" which defines Fanon's affinity to Hegelian thought, indicates its intimate knowledge of the problematic dialectic of universalism and situates the new historical subject, the very "we" that Fanon invokes, inside the framework of a historical *Aufhebung*. The journey towards real humanism must have as its point of departure a new foundation, a new spirit that may overcome the antinomies of the European spirit, without neglecting the "prodigious theses which Europe has put forward" (Fanon 1967: 252; 1991: 373).

This complex of problems is the focus of this essay. We are in the presence of a mode of reasoning which constantly undermines absolute oppositions:

21

Fanon's dialectic involves both learning and transcendence from Europe, both a critique of humanism and an emphasis on its necessity, both a revolt against and a rehabilitation of Hegel; a dialectic strategically concerned with the actual war between the master and the slave, the colonizer and the colonized, taking place in the country that Fanon's destiny gradually had come to coincide with: Algeria. Algeria becomes the name of the historical subject, the spirit, that Fanon invokes to transcend the antinomies that have marked the history of mankind.

THE DOUBLE BIND OF MANICHEISM

What are, more precisely, the antinomies? What are the historical and philosophical problems that Fanon tries to analyze and overcome? Fanon's first work, *Black Skin, White Masks* (1952), can be read as a critical reflection of four contradictory experiences: the encounter with Martinican reality, with France, with the reality of colonialism in North Africa, and with certain formations of thought. *Black Skin, White Masks* deepens the revolutionary reappraisal of Europe and the West, already initiated by thinkers like Aimé Césaire, Léopold Sédar Senghor and Léon Damas. Jean-Paul Sartre is given a central place among the thinkers both set to work and criticized in this critical mission – the liberation of Man. A passage from Sartre's *Anti-Semite and Jew* (1946), accounting for the Jew's situation in an anti-Semitic society, offers some conceptual tools for Fanon's analysis of the colonized people's experience of the European spirit:

> Such, then, is this haunted man [the Jew], condemned to make his choice of himself on the basis of false problems and in a false situation, deprived of metaphysical sense by the hostility of the society that surrounds him, driven to a rationalism of despair. His life is nothing but a long flight from others and himself. He has been alienated even from his body; his emotional life has been cut up in two; he has been reduced to pursuing the impossible dream of universal brotherhood in a world that rejects him.
>
> (Sartre 1995: 135; 1954: 164)

In the colonial situation, Fanon stresses, this logic finds its equivalent expression: *Turn White or Disappear*. The crucial moment for every struggle for liberation lies in the question of how this contradiction is to be resolved, in the question of how a true liberation can avoid the double-bind that seems to bind the revolution to a logic of substitution, threatening to reproduce the Manichean structure:

- Either the black man is doomed to escape the gaze of the white man, the violence and mechanisms of exclusion in the colonial system, by entering the white side of the dividing line, by melting together with the Other to such an extent that his blackness no longer can be detected. The colonized becomes "free" by rejecting himself, by fulfilling his desire to turn white.
- Or he is forced to affirm his blackness by positing himself against the white man and by all means necessary endeavoring to replace him on the throne. The colonized becomes "free" by learning to master the logic of the Manichean order more thoroughly than the colonizer, by imitating his methods in order to outwit the master at his own game.

Sartre's remarks on the hopelessness of this situation, of the dream of a "universal brotherhood," allude precisely to the tragic conditions of this choice: no matter what the slave does, *he is bound to reproduce the very order of things and identities that he attempts to destroy.* In both cases the odious structure, embodied by the master, remains – the difference between the two alternatives is merely a shifting of places between the master and the slave.

Fanon's specific project involves both a careful examination of this dilemma and an effort to transcend it. While the early Sartre ends up in a profound pessimism over the basic hopelessness of the human condition, in the designation of man as a "passion inutile" and of the impossibility of any "we" becoming a unified subjectivity, Fanon continues to assert the dream of universal brotherhood and thus starts in reverse order: "Today I believe in the possibility of love; that is why I endeavor to trace its imperfections, its perversions" (1986: 42; 1952: 33). Fanon discerns a space beyond the fundamental positions of subjectivity that colonialism creates. Between lordship and bondage, between "turn white or disappear," Fanon introduces a mediation, a dialectic of reconciliation.

THE FANONIAN "I" BETWEEN FRANCE AND ALGERIA

From the middle 1950s a radical dislocation takes place in Fanon's universe. It is clear already from how Fanon locates his own "I": it is no longer "we Frenchmen," or "we Martinicans," but rather "we Algerians." Fanon has chosen to take part in this new historical formation, chosen to answer and recognize himself in its interpellation, and at the same time designate it as the foundation for a new humanism.[1]

The decisive factor for his conversion is, of course, his close encounter with the ongoing war for independence in Algeria. One year after his dissertation at the faculty of medicine in Lyon in 1952, Fanon was offered a position as *chef de service* at the Blida-Joinville Psychiatric Clinic, outside of Algiers. As Simone de Beauvoir recalls, this period came to be a genuine trial for Fanon. His loyalty

23

both to France and the colonized population was stretched to the limit. He could, for instance, treat both torturers and tortured on the same day. It was also here that he came into contact with the FLN (Front de Libération Nationale) and, in 1956, finally chose to resign in order to join the liberation movement.[2] The contractions were no longer possible for him to bear and "the duty of the citizen," as Fanon writes in his letter of resignation, forced him to condemn the "systematized dehumanization" of the Algerians:

> There comes a time when silence becomes dishonesty. The ruling intentions of personal experience are not in accord with the permanent assaults on the most commonplace values. For many months my conscience has been the seat of unpardonable debates. And the conclusion is the determination not to despair of man, in other words, of myself. The decision I have reached is that I cannot continue to bear a responsibility at no matter what cost, on the false pretense that there is nothing else to be done.
>
> (1988: 54; 1969: 52–3)

In Algeria the violence and exploitation of the colonial power had indeed taken on atrocious forms. Fanon realizes that no real "assimilation" or "integration" is possible inside the colonial hierarchy: the promises of assimilation, freedom and equality have their conditions of impossibility in the very colonial reality they try to legitimate. The frontiers, instituted by violence since 1830, were not accidental creations bound to be abrogated in the name of French civilization and equality. Rather, they were the fundamental requests for the double investments of colonialism: on the one hand, Fanon points out, colonialism is fighting to strengthen its domination and economic exploitation; on the other, it is fighting "to maintain the image it had of the Algerian and the depreciated image that the Algerian had of himself" (1989: 30; 1968: 12). The dividing line between "the master" and "the slave" is the very basis for the French colonial empire, the founding principle for the designation of France as the embodiment par excellence of the universal subject endowed with a mission to globalize itself.

Of course, Fanon was not the first to expose this paradox in the ideology and reality of *L'Algérie Française*. Critical voices had long been raised, not only among other *évolués* in the different colonies of France, but also among French intellectuals (see Girardet 1972; Sirinielli and Rioux 1991). In this respect, Albert Camus, born as a *pied noir* in colonial Algeria, is of particular interest. Already in 1939 Camus had launched a harsh criticism against the shortcomings of the colonial system and, after the massacres in Sétif and Guelma in 1945, he declared that France must take responsibility for the rights of the "natives." In contrast to Fanon, however, Camus never takes the crucial step from "Frenchman" to "Algerian": in fundamental respects, he remains a spokesman for *L'Algérie Française*. France always remains the exclusive subject and thus

"the best future possibility of the Arab peoples" ("la meilleure chance d'avenir au peuple arabe") (Camus 1965: 980). In Camus, we won't be able to find the displacement found in Fanon, which involves nothing less than the replacement of France with Algeria.[3] Or, put in other terms, Camus maintains the colonial mythology that Fanon criticizes so thoroughly in *The Wretched of the Earth*. According to it, the life of the colonizer is "an epoch, an Odyssey":

> He is the absolute beginning: "This land was created by us"; he is the unceasing cause: "If we leave, all is lost, and the country will go back to the Middle Ages."...And because he constantly refers to the history of the mother country, he clearly indicates that he himself is the extension of that mother country.
>
> (Fanon 1967: 39–40; 1991: 82)

THE ALGERIAN SPIRIT: BETWEEN ARISTOTLE AND HEGEL

In order to grasp how Fanon conceives the movement which shall replace France with Algeria, transcend the antinomies of the European spirit and expose the contradictions of colonialism, we have to scrutinize more closely how he posits the logic of the colonial *dividing line*. In *The Wretched of the Earth* we find a very precise description:

> The colonial world is a world cut in two. The dividing line, the frontiers, are shown by barracks and police stations....The two zones are opposed, but not in service of a higher unity. Obedient to the rules of pure Aristotelian logic, they both follow the principle of reciprocal exclusivity. No conciliation is possible, for of the two terms, one is superfluous.
>
> (1967: 29–30; 1991: 68–9)

This tension is a guiding principle in Fanon's narrative: on the one hand the Aristotelian logic, with its mutually exclusive oppositions; on the other, the Hegelian logic which stages the lack, the contradiction in the Aristotelian logic itself, by introducing a subversive negation. Thus, first the Aristotelian logic exemplified by the master in *Black Skin, White Masks*; beyond the Hegelian dialectic he only "laughs at the consciousness of the slave. What he wants of the slave is not recognition but work" (1986: 220; 1952: 179). The slave is *de trop*. Secondly, the Hegelian logic which reminds both the master and the slave that the order of things is contingent and reversible. While the slave hereby becomes alert for any possibility of putting himself in the place of the colonizer, the master is compelled to guard the dividing line with "terrible watchdogs." Hegel is *always already* deconstructing Aristotle from within.[4] The breakdown of the

Manichean structure is accordingly staged already in Fanon's appeal to the colonized peoples to "make history" and to start a "new history of Man."

It also becomes clear that it is in this new dialectical upheaval that we must seek both Fanon's theory of violence and his conception of Algeria's place in the *global* revolution against colonialism. The Aristotelian and the Hegelian systems of logic have, according to Fanon, a common denominator in the necessity of violence: in both cases the master must be overthrown with violence. Colonialism "is violence in its natural state, and it will only yield when confronted with greater violence" (1967: 48; 1991: 98).

However, a fundamental difference remains: the moment his theory of violence is based upon an Aristotelian conception, Fanon will be trapped inside the scope of the double-bind and thus reproduce the Manichean logic. The violence will not upset its logic of substitution and the slave that yields to pure force will only be tomorrow's master. Here, it is actually the colonizer that shows him the way:

> He [the native] of whom they have never stopped saying that the only language he understands is that of force, decides to give utterance by force. In fact, as always, the settler has shown him the way he should take if he is to become free. The argument the native chooses has been furnished by the settler, and by an ironic turning of the tables it is the native who now affirms that the colonialist understands nothing but force.
>
> (1967: 66; 1991: 116)

It is precisely here that we find Fanon's greatest challenge. How can Algeria replace France without reproducing its ideology and colonial structures? Under what circumstances is it possible to create a "new humanism," a new kind of nationalism and a social structure that doesn't reflect the colonial system? Is there a universal brotherhood beyond the Aristotelian logic?

The invocation of Hegel implies a fundamental promise in Fanon's thoughts on violence. In Jean-Paul Sartre's "Preface" to *The Wretched of the Earth*, this promise finds its most hopeful expression: "To shoot down a European is to kill two birds with one stone, to destroy an oppressor and the man he oppresses at the same time: there remain a dead man, and a free man" (1967: 19; 1991: 52). It is on the level of liberation and freedom that the fundamental difference between the Aristotelian and Hegelian logic must be found. In the first case, liberation is primarily a question of transcending the dividing line, penetrating the other zone guided by its terrible watchdogs, and taking the colonizer's place. In the other, the aim is to abolish the dehumanizing system of colonialism at its very roots, to liberate both the colonizer and the colonized. As Fanon points out in the introduction to *A Dying Colonialism*, an independent Algeria must not be "the result of one barbarism replacing another barbarism, of one crushing of man replacing another crushing of man" (1989: 32; 1968: 15).

Already in *Black Skin, White Masks* this is one of the principal themes: a true liberation must involve a radical dissolution, not only, or even primarily, of the physical violence of the colonial-racist situation, but ultimately a dissolution of the inferiority complex and the alienation epidermalized in the colonized. In his comments on Hegel, Fanon designates violence as the very negation that can crush the atmosphere of submission that holds the slave as a captive of himself. Choosing violence is from this perspective nothing less than choosing an existence that transcends mere life, to risk death for the foundation of a subjectivity and freedom (*être-pour-soi*) of one's own:

> I demand that notice be taken of my negating activity insofar as I pursue something other than life; insofar as I do battle for the creation of a human world – that is, of a world of reciprocal recognitions.…Historically, the Negro steeped in the inessentiality of servitude was set free by his master. He did not fight for it.
>
> <div align="right">(1986: 218–19; 1952: 177)</div>

In *The Wretched of the Earth* this analysis, woven together subtly by Hegelian and psychoanalytical elements, is further developed: the colonized "thing," Fanon writes, becomes human during the same process by which it frees itself (1967: 28; 1991: 67).[5] He continues:

> The well-known principle that all men are equal will be illustrated in the colonies from the moment that the native claims that he is the equal of the settler.…Thus the native discovers that his life, his breath, his beating heart are the same as those of the settler. He finds out that the settler's skin is not of any more value than a native's skin; and it must be said that this discovery shakes the world in a very necessary manner. All the new, revolutionary assurance of the native stems from it.
>
> <div align="right">(1967: 34–5; 1991: 75–6)</div>

The moment the gaze of the colonizer no longer paralyzes the colonized, the first step is taken towards the destruction of the two zones: nobody can be a lord when the slaves are missing. However, some fundamental questions arise: on what – besides violence – shall the liberated nation be founded? What remains of the newly won unity the moment the most unifying element – the enemy – has been conquered? How shall the future Algeria be organized?

Again, the conceptual tools put forward by Sartre in *Anti-Semite and Jew* can serve as a starting-point. The Manichean ideology of anti-Semitism is here designated as a pure, abstract negation, a social movement rooted only in the call for an eradication of the Other:

Therefore Good consists above all in the destruction of Evil. Underneath the bitterness of the anti-Semite is concealed the optimistic belief that harmony will be re-established of itself, once Evil is eliminated. His task is therefore purely negative: there is no question of building a new society, but only of purifying the one which exists.

(Sartre 1995: 43; 1954: 50)

In Fanon this analysis becomes a critical weapon of self-examination. For Algeria to become a country that is "open to all" and, as Fanon writes, a society "in which every kind of genius may grow," certain pitfalls must be avoided (1989: 32; 1968: 15). Let us examine them more closely.

FROM FRENCH ALGERIA TO AFRICAN ALGERIA

A reading of Fanon's articles in *El Moudjahid*, the FLN mouthpiece, indicates how "Algeria" gradually becomes charged with a modified significance and function.[6] It appears as a moment in a wider destiny, a process that transcends the national consciousness and the national revolution. "We Algerians" are now intimately linked to a new subject: "We Africans." Fanon's ultimate aim seems to be the conceptualization of the conditions of possibility for a unified Africa, even a "United States of Africa" (1988: 187; 1969: 185). Algeria's function in the war against colonialism is thus to pave the way, to uncover the contradictions in the French colonial policy, *to stage the weakness of the master by exposing him to the persistent and violent will of the former slaves.* Put in Hegelian terms: Algeria is the negation – "the most active and also the truest element in this dialectic" (1988: 112; 1969: 115) – that stages the historical contingency of French colonialism by showing that its power only resides upon the submission of the colonized. From this perspective, the Algerian revolution becomes nothing less than the "scandal" that "upsets the established balances, the accepted truths and fundamentally challenges the prospects of the French nation" (1988: 111; 1969: 114). Several texts address themselves directly to the people of the African continent, urging them to follow the example of Algeria. The Algerian struggle becomes both the weak point of the colonial system and "the rampart of the African peoples":

The war of liberation of the Algerian people has spread the gangrene and carried the rot of the system to such a point that it has become obvious to observers that a global crisis must result....When we address ourselves to colonial peoples, and more especially to the African peoples, it is because we have to hurry to build Africa, so that it will express itself and come into being, so that it will enrich the world of men, and so that it may be authentically enriched by the world's contributions.

(1988: 114–15; 1969: 118–19)

Fanon uncovers the logic which is at stake on both sides: for France "Algeria" is the scandal, the contradiction, that must be concealed; for Algeria its possible success would constitute itself as a "guide territory," paving the way for other oppressed peoples to continue the struggle against colonialism. The guide territory, Fanon writes, functions as "an invitation, an encouragement, a promise." In this process the colonized peoples gradually come to know their real enemy and each struggle for independence is, therefore, "dialectically linked to the struggle against colonialism in Africa" (1988: 171; 1969: 173).

Such a revolutionary consciousness is, however, yet to be formed. Fanon's experiences of the newly independent states in Africa filled him with doubt. No humanism would spring automatically from the defeat of the colonial power. Colonialism threatens to be replaced by a "pseudo-independence." Fanon observes that the greatest menaces to the future of Africa are to be found in the absence of ideology, the great appetites from the national middle classes who believe that they "can conduct political affairs like their business," the nationalist parties' distrust toward the rural masses, and finally the new state's extreme mili-tarist policy, which together create a repression as pitiless as that of the colonial periods.

In *The Wretched of the Earth* these warnings find their most pregnant expression. The tragic reality that plagues many postcolonial states in Africa bears witness to Fanon's remarkable gift of prophecy (see Taiwo 1996). The common front, mobilized and formed during the war against the colonial power, is threatened by disintegration the very moment the enemy has been physically vanquished. The nation's lack of common interests is now exposed, and it becomes necessary to transform the energies of spontaneity into political organization. Fanon insists on "the objective necessity of a social program which will appeal to the nation as a whole" (1967: 97; 1991: 160). A nation that aspires to democracy can be built neither upon the eradication of the enemy as the only means of preserving unity amongst its own people, nor on the notion of a given identity and solidarity inherent *a priori* in the nation:

> The people will thus come to understand that national independence sheds light upon many facts which are sometimes divergent and antagonistic. Such a taking stock of the situation at this precise moment of the struggle is decisive, for it allows the people to pass from total, undiscriminating nationalism to social and economic awareness. The people who at the beginning of the struggle had adopted the primitive manicheism of the settler – Blacks and Whites, Arabs and Christians – realize as they go along that it sometimes happens that you get Blacks who are whiter than the Whites and that the fact of having a national flag and the hope of an independent nation does not always tempt certain strata of the population to give up their interests or privileges....Everything seemed to be so simple before: the bad people were on one side, and the good on the other.
>
> (1967: 115; 1991: 182–3)

The national movement will meet its terminal point, Fanon continues, if it is not deepened by a rapid "transformation into a consciousness of social and political needs, *in other words into humanism*" (1967: 165; 1991: 247; my emphasis). Consequently, the transformation of manicheism requires both a dissolution of the primitive categories of identification, upheld by the colonial power, the middle class and the spontaneous masses, and a scrupulous analysis of the social and economic state of affairs. The colonized people must, Fanon writes, insist on the necessity of a global "redistribution of wealth," on the fact that the colonial powers have an enormous debt to pay to the colonized world for all the riches they have stolen from it. The Marxist spirit invoked in *The Wretched of the Earth* is already present in the introduction to *Black Skin, White Masks*: "There will be an authentic disalienation only to the degree to which things, in the most materialistic meaning of the word, will have been restored to their proper places" (1986: 14; 1952: 9).

Fanon endeavors to pave the way for an Algerian – and African – development beyond "the middle class chauvinistic national phase," or more precisely, beyond the national elite's identification with, and reproduction of, the cultural and economic logic of the former colonial state. The national middle class has already shown its delight in playing the role of "transmission line between the nation and capitalism, rampant though camouflaged, which today puts on the masque of neocolonialism" (1967: 122; 1991: 193). The whole future of Africa is at stake:

> African unity, that vague formula, yet one to which the men and women were passionately attached, and whose operative value served to bring immense pressure to bear on colonialism, African unity takes off the mask, and crumbles to regionalism inside the hollow shell of nationality itself....Colonialism, which had been shaken to its very foundations by the birth of African unity, recovers its balance and tries now to break that will to unity by using all the movement's weaknesses.
>
> (1967: 128; 1991: 200–1)

Africa is divided into black and white, Muslim and Christian, into a variety of ethnic groups and tribes. The unity that made the revolution possible is split into fundamental disunity. "The hollow shell of nationality" is indeed a very precise notion of the traumatic state that afflicts many postcolonial states of today – Algeria not the least. The tragic turn of events that has torn Algeria apart since the violent interruption of the elections in the late 1980s finds here its crucial designation: today's Algeria designates mainly an empty formula, a purely formal identity, and the clashes of ideologies are focused precisely on the question of *which social reality and cultural identity should give content to this empty form.*

The Manichean logic is here put at the service of a "hermeneutics of eradication" where every sign of difference and deviation, from the perspective of one (or the other) faction's projection of the content of "the true Algeria," is enough for a death sentence. Civilians and innocence no longer exist. The ideology of "cleansing" and "purification" involved in this tragic process expresses the dream of total liberation, of a subjectivity beyond Otherness, that certain elements in Algeria nourish.[7]

Stressing the importance of conceiving Fanon's notion of humanism *as a specific negation of the Manichean order*, we are required to understand it as the very moment which enables us to transcend the inhuman in such a relation to the other. Fanon's humanism must be interpreted in terms of praxis, in the sense that it is explicitly "prefigured in the objectives and methods of the conflict" (1967: 197; 1991: 294). In Hegelian terms: as the mediation of the "abstract negation" inherent in the many attributes to the Manichean logic that Fanon develops in his works: "the narcissistic monologue," "the metaphysics of absolute difference," "systematic de-humanization," "paternalistic understanding," etc.

Accordingly, the logic of substitution that is set to work by Fanon is always situated. Algeria as the subject which undermines the Manichean society and destroys the reification inherent in colonialism serves a double purpose: to reveal "the strange roots" of the European spirit and to stage the possibility of a humanism without *these* specific antinomies. The basic ground for Fanon's disavowal of race or ethnicity as foundations of subjectivity is his insistence on the possibility of a dialectical transcendence which, in the end, amounts to nothing less than a "right to citizenship" in a world of "reciprocal recognitions." Fanon's visionary narrative would not be possible if he did not assume the possibility of dialectical transcendence, of the possibility of a national consciousness which may give birth to an "opening of oneself to the other" on a personal level and, on a further scale, to an "international consciousness" (1967: 199; 1991: 296). The absence of any exhaustive account in Fanon of the state of affairs awaiting mankind at the end of this dialectic should not upset us; rather we should be grateful that he refrains from reducing his critical legacy to just one among many other hallucinatory phantasms of an End of History beyond the unforseeable [*imprévisible*] possibilities that true human encounters imply.

NOTES

1 This "conversion" has been discussed in various terms. See for example Françoise Vergès (1997) on Fanon's disavowal of his Antillean history and his invention of a symbolic ancestry in Algeria. For a convincing critique of the perspective elaborated by Albert Memmi and others on Fanon as either a European interloper or a "pretended" Algerian, see Lewis R. Gordon (1995, chapter 5). It is necessary to recapture the significance of Fanon's early identification with France – "I am a Frenchman. I am interested in French culture, French civilization, the French people. We refuse to be considered 'outsiders,' we have full part in the French drama" – to

really understand the meaning of this "shift" for his life and thought (1986: 203; 1952: 164). While this subject is not developed here, it will be thoroughly examined in my forthcoming thesis, *In the Name of the Spirit, Representations of a War: Albert Camus, Jean-Paul Sartre, and Frantz Fanon.*

2 See Beauvoir (1963, chapter 11) and Perinbam (1982, chapter 4) for a discussion of this period in Fanon's life.

3 See Azar (1995; 1997) for a more detailed analysis of Camus and Fanon in this respect.

4 For an excellent discussion of this tension in Fanon's work see Sekyi-Otu (1996, chapter 2). See also Bernasconi (1996) and Bhabha (1994), where this tension, although theorized in other concepts (i.e. ambivalence), is central for their readings of Fanon.

5 See Bulhan (1985) and Azar (1995) for a more substantial examination of Fanon's relation to psychoanalysis. Also of interest are Fanon's lecture notes from 1959 to 1960, where he returns to Lacan and others in a critical examination of the value of certain psychologies in the light of colonial Algeria (Fanon 1959–60).

6 These texts are collected in his *Toward the African Revolution* (1988) (*Pour la révolution africaine* (1969)).

7 For a short, but convincing, analysis of the postcolonial history of Algeria, see Stora (1995). The formula "in the name of the spirit" designates here the incessant proclamation of different Subjects (Islam, Modernity, Arabism, etc.) charged with the burden of cleansing Algeria from all "Evil" elements. This logic is thoroughly described by Hegel, where this "abstract negation" implies a fundamental inability to accept the negativity that dwells in the "lack" that every identity – personal or social – is endowed with. The Other in fundamentalist discourse – religious or not – functions as the embodiment of *the very reason for the existence of the lack* (before the appearance of the Other everything was in perfect order). This makes it possible to imagine an existence, a society, without the Other – after it has been eradicated. Of course, it is a form of ideology which constantly threatens itself: the very moment the Other is actually eradicated the whole structure of the phantasm may be exposed as an illusion; that is the precise reason why these ideologies must constantly invent new enemies to the Cause (Spirit). The Hegelian concept of "the loss of the loss" designates this logic perfectly: for the fundamentalist nothing could be worse than facing an actual loss of the enemy, *because it would only expose that he never had (and never can have) what he supposed to have lost.* The moment of victory is therefore the moment of greatest loss as he now loses the very loss he had blamed the Other for (see Žižek 1990). Here it is also important to stress Fanon's acute criticism of, for instance, négritude, where he refrains from yielding to this very illusion of an identity, or a society, without an inherent negativity.

REFERENCES

Azar, M. (1995) "Fanon, Hegel och Motståndets Problematik," preface to the Swedish edition of *Black Skin, White Masks* (*Svart Hud, Vita Masker*), Götesborg: Daidalos.

——— (1997) "Albert Camus och L'Algérie française," *Ord & Bild* (Uddevalla) (June).

Beauvoir, S. de (1963) *La Force des choses*, Paris: Gallimard.

Bernasconi, R. (1996) "Casting the Slough: Fanon's New Humanism for a New Humanity," in L.R. Gordon, R.T. White, and T.D. Sharpley-Whiting (eds) *Fanon: A Critical Reader*, Oxford: Blackwell.

Bhabha, H.K. (1994) *The Location of Culture*, New York: Routledge.

Bulhan, H.A. (1985) *Frantz Fanon and the Psychology of Oppression*, New York: Plenum.

Camus, A. (1965) *Essais*, Paris: Éditions Gallimard.

Fanon, F. (1952) *Peau noire, masques blancs*, Paris: Éditions du Seuil.

—— (1959–60) *Rencontre de la société et de la psychiatrie: Notes de cours Tunis 1959–69*, Tunis: University of Oran.

—— (1967) *The Wretched of the Earth*, trans. C. Farrington, London: Penguin.

—— (1968) *Sociologie d'une révolution*, Paris: François Maspero.

—— (1969) *Pour la révolution africaine: Écrits politiques*, Paris: François Maspero.

—— (1986) *Black Skin, White Masks*, trans. C.L. Markmann, London: Pluto.

—— (1988) *Toward the African Revolution*, trans. H. Chevalier, New York: Grove.

—— (1989) *Studies in a Dying Colonialism*, trans. H. Chevalier, London: Earthscan.

—— (1991) *Les Damnés de la Terre*, Paris: Éditions Gallimard.

Girardet, R. (1972) *L'Idée coloniale en France*, Paris: La Table Ronde.

Gordon, L.R. (1995) *Fanon and the Crisis of European Man: An Essay on Philosophy and the Human Sciences*, New York: Routledge.

Perinbam, M. (1982) *The Revolutionary Thought of Frantz Fanon: An Intellectual Biography*, Washington, DC: Three Continents Press.

Sartre, J.-P. (1954) *Réflexions sur la question juive*, Paris: Éditions Gallimard.

—— (1995) *Anti-Semite and Jew*, New York: Schocken.

Sekyi-Otu, A. (1996) *Fanon's Dialectic of Experience*, Cambridge, MA: Harvard University Press.

Sirinielli, J.-P. and Rioux, J.-P. (1991) *La Guerre d'Algérie et les intellectuels français*, Paris: Éditions Complexe.

Stora, B. (1995) *L'Algérie en 1995: La guerre, l'histoire, la politique*, Paris: Éditions Michalon.

Taiwo, O. (1996) "On the Misadventures of National Consciousness: A Retrospect of Frantz Fanon's Gift of Prophecy," in L.R. Gordon, T.D. Sharpley-Whiting, and R.T. White (eds) *Fanon: A Critical Reader*, Oxford: Blackwell.

Vergès, F. (1997) "Creole Skin, Black Mask: Fanon and Disavowal," *Critical Inquiry* 23, 3: 578–95.

Žižek, S. (1990) "Beyond Discourse-Analysis," Appendix to Ernesto Laclau, *New Reflections on the Revolution of Our Time*, New York: Verso.

3

THE POLITICS OF ADMITTANCE

Female sexual agency, miscegenation, and the formation of community in Frantz Fanon

Rey Chow

Male subaltern and historian are...united in the common assumption that the procreative sex is a species apart, scarcely if at all to be considered a part of civil society.

Gayatri Chakravorty Spivak (1988)

Whenever women continue to serve as boundary markers between different national, ethnic and religious collectivities, their emergence as full-fledged citizens will be jeopardized.

Deniz Kandiyoti (1994)

As long as woman is excluded from the community, it is not really *common*.

Mieke Bal (1987)

A leading feature that connects the many studies of the black psychiatrist Frantz Fanon since the first publication of his work in the 1950s is undoubtedly the politics of identification. As Henry Louis Gates, Jr., writes, "Fanon's current fascination for us has something to do with the convergence of the problematic of colonialism with that of subject formation" (1991: 458). Beginning with Jean-Paul Sartre, critics have, when examining Fanon's texts, focused their attention on the psychic vicissitudes of the black man's identity. While Sartre, writing in the heyday of a leftist existentialism, draws attention to those vicissitudes in terms of a third-world nationalism in formation, a collective revolt that could be generalized to become the revolt of the world proletariat,[1] contemporary critics, geared with lessons in poststructuralism, have alternately reformulated those vicissitudes by way of Derridean deconstruction, Lacanian psychoanalysis, and gender politics involving the representations of white women and the issues of homosexuality.[2] If these critics have rightly foregrounded the tortuous ambiguities that inform the politics of identification in the contexts of colonization and postcolonization, their discussions tend nonetheless to slight a fundamental issue – the issue of community formation. Once we put the emphasis on community, it would no longer be sufficient

34

simply to continue the elaboration of the psychic mutabilities of the postcolonial subject alone. Rather, it would be necessary to reintroduce the structural problems of community formation that are always implied in the articulations of the subject, even when they are not explicitly stated as such.

As the etymological associations of the word "community" indicate, community is linked to the articulation of commonality and consensus; a community is always based on a kind of collective inclusion. In the twentieth century the paradigm of ideal community formation has been communism, which is the secular version of a holy communion with a larger Being who is always beyond but with whom man nonetheless seeks communication.[3] At the same time, however, there is no community formation without the implicit understanding of who is and who is not to be admitted. As the principle that regulates community formation, admittance operates in several crucial senses.

There is, first, admittance in the most physical sense of letting enter, as when we say we are admitted to a theater, an auditorium, a school, a country, and so forth. The person who is or is not admitted bears on him or her the marks of a group in articulation. This basic, physical sense of admittance, of being allowed to enter certain spaces, governs a range of hierarchically experienced geographical and spatial divisions in the colonial and postcolonial world, from the segregation of black and white spaces in countries such as the United States and South Africa, to the rules forbidding local people to enter "foreign concessions" in their own land during the heyday of the "scramble" for Africa and China, to the contemporary immigration apparatuses in politically stable nations that aim to expel "illegal immigrants" from such nations' borders. Meanwhile, to "let enter" is, as can be surmised from these examples, closely connected with recognition and acknowledgment, which is the second major connotation of admittance. Admittance in this second sense is a permission to enter in the abstract, through the act that we call validation. To be permitted to enter is then to be recognized as having a similar kind of value as that which is possessed by the admitting community. Third, there is admittance in the sense of a confession – such as the admittance of a crime. Insofar as confession is an act of repentance, a surrender of oneself in reconciliation with the rules of society, it is also related to community.

To this extent, I feel that the work in cultural studies that has followed poststructuralist theory's close attention to issues of identification and subjectivity is both an accomplishment and a setback: an accomplishment, because such work – which I shall call "subject work" – enables the subject to be investigated in ever more nuanced manners across the disciplines, holding utopian promise often by concluding that the subject, be it masculine, feminine, gay, postcolonial, or otherwise, is infinitely "unstable" and therefore open-ended; a setback, because nuanced readings of the subject as such also tend to downplay issues of structural control – of law, sovereignty, and prohibition – that underlie the subject's relation with the collective. Much "subject work" has, in other words, too hastily put its emphasis on the "post" of "poststructuralism,"

(mis)leading us to think that the force of structure itself is a thing of the past. I believe that these neglected other issues, which are the issues of admittance, pertain even more urgently to the kind of conceptualization of community that begins as a revolt against an existing political condition, such as the condition of colonization. In turning to the texts of Fanon, then, the questions I would like to explore are not questions about the colonized or postcolonized subject per se, but rather: how is community articulated in relation to race and to sexuality? What kinds of admittance do these articulations entail, with what implications?

RACE AND THE PROBLEM OF ADMITTANCE[4]

Fanon's discussions of the existential dilemmas facing the black man, which he interprets with the explicit purpose of liberating the black man from himself, are well known. From the feelings of "lust" and "envy" that accompany the historically inevitable violence toward the white man in *The Wretched of the Earth*, we move to the picture of an "infernal circle" of shame and longing-for-recognition in *Black Skin, White Masks*:

> I am overdetermined from without, I am the slave not of the "idea" that others have of me but of my own appearance....
> Shame. Shame and self-contempt. Nausea. When people like me, they tell me it is in spite of my color. When they dislike me, they point out that it is not because of my color. Either way, I am locked into the infernal circle.
> (1967: 116)

> Man is human only to the extent to which he tries to impose his exis-tence on another man in order to be recognized by him. As long as he has not been effectively recognized by the other, that other will remain the theme of his actions. It is on that other being, on recognition by that other being, that his own human worth and reality depend. It is that other being in whom the meaning of his life is condensed.
> (1967: 217)

These compelling passages indicate that for the black man, selfhood and communal relations are entirely intertwined with skin color and race. If the forced coexistence with the white man is impossible as a basis for community, it is because the white man, with his attitudes of racist superiority, does not *admit* the black man as an equal. Significantly, admittance here operates in the first two senses I mentioned: first, in the sense of letting enter; second, in the sense of validation and acknowledgment. The physical sense of admittance connotes in a vivid manner the process of acceptance by permission, and hence the process of identification as the successful or failed acquisition of a particular kind of entry permit. And yet, being "admitted" is never simply a matter of possessing the right permit, for validation and acknowledgment must also be

present for admittance to be complete. The existential burden that weighs on the black man is that he never has admittance in these first two, intimately related senses of the word: his skin color and race mean that even if he has acquired all the rightful permits of entry into the white world – by education, for instance – he does not feel that he is acknowledged as an equal.

For Fanon, the conceptualization of a community alternative to the colony is thus inseparable from a heightened awareness of race as a limit of admittance. If the black man is not admitted by the white man because of his skin color, then this very skin color would now become the basis of a new community – the basis of entry into and recognition by the postcolonial nation. But how does race operate as a new type of admittance ticket, a new communal bond? On close reading, it would seem that race, in spite of the fact that it is imagined at the revolutionary moment as the utopian communion among people who suffer the same discrimination, nonetheless does not escape the problems structural to all processes of admittance. The issue of admittance – of legitimate entry and validation – becomes especially acute when we introduce sexual difference – when we read the different manners in which Fanon describes the black man and the black woman.

Fanon's analyses of the woman of color are found in a chapter of *Black Skin, White Masks*, the chapter entitled "The Woman of Color and the White Man." The title signals, already, that identification for the woman of color is a matter of exchange relations, a matter of how the woman of color is socially *paired off* or *contracted*. Unlike the black man, who is considered a (wronged) sovereign subject, the woman of color is first of all an object with exchange value. Fanon's views are based in part on his reading of fiction – such as the stories *Je suis Martiniquaise*, by Mayotte Capécia, and *Nini*, by Abdoulaye Sadji – even though it is clear that his reading is intended beyond the "fictional" contexts. Fanon describes the woman of color in terms of her aspiration toward "lactification" and summarizes her "living reactions" to the European in this manner:

> First of all, there are two such women: the Negress and the mulatto. The first has only one possibility and one concern: to turn white. The second wants not only to turn white but also to avoid slipping back. What indeed could be more illogical than a mulatto woman's acceptance of a Negro husband? For it must be understood once and for all that it is a question of saving the race.
>
> (1967: 54–5)

For, in a word, the race must be whitened; *every woman* in Martinique knows this, says it, repeats it. Whiten the race, save the race, but not in the sense that one might think: not "preserve the uniqueness of that part of the world in which they grew up," but make sure that it will be white. Every time I have made up my mind to analyze certain kinds of behavior, I have been unable to avoid the consideration of certain

nauseating phenomena. The number of sayings, proverbs, petty rules of conduct that govern the choice of a lover in the Antilles is astounding. It is always essential to avoid falling back into the pit of nigger-hood, and *every woman* in the Antilles, whether in a casual flirtation or in a serious affair, is determined to select the least black of the men. Sometimes, in order to justify a bad investment, she is compelled to resort to such arguments as this: "X is black, but misery is blacker." I know a great number of girls from Martinique, students in France, who admitted to me with complete candor – completely white candor – that they would find it impossible to marry black men.

(1967: 47–8; my emphases)

In the light of these extended remarks, Fanon's later remark regarding the woman of color, "I know nothing about her" (1967: 180), can be taken only as a disclaimer of definitive views that he has, in fact, already pronounced. To this extent, critics who, despite their critical sensitivity, accept Fanon's "I know nothing about her" at face value are simply sidestepping a problem that would interfere with the coherence of their own interpretations. This is the problem of the sexuality of the woman of color, the legitimation and delegitimation of which is crucial to the concept of a postcolonial national community.[5] The predominant impression given by the passages just quoted is that women of color are *all alike*: in spite of the differences in pigmentation between the Negress and the mulatto, for instance, they share a common, "nauseating" trait – the desire to become white – that can be generalized in the form of "every woman." In an account of black subjecthood that is premised on the irreducible (racial) difference between black and white people, thus, Fanon's descriptions of the women of color are paradoxically marked by their non-differentiation, their projection (onto femininity) of qualities of indistinguishability and universality.[6] Before we examine Fanon's descriptions of the sexuality of women more specifically, however, I would like to dwell for a moment on the theoretical linkage between community formation and sexual difference by turning to a classic text about community formation – Sigmund Freud's *Totem and Taboo*.

COMMUNITY FORMATION AND SEXUAL DIFFERENCE: A DOUBLE THEORETICAL DISCOURSE

In *Totem and Taboo*, Freud offers a theory of community formation that is drawn from anthropological, sociological, and religious studies of "primitive" societies. As is well known, Freud, instead of contradicting the findings of early studies, supports them by focusing on two interrelated aspects of community formation.[7] First, participation in a common bond is achieved through the murder and sacrifice of the primal father, who is afterward venerated and raised

to the status of a god, a totem. Second, this bond is secured through the institution of a particular law, the law against incest:

> Thus the brothers had no alternative, if they were to live together, but – not, perhaps, until they had passed through many dangerous crises – to institute the law against incest, by which they all alike renounced the women whom they desired and who had been their chief motive for dispatching their father. In this way they rescued the organization which had made them strong – and which may have been based on homosexual feelings and acts.

> (Freud 1952: 144)

The two principles at work in community formation are thus the incorporation of kin (the primal father is being eaten and internalized as law) and the exportation of sex (the women are being banned and transported outside). Freud's model is thought-provoking because it signals the crisis-laden nature of the relationship between community and sexual difference. Here is an area, his text suggests, where things are likely to be explosive. If the potential destruction of the group is likely to result from heterosexual relations within the group, then precisely those relations must be tabooed – hence the prohibition of incest.

But what is dangerous about incest? In his explication of taboos, Freud emphasizes that touching or physical contact plays a major role in taboo restrictions because touching is "the first step toward obtaining any sort of control over, or attempting to make use of, a person or object" (1952: 33–4). In other words, the taboo has as its power the force of contagion – the force of passing from object to person and then from person to person – through physical contact. If a taboo is not only a thing or an act, but also the person who has violated the taboo, then the person who *embodies* "touching" and "physical contact" must be looked upon as the taboo as well. Women, because they have the capability of embodying physical contact – of giving material form to "touching," to the transgression of bodily boundaries – in the form of reproduction, are always potentially dangerous; and incest, which could result in such reproduction within the same tribe, is thus danger raised to the second degree and the cultural taboo par excellence. Even though Freud's account leaves many questions unanswered, what stands out from his text is the unmistakable recognition of female sexuality as a form of physical power. It is this physical power, this potentiality of transmission, confusion, and reproduction through actual bodies, that could break down all boundaries and thus disrupt social order in the most fundamental fashion. Because of this, female sexuality itself must be barred from entering a community except in the most non-transgressive, least contagious form.

The implications of Freud's theory are eventually extended, among others, by Claude Lévi-Strauss, who argues that the incest taboo is the origin of human culture because it ensures the practice of exogamy and thus the social relations

among different groups of men. Following Marcel Mauss's theory of gift-giving as what sustains the equilibrium of power in tribal society, Lévi-Strauss reads women as the gifts in the kinship system: women are exchanged between families so that kinship as an elaborate network can function (see Lévi-Strauss 1969; Mauss 1990). But even though they facilitate *communication* and thus *community relations*, women themselves are not considered as initiators of communication or active partners in community formation. As Gayle Rubin comments in her classic essay, "The Traffic in Women":

> If it is women who are being transacted, then it is the men who give and take them who are linked, the woman being a conduit of a relationship rather than a partner to it….If women are the gifts, then it is men who are the exchange partners. And it is the partners, not the presents, upon whom reciprocal exchange confers its quasi-mystical power of social linkage…it is men who are the beneficiaries of the product of such exchanges – social organization.
>
> (1975: 174)

Moreover, one could argue that this exchange of women as gifts – this "admittance" that in fact preempts women from having the same rights as men – operates not only as the content but also as the structure of Lévi-Strauss's theorizing. For, once the problem of female sexuality is displaced onto the regulation of kinship structures, it is kinship structures that become the primary focus, while the potential significance of female sexuality as a transgressive force becomes subordinated and thus minimized. By barring female sexuality from entering their writings as a disruptive force, Freud's followers such as Lévi-Strauss thus uncannily repeat, with their acts of theorizing, the story of *Totem and Taboo*: even though these male theorists have, following Freud, identified the handling of sexual difference as what makes a community work,[8] seldom do they bother to elaborate sexual difference itself beyond the point that it serves to support the community formation that is, in the final analysis, a veneration of the father. The continual incorporation/internalization of the voice/narrative of the father (in this case, Freud) and the exportation of the "touch" of sexual difference represented by women mean that the paradigm of community building doubles on itself even as it is being enunciated as theory: we have, in the (psychoanalytic, anthropological, sociological) writings about community formation, a metacommunity building that can be named the solidarity of "male homosocial readings." We must note that in this metacommunity building, this solidarity forming through interpretation, women are never being erased but always given a specific, corollary place: while not exactly admitted, neither are they exactly refused admission. To interrupt this metacommunity building, it would therefore not be enough simply to take sexual difference into consideration; what is more crucial is moving sexual difference beyond the status of

"corollary" or "support" that Freud and his followers allow it. Instead of the incorporation of the father and the community among men, then, we need to look at what is "exported," the taboo that is female sexuality itself.

Another problem with *Totem and Taboo* is that, as is characteristic of many of Freud's writings, it is most suggestive in its explanation of the mechanics – the displacements, negations, and emotional ambivalences – *within* a group. And yet if this text is eminently useful as a reminder of the linkage between community formation and sexual difference, it is inevitably inadequate in a situation where more than one community is involved. The postcolonized situation, in which a formerly colonized group seeks to establish its new status as a national community that is alternative to the one in pre-independent times, necessarily complicates Freud's binarist, interiorist model. The most outstanding feature in the postcolonized situation is not one group of men and women (and the problem of sexuality within their community), but the conflictual relations between the colonized subject, his own ethnic/racial community, and the lingering effects of the colonizer. The presence of what are at the very least two groups – colonizer and colonized – rather than one, as well as the persistent hierarchical injustices brought about by the domination of one over the other, means that any consideration of community formation in the postcolonial aftermath must exceed the model of the *in-house* totemism and taboo as suggested by Freud.

It is, thus, with a twin focus on female sexuality and on the *double* theoretical discourse of admittance and nonadmittance regarding female sexuality that I return to the problem of community formation in Fanon. The question here is not whether Fanon gives us more or less satisfying answers, but how, precisely because Fanon's texts are explicitly political and aimed at revolutionizing thinking about the social bases of identification – from the stage of colonization to national culture, from white imperialist domination to the reclamation of black personhood and agency – they offer a demonstration of the problems that are inherent in all masculinist conceptions of community formation more starkly and thus more disturbingly than most. My aim, in other words, is not to belittle the epochal messages of a seminal political thinker. Rather it is to argue, first, the ineluctability of considering female sexuality and sexual difference as *primary* issues in a discussion of community formation; and second, how, once introduced, female sexuality and sexual difference at both the empirical and theoretical levels interrupt community formation with powerful fissures. Ultimately, my question is: could female sexuality and sexual difference ever be reconciled with community? Are these mutually exclusive events? To begin to answer these questions, we will now examine the specific kinds of analyses Fanon gives of female sexuality.

WHAT DOES THE WOMAN OF COLOR WANT?

Unlike his analyses of the black man, with their intent of foregrounding the existential ambivalences of the black male psyche, Fanon's depictions of women

of color are, as we see in the passages quoted earlier, direct and with little doubt: the women of color *want* to have sexual relations with white men because it is their means of upward social mobility, their way of so-called "saving the race." If Fanon's manner of dealing with what the woman of color wants sounds somewhat familiar in its confident tone, it is because it reminds us of the manner in which Freud describes the little girl's acquisition of sexual identity. As feminists have often pointed out, Freud's portrayals of the psychic labor spent by the little girl and little boy in acquiring their respective sexual identities are remarkably different. While the little boy's psyche is full of the complexity of belated or retroactive consciousness – he does not understand the meaning of the female genitalia and hence sexual difference until he is threatened with the possibility of castration – the little girl, by contrast, "behaves differently. She makes her judgment and her decision in a flash. She has seen it and knows that she is without it and wants to have it" (Freud 1963: 187–8). As portrayed by Freud, the little boy is an *innocent victim* of his cultural environment, whereas the little girl is an *active agent* in her grasp of the politics of sexuality. Similarly, in Fanon's portrayals, we sense that the black man is viewed as a helpless victim of his cultural environment, whereas the woman of color is viewed as a knowledgeable, calculating perpetrator of interracial sexual intercourses. If the black man's desire to elevate himself to whiteness is a plea for what Fanon affirms as "active understanding" (1967: 81), the similar desire on the part of the woman of color is not given as complex a treatment. To paraphrase Freud, the woman of color simply "has seen it and knows that she is without it and wants to have it."

By refusing the woman of color any of the kind of emotional ambivalence that is copiously endowed upon the psyche of the black man, what Fanon accomplishes is a representation – representation both in the sense of portraying and in the sense of speaking for (see Spivak 1988) – of the woman of color as potentially if not always a whore, a sell-out, and hence a traitor to her own ethnic community. Women of color are, in other words, shameless people who forsake their own origins ("the uniqueness of that part of the world in which they grew up") for something more "universally" desirable and profitable – association with the white world. Rather than living and working alongside her black kinsmen and sharing their ordeals, the woman of color jumps at any opportunity for getting out of her ghetto. While the black man is sympathetically and empathetically portrayed as filled with existentialist angst, as subjected to a state of psychic castratedness that is nonetheless a sign of his honor, his integrity as a cultural hero, the choices and actions of the woman of color are rather associated with efficiency, with determination, with confidence, even with "candor" – qualities which, however, become signs of her dishonor, her natural degeneracy. And it is as if, because of these qualities, the woman of color is unworthy of the careful *analytic* attention that is so painstakingly bestowed on her male counterpart.

In contrast to the view that the woman of color has been made to disappear or is deprived of her agency, therefore, I would argue that Fanon in fact gives her a very specific kind of appearance and agency. To confront the issue of female sexuality in Fanon, what is required is not exactly an attempt to "restore" the woman of color by giving her a voice, a self, a subjectivity; rather we need to examine *how* the woman of color has *already* been given agency – by examining the form which this attributed agency assumes. To use the terms of our ongoing discussion, this is, once again, a question about admittance. What kind of admittance does Fanon extend to the woman of color – what kind of entry permit and what kind of acknowledgment?

Fanon describes the woman of color in terms of her conscious wishes and her unconscious desires. This distinction does not in the end amount to a real difference because, as we shall see, whether conscious or unconscious, the woman of color is headed toward the same fate.

We will begin with her conscious wish, her supposed desire for the white man. Since the white man is the oppressor of black people, is this colored female agency, this desire for the white sexual partner, a masochistic act? Viewed as a way to climb up the social ladder in a world where white is superior, it would, at first, not seem so: the woman of color is in fact benefiting rather than bringing pain to herself from such an act. Unlike her black brother, Fanon suggests, she has everything to gain from her association with the white world. But the matter of masochism is not so clear once we juxtapose Fanon's description of the woman of color with yet another counterpart – this time the white woman. This juxtaposition reveals a much more disturbing perspective on the so-called "unconscious" of women *in general*.

In a manner paralleling his description of the woman of color, Fanon's description of the white woman fixes her with a determined sexual agency. The white woman, too, "wants it": she desires to have sex with the Negro in her fantasy. Moreover, this time what the woman "wants" is definitely a part of her masochism – her wanting to be raped:

> First the little girl sees a sibling rival beaten by the father, a libidinal aggressive. At this stage (between the ages of five and nine), the father, who is now the pole of her libido, refuses in a way to take up the aggression that the little girl's unconscious demands of him. At this point, lacking support, this free-floating aggression requires an investment. Since the girl is at the age in which the child begins to enter the folklore and the culture along roads that we know, the Negro becomes the predestined depository of this aggression. If we go farther into the labyrinth, we discover that when a woman lives the fantasy of rape by a Negro, it is in some way the fulfillment of a private dream, of an inner wish. Accomplishing the phenomenon of turning against self, *it is the woman who rapes herself.*
>
> (1967: 179; my emphasis)

43

From this analysis of the white woman Fanon shifts to a speculation about women in general:

> We can find clear proof of this in the fact that *it is commonplace for women, during the sexual act, to cry to their partners: "Hurt me!"* They are merely expressing this idea: Hurt me as I would hurt me if I were in your place. *The fantasy of rape by a Negro is a variation of this emotion*: "I wish the Negro would rip me open as I would have ripped a woman open."
>
> (1967: 179; my emphases)

This passage indicates that all women fantasize being hurt in the sexual act and that this fantasy, which women project onto their sexual partners, is ultimately a fantasy of women *themselves hurting themselves*. ("It is the woman who rapes herself.") Accordingly, there is no such thing as a man hurting a woman; there is no such thing as rape. The implicit assumption that women are fundamentally unrapable is perhaps the reason, as critics have pointed out, in spite of his sensitivity to interracial sexual violence, Fanon has not attempted/bothered to deal with the prominent issue of the rape of women of color by white men.[9] Instead, women's essential unrapability means that the rape of women must be inverted to become women's desire and that the violence committed against women must be inverted to become the women's violence against themselves. And, since such violence is a condition character-istic of *all* women, the white woman's desire for her racial other, the black man, is merely "a variation of this emotion," to which (the emotion) skin color is but an accident.[10]

The above description of white female sexuality is then followed by the line in which Fanon claims his lack of knowledge about the woman of color. Revealingly, even as he makes this disclaimer, he adds an observation that in effect shows not exactly his lack of knowledge but (in accordance with the logic of his immediately preceding discussion) his understanding that black and white women are universally alike. If his preceding discussion shows the white woman to "want" rape by a Negro (since all women "want" rape), he now shows that black women, too, "want" the Negro who is socially inferior to them:

> Those who grant our conclusions on the psychosexuality of the white woman may ask what we have to say about the woman of color. I know nothing about her. What I can offer, at the very least, is that *for many women in the Antilles – the type that I shall call the all-but-whites – the aggressor is symbolized by the Senegalese type, or in any event by an inferior (who is so considered)*.
>
> (1967: 179–80; my emphasis)

In an account that ultimately minimizes if not effaces the racial and ethnic differences between black and white women, Fanon portrays women's sexuality in the main as characterized by an active, sadomasochistic desire – to be raped, to rape herself, to rip herself open. Furthermore, as in the case of the women in the Antilles who fantasize sex with Senegalese men, this sadomasochistic desire is implicated in class, as it is enacted through fantasies of relations with a socially inferior male. Not only is sex with a woman always a kind of rape generated by herself, but her essential femininity/depravity is proven by her desire for a man of the lower class.

We have by this point two seemingly contradictory descriptions of the woman of color: on the one hand, she wants the white man because he is socially *superior*; on the other hand, she wants certain types of black men because they are socially *inferior*. The first description pertains to the greed for upward social mobility; the second pertains to the realization of lewd sexual fantasies. However, from the perspective of the woman of color, the effect produced by both types of descriptions is the same. This is the effect of the construction of a female sexual agency that is entirely predictable and already understood, conscious or unconscious. Most crucially, this construction, because it admits women *as* sexuality and nothing more, leaves no room for the woman of color to retain her membership among her own racial/ethnic community. In terms of the community formation that is based on race, the admittance that Fanon gives the woman of color is solely based on sex.[11] Fanon's reading means that the woman of color is either a *black traitor* (when she chooses the white man) or a *white woman* (when she chooses a black man). Fanon's admittance of the sexual agency of the woman of color signifies her inevitable expulsion from her community. Between her conscious actions and her unconscious desires, between her wish for "lactification" and her fantasy of being raped "by a Negro," the woman of color is thus, literally, *excommunicated* even as she is being acknowledged, attacked and assaulted even as she is being "admitted."[12]

In contrast to the agency given to the woman of color, the black man is, as I mentioned, portrayed much more sympathetically as a victim of multiple forces of colonialism, of his own tormenting emotional responses to history, and ultimately of the infidelity and "whiteness" of "his" women. Instead of a concrete agency, conscious or unconscious, the black man is throughout enhanced with what I will call *the privilege of ambivalence*, a reaction that is defined as the impossible choice between whiteness and blackness. If ambivalence is a privilege, it is because it exempts the black man from the harsh requirements imposed upon the woman of color. Whereas the women of color are required to stay completely within boundaries, the black man is allowed to waver between psychic states and ethnic communities, to be "borderline." The black man is allowed to go in and out of his community – to mate with white women, for instance – without having his fidelity questioned.[13] If unconditional admittance to his ethnic community is what distinguishes the black man from

the woman of color, it is because, in the texts of Fanon at least, the black man alone holds "ambivalence" as his entry and exit permit.

THE FORCE OF MISCEGENATION

Clearly, Fanon's descriptions of women do not depart significantly from the traditional masculinist view that equates women with sex. In contrast to men, who are defined by violence and ambivalence, Fanon's construction of womanhood is a construction through notions of sexual chastity, purity, fidelity, depravity, and perversion. Such notions of female sexuality are then welded onto the conceptualizations of the colonized subject and thus inevitably of the prospective communities to come after colonization. But why is the sexual agency of women such a prohibitive concern in the aftermath of colonization?

As can be glimpsed already in Freud's text, any conceptualization of community is by implication a theory about reproduction, both biological and social. Female sexuality, insofar as it is the embodiment of the "touching," the physical intimacy that leads to such reproduction, is therefore always a locus of potential danger – of dangerous possibilities. If the creation of a postcolonial national community is at least in part about the empowerment of the formerly colonized through the systematic preservation of their racial and ethnic specificities, then such an empowerment could easily be imagined to be threatened by miscegenation, the sexual intermixing among the races. Such sexual intermixing leads to a kind of reproduction that is racially impure, and thus to a hybridization of the elements of the community concerned.

Miscegenation leading to the mixing of races and cultures, the threat of impurity, the danger of bastardization – this much is common knowledge. Is this the reason why women's sexual agency is tabooed and excommunicated – since, as Fanon portrays it, women are consciously or unconsciously prone to miscegenation?[14] What dangers does a *female* tendency toward miscegenation hold for a theory of community formation in the aftermath of colonialism?

This is the juncture where two readings of Fanon's texts are, I think, possible. The first is that Fanon is just like any other man – that he is simply a patriarch who cannot tolerate differences and impurities. Instead of letting in Fanon's concerns as specifically the concerns of a person of color, such a reading would read him exclusively by way of his sexuality. The second reading, which is the one I would follow, is less straightforward and perhaps more contradictory, because it tries to admit the implications of Fanon's race as well as sexuality. This reading would show that what makes the women's conscious or unconscious desires for miscegenation such a traumatic event in Fanon's theory is that such *"sexual"* desires in fact share with the male intellectual's *race*-conscious, anti-colonialist message a common goal – the goal of ending the compartmentalized, Manichean division of the world into colonizer and colonized, us and them, that is colonialism's chief ideological legacy. In place of

a pure grouping, racial sexual intermixing is the very force – the force of biological procreation and of social connotation – that gives rise to alternative groups of people whose origins are all bastardized and whose *communal bond* can henceforth not be based on the purity of their status as black or white. These groups would be the actual externalizations, the actual embodiments, of the psychical ambivalences, the split between being white and being black, that torment the black man as Fanon describes it. What such groups would have in common – what would make them a community – is paradoxically what they do *not* absolutely have in common in terms of blood, skin color, or ethnicity.

This other, alternative kind of community, a community in which the immanence and specificity of corporeality would coexist with a democratic, open-ended notion of collectivity, is the foreseeable consequence of a kind of sexual agency that disrupts the existing boundaries that mark different racial groups apart. It is also, theoretically speaking, the utopian transformative vision that underlies the clear pronouncements made by Fanon against the domineering racist practices of European imperialism. But the difficulty for Fanon is precisely the difficulty inherent to all events of community formation: admittance (into a group) by necessity implies exclusion. What and who must be excluded and why? This fundamental law about community formation is further exacerbated by the postcolonial situation, in which utopian vision and political reality do not exactly correspond. Even though the passionate imagining of a national culture must, in theory, oppose the segregational assumptions inherent in colonialism, the practical implementation of the postcolonial nation as such cannot but mark new boundaries and reinforce new exclusions. The (female) force of miscegenation, with its seemingly opportunistic oblivion to the injustices of a racist history, must be barred from entering the new realm of political necessity.

For Fanon at the postcolonized moment of nation formation, female sexuality is a traumatic event because it poses the danger of a double transgression. What disturbs him is that the women of color, instead of staying put in their traditional position as "gifts," as the conduits and vehicles that facilitate social relations and enable group identity, actually *give themselves*. By giving themselves, such women enter social relationships as active partners in the production of meanings rather than simply as the bearers of those meanings. And, if such sexual giving constitutes a significant form of transgression, this transgression is made doubly transgressive when women of color give themselves *to white men*. In the latter case, the crossing of patriarchal sexual boundaries crosses another crossing, the crossing of racial boundaries. The women of color are, accordingly, the site of *supplementary* danger – of the dangerous supplement (Jacques Derrida's term) – par excellence, adding to the injustice of race the revolt of sex (and vice versa), and substituting/transforming the meaning of both at once.

In the typical dilemma facing nationalist discourse once nationalist discourse encounters gender, thus, Fanon's discourse is beset with the contested issues of

identity, agency, and sovereignty. Deniz Kandiyoti comments on this dilemma succinctly:

> A feature of nationalist discourse that has generated considerable consensus is its Janus-faced quality. It presents itself both as a modern project that melts and transforms traditional attachments in favor of new identities and as a reaffirmation of authentic cultural values culled from the depths of a presumed communal past. It therefore opens up a highly fluid and ambivalent field of meanings which can be reactivated, reinterpreted and often reinvented at critical junctures of the histories of nation-states. These meanings are not given, but fought over and contested by political actors whose definitions of *who* and *what* constitutes the nation have a crucial bearing on notions of national unity and alternative claims to sovereignty as well as on the sorts of gender relations that should inform the nationalist project.
>
> (1994: 378; emphases in original)

If the woman of color can be of value to her ethnic community only as a gift and a defenseless victim, then her assumption of any agency would in effect invalidate her and deprive her of admittance. The ultimate danger posed by the Negress and the mulatto is hence not their sexual behavior per se, but the fact that their sexual agency carries with it a powerful (re)conceptualization of community – of community as based on difference, heterogeneity, creolization; of community as the "illegitimate" mixings and crossings of color, pigmentation, physiognomy – that threateningly *vies with the male intellectual's*. The fact that the women are equal, indeed avant garde, partners in the production of a future community – is this not *the* confusion, the most contagious of forces, that is the most difficult to *admit*, to permit to enter, to acknowledge, and to confess? The ultimate taboo, it would seem, is once again the "taboo against the sameness of men and women," the "division of labor by sex" (Rubin 1975: 178).

The woman of color, by virtue of being both female and colored, having entrance points into and out of the community through sex and through ethnicity, becomes extremely suspect in a situation when supposedly only the black man has such privilege of "ambivalence" and when supposedly only "race" as the black man experiences it matters in the articulation of community consciousness. Once we put our focus on this "tabooed" area of female sexuality, we see that female sexuality is what interrupts the unidirectional force of existential violence that is otherwise justified in Fanon's theory of postcolonial nation-building.[15] At this point, the three senses of admittance I mentioned earlier come together. The strategies of simplification and reduction Fanon adopts toward the woman of color (in the many forms of "she wants it") are, in this light, not exactly attempts to refuse her *entry* but rather signs of an implicit, though reluctant, *acknowledgment* of her claim (equal to his) to being the progenitor of the community to come. At the same time, if this acknowledg-

ment could also be seen as a kind of *confession*, it is nonetheless only a confession that reconciles (the male intellectual) with the community of color *and* with male sexuality but not with the women of color; a confession that surrenders to the demands of race and to the distinctions of sex but not to the supplementary transgression of colored female agency.

Because women are, with their sexual behavior, powerful agents in the generation of a different type of community, the male intellectual senses that he cannot trust – cannot bond with – them. He cannot trust them because he cannot control the potentiality that ensues from their acts of miscegenation. But how is the future community to be conceived without women? Fanon, like all revolutionary male thinkers, would bond instead with "the people," which is the figure that empowers him in this *competition between the sexes* for the *birthing* of a new community. Community formation thus takes on, at the theoretical level, the import of a sexual struggle – a seizing of the power to reproduce and procreate. It is in this sense that the "native" – etymologically linked to "nation" and also to "birth" – becomes the progeny of the male postcolonial critic. The exclusive bond with this progeny allows for the fantasy of undoing and outdoing woman.

Interestingly, then, the "native" and the "people" in Fanon's texts are, like the black man, signs that waver with ambivalence. The people waver between complete deprivation – having nothing and thus nothing to lose – and an essential "resistance" toward colonialism (see Fanon 1968: 52–3, 60–1, and throughout). The descriptions of the native/people as possessing nothing and something at once raises fundamental questions. On the one hand, if colonialism is an all-encompassing environment, leaving the native with utterly nothing, where does the native get his readiness to attack, to fight back? This could only mean either that there is an essential something (nature, history) that allows the native to resist, in which case the native is not "nothing"; or that there are gaps and fissures within the colonial system itself that allow the native some room to resist, in which case colonialism as a system of domination is less than airtight.[16]

By portraying the "native" and the "people" in this ambivalent light – now totally deprived, now possessed of resistive energy; now entirely at the mercy of colonial domination, now definitely the source of rebellion against the colonizer – Fanon retains them as empty, mobile figures, figures of convenience onto which he, like other revolutionary male thinkers, can write his own script.[17] Because the "native" and the "people" are fundamentally empty, they accommodate the revolutionary intellectual with a rhetorical frame in which to hang his utopian vision, whereas women, because they are understood to possess a potent sexual agency, stand as an obstinate stumbling block in the path of revolutionary thought. As a result, while the "native"/the "people" continue to be exonerated in the imagined community of the new nation, women are admitted only with reservation – and only as "sex."

COMMUNITY BUILDING AMONG THEORISTS OF POSTCOLONIALITY

Once introduced, female sexuality, because it foregrounds the difference in the kinds of admittance extended to men and women, complicates the entire question of how a new community is conceptualized in the postcolonial aftermath. If, in terms of the inequality of race, Fanon correctly identifies the "infernal circle" of shame and longing-for-recognition as the condition that traps the black man, who is not exactly refused entry yet not exactly given his due recognition by the white world, he also uncannily inflicts a similarly "infernal" circle on the woman of color. If the black man's "skin color" is the place where he can never be sure of his admittance into the world of the "other" men, the white men, then for the woman of color, sexuality as much as skin color is what renders admittance by all communities, *especially that of her own "race,"* problematic.[18]

As in the case of Freud, the politics of admittance works not only at the level of the content and structure of Fanon's articulations, but also at the level of his works' reception. In choosing not to discuss the obviously fraught issues of sexuality in Fanon, in choosing to pass over this significant part of his texts with silence, many postcolonial critics are themselves implicitly building a type of discursive community that repeats the ambivalences and neuroses of Fanon's articulations.[19] This kind of silence is often justified by way of "the more important" issues of racism and colonialism, and by way of the implicit assumption that any discussion of sexuality as such is, like the sexual behavior of Fanon's woman of color, a suspect move toward "lactification." In the collective incorporation of the rhetorical violences of the sexually troubled male intellectual, we see something of the "longing for the father" that Freud describes as the foundation of totem formation. Totemism in the context of postcolonial theory is a revolutionary male narcissism writ large, instigating the male revolutionary figure as the "primal father" who bestows meaning on the postcolonial horde,[20] while the sexuality of women, in particular the women who "belong" to the father – the women of color, the women of the tribe – continue to have their agency prohibited, exiled, and deferred – this time by postcolonial critics.

On the other hand, what I specify as female sexual agency in this essay is a name for that which is *equivalent* in potentiality to male intellectual agency, and which the latter must therefore ward off with *ambivalence*, as primitive peoples ward off particular powers through specially instituted taboos. Since female sexual agency is a taboo – a prohibited area of potential contagion, miscegenation, and danger – its admittance would always be at a major cost. Admitting female sexual agency would mean that a more purist notion of community cannot but dissolve.

Ultimately, Fanon's opinions about female sexual agency could also be read as a parable about the *inadmissible* position occupied by the "intellectual of color" in the postcolonial situation. Here I can merely allude to the many

anxieties and displeasures expressed about such intellectuals' "selling out" to the West in oblivion of the "real" historical tasks at hand. The much criticized use of "Western theory," for instance, could, in the light of this parable, be rewritten as a licentious mixing with the white folks, an *intellectual miscegenation* shall we say, that is, for many, not unlike the depraved sexual behavior of Fanon's woman of color. "The most painful sting of patriarchy," writes one feminist critic, is "the solidarity *against* the other" (Bal 1987: 36; emphasis in original).[21] The fear and accusation of "compradore" mentalities, of intellectual whoredom, and of the lethal infidelities of *others* would thus always remain part and parcel of the patriarchal gestures of community building, and a discursive community – in the academy in particular – is no exception.[22] As we have seen with Fanon, however, such fears and accusations contain an implicit acknowledgment of the alternative agency that the "women of color" – the black whores – possess with their condemned behavior. Perhaps, as in the case of Fanon's reading, what cannot be admitted in the community of postcolonial theorists is that such depraved behavior of intellectual miscegenation, too, shares with those who condemn it similar emancipatory goals. This argument, obviously, will need to be elaborated on a separate occasion.[23]

NOTES

1 In certain passages of *Orphée noir* (1948), Sartre offers the view that négritude, as a subjective, existential, and ethnic idea, is insufficient as a means of asserting a future society without race discrimination, and that it must by necessity pass into the objective, positive, and exact idea of the proletariat. "Thus," he writes, "négritude is the root of its own destruction, it is a transition and not a conclusion, a means and not an ultimate end." These passages are quoted by Fanon in *Black Skin, White Masks* (1967: 132–3). Fanon strongly objects to Sartre's view:

> I felt that I had been robbed of my last chance....In terms of consciousness, the black consciousness is held out as an absolute density, as filled with itself, a stage preceding any invasion, any abolition of the ego by desire. Jean-Paul Sartre, in this work, has destroyed black zeal.
>
> (132–4)

2 See for instance Bhabha (1986a: vii–xxvi); Doane (1991: 215–27); Fuss (1994) (this essay contains a useful and detailed bibliography of works on Fanon); Bergner (1995) (I share many of the observations of Bergner's essay, which was published after this present chapter was first completed and presented as a paper at the conference on "Intellectuals and Communities" in Sydney, Australia, in early December 1994); Read (1996) (I had access to this collection only after the final revisions of this essay had already been completed). See also the comments on the various readings of Fanon by Edward Said, Abdul JanMohammed, Benita Parry, and Homi Bhabha among others in Gates (1991). For biographical studies of Fanon, see Geismar (1971) and Gendzier (1973).

3 For an example of a detailed theoretical reflection on community, see Nancy (1991), who deconstructs – de-works – the notion of "community" and argues for "mortal truth" and "limit" as the basis of a community's sharing.

4 I am using the word "race" here not only to signify "racial difference" or "racial identity" in a neutral sense. More importantly, "race" signifies the major historical

legacy of colonialism – namely, the injustices and atrocities committed against so-called "peoples of color" in the name of their racial inferiority. "Race" as such is thus implicated in the history of racism. To that extent I find the following analytic formulation of "race" useful:

> Race is not part of an unproblematic continuum alongside discursive categories such as linguistic rupture, syncretism, hybridity and so on. In all kinds of oppositional post-colonialism (within settler countries themselves and without) race was part of a larger struggle for self-respect. The post-colonial is the single most important phenomenon in which it played such a decisive role.
>
> (Mishra and Hodge 1991: 405)

5 Both Bhabha and Doane, for instance, cite Fanon's line "I know nothing about her" as "proof" of how he actually deals with the woman of color. Bhabha uses the strategy of deferral:

> Of the woman of color he has very little to say. "I know nothing about her," he writes in *Black Skin, White Masks*. This crucial issue requires an order of psychoanalytic argument that goes well beyond the scope of my foreword. I have therefore chosen to note the importance of the problem rather than to elide it in a facile charge of "sexism."
>
> (1986a: xxvi)

For more detailed criticisms of Bhabha, see Bergner (1995: 84–5). Doane, focusing on the white woman as the pivotal point of a racist representational economy, asserts time and again the "disappearance" of the woman of color from Fanon's analytic schema (see 1991: 220–1, 222, 225). By interpreting Fanon's claim of lack of knowledge at its face value, Bhabha and Doane avoid having to deal with its most important aspect – its self-contradiction – which is a clear indication of Fanon's troubled views about colored female sexuality. By the same gesture, they also avoid having to examine closely the disturbing manner in which Fanon does, in fact, give the woman of color agency.

6 See also Fuss's discussion of what she calls "Fanon's retrieval of an essentialist discourse of black femininity" (1994: 28) in his reading of the Algerian Revolution in *A Dying Colonialism* (1965). Fuss is referring to Fanon's notion that the act of mimesis – mimicry and/or masquerade – is *natural* to women.

7 See Freud (1952: 146): "Thus psychoanalysis, in contradiction to the more recent views of the totemic system but in agreement with the earlier ones, requires us to assume that totemism and exogamy were intimately connected and had a simultaneous origin."

8 See for instance Girard (1977), in particular chapters 8 and 9. For a feminist analysis of the Freudian framework of community formation, see Mitchell (1975), in particular the conclusion.

9 Doane: "Fanon's analysis situates rape only as the white woman's fantasy and neglects its status as the historical relation between the white male and the black female both in the colonial context and in that of slavery" (1991: 222).

10 Whether or not skin color is simply an accident in a more universal scheme of oppressive experience is a point on which Fanon remains ambivalent. For instance, in the chapter "The Man of Color and the White Woman" in *Black Skin, White Masks*, Fanon argues that blackness is, for the black man, but a coincidence that compounds his neurotic condition:

> Jean Veneuse, alias René Maran, is neither more nor less a black abandonment-neurotic. And he is put back into his place, his proper place. He is a neurotic

who needs to be emancipated from his infantile fantasies. And I contend that Jean Veneuse represents not an example of black–white relations, but a certain mode of behavior in a neurotic who by coincidence is black.

(1967: 79)

And yet, if this passage clearly suggests that the black man has psychic problems *just like any other man*, Fanon is much more emphatic elsewhere about the absolutely determining power of skin color. See, for instance, p. 163 of *Black Skin, White Masks*: "It is in his corporeality that the Negro is attacked." See also the chapter "The Fact of Blackness" (1967: 109–40) in which Fanon is primarily concerned with race as the determining factor for individual identity.

11 "Fanon does not ignore sexual difference altogether, but he explores sexuality's role in constructing race only through rigid categories of gender. In *Black Skin, White Masks*, women are considered as subjects almost exclusively in terms of their sexual relationships with men; feminine desire is thus defined as an overly literal and limited (hetero)sexuality" (Bergner 1995: 77). See also the discussion in Young (1996).

12 The black woman's predicament is succinctly summarized in the title of the anthology *All the Women Are White, All the Blacks Are Men, but Some of Us Are Brave* (Hull *et al.* 1982).

13 See the very different analyses of black female agency in, for instance, Carby (1987), who alerts us to how the consideration of black womanhood must take into account the sexism of black men. She also offers very different ways of reading the mulatto figure, who stands as a mediator between the races rather than simply as the offspring of black women's desire for upward social mobility (as Fanon describes it).

14 In this regard the biographical details about Fanon – that his mother was of Alsatian descent, that he grew up in Martinique thinking of himself as white and French, that he "became" a black West Indian only when he arrived in Paris, and that, however, he never afterward returned to négritude and to the West Indies – become an interesting and thought-provoking intertext. See the brief account by Gates (1991: 468). Gates's major source of information is Albert Memmi (1971).

15 See for instance the chapter "Concerning Violence" in *The Wretched of the Earth* (1968: 35–106). Fanon argues that for the colonized people, the violence of destroying the colonizer "invests their characters with positive and creative qualities. The practice of violence binds them together as a whole" and mobilizes their consciousness toward "a common cause," "a national identity," and "a collective history" (93).

16 This last possibility is the one taken up, for instance, by Homi Bhabha, who emphasizes the "ambivalence" of the imperialist's speech as a way to subvert imperialist discourse (1986a: 116; 1986b: 163–84). I have elsewhere critiqued Bhabha's reading of "ambivalence" as a critical gesture that makes it ultimately unnecessary to pay attention to anything other than the imperialist's speech. See the chapter "Where Have All the Natives Gone?" in Chow (1993).

17 It is important to note that Fanon conceives of the moment of decolonization as a kind of *tabula rasa*: "we have precisely chosen to speak of that kind of *tabula rasa* which characterizes at the outset all decolonization" (1968: 35). Among male revolutionary thinkers, Mao Zedong's attitudes toward "the people" come readily to mind in resonance with Fanon's. For comparison, see Maurice Meisner's incisive analysis of the manner in which Mao Zedong imagined "the people" for his political purposes:

Mao Tse-tung, by declaring the Chinese people "blank," was driven by a utopian impulse to escape history and by an iconoclastic desire to wipe the historical-cultural slate clean. Having rejected the traditional Chinese cultural heritage, Mao attempted to fill the emotional void by an even more iconoclastic proclamation of the nonexistence of the past in the present. A new

culture, Mao seemed to believe, could be fashioned *ex nihilo* on a fresh canvas, on a "clean sheet of paper unmarred by historical blemishes."

(1986: 316–17)

Immanuel Wallerstein has analyzed how, because "peoplehood" is fundamentally ambiguous, it is "an instrument of flexibility" into which political movements – those based on class, for instance – always collapse. See the chapter "The Construction of Peoplehood: Racism, Nationalism, Ethnicity" (1991), especially pp. 84–5.

18 See also Bergner's account of what she calls black women's "double oppression or exclusion" (1995: 78).

19 Fuss writes:

Fanon's disquieting discussions of not only femininity but homosexuality – inextricably linked in Fanon as they are in Freud – have received little if any attention from his critical commentators. Passages in Fanon's corpus articulating ardent disidentifications from black and white women and from white gay men (for Fanon homosexuality is culturally white) are routinely passed over, dismissed as embarrassing, baffling, unimportant, unenlightened, or perhaps simply politically risky.

(1994: 30)

Kobena Mercer has also pointed out that Fanon's misogyny is linked to his homophobia in a defensive masculinity revolving around castration (1995; 1996; see also his essay in this volume).

20 For a critique of how the study of Fanon has become a fashionable event in postcolonial criticism, see Gates, who describes Fanon as "both totem and text," "a composite figure, indeed, an ethnographic construct" that has been put together by postcolonial critics' collective desire for a global theorist (1991: 457, 459). It would be interesting to juxtapose the worship of Fanon as a theoretical *leader* with the analyses of coercive group psychology as laid out in Freud's *Group Psychology and the Analysis of the Ego* (1959); see in particular chapters 7, "Identification"; 9, "The Herd Instinct"; and 10, "The Group and the Primal Horde." As Freud points out, it is precisely the father's excesses and neuroses which "forced them [the horde], so to speak, into group psychology" (56). In the process, the father becomes the group ideal, which governs the ego in the place of the ego ideal.

21 Even though it deals with an entirely different topic, Bal's book offers many useful insights into the formation of intellectual/interpretive as well as mythic and tribal communities, a formation that often takes place at the expense of women. See in particular her chapter on the story of Samson and Delilah, a story which is, among other things, about the conflict between kinship (which is signified by loyalty to the community that is one's tribe) and sexuality (which is signified by relations with the foreigner, the "unfaithful" woman).

22 For a discussion of the problems inherent in the facile indictment of postcolonial intellectuals "selling out" or being worked over by the language of the "first world," see Ray and Schwarz (1995); see also Li (1995). For a related discussion of the impasses created by moralistic dismissals of "Westernized" native intellectuals, see my reading of the debates around Zhang Yimou's films in Part II, chapter 4 of Chow (1995).

23 In her response to the version of this essay that was first published in *The UTS Review* (1, 1, July 1995), Susan Schwartz points out that Fanon did in fact attribute a revolutionary capacity to women (in the Algerian Revolution, for instance) and acknowledge women's agency in the formation of a utopian new community (Schwartz 1995). However, insofar as "revolution" was a cause to which the Algerian women revolutionaries had, in Fanon's eyes, submitted themselves *loyally*, their

"agency" was strictly confined within that cause (and the community it engendered) and therefore did not constitute a disruptive issue. Just as the father did not ask what his bomb-bearing daughter had done (Fanon 1965), so neither did the fatherly male theorist need to interrogate such revolutionary women: from the perspective of the revolution, their "female agency" remained a gift to patriarchy (in the terms discussed in this essay) and posed no threat. For a critique of the problematic nature of (white intellectuals' fondness for) attributing "revolutionariness" to "third world" intellectuals, men or women, see chapter 2 of Chow (1998).

REFERENCES

Bal, M. (1987) *Lethal Love: Feminist Literary Readings of Biblical Love Stories*, Bloomington: Indiana University Press.

Bergner, G. (1995) "Who Is That Masked Woman? or, The Role of Gender in Fanon's *Black Skin, White Masks*," *PMLA* 110, 1: 75–88.

Bhabha, H. (1986a) "Remembering Fanon: Self, Psyche and the Colonial Condition," preface to *Black Skin, White Masks*, London: Pluto.

—— (1986b) "Signs Taken for Wonders: Questions of Ambivalence and Authority under a Tree outside Delhi, May 1817," in H.L. Gates (ed.) *"Race," Writing, and Difference*, Chicago: University of Chicago Press.

Carby, H.V. (1987) *Reconstructing Womanhood: The Emergence of the Afro-American Woman Novelist*, New York: Oxford University Press.

Chow, R. (1993) *Writing Diaspora: Tactics of Intervention in Contemporary Cultural Studies*, Bloomington: Indiana University Press.

—— (1995) *Primitive Passions: Visuality, Sexuality, Ethnography, and Contemporary Chinese Cinema*, New York: Columbia University Press.

—— (1998) *Ethics After Idealism: Theory–Culture–Ethnicity–Reading*, Bloomington: Indiana University Press.

Doane, M.A. (1991) *Femmes Fatales: Feminism, Film Theory, Psychoanalysis*, New York: Routledge.

Fanon, F. (1965) *A Dying Colonialism*, trans. H. Chevalier, New York: Grove.

—— (1967) *Black Skin, White Masks*, trans. C.L. Markmann, New York: Grove.

—— (1968) *The Wretched of the Earth*, trans. C. Farrington, New York: Grove.

Freud, S. (1952) *Totem and Taboo: Some Points of Agreement between the Mental Lives of Savages and Neurotics*, trans. J. Strachey, New York: Norton.

—— (1959) *Group Psychology and the Analysis of the Ego*, trans. and ed. J. Strachey, New York: Norton.

—— (1963) "Some Psychological Consequences of the Anatomical Distinction between the Sexes," in P. Rieff (ed.) *Sexuality and the Psychology of Love*, New York: Collier.

Fuss, D. (1994) "Interior Colonies: Frantz Fanon and the Politics of Identification," *diacritics* 24, 2–3: 20–42.

Gates, H.L. (1991) "Critical Fanonism," *Critical Inquiry* 17, 3: 457–70.

Geismar, P. (1971) *Fanon*, New York: Dial Press.

Gendzier, I. (1973) *Frantz Fanon: A Critical Study*, New York: Grove.

Girard, R. (1977) *Violence and the Sacred*, trans. P. Gregory, Baltimore: Johns Hopkins University Press.

Hull, G., Scott, P.B. and Smith, B. (eds) (1982) *All the Women Are White, All the Blacks Are Men, But Some of Us Are Brave*, Old Hardbury, NY: Feminist Press.

Kandiyoti, D. (1994) "Identity and Its Discontents: Women and the Nation," in P. Williams and L. Chrisman (eds) *Colonial Discourse and Post-Colonial Theory: A Reader*, New York: Columbia University Press.

Lévi-Strauss, C. (1969) *Elementary Structures of Kinship*, Boston: Beacon.

Li, V. (1995) "Towards Articulation: Postcolonial Theory and Demotic Resistance," *Ariel: A Review of International English Literature* 26, 1: 167–89.

Mauss, M. (1990) *The Gift: The Form and Reason for Exchange in Archaic Societies*, trans. W.D. Halls, New York: Norton.

Meisner, M. (1986) *Mao's China and After: A History of the People's Republic*, New York: Free Press.

Memmi, A. (1971) Review of P. Geismar, *Fanon*, and D. Caute, *Frantz Fanon*, *New York Times Book Review* (14 March): 5.

Mercer, K. (1995) "Thinking Through Homophobia in Frantz Fanon," talk delivered at the conference "Blackness and the Mind/Body Split: Discourses, Social Practices, Genders, Sexualities," University of California, Irvine.

—— (1996) "Decolonization and Disappointment: Reading Fanon's Sexual Politics," in A. Read (ed.) *The Fact of Blackness: Frantz Fanon and Visual Representation*, Seattle: Bay Press.

Mishra, V. and Hodge, B. (1991) "What Is Post(-)colonialism?" *Textual Practice* 5, 3: 399–414.

Mitchell, J. (1975) *Feminism and Psychoanalysis: Freud, Reich, Laing and Women*, New York: Vintage.

Nancy, J.-L. (1991) *The Inoperative Community*, ed. and trans. P. Connor, Minneapolis: University of Minnesota Press.

Ray, S. and Schwartz, H. (1995) "Postcolonial Discourse: The Raw and the Cooked," *Ariel: A Review of International English Literature* 26, 1: 147–66.

Read, A. (ed.) *The Fact of Blackness: Frantz Fanon and Visual Representation*, Seattle: Bay Press.

Rubin, G. (1975) "The Traffic in Women: Notes on the 'Political Economy' of Sex," in R. Reiter (ed.) *Toward an Anthropology of Women*, New York: Monthly Review.

Sartre, J.-P. (1948) *Orphée noir*, preface to *Anthologie de la nouvelle poésie nègre et malgache*, Paris: Presses Universitaires de France.

Schwartz, S. (1995) "Fanon's Revolutionary Women," *UTS Review* 1, 2: 197–201.

Spivak, G.C. (1988) "Subaltern Studies: Deconstructing Historiography," in R. Guha and G.C. Spivak (eds) *Selected Subaltern Studies*, New York: Oxford University Press.

Wallerstein, I. (1991) "The Construction of Peoplehood: Racism, Nationalism, Ethnicity," in E. Balibar and I. Wallerstein, *Race, Nation, Class: Ambiguous Identities*, London: Verso.

Young, L. (1996) "Missing Persons: Fantasizing Black Women in *Black Skin, White Masks*," in A. Read (ed.) *The Fact of Blackness: Frantz Fanon and Visual Representation*, Seattle: Bay Press.

FANON AND CAPÉCIA

T. Denean Sharpley-Whiting

I am a Frenchwoman, as any other.
<div align="right">Mayotte Capécia, Je suis Martiniquaise</div>

What is your real value in the world's economy? What are you worth?
<div align="right">Anna Julia Cooper, A Voice from the South</div>

With the exception of a few misfits within the closed environment, we can say that every neurosis, every abnormal manifestation, every affective erethism in an Antillean is the product of his cultural situation.
<div align="right">Frantz Fanon, Black Skin, White Masks</div>

In 1892, Anna Julia Haywood Cooper posed a series of peculiar but thought-provoking questions in a collection of essays entitled *A Voice from the South*: "What are we worth?...what do we represent to the world? What is our market value? Are we a positive and additive quantity or a negative factor in the world's elements?" (1988: 233). With a highly methodical practicality, this black feminist "casts up" and "carefully overhauls" the account of blacks (229). While valuable black resources and raw materials are wasted owing to pervasive antiblack racism, classism, and sexism, Cooper concludes optimistically that no amount of blackphobia can mitigate individual and collective black contributions to "those things the world prizes," nor deny the aggregate worth of blacks as a race. "What are we worth?" recommends industriousness, black philanthropy, education, and other socioeconomic strategies of resistance as a means through which to change the value of blacks to the world (284–5). And while Cooper, in her practicality, resists "brooding" and "orating" over the black problem, her riveting cognizance of the blacks' situation compels us to examine further the existential worth of blacks.

Troubling from a philosophically humanist perspective, a sentiment Cooper concedes but readily dispenses with, her insightful query opens the floodgates for the contemplation of black existence in the midst of racialized cultural and economic domination. To ask blacks what they are worth is in fact to ask them to justify their presence, their continued existence. The existential reality is that

blacks are still fundamentally worth less in the world economy because of their blackness. Indeed, they are the antithesis of values and value, a not fully human presence-as-absence dispossessed of inalienable rights. As Frantz Fanon observes in his discussion of the "wretchedness" of the colonized, the Arabs, the blacks:

> The natives represent not only the absence of values but also the negation of values...they are the corrosive element, destroying all that comes near them; they are the deforming element, disfiguring all that has to do with beauty and morality; they are the depository of maleficent powers and the unconscious and irretrievable instrument of blind forces.
>
> (1968: 41)

Cooper's "What are we worth?" reveals the lived experience of blacks as historical and contemporary markers of negativity within the social world.[1] Hence, if blacks are existentially devalued, worth less, then black contributions are ultimately worthless. In this vein Howard Ward Beecher affirms:

Were Africa and the Africans to sink tomorrow, how much poorer would the world be? A little less gold and ivory, a little less coffee, a considerable ripple, perhaps, where the Atlantic and Indian Oceans would come together – that is all; not a poem, not an invention, not a piece of art would be missed from the world.

(quoted in Cooper 1988: 229)

The disappearance of Africa would constitute not the disappearance of viable human life, but merely dent the world's (i.e. the Occident as this world is conceived) supply of raw materials. It is assumed that contributions in the higher forms of art and culture are nonexistent. And the "objects" that inhabit that land mass, the Africans, are ultimately worthless, as they lack inventiveness; blacks serve absolutely no earthly purpose. The aggregate value of Africans and the black diaspora in the Western, that is, white hegemonic world, amounts to nil.

But what happens when the black recognizes that his or her debt and credit ledger is perpetually in the red: that they owe more to the world than they are worth? How does the black experience his or her devaluation in the world's human economy? Devaluation, as Fanon notes, is not experienced exclusively in material terms. Economic worthlessness, and dis-eases mediated through racial difference, are experienced internally or psychologically. "What are we worth?" in an antiblack body politic depends on "who we are." If one is white, one is valued; if one is black, one is devalued. Oppression is concomitantly experienced in such a polity along a gender hierarchy. If one is male, one is valued; if one is female, one is less valued – if one is black and female, one has no value (see Lorde 1993). This devaluation is further compounded when class and

sexuality are figured into the equation. Trapped in a valued-less existence, what resources are open to the worth less (black males) and the worthless (black females)?

In his clinical study of the colonized Antillean, Fanon observes that, at the moment the colonized black becomes conscious of his or her negation, and worthlessness, a psychoexistential complex occurs. The desire to be rid of the epidermal schema, to slough off the black skin and the historical realities of black existence, arises. The black body becomes a phobogenic object. Escape hatches are sought from the corporeal malediction. And mastery of the colonizer's language is perceived as one potentially liberatory, vindicating, resource, as Anna Julia Cooper remarks:

> Stung by such imputations as that of Calhoun that if a Negro could prove his ability to master the Greek subjunctive he might vindicate his title to his manhood, the newly liberated race first shot forward along this line with an energy and success.

> (1988: 260)

In "The Negro and Language," the first chapter of *Black Skin, White Masks*, Fanon theorizes that language is a crucial component of culture; it structures cultures and mediates social intercourse. The acquisition of such and such language represents the acquisition of such and such culture. In the colonial situation, mastery of the language of the metropole is held out as a card of entry to the culturally deprived Antillean for honorary citizenship among whites, as a carrot to be voraciously and gratefully gobbled up. The Antillean who masters the French language becomes more French, more white, and less black. As language is the organ for the expression of thought, the Cartesian "I think, therefore I am" is transformed into "I speak, therefore I am." The colonized becomes convinced that the burden of his or her corporeality can be purged through the acquisition of the French language. The more the Antillean strives to assimilate linguistically, hence culturally, the more he or she ascends the great chain of being, moves closer to being recognized as fully human.

This strategy proves utterly futile. Forever sealed in blackness, one is unable to become assimilated into French culture by virtue of the "idea" that others have of their bodily schema. The black is a slave of his or her appearance. The language that the colonized have mastered reaffirms their inhumanity and inferiority, with its mulitiplicity of negative values and meanings for their existence. As Jacques Derrida writes in "Racism's Last Word," "There is no racism without language...racism always betrays the perversion of man...it...writes, inscribes, prescribes" (1985: 292). The black can never really *be* French because he or she *is* black, the antithesis of white, which *is* French. To *be like* or as is never quite the same as *being*: "Wherever he goes, the Negro remains a Negro" (Fanon 1967: 173). The colonized will be perpetually locked in the state of becoming; they are marked as *évolués*. Therein lies the rub, the angst of their existence. Jean Veneuse,

the character from René Maran's *Un homme pareil aux autres*, attests to the illusion and elusiveness of Antillean assimilation: "The Europeans in general and the French in particular, not satisfied with simply ignoring the Negro of the colonies, repudiate the one whom they have shaped into their own image" (quoted in Fanon 1967: 64). The official French position on the "Negro of the colonies," expressed in 1925 by Monsieur Tesseron, the *Directeur Honoraire au Ministère des Colonies*, and contained within "*Rapport sur la condition légale des sujets dans les colonies françaises et sur les prérogatives qui en résultent*," confirms Veneuse's observations:

> The point is to know to what degree it is possible to satisfy the aspira-tions of the indigenous populations without jeopardizing our domina-tion....Is it politic, is it in our interest to encourage naturalization? Generally speaking, no. Certainly, we must welcome those...of our subjects who can genuinely be assimilated, that is to say who have sin-cerely moved close to us by abandoning their customs, their mores and adopting ours....But how many will we find who fit this category? Obviously very few. The others, those who solicit the status of citi-zen...only to obtain certain advantages will always be dangerous.
>
> (quoted in Conklin 1993: 12)

Another counsel on the native situation and citizenship read: "Although the new citizen...may have personally and momentarily elevated himself...he often falls back down before the end of his career...from which it is necessary to conclude that citizenship is not made for our natives" (quoted in Conklin 1993: 17). Besides the abandonment of custom and mores, the colonized had to demonstrate sufficient mastery of the French language for citizenship. The danger for the French was embodied in the delicate balance of cultural and racial domination and their rhetoric of *liberté, égalité*, and *fraternité*.[2] Implicit in the granting of a French identity was the notion that the colonized would assume themselves to be somehow equal to whites, expect the same privileges as whites, most notably, venture to intermarry, subverting the clearcut boundaries of racial superiority through miscegenation and *métissage*.[3]

Love, in this context, presents itself as another self-deluding resource of emancipation from blackness. In *Black Skin, White Masks*, Fanon writes: "The person I love will strengthen me by endorsing my assumption of my manhood, while the need to earn the admiration or the love of others will erect a value-making superstructure on my whole vision of the world" (1967: 41). In effect, love, by way of Sartre and Lacan, is a narcissistic investment of feelings; it bestows the beloved with value. One loves in order to be loved. It is, in Sartrean terms, dishonest. And so, when Mayotte Capécia writes in *Je suis Martiniquaise*, "I wanted so much to become a respectable woman. I should have liked to marry, but to a white man," this statement should have piqued our curiosity (1948: 202). For this woman of color in a patriarchal, antiblack

culture, who is presently the subject of our feminist inquiry, the white male stands as the ultimate purveyor of value.

Fanon, unlike Sartre, believes in the possibility of authentic love. And the aforementioned type of love, linked to the phobogenic complex is, for him, inauthentic and/or perverse. Thus he examined it at length in "The Woman of Color and the White Man," the second chapter of *Black Skin, White Masks*. Using Capécia as his point of departure, Fanon levels deft criticism at the writer and her autobiographical novel, *Je suis Martiniquaise*. For Fanon, Capécia is duped. In the view of some contemporary feminists, Fanon is a misogynist. The following revisits the conflicts over disalienation, antiblack racism, sexism, and sexuality by engaging Fanon and feminist theorists in a rereading of Mayotte Capécia and her novels, *Je suis Martiniquaise* and *La Négresse blanche*.

In 1949, Mayotte Capécia would become the fourth Antillean and the first black woman to be awarded the renowned *Grand Prix Littéraire des Antilles* for *Je suis Martiniquaise*. The annual award, paying the handsome sum of 20,000 francs, was established in 1946 in Paris for novels, historical novels, essays, and poetry. Interestingly, the jury who found Capécia's work worthy of recognition was composed of thirteen Frenchmen.

This autobiographical novel was hardly seen as a *chef d'oeuvre* among the writers of the négritude movement, nor did it even gloss the pages reserved for literary criticism and book reviews in *Présence Africaine*. And the authenticity, i.e., Capécia's authorship, of the book has recently come under scrutiny.[4] Notwithstanding Maryse Condé's bibliography of Francophone Antillean women writers in *Parole des femmes*,[5] Capécia's work is not mentioned in Patrick Chamoiseau's and Raphaël Confiant's historical-literary tour de force on writings by Antilleans, *Lettres Créoles: Tracées Antillaises et Continentales de la Littérature 1635–1975*.

One could certainly argue that the marginalization of black women writers by black male literati is not surprising and even that it is indicative of persistent attempts to privilege male voices and silence women's candid articulation of their experiences. However, such a statement would be in haste, for the monthly 1940s–50s issues of *Présence Africaine* include scores of writings by black and white women, and *Lettres Créoles* does in fact have a cadre of Antillean women writers, including Maryse Condé, Simone Schwarz-Bart, and Suzanne Césaire. Capécia's resurgent popularity among and recovery by American literary and cultural studies feminist theorists is thus owing primarily to Frantz Fanon.

Of Capécia and *Je suis Martiniquais*, Fanon wrote in *Black Skin, White Masks*:

> One day a woman named Mayotte Capécia, obeying a motivation whose elements are difficult to detect, sat down to write 202 pages – her life – in which the most ridiculous ideas proliferated at random. The enthusiastic reception that greeted this book in certain circles

forces us to analyze it. For us all circumlocution is impossible: *Je suis Martiniquaise* is cut-rate merchandise, a sermon in praise of *unhealthy behavior*.

> (1967: 42; translation slightly altered)

Fanon's scathing condemnation of the novel and writer were rooted initially in the novel's commercial success, literary kudos, and appeal to French audiences, an appeal undeniably linked to Capécia's seemingly effortless adeptness at acting as a mirror for the French, reflecting back their idealized conceptions of themselves. But it is precisely this dismissive critique that has led Fanon into a myriad of conflicts with feminists and helped to catapult him into misogynist and sexist orbits. As Gwen Bergner notes:

> The terms of Fanon's censure reveal much about the economy of gender, class, and sexuality that binds black women. Fanon belittles Capécia's life story in terms of economic worth ("cut-rate merchandise") and sexual morality ("a sermon in praise of corruption") – the charges conventionally brought against women's writing and other assertions of feminine autonomy.
>
> (1995: 83)

Bergner continues: "Capécia sometimes – but not always – lapses into valorizing whiteness in her aspirations to privilege." In *Femmes Fatales: Feminism, Film Theory, Psychoanalysis*, Mary Anne Doane states: "Fanon is relentless in his critique of Capécia's overwhelming desire to marry a white man....Fanon sees the black woman's desire as representative of a black pathology which he despises" (1991: 219). And finally, we cite at length Susan Andrade's equally aggressive critique of Fanon:

> The figural supplement to the European representation of the oversexed black woman, that of the betrayer of black men, is powerfully articulated in Frantz Fanon's *Peau noire, masques blancs*. Fanon launches a virulent critique of Mayotte Capécia, using her first person narrative as a transparent paradigm of black alienation, even comparing her to the arch-racist, Gobineau. His reading permits no ironic distance between the author and her first person narrative. Most damning of all, he accuses Capécia and, by extension, all Caribbean women of color who marry lighter men (either white or mulatto) of lactification, or attempting to whiten the race.
>
> (1993: 219)

It is criticisms accented with adjectives like "relentless" and "virulent" that call for an examination of Fanon's and Capécia's texts in greater detail. Capécia's text not only uses the first-person narrative voice, but the character's

name is Mayotte Capécia. Hence the charge regarding Fanon's inability to separate author from the work of fiction appears moot. Moreover, Fanon does not accuse all Caribbean women of wanting to whiten the race via their marital choices, merely the duped. The Fanonian context seems to have slipped by the second of these feminist literary critics.

In Andrade's, Doane's, and Bergner's scenarios, Fanon wants to police black women's desires and damn them as sexually immoral if they demonstrate agency by selecting partners outside of their race. But there is something particularly troubling within Bergner's and Andrade's attempts to rescue the Antillean novelist from Fanon's "sexist-patriarchal circumscription" of her sexual autonomy and economic mobility. Both construct unpersuasively their own justifications for Capécia's exclusive desire for white men as economically motivated, which the novelist herself explicitly rejects throughout *Je suis Martiniquaise*.

In sum, according to Bergner and Andrade, Capécia's predilection is a matter of survival, a black woman working in the service of whites, using the only commodities of exchange she has to eke out her existence in the colonies: her body. Here one is reminded of the black women described at the Bronx slave marts in Ella Baker and Marvel Cooke's study (see James 1997), or even the black women forced to prostitute themselves in Martinique, contemptuously and unsympathetically described by Capécia in her second novel, *La Négresse blanche*. But Capécia's sagas in *Je suis Martiniquaise* and *La Négresse blanche* are quite different; these feminists' observations simply do not gel with the recountings in the novels. In both texts, she is self-sufficient, an entrepreneur: a laundress in the former, a bar owner in the latter. She expressly refuses to use André, the French officer in *Je suis Martiniquaise*, for financial mobility, safety, or anything else besides his presence. She even refuses a gold and diamond ring from the officer, declaring that he "is treating her like a prostitute" and if he "had given her an object without value," she would have believed he was not treating her disrespectfully (Capécia 1948: 145). Indeed, Mayotte gives André a gold medallion. Once Mayotte moves into the officer's house, she pays for the food, the maid, and the laundry in order to establish herself as a "legitimate" woman, as respectable and worthy of his love (148). She becomes infuriated when he leaves money in her purse to meet the household expenses: "One morning, I found some unexpected bills in my purse. For the first time, I was violently angry with André." She tells him, "I put them back in your drawer. I do not sell my love and my services" (147). After André leaves Mayotte, sending her a check, a veritable sign of her worth, she refuses to pursue him legally in order to obligate him to recognize and financially support their son, François.

These feminist critics deny Capécia's agency or at least circumscribe her autonomy and agency more than Fanon ever could. In their logic, the only way a colonized black woman would ever acquiesce emotionally/sexually to her oppressor was under extreme economic duress; it becomes unfathomable that a

black woman would *desire*, "love," or "sleep with the enemy," so to speak. Clouded it seems by images of the black superwoman with a will and psychical makeup of steel, inserted within the folds of these analyses is a sheer lack of understanding of the terrorizing effects of colonialism and systemic racism and sexism on the psyche of the colonized.

So what does Mayotte's desire for white men convey, if not the socioeconomic privilege put forth by Andrade *et al.*? Here we turn to Fanon's clinical observations of the epidermalization of oppression. It would appear that "all she wants is a bit of whiteness in her life" (Fanon 1967: 42). Her motivation represents a psychoexistential complex. André's love humanizes Mayotte in the virulently dehumanizing colonial world. She is "unable to see herself as equal to whites" (Capécia 1948: 191). By loving her, he proves that she is worthy of white love; she is loved like a French woman. She is a French woman (Fanon 1967: 63).

Bergner's citing of Fanon's criticisms sticks very closely to Charles Lamm Markmann's translation of *Peau noire, masques blancs*. The "unhealthy behavior" used in this translation is indeed more in keeping with Fanon's clinical investigation of the epidermalization of inferiority. Bergner realizes the glaring difference in the translation in footnote 22 of her article. She concludes, however, that either translation – "a sermon in praise of corruption" or "unhealthy behavior" – suggests that Capécia is a degenerate influence. But does it? A sermon in praise of corruption with the sexual immorality ascribed to it *by* Bergner is clearly not the same as someone indulging in behavior that is in effect "unhealthy" to his or her own mental and physical well-being.

To romanticize *Je suis Martiniquaise* as a "rare, unapologetic, and *invigorating* representation of a black woman's effort to carve economic and sexual autonomy" that "sometimes lapses into valorizing whiteness" and to suggest that this is not on a profound level "unhealthy behavior" decontextualizes the colonialist framework out of which Capécia was writing (Bergner 1995: n. 23). This colonialist framework, in its *a priori* function, inspires acute racial/sexual *malaise* in the psyche of colonial subjects. Fanon writes: "the (white) man who adores the negro is as 'sick' as the one who abominates him. Conversely, the black who wants to turn his/her race white [who valorizes the white] is as miserable as he who preaches hatred for the whites" (Fanon 1967: 8–9).

The negrophobe and exoticizing negrophile as well as the *cauca*phobe and *cauca*phile are emotionally crippled. The desire on the part of the black to whiten herself or flee the black body to a white or whiter body is indicative of affective erethism and lactification, a miserable state of affairs. And Mayotte Capécia is indeed miserable. Capécia is blackphobic, and as we will discuss in *La Négresse blanche*, a black black*femme*phobe:

> I found that I was proud of it. I was certainly not the only one who
> had white blood, but a white grandmother?...So my mother, then, was
> a mixture?...I found her prettier than ever, and cleverer, and more re-

fined. If she had married a white man, do you suppose I should have been completely white?...And life might not have been so hard for me?...I could never stop thinking of our priest, and I made up my mind that I could never love anyone but a white man, a blue-eyed blonde, a Frenchman.

(Capécia 1948: 59)[6]

Whiteness represents beauty, intelligence, privilege. Her mother is suddenly, magically, transformed before the adolescent's eyes into a "prettier, cleverer, and more refined" woman because of this infusion of whiteness. The lived experiences of black women in colonial Martinique are indeed arduous ones. Hence, our heroine finds a bit of solace in her musings that she could have been a white woman. But because Capécia cannot be a white woman, she can at least have the love of a white man, which she believes will liberate her from the black female body, endow her with value, and thus ultimately allow her to exist as a human being. André, for his part, has followed manuals along the lines of Dr. Barot's *Guide pratique de l'Européen dans l'Afrique occidentale* (1902), which suggests: "For those who lack the moral strength necessary to endure two years of absolute continence, only one line of conduct is possible: a temporary union with a well-chosen native woman" (1902: 329). And André does indeed live with Capécia for two years.

After the heroine has been sexually exploited, impregnated, and abandoned by the French officer just days before she gives birth, she concludes *Je suis Martiniquaise* with the realization: "I would have liked to marry, but to a white man. Only a woman of color is never all in fact respectable/valued in a white man's eyes. Even if he loves her, I knew this" (1948: 202). To be sure, there is something saddening about Capécia's resignation. While Fanon may have been "relentless" in his critique of Capécia's desire to marry a white man, Capécia is equally relentless in her blackphobia, her self-hatred. For all of *Je suis Martiniquaise*'s frankness, its unapologetic tone (as it should be, for Mayotte Capécia has every right to present her autobiographical narrative), this is "unhealthy behavior" par excellence.

Fanon's endeavor to explore the imperfections of love must again be examined. Authentic love is free of conflict. Both Capécia and André are sealed in the respective social constructions of their inferiority and superiority. She offers him little value in an antiblack and antifemale world, while he is valued in this same world. Fanon's impatient, dismissive reading of Capécia is not related to her interracial relationship proper, nor to his own desire to "circumscribe black women's sexuality and economic autonomy in order to ensure the patriarchal authority of black men" (Bergner 1995: 81), but to the internalized oppression she invokes in articulating her desire. The articulation of authentic love without racial *malaise* or exoticism guides Fanon's critique. Love – more specifically, white male love – as a strategy of evasion/redemption, as a *moyen* through which to liberate oneself from the black female body and hence the historical

reality of black femaleness, is as futile as the mimetic strategies deployed with language.

Fanon's diagnosis of Capécia's affective erethism is unique to this woman of color. It is not specific to all colonized women of color. As Fanon concedes, "there was a touch of fraud in trying to deduce from the behavior of Nini[7] and Mayotte Capécia a general law of behavior of the black woman with the white man" (1967: 81). That love has failed in its redemptive capacity and that Mayotte Capécia realizes its failure are sadly evident toward *Je suis Martin-iquaise*'s denouement. She and her son, François, attempt to depart for Guadeloupe in order to follow André. She is denied a passport. She relates in *r*-eating dialect, nonetheless, to the French administrator: "je suis F'ançais, tout comme aut" ("I am a French woman as any other") (1948: 178). But the French commandant reassures her that she is "forget[ting] that you are a woman of color" (181).

The identity crisis typical of the colonized, the "In reality, who am I?" described in Fanon's treatise on mental disorders in *The Wretched of the Earth*, is here presented (Fanon 1968: 250). Mayotte believes that she *is* a French-woman because she has been "loved" by a Frenchman. But she is not. The Fanonian *évidence* rests with her *r*-eating dialect and her blackness. She is not *Française*, but *Martiniquaise*. Just as Frenchman means white male, French-woman means white female. Capécia, even with her white grandmother, is undeniably "native." And so, the novel reflects this abject realization in its title: *Je suis Martiniquaise*.

Fanon's phenomenology of oppression has been useful in discerning the disalienation of the colonized woman of color, specifically Mayotte Capécia. Love has played a strategic but futile role as a resource of emancipation, redemption, and mimicry for the inferiorized native. Let us turn now to Fanon's psychology of oppression amid feminist conflicts for a reading of Capécia's seldom-read, semi-autobiographical novel, *La Négresse blanche* (1950).

Although it was not an award-winning work, reviews of this novel in the French press were complimentary. For instance, critic Robert Coiplet wrote:

> The style of Miss Mayotte Capécia is lively…her narrative is pleasant, free….*La Négresse blanche* has this tone…it is the story of a mixed-race woman who tends bar…. At twenty years of age, she has a three-year-old son whiter still than she. Her black blood taunts her. It also brings her some humiliations. She will leave the island for France.
>
> (1950: 7a)

Capécia's heroine suffers humiliation because of her strain of black blood. Blackness, not colonial oppression and its psychological and material manifestations, is the fundamental source of angst. Her convoluted responses to this existential dilemma range from condescending pity to hatred toward the island blacks and desire to be recognized as anything but a Negress by the whites.

Hence, our reading will focus particularly on Capécia's black*femme*phobia exhibited in her oftentimes contemptuous and stereotyped sexualized portraits of black femininity, in which the heroine incessantly tries to situate herself as "different" from, or a step above, black women.

The Adlerian exaltation that Fanon ascribes to Capécia is no longer exclusively premised upon "white male love," but bound up with such a feeling of inferiority linked explicitly to black femininity that transcendence is necessarily articulated in terms of a mixed-race female identity. Given Capécia's conclusion regarding the respectability of the woman of color (read: black woman), the desire to transcend black femininity in *La Négresse blanche* becomes ever-pressing. For Capécia, a woman of color is a woman who is perceptibly black. In her construction of the mixed-race female identity, her heroine is consistently rendered not necessarily white but, most importantly, not black. Yet whiteness is undoubtedly, as this exploration will reveal, the ultimate goal.

Written two years after the successful *Je suis Martiniquaise*, *La Négresse blanche* recounts the story of the 25-year-old Isaure. The plot of *Je suis Martiniquaise* frames that of *La Négresse blanche*. The heroine, Isaure, is a single, working mother, whose child, François, is fathered by a white Creole who seduced and abandoned the trusting Martinican some years before. Isaure will marry a white childhood friend, Pascal, who was ostracized by the white Creoles because of his family's poverty, but whose family nevertheless objects to his marrying a black woman. Pascal ironically declares a profound affinity for and understanding of the island "Negroes," but insists that his wife, Isaure, is not really black. He, Isaure, and François live on the sugar plantation where Pascal works as overseer of the black natives. In an upheaval over pay inequities and colonial injustices, Pascal is brutally murdered by the "savages" he so loves and (mis)understands, and Isaure flees Martinique for France.

Fanon writes of Capécia's work:

> She must have recognized her earlier mistakes, for in this book one sees an attempt to reevaluate the Negro. But Mayotte Capécia did not reckon with her own unconscious. As soon as the novelist allows her characters a little freedom, they use it to belittle the Negro. All the Negroes whom she describes are in one way or another either semi-criminal or "sho good" *niggers*.
>
> In addition – and from this one can foresee what is to come – it is legitimate to say that Mayotte Capécia has definitively turned her back on her country. In both her books only one course is left for her heroines: to go away. This country of niggers is decidedly accursed.
>
> (1967: 52–3 n. 12)[8]

From the novel's opening scenes, blacks are described as sexually jealous and *sales nègres* ("dirty niggers"). When questioned about the sexual practices of black men by the white colonial officers who frequent her bar, Isaure reveals,

"They can make love in a terrible fashion. I have never made love to a black man. They disgust me, they scare me" (Capécia 1950: 12).

Isaure affects the same fears of black (male) sexuality as the colonialists. In this instance, the black male is projected as having the keys, namely an overendowed penis and overzealous sex drive, to a frenzied sexual universe. The black is the biological and hence represents a biological danger. By way of Fanon, we cite Michel Cournot on black male sexuality:

> The black man's sword is a sword. When he thrust it into your wife, she has really felt something. It is a revelation. In the chasm that it has left, your little toy is lost. Pump away until the room is awash with your sweat, you might as well just be singing.
>
> (Fanon 1967: 169)

Isaure insists, however, that she has not suffered such defilement, a chasmic space left by a hefty black sword. Such a concession would equally imprison her sexual impulses within the same imaginative lascivious universe of the black female body she intends to flee.

Following her revelation of sexual purity, Isaure then proceeds to reflect on her negrophobia:

> It was true, she had never had a black lover. Perhaps solely because the first, who had taken her at seventeen years old and who had fathered her son whose skin is so white, was white. The first lover orients one's life. It could have been very different. Perhaps if she would have married....Marriage with a black, would it not be worth/valued [*valoir*] more than concubinage with a white? The children, at least, wouldn't have been bastards.
>
> (1950: 121)

The character poses nothing short of a rhetorical question around value: "Would not marriage to a black be valued more than concubinage with a white?" As the scales of humanity are unbalanced, legitimate black children weigh comparatively less, are valued less, than illegitimate "whiter" children to Isaure. Isaure even refuses to allow her black compatriots in her bar, calling one patron a *sale nègre*. She is, however, punished for this indiscretion in a court of law when the judge tells her, "One does not use 'black' and 'nigger' interchangeably, for Martinique is not part of the United States" (1950: 13).

But one is struck straightaway by the novel's title, a reification of Capécia's *mal de couleur* presented intially in her autobiography. *La Négresse blanche* or *The White-Negro Woman* seemingly supports Fanon's assertion that Capécia's entrepreneurial endeavor as laundress in *Je suis Martiniquaise* was indicative of a desire to whiten (*blanchir*) herself (Fanon 1967: 45). Isaure struggles with her racial identity, eschewing both blackness and whiteness for the concept of

métissage. She cannot claim to be a *mulâtresse*, but she will not accept the term *négresse*. This refusal to situate herself racially is betrayed by a clear desire to flee blackness.

Capécia's heroine mulls over the profound alienation of being "alone, neither black nor white," and even offers quasi-philosophical thoughts on the "unfairness" of the categories of race. Race, it seems, is pure fiction; however, every one of Isaure's pronouncements on black women is undergirded by racist logic. Superficial distinction after distinction, reducible to color, between the heroine and black women is proffered as evidence of difference. Besides Isaure's color, a blend of fruits – banana, coconut, orange – and coffee, her difference manifests itself in the articulation of the notorious French *r*.[9] "She had a soft voice, a bit melodic: the accent of Island girls that resembles English accents. It was not at all like that of the black girls who completely eat the r" (1950: 9). Even Isaure's cheekbones "had the appearance of a white face" (10). And to highlight her appearance, she would put a "touch of pink on her cheeks which she thought made her appear less black....She did not exaggerate like those black women disgustingly made up, whom one encounters in the cafes at the port" (92). Capécia chronicles each and every minute detail of Isaure's difference – in gestures, accent, physiognomy – from the "black girls" toward whiteness via the unfixed racial identity of *femme métissée*. And character after character affirms Isaure's *métissage*. Yet in the chapter entitled "The Love of Lucia," Capécia provides another yardstick by which to measure Isaure's veritable difference.

Lucia is Isaure's buffoonish, "r-eating" maidservant. Capécia describes Lucia as

> not being able to wear real shoes. Like many other negresses, she had large heels. She was of the most pure African type. She had full lips, a flat nose, frizzy hair and brilliant black skin. She was beautiful in her way, distinguishing her from all the half-whites and half-blacks which form the foundation of the population of Martinique. Since her distant ancestors, imported by slave traders from the time of Father Labbat, there must not have been any mixing in her ancestry. Not a drop of white blood....A sort of familiarity was established between the black woman and the mixed woman.
>
> (1950: 34, 36)

Indeed, Capécia's comparing and contrasting reads like a nineteenth-century text on natural history or Gobineau's *Essai sur l'inégalité des race humaines*, as Lucia's pure blackness is physiognomically, physiologically, and psychologically gleaned and syncretized. Her devotion and deference – a remnant of "her slave mentality" bequeathed by her ancestors – to Isaure is so self-sacrificing, deprecating, according to Capécia, that Isaure could have been a white woman

(36). Isaure's attitude toward the Negress is one of condescension, indulging Lucia's tales of her many wanton sexual escapades:

> The mistress was up to date on all her servant's adventures which were numerous....She sought pleasure with such a frenzy, she was worse than a cat in heat. Isaure listened to her with a mysterious smile. Sometimes she was envious of the black woman who didn't have any more scruples than an animal.
>
> (36–7)

And while Isaure contemptuously envies Lucia's reckless abandon, she, possessing "drops of white blood," is governed by an entirely different and higher morality. Lucia is the embodiment of the lascivious Negress stereotype. This black woman is reduced to her base corporeal, specifically sexual, function, copulating like an unscrupulous animal with the poor *békés* (whites) and even poorer *sale nègres*. Love is as fleeting as an orgasm; Lucia is forever on the lookout for a quick fix. For Lucia, love is sex, and sex is love. Thus her love story, or rather love stories, are ones driven by sheer need for satiation.

For Capécia, black femininity represents bestiality and immorality; black women are either hideously made-up prostitutes, like the Negresses at the cafés, or possess prostitute proclivities like Lucia. They are aberrations for Isaure; her mirrors, rearing their loathsome black female heads in identification, dragging her down with their very presence and proximity. Yet one is left wondering why Isaure expresses such a profound alienation in Martinique where the population is, as she relates in the novella's first chapter, utterly mixed. Why does she at the novel's end seek to exile herself to a country where she is neither black, nor white, but "raceless"? And finally, how does this self-imposed exile and desire to flee blackness cloaked in the ambiguity of racelessness relate to her contempt for black women? For Fanon, the answer is simple. To situate oneself as a *négresse blanche* among hypersexual Negresses is but a small feat, a too-easily drawn fine line. It is most essential, writes Fanon, "to avoid falling back into the pit of niggerhood" that black femininity represents (1967: 47).

And so we conclude our engagement with and re-reading of Fanon and Capécia with a few observations on the preceding feminist critiques of Fanon. To dismiss Fanon as antifeminist, or anti-Caribbean woman of color, because he does not fit liberal feminists' paradigms of feminism undermines intellectual and pragmatic integrity, leaving instead a postmodern mythology – Fanon as a misogynist. Nowhere is this "truism" more apparent than in specious feminist readings of gender inequity in Fanon's rigorous critique of Mayotte Capécia and his "sympathetic" reading of the equally popular novelist, poet, négritude proponent, and *Prix Goncourt* winner Rene Maran, whose *Un homme pareil aux autres* was written one year before *Je suis Martiniquaise* in 1947.[10]

What "sympathetic" tenor rings out in Fanon's observations that "Jean Veneuse...is a beggar. He looks for appeasement, for permission, in the white

man's eyes"; or "*Un homme pareil aux autres* is a sham, an attempt to make the relations between two races dependent on an organic unhealthiness"; or better still, in embarking upon uncovering Veneuse's complicated neurosis, when Fanon offers: "Veneuse is the lamb to be slaughtered. Let us make the effort" (1967: 76, 80, 66)? Suffering from an acute "Cinderella complex," Veneuse "wants to prove to the others that he is man, their equal" (77, 66).

Veneuse is an abandonment-neurotic of the negative-aggressive type (Fanon 1967: 80). And race, more specifically blackness, becomes the mask for this alienation. Capécia's psychical crises are culturally produced, emanating from without, while Veneuse's emanate from within: blackness functions as the vehicle through which he can externalize his neurosis. Reading Fanon's observations within this schema, Veneuse, rather than Capécia, emerges as debilitated by a congenital neurosis exacerbated by his appearance, his blackness. Just as one cannot deduce a general law of behavior between black women and white men from Capécia's example, "there would be a similar lack of objectivity, I believe in trying to extend the attitude of Veneuse to the man of color as such" (Fanon 1967: 81).[11]

While black women clearly experience oppression differently from black men, one can even explain away Capécia's complicity in her sexploitation, but one has to go a long way to ignore Capécia's re-inscription of sexually racist stereotypes of black women ironically heaped upon Fanon by lit-crit feminists. The conflation of Fanon's analyses of two very distinct psychoses of novelists whose works are written in two extremely different authorial tones represents a feminist literary/cultural criticism strangely unconcerned with racist and sexually racist logic. Readings of this nature are at the heart of Audre Lorde's critical observations that "it is easier to deal with external manifestations of racism and sexism than it is to deal with the results of those distortions internalized within our consciousness of ourselves and one another" (1993: 147).

A more appropriate and plausible critique of Fanon's gender politics with respect to Mayotte Capécia lies ultimately in his *not* exploring her sexism, specifically her antiblack woman phobia, her intraracial gendered relations. While Euro-American lit-crit feminists' gendered criticisms of Fanon are undercut by their lack of antiracist, anticapitalist, and antifemale-sexist analyses, Fanon's analyses of Capécia fixate on antiblack racism, alienation, and economic disease. One is left with gaping holes, "blind spots," if you will, in both critical analyses.

To reconstruct Capécia's story as an example of black feminism in practice because she is a black woman and because she was vigorously, but importantly, taken to task by Fanon is, to say the least, a dangerous feminist politics. One has to ask equally what is so invigorating about Capécia's representations and for whom are they invigorating? Are they invigorating merely because of their candor, the openness with which the novelist recounts her innermost racial, sexual, and class conflicts? Capécia's works should not be panned, but rather seriously engaged because of their troubling conclusions. Indeed, as bell hooks writes in her "Feminist Challenge: Must We Call Every Woman Sister?": "While

it is crucial that women come to voice in a patriarchal society that socializes us to repress and contain, it is also crucial what we say, how we say it and what our politics are" (1992: 80).

Fanon's honesty in *Black Skin, White Masks* may be brutal, but it is not brutalizing. In an antiblack world, black male and female bodies are imagined as excess. Black males are constructed as more sexist, violent, and sexual. And black females, who have been vilified as sexually licentious and consequently rendered more vulnerable to sexual victimization by black and white males, are often solely and more comfortably highlighted as victims of black males. Given these constructions, it is not surprising that Mayotte Capécia would be immortalized in feminist writings as the lamb at Fanon's sacrificial altar, rather than the complicit victim of the sexploitative, antiblack woman colonial condition.

NOTES

1 I am not using "negativity" in the Hegelian sense of "absolute negativity."

2 Contemporary French policies on immigration and citizenship continue to reflect this ambivalence. Campaigns such Jean-Marie Le Pen's "France aux Français" appeal to the vast number of (white) French citizens, who see Arabs, Africans, Antilleans, even French-born people with colonial origins as a threat to employment, responsible for crime, etc. While Jacques Chirac's rhetoric on naturalization is not as openly hostile as Le Pen's, his social policies reflect these same animosities and fears. Chirac's pledge when running for office was to crack down on immigration and naturalization. The fiasco in Paris over immigration involving the teargassing and beating of Africans in church and the Debré Law has reopened the immigration debate. See "French police attack church oust 300 African immigrants," *Indianapolis Star*, August 24, 1996, p. A-10. The article reveals that the status of immigrants is confused by a succession of sometimes contradictory immigration laws. Some of the protesters, for instance, have gone from being legal residents under older laws to illegal ones under more recent statutes. Others have achieved at least a claim to legal residency with the birth of children on French soil.

 Deportations of illegal immigrants have significantly increased since Jacques Chirac's winning the presidential office with his unbending rhetoric on immigration. See also "Illegal African immigrants routed by Paris cops: Rage, astonishment fuel protest marches," *Chicago Tribune*, August 24, 1996, Section 1, p. 3.

3 See Maunier (1932), who, like others, condemned hybridization and influenced colonial policy on such issues. He believed that the "native type," a "return to the primitive," was inevitable.

4 See Zimra (1977; 1978; 1990). Many of the issues in Zimra's articles are raised by Doane *et al.* And many of the analyses presented in this essay suffice to cover those issues. Fanon is, for Zimra, a hater of women as well. And black women who sleep with white men are especially unnerving to Fanon, according to the Zimra script. But more importantly, Fanon's woman-hating comes full circle as his thoughts on liberation, etc., were espoused by sexist, Marxist black men during the 1960s and 1970s. For Zimra, this reflects Fanon's sexism. How would one explain then Fanon's theories on liberation coming out of the mouths of black revolutionary feminists of this same era?

5 While Condé believed Fanon was a bit harsh on Capécia, the heroine of her own
 novel explains that while she dates white men, she is "no Mayotte Capécia." See
 Heremakhonon (1982: 30).

6 Much has been made of the "cruelty" of Mayotte's father (see the feminist
 commentary in Isaac Julien's film *Frantz Fanon: Black Skin, White Mask*). But we
 must remember that once Mayotte was abandoned by André, it is her father who
 welcomes her with open arms and to whom she turns for moral support. He accepts
 her child without question or admonishment. And when the women of Martinique
 accuse her of "betraying her race" and ostracize her and her child, her father takes
 the child's hand to show his love and support. Mayotte is quite touched by this
 gesture, considering her son recoils when he is introduced to his black grandfather.
 Mayotte explains this by saying that the child was just put off that a man *so* black
 could be related to him. But this is a child. And children learn certain racist behav-
 iors. Why would this child recoil if the question of color and race were of no conse-
 quence to Mayotte?

7 *Nini* was written by a man, Abdoulaye Sadji. Sadji wrote frequently for *Présence
 Africaine*.

8 Exile is a recurring theme in colonial and postcolonial writings. However, Capécia's
 pursuits of exile do not fit the traditional paradigms of the novel of exile. She longs
 to go to France in order to avoid a racial identity. But it is precisely in the metropole
 that the constructions of these racial identities were born. See the discussion of exile
 in Salvodon (1997).

9 It is interesting to note that, in the autobiographical novel, Capécia eats the *r* like all
 the other black women and natives. There are even Creolisms sprinkled throughout
 the first part of the book. André does try to teach Capécia to roll her *r*'s, but her
 tongue, she tells the reader, just wouldn't cooperate. Again, the desire to flee the
 black body was exclusively premised upon white male love. In this novel, the escape
 route is multilayered.

10 Maran won the *Prix* in 1921 for his novel *Batouala*. He also wrote *Le Coeur serré*
 (1931) and documentaries on Africa (such as *Le Tchad*, 1931). He was considered a
 forerunner of the négritude movement, and he hosted many Afro-Caribbean writers
 at his home in Paris.

11 See Maran (1947: 185). Andrade also assumes that Fanon's discussion of the ways
 that interracial sex between white women and black men is perceived by the colo-
 nized as a "giving rather than a seizing," as something "romantic," reflects Fanon's
 own perceptions; hence, he endows white women with an agency he denies black
 women. He was merely remarking on the way the "duped" Antillean thinks of the
 relationship, particularly Mayotte Capécia and Veneuse. She was astounded that any
 white woman would want a Martinican. Thus, her white grandmother had to have
 really loved her grandfather. And because of white men's consistent and not so often
 clandestine sexploitation of black women, leaving in their wake thousands of mulat-
 toes, etc., Capécia could cling to the notion that her mother was not "made in the
 bush." The fact of the matter is that, even today in the United States, most black–
 white interracial relationships are made up of white women and black men, a fact that
 may lead one to conclude that Capécia's observation that "a woman of color is not
 altogether respectable in a white man's eyes" has some validity. Studies have shown
 that African-American women are the least likely to marry outside the race. Whether
 this is due to choice is debatable.

REFERENCES

Andrade, S. (1993) "The Nigger of the Narcissist: History, Sexuality, and Intertextuality in Maryse Condé's *Heremakhonon*," *Callaloo* 16, 1: 219–31

Bergner, G. (1995) "Who Is That Masked Woman? or, The Role of Gender in Fanon's *Black Skin, White Masks*," *PMLA* 110, 1: 75–88.

Barot, L.J. (1902) *Guide pratique de l'Européen dans l'Afrique occidentale*, Paris: Flammarion.

Capécia, M. (1948) *Je suis Martiniquaise*, Paris: Editions Corrêa.

—— (1950) *La Négresse blanche*, Paris: Editions Corrêa.

Coiplet, R. (1950) Review of *La Négresse blanche*, *Le Monde* (22 April): 7a.

Condé, M. (1982) *Heremakhonon*, Colorado Springs: Three Continents Press.

Conklin, A. (1993) "Redefining 'Frenchness': The New Politics of Race, Culture, and Gender in French West Africa, 1914–1940," paper delivered at the University of Rochester.

Cooper, A.J. (1988) *A Voice from the South*, New York: Oxford University Press.

Derrida, J. (1985) "Racism's Last Word," *Critical Inquiry* 12: 290–99.

Doane, M.A. (1991) *Femmes Fatales: Feminism, Film Theory, Psychoanalysis*, New York: Routledge.

Fanon, F. (1967) *Black Skin, White Masks*, trans. C.L. Markmann, New York: Grove.

—— (1968) *The Wretched of the Earth*, trans. C. Farrington, New York: Grove.

hooks, b. (1992) *Black Looks: Race and Representation*, Boston: South End.

James, J. (1997) "Ella Baker, 'Black Women's Work,' Activist-Intellectuals," in T.D. Sharpley-Whiting and R.T. White (eds) *Spoils of War: Women of Color, Cultures, and Revolutions*, Lanham, MD: Rowman & Littlefield.

Lorde, A. (1993) *Sister Outsider*, New York: Book of the Month Club.

Maran, R. (1947) *Un homme pareil aux autres*, Paris: Arc-en-Ciel.

Maunier, R. (1932) *Sociologie coloniale: Introduction à l'étude du contact des races*, Paris: Editions Domat-Montechrestien.

Salvodon, M. (1997) "Contested Crossings: Identities, Gender and Exile in *Le Baobab fou*," in T.D. Sharpley-Whiting and R.T. White (eds) *Spoils of War: Women of Color, Cultures, and Revolutions*, Lanham, MD: Rowman & Littlefield.

Zimra, C. (1977) "Patterns of Liberation in Contemporary Women Writers," *L'Esprit créateur* 17, 2: 104–14.

—— (1978) "A Woman's Place: Cross-Sexual Perceptions in Race Relations: The Case of Mayotte Capécia and Abdoulaye Sadji," *Folio* (August): 174–92.

—— (1990) "Righting the Calabash: Writing History in the Female Francophone Narrative," in C.B. Davies and E.S. Fido (eds) *Out of the Kumbla: Caribbean Women and Literature*, Trenton, NJ: Africa World Press.

5

SAINT FANON AND "HOMOSEXUAL TERRITORY"

Terry Goldie

As Henry Louis Gates notes in "Critical Fanonism," Frantz Fanon "has now been reinstated as a global theorist" (1991: 457). And has become extremely various:

> It may be a matter of judgement whether his writings are rife with contradiction or richly dialectical, polyvocal, and multivalent; they are in any event highly porous, that is, wide open to interpretation, and the readings they elicit are, as a result, of unfailing *symptomatic* interest: Frantz Fanon, not to put too fine a point on it, is a Rorschach blot with legs.
>
> (458)

Although, as Gates observes, there is an argument that late Fanon is more successful, it is an early text, *Black Skin, White Masks*, which is the focus of Gates and of most other commentators at present. It treats decolonization, the essential postcolonial problem, but is primarily interested in understanding the racial subject, with an almost contemporary concern for an embodied subject. Even the title suggests the play of a Grosz, a Butler or a de Lauretis.

Two recent examples of critical Fanonism are an essay on Fanon and homosexuality by Kobena Mercer, "Decolonization and Disappointment: Reading Fanon's Sexual Politics" (1996), and Isaac Julien's most recent film, *Frantz Fanon: Black Skin, White Mask* (1995). These are especially noteworthy first because of their creators. Mercer, the author of *Welcome to the Jungle* (1994), has been called "the doyen of Black intellectual diasporic culture." He was given that praise by Julien, the best-known of the young black British filmmakers. His documentary, *Looking for Langston* (1989), has been celebrated for its sensitive and enigmatic look at the Harlem Renaissance writer Langston Hughes.

And at his homosexuality. One of the most important early works by Mercer and Julien was their essay on Robert Mapplethorpe, "Race, Sexual Politics and Black Masculinity: A Dossier" (1989). In the first version, they accused Mapplethorpe of objectifying the black man in his various nudes. Later, Mercer

problematized this response to consider a more complicated vision. Mapplethorpe himself never offered more than an artist's "I-do-what-I-do" justification, but his homoerotic images might be justified by his homosexuality. Rather than a white man looking at a black man, it was a homosexual ironically looking at a homosexual.

Is this the feminist quandary: does a white woman understand a black woman because a woman understands a woman? But sexual orientation is not quite the same thing. The Woman, as opposed to women, is certainly a hegemonic mistake and untenable, but even a brief perusal of the literature on homosexuality suggests that The Homosexual is more than that, it is impossible. Regardless of the various biological and social construction theories there is no acceptable definition of the homosexual except someone who has sexual relations with another person of the same sex. Thus, arguably, when no sex is happening, the homosexual does not exist as an identity. I will return to this central Foucauldian knot only in my conclusion, but it should be remembered in all the following discussion of Fanon. In this very central way, sexual orientation cannot be analogized with race or ethnicity.

My title attempts to move in two directions. The first is an intertextual one, to David Halperin's *Saint Foucault* (1995), partly because I have the same ambivalent response to Fanon that Halperin has to Foucault. I have been working in what is now called postcolonial studies since the early 1970s and Fanon's work has been central to my understanding from the beginning. Like Halperin's, my topic is a theorist who offers a myriad of possibilities. And who has developed into a focus of hagiography, both because of and in spite of that fecundity. As Foucault's slippery comments on sexual diversity have been contorted into a hymn to homosexuality, so Fanon's calls to action on race and colonialism have turned him into the patron of all marginalized peoples.

My second direction suggests at least one marginalized group who have found it difficult to pray to the statue of Saint Fanon. In *Black Skin, White Masks*, Fanon presents a disparaging and yet offhand reference to "homosexual territory." At least on the surface it appears to reflect Fanon's assumption of the pathology of homosexuality. In the era in which he wrote, the 1950s, this view of homosexuality as disease seemed to be a rather sophisticated analysis, far superior to the still common belief that homosexuality was a sin to be damned. Is Fanon's comment then simply dismissible as dated? If so, why should Mercer and Julien continue to be interested in a theorist who is so unable to cope with the raced homosexual?

In his article "Jungle Fever?" in *GLQ*, Darieck Scott holds off to the end his admission that he has a white lover "because I do not consider, as so many apparently do, my relationship with a white man to be the basis for or constitutive of any identity or settled subject-position upon which I would build a politics" (1994: 317). I would like to make a similar claim, but I feel my following analysis still requires that you see what Matthew Arnold would call my interest. I am a white man whose primary sexual attraction is to black men.

Some would unkindly call me "a dinge queen looking for black dick." Fanon would call me a problem.

Fanon's psychoanalysis depicts phobia as an absolute product of desire: "the Negrophobic woman is in fact nothing but a putative sexual partner – just as the Negrophobic man is a repressed homosexual" (1967a: 156). He goes on to refer to "men who go to 'houses' in order to be beaten by Negroes; passive homosexuals who insist on black partners" (177). He suggests that the only men from Martinique who are homosexual are those in France who earn their living servicing Europeans, and they are not examples of, as he puts it, "neurotic homosexuality."

Mercer's "Decolonization and Disappointment" is, like the book in which it is published, *The Fact of Blackness*, unusually sensitive to the benefits and limits of Fanon. Mercer says of this passage that it "initially suggests that Fanon knows little about homosexuality, but which then reveals that he knows all too much." Mercer believes that this comment – and Fanon's general avoidance of black homosexuality – "can be taken as a symptom of homophobic fixation and disavowal in the political economy of masculinity in black liberationist discourse" (1996: 125). But if this were simply the extreme homophobia with which such black leaders as Eldridge Cleaver and Richard Wright rejected James Baldwin, presumably Fanon would not be worthy of discussion. Clearly Mercer does not believe that.

The structure of this homophobia might also come from various threads visible in psychoanalysis, beyond the traditional psychoanalytic claim that homosexuality in the male is simply a problem of arrested development. In *Freud, Race and Gender*, Sander Gilman notes two specific yet opposing associations which he sees reflected in Freud: "the Jew is seen as overwhelmingly at risk for being (or becoming) a homosexual." Then, "For Zweig, the anti-Semitic German was the psychotic homosexual" (1993: 162, 196). Thus Freud's homosexual is racialized as both Jew and ultimate anti-Semite. This apparent contradiction might seem surprising, but it suits the common opposing stereotypes of the homosexual as effeminate and hypermasculine.

Gilman also remarks on how common in a variety of racial and racist discourses was the comparison between Jew and African. Throughout *Black Skin, White Masks* Fanon makes extensive use of the arguments Sartre employed in *Réflexions sur la question juive* (1954). Thus two of Fanon's central influences, Sartre and Freud, lead him to an analogy of Jew and black, of anti-Semite and Negrophobe. And scurrying among them all is the homosexual.

It is possible, of course, that Fanon's homophobia is more specifically personal, as in his own claims about Negrophobia. Perhaps his book is a Rorschach test with an erection. I know of no suggestions that Fanon was homosexual, but he made many statements which are aggressively homosocial, some with a barely hidden homoeroticism. He responds to a study by Michel Salomon: "M. Salomon, I have a confession to make to you: I have never been able, without revulsion, to hear a *man* say of another man: 'He is so sensual!' I

do not know what the sensuality of a man is" (1967: 201). As so often happens in the confessional, Fanon doth protest too much.

When, in *Peau noire, masques blancs*,[1] he refers to "l'homme," it is not just the usual casual sexism of using "man" for "human": it is very much a male, and it is freedom of males he seeks. I think this then is the way to read, "Pourquoi tout simplement ne pas essayer de toucher l'autre, de sentir l'autre, de me révéler l'autre?" (1952: 208). The specific intimacy of his freedom as a man is suggested by the following: "Ma liberté ne m'est-elle donc pas donnée pour édifier le monde du *Toi*?" (208). And he concludes the book with his oft-quoted envoi which very clearly places his sense of self in the male body: "O mon corps, fais de moi toujours un homme qui interroge!"

I am thus not tempted here to use the usual disclaimer that when I am commenting on homosexuality it is primarily male homosexuality but lesbians are somehow, in some spaces, implicated. Fanon's dismissal of homosexuality and flirtations with the homoerotic possibilities of homosociality have no connection to a female realm, hetero- or homosexual. The romance he depicts is that suggested by Eve Kosofsky Sedgwick's wonderful title, *Between Men*.

Françoise Vergès's article, "Chains of Madness, Chains of Colonialism: Fanon and Freedom," also in *The Fact of Blackness*, provides a number of perceptive comments on the importance of masculinity in Fanon. According to Vergès, colonial psychiatry saw the violence of the colonized as simply expressions of their castration: they vandalized themselves and others because they had no way of being masculine in this world. The French response was assimilation and the liberation of the individual while nationalist calls were often for a return to nativism. Fanon was yearning, not for the precolonized state, but rather a "new man": "Colonialism prevented colonized masculinity from becoming modern by branding it with the mark of the pre-modern. Decolonized masculinity would be heroic and modern" (Vergès 1996: 61).

But what might be its relation to decolonized feminism? In Julien's film, Fanon's brother dismisses their marriages to white women as irrelevant, just the result of meeting someone and falling in love. As Darieck Scott says of his own life, this is a far too easy explanation of interracial romance. It is especially so given the way Fanon pathologizes such relationships. But it seems possible to me that to Fanon an inappropriate heterosexual coupling might reflect alienation but an appropriate one would offer no dis-alienation. And either case could be irrelevant depending on the man, because the woman, as in Sedgwick's study, is at the most a symptom, at the least a bit of stage clutter. Fanon shows the essential relationship of black liberation as homosocial. Thus in *Toward the African Revolution*, Fanon recalls one of his central experiences as a time when he and an FLN major shared the same bed. It seems to be a bonding moment which made him a part of the Algerian revolution.

In *Les Damnés de la Terre*, male bonding is consistently the central energy. Fanon depicts the moment of revolution as overcoming traditional divisions, even those which isolate the most extreme fringes: "Alors les souteneurs, les

voyous, les chômeurs, les droits communs, sollicités, se jettent dans la lutte de libération comme de robustes travailleurs" (1961: 98). On the other hand, similar powers endanger the revolution when some of the colonizers reject their superior position and join the colonized. "Ces exemples désarment la haine globale que le colonisé ressentait à l'égard du peuplement étranger. Le colonisé entoure ces quelques hommes d'une sort de surenchére affective, à leur faire confiance de façon absolue" (1961: 108).[2] The homosocial leads to desires which endanger the larger vision for which Fanon homosocially yearns.

For Fanon, true liberation is the achievement of subjectivity. The last chapter of *Peau noire, masques blancs* is titled sententiously, "L'Expérience vécue du noir," which Ronald Judy translates as "The lived-experience of the Black," after Merleau-Ponty (Judy 1996: 54). Fanon suggests the beginning of this experience was "je me découvrais objet au milieu d'autres objets" (1952: 108). He recovers subjectivity through an act of will described by Vergès: "To Fanon, man constructs his own history, free from the chains of both alienation and desire. Man must seize his freedom and be free to act, to choose. This freedom demands mastering one's life, one's desire, one's position in society" (1996: 49). Fanon finds this mastery in homosocial relations and tends to elide female participation. Rejecting the possibility of homosexual Martinicans allows Fanon to see homosexuality not as desire which might disrupt homosocial mastery from within, but as an aspect of oppression from without. The homosexual is not a subject but the creator of the black man as object.

If *Black Skin, White Masks* is the most interesting Fanon text for the study of colonial subjectivity, it receives at least some competition from the first chapter of *A Dying Colonialism*, "Algeria Unveiled." Like Gayatri Chakravorty Spivak's famous line about sati, "White men saving brown women from brown men" (Spivak 1988: 297), it encapsulates one of the problems of Western feminism: is the removal of the veil a liberation of the Algerian woman from bondage by patriarchal tradition or is it an opportunity for the West to disintegrate her culture and open her to its patriarchal gaze? To Fanon disintegration is not too strong a word:

> The body of the young Algerian woman, in traditional society, is revealed to her by its coming to maturity and by the veil. The veil covers the body and disciplines it, tempers it, at the very time when it experiences its phase of greatest effervescence. The veil protects, reassures, isolates....Without the veil she has an impression of her body being cut up into bits, put adrift....The unveiled body seems to escape, to dissolve.
>
> (1970: 44)[3]

Regardless of Fanon's attempt to inhabit the woman's subjectivity, she is doubly object to him, by gender and by ethnicity. Thus his situating of her as an object which must be veiled in order to be an integrated subject is intriguing.

Still more interesting to me is his contrast of the male European and Algerian in their response:

> A strand of hair, a bit of forehead, a segment of an "overwhelmingly beautiful" [*bouleversant*] face glimpsed in a streetcar or on a train, may suffice to keep alive and strengthen the European's persistence in his irrational conviction that the Algerian woman is the queen of all women....The Algerian has an attitude towards the Algerian woman which is on the whole clear. He does not see her. There is even a permanent intention not to perceive the feminine profile, not to pay attention to women.
>
> (1970: 28–9)

Here it is European heterosexuality which is the problem. I include the French, "bouleversant," because the word suggests that the European sees the Algerian woman as literally overwhelming: he is bewildered by her beauty to the point of becoming dysfunctional. This is the Orientalist heterosexual of a rather extreme variety. But the Algerian, the object of Fanon's homosocial affection, does not even see the woman. She is taken beyond object to the point of invisibility. Shades of the Martinican homosexual.

In *Identification Papers*, Diana Fuss's discussion of Fanon follows a trajectory similar to mine here, starting with *Black Skin, White Masks*, and then turning to "Algeria Unveiled." She concludes with *The Wretched of the Earth*, in particular a synopsis of Fanon's description of the brainwashing of Algerian intellectuals by the French. Fuss comments on the process:

> the intellectual is ordered to "play the part" of collaborator; his waking hours are spent in continuous intellectual disputation, arguing the merits of French colonization and the evils of Algerian nationalism; he is never left alone, for solitude is considered a rebellious act; and he must do all his thinking aloud, since silence is strictly forbidden.
>
> Ultimately, the native intellectual's life depends upon his ability to imitate the Other perfectly, without a trace of parody; it depends, in short, upon his ability to mime without the perception of mimicry. Once again, mimicry must pass as masquerade if the subject who performs the impersonation is to survive to tell the tale.
>
> (1995: 153)

These terms, as used by Fuss, seem quite precise. She follows Irigaray for whom " 'mimicry' (the deliberate and playful performance of a role) is offered as a counter and a corrective to 'masquerade' (the unconscious assumption of a role)" (Fuss 1995: 146). Thus in this analysis, the Algerian performs an action which in actuality parodies the dominant other but in appearance shows the Algerian inhabiting the identifying attitudes of the other. The process depends

on consciousness, as one might assume from a term such as brainwashing. A conscious parody, mimicry, maintains the identity as guise. The male Algerian must accept his own veil, a veil of French ideology. If truly brainwashed, to the point of living an unconscious masquerade, the veil moves within, the disintegrated self becomes reintegrated as other.

Is Fanon in the same game? If so, what is Fanon's impersonation? The title of Julien's film, *Black Skin, White Mask*, makes Fanon's mask singular. The original book would seem to suggest that while the skin is the natural self, there are many possible shells in that skin's venture into the white world. The film doesn't comment on its title, but a possible inference is that Fanon's own work has one individual white mask for his argument. To follow Fuss and Irigaray, Fanon's analysis observes his own mimicry, but the film suggests the possibility of masquerade.

Perhaps. But if so, only in the title. The film offers at most glimpses of elements which might dent the usual hagiography: the mention of his wife, an FLN (Front de Libération Nationale) suggestion that he did not die as the Algerian he had hoped to become, a few questions as to the efficacy of his calls to action. But this unitary character seems to limit the possibilities, both positive and negative, in Fanon's performance. I would rather argue that Fanon's mask is a polymorphous process, and a masking. He emulates the Algerian in not seeing the Martinican homosexual, in masking his eyes. He does not see the veiled woman but becomes the veiled man. In the ideal homosocial world, the impersonation must be beyond heterosexual or homosexual desire. In bed with the FLN.

Fanon describes a psychopathology of the black but this is predominantly from without, created by a racist society. Psychopathology is produced within the European, whether manifested heterosexually or homosexually. In an interesting reversal, the problem is the primitive sensuality not of the black or the native but of the European. Thus the veil represents Fanon's concern not for the female but for the male Arab. Male heterosexuality is a European thing which disrupts the solidarity of Fanon and the Algerians. So the question of the veil is how to situate the Arab woman as a medium of exchange between various types of homosociality. The veil acts as perverse attraction for the European male and its removal is likened to rape, of woman and culture. Fanon would certainly reject my claim, but it seems possible that the removal of the veil leads to disintegration not just because of the desire of the European male but because of the subjectivity of the Algerian female. As the veil is removed neither she nor the males of either ethnicity can control all the different eruptions of desire. The mastery which Vergès notes is seriously endangered.

This might seem like a great leap but I am tempted to argue that the problem of the veil is like the closet. Most would assume that the homosexual who comes out, who presents himself as homosexual, is liberated from a veil over his life. But to pursue the metaphor in a different direction, what if outing is rather the production of a veil? The very claim of homosexuality is an attractive

covering: the leather clothes as Algerian veil. What do they do during sex? What do they do in the baths? What do they do? In "In/Visibility and Super/Vision: Fanon on Race, Veils and Discourses of Resistance," David Theo Goldberg says:

> one's visibility is predicated also on the assumption of self-determination. Being recognized – whether as self-conscious or as Other, and thus being visible, requires that one be outside of the Other's imposition, free of the Other's complete determination. To establish self-consciousness, then, to be free, one paradoxically has to engage the Other in combative conflict, to risk one's freedom, to place one's very life, one's humanity, in question.
>
> (1996: 181)

While Fanon seems homophobic in many ways, he also provides some suggestions of the way the homosexual, as consciousness, as veil, might move into such recognition through the veil as label, the self-outing of so many social occasions. The veil offers a position which acclaims a culture and yet contains subjectivity within that culture. In Goldberg's terms, it is the Other engaging its Otherness in order to combat its own Other and thus become self-consciousness. This Other's Other, the many possible Other masks, can see the veil as outrageously visible as an object of desire, as secret glimpse of a mysterious subjectivity, or as invisible in a homosocial world which has no such veils. Or to put them in other terms, these are: "Did you see that waiter? I'm sure he's gay;" "What does it mean to you to be gay?" or "Your sexuality makes no difference to me."

In *Les Damnés de la Terre*, Fanon represents the homosocial urge of the native intellectual in a way which links the skin and the veil in a search for collectivity. For him the native returning is not the organic intellectual of Gramsci but rather an alien, "en fait comme un étranger." Fanon claims, "Voulant coller au peuple, il colle au revêtement visible. Or ce revêtement n'est qu'un reflet d'une vie souterraine, dense, en perpétuel renouvellement" (1961: 167).[4] In the world of the other, there is hidden an amorphous, constantly renewing, underground life. The part accessible to the intellectual is only the "revêtement," a covering, perhaps a veil.

The second part of my title comes from a line in *Black Skin, White Masks*: "Fault, guilt, refusal of guilt, paranoia – one is back in homosexual territory" (1967: 183). In *Peau noire, masques blancs*, the phrase is "terrain homosexuel." The distinction here is worthy of note. "Territory," the word chosen by Markmann, the translator, would seem to imply a political state. At the time, Algeria, the place soon to become forever associated with Fanon's name, was a French *territoire*. Markmann, presumably unconsciously, offers the homosexual a colonized country.

The geography of homosexuality has both a long and a recent history. The homosexuality of Greece has always been an irritant for some devoted

Hellenics. Richard Burton's sotadic zone defined a region of the globe in which same-sex love flourished (Bleys 1995: 216–19). With the development of views of homosexuality as a psychological truth, whether pathology or orientation, such mapping became less popular. Differences in the way homosexuality is ordered throughout the world seem just part of social policy. Homosexuals are everywhere but like other universal cultures, children, the disabled, they appear in various forms.

But another form of geography has begun in books such as *Queers in Space* (Ingram *et al.* 1997). These studies examine the differences of such cultures in spatial terms. They demonstrate how the geographies of gay societies affect and reflect those societies. For the most part, gay spaces are small spaces which fit within the space of the larger society. Very few homosexuals live their lives wholly or even primarily in such spaces, anywhere in the world. Just to comment locally, in Toronto it is always thought interesting to note that someone "never gets away from Church and Wellesley." Such people, almost invariably men, work, live and play in a few blocks of the downtown "gay ghetto." Many suggest that it is even possible to pick out these very particular figures on the street because their spatial life controls the "space" of their inner and outer identities. As natives who live in the souk, their veils are ever visible.

Fanon's original might lack the colonial resonance of Markmann's word, but it has more dimensions, literally. "Terrain" implies a space but also a topography. It has hills and valleys, land that is easy and difficult to negotiate. It is in that latter area that Fanon is that inspiring Rorschach test. If the self/other paradigm is used for the homosexual, and I must here refer specifically once more to the gay man, not as an explanation of homosexuality but as an explanation of the alienation of the homosexual, many of the observations in *Black Skin, White Masks* can be turned to apply to us. Homosexuality is not pathology but the oppression of the straight world has made it pathology. *Gay Skin, Straight Masks.*

I hesitate to pursue this too far. Analogies are always decontextualized, the danger of which Gates warns. Fanon's representation shows the homophobia of his psychoanalytic model. And my representation here is all too likely to elide the importance of race for the gay African Canadian. As Peter Dickinson says in "Here is Queer: Nationalisms and Sexualities in Contemporary Canadian Literatures" (1997), the queer Canadian nation is always a hyphen-nation. But if thwarted desire is a possible explanation of Negrophobia in France in 1952, expressions of desire might provide similar insights for homosexuality and homophobia today, here. To mention but one such trace, Fanon states, "the Negro is fixated at the genital; or at any rate he has been fixated there" (1967a: 165). This perhaps is true of the image of African-Canadians, or at least was true, but is it not still true of homosexuals of all races? The obvious answer is how could a group organized on the basis of sexuality not be fixated on the genitals? But as gay culture evolves, it seems already to be going through similar processes. If, as I noted in the beginning, there is no identity intrinsic to

homosexuality, those who feel themselves defined by their sexual orientation have come to assume specific homosexual identities, associated with that word "gay." It is presumably not too strong a point to mention the liberation of straight washrooms. In the past, labeling of colleagues as homosexual was scurrilous and hidden. Now straight men must daily deal with openly gay men in their washrooms. What might they do? Can all that genital power be controlled? In light of Fanon's comment, I should mention the night I shared a bed with a man who could be called "openly straight." I was impressed that he was so beyond homophobia to have no fear I might "attack." Or might it have been like the FLN bed, my friend's non-sexual journey into homosexual space?

Fanon struggled to find a non-alienated space for the black man. He had grown up in a territory which was predominantly black but which claimed to be white. Not an uncommon problem in the Caribbean, as noted by anglophone writers such as George Lamming and Austin Clarke. His personal crisis of alienation in France led to *Peau noir, masques blancs* and then to Algeria, a space in which the confusions of Fanon's position as a black man contextualized as French but identifying with Arabs became overwhelming, to fluctuate strangely even more strongly after his death. But Fanon's inner space, which so clearly responds to that process, and his scientific space, so much a part of his age, led him to fear "homosexual territory." For "us" it is a place to live.

NOTES

1 In general, I have referred to the English translations of Fanon's texts, but in some cases I have used the original, where there appears to be a nuance which is missing in the English. I readily admit, of course, that this choice on my part is subjective and perhaps arbitrary. In this instance I wish to note, among other things, the use of the phrase "me révéler l'autre," which can have a more intimate implication than the English translation, "to explain the other to myself," and of the second person singular, rather different from the possibly vague collective nature of the English translation, "the world of the *You*."

2 The Farrington translations of these two passages are: "the pimps, the hooligans, the unemployed and the petty criminals, urged on from behind, throw themselves into the struggle for liberation like stout working men" (1963: 130) and "Such examples disarm the general hatred that the native feels toward the foreign settlement The native surrounds these few men with warm affection, and tends by a kind of emotional over-valuation to place absolute confidence in them" (145). Here I wish to emphasize one phrase in the first, "les droits communs," which implies a much more general base than Farrington's "from behind." In the second, "surenchére affective" goes beyond "emotional over-valuation" to a suggestion of a hyperbolic trumping, based on a shift into a decidedly non-rational understanding. Again, the profound power of the homosocial.

3 I have not used the French here, as the translation seems to convey the sense, although perhaps a bit more restrained than the original in its representation of disintegration. However, it might be useful to note that at one point the translation refers to the Algerian woman's "body" while Fanon writes of "le corps vécu," or in other words the body as it is experienced.

4 Farrington translates this as: "He wishes to attach himself to the people, but instead
 he only catches hold of their outer garments. And these outer garments are merely
 the reflection of a hidden life, teeming and perpetually in motion" (1963: 223–4).

REFERENCES

Bleys, R.C. (1995) *The Geography of Perversion: Male-to-Male Sexual Behavior outside the
West and the Ethnographic Imagination, 1750–1918*, New York: New York University
Press.

Dickinson, P. (1997) "Here is Queer: Nationalisms and Sexualities in Contemporary
Canadian Literatures," unpublished dissertation, University of British Columbia.

Fanon, F. (1952) *Peau noire, masques blancs*, Paris: Éditions du Seuil.

—— (1959) *L'An V de la révolution algérienne*, Paris: François Maspero.

—— (1961) *Les Damnés de la Terre*, Paris: François Maspero.

—— (1963) *The Wretched of the Earth*, trans. C. Farrington, New York: Grove.

—— (1967a) *Black Skin, White Masks*, trans. C.L. Markmann, New York: Grove.

—— (1967b) *Toward the African Revolution*, trans. H. Chevalier, New York: Grove.

—— (1970) *A Dying Colonialism*, trans. H. Chevalier, Harmondsworth, England:
Penguin.

Fuss, D. (1995) *Identification Papers*, New York: Routledge.

Gates, H.L. (1991) "Critical Fanonism," *Critical Inquiry* 17, 3: 457–470.

Gilman, S. (1993) *Freud, Race and Gender*, Princeton, NJ: Princeton University Press.

Goldberg, D.T. (1996) "In/Visibility and Super/Vision: Fanon on Race, Veils and
Discourses of Resistance," in L.R. Gordon, T.D. Sharpley-Whiting and R.T. White
(eds) *Fanon: A Critical Reader*, Oxford: Blackwell.

Halperin, D. (1995) *Saint Foucault: Notes towards a Gay Hagiography*, New York:
Oxford University Press.

Ingram, G.B., Bouthillette, A.-M., and Retter, Y. (eds) (1997) *Queers in Space:
Communities, Public Places, Sites of Resistance*, Seattle: Bay Press.

Judy, R.A.T. (1996) "Fanon's Body of Black Experience," in L.R. Gordon, T.D.
Sharpley-Whiting and R.T. White (eds) *Fanon: A Critical Reader*, Oxford: Blackwell.

Julien, I. (1989) *Looking for Langston*, Sankofa Film & & Video.

—— (1995) *Frantz Fanon: Black Skin, White Mask*, Normal Film.

Julien, I. and Kobena Mercer (1989) "Race, Sexual Politics and Black Masculinity: A
Dossier," in R. Chapman and J. Rutherford (eds) *Male Order: Unwrapping Masculin-
ity*, London: Lawrence & & Wishart.

Mercer, K. (1994) *Welcome to the Jungle: New Positions in Black Cultural Studies*, New
York: Routledge.

—— (1996) "Decolonization and Disappointment: Reading Fanon's Sexual Politics," in
A. Read (ed.) *The Fact of Blackness: Frantz Fanon and Visual Representation*, London:
Institute of Contemporary Arts.

Sartre, J.-P. (1954) *Réflexions sur la question juive*, Paris: Gallimard.

Scott, D. (1994) "Jungle Fever? Black Gay Identity Politics, White Dick, and the
Utopian Bedroom," *GLQ* 1: 299–321.

Sedgwick, E.K. (1985) *Between Men: English Literature and Male Homosocial Desire*.
New York: Columbia University Press.

Spivak, G.C. (1988) "Can the Subaltern Speak?" in C. Nelson and L. Grossberg (eds)
Marxism and the Interpretation of Culture, Urbana: University of Illinois Press.

Vergès, F. (1996) "Chains of Madness, Chains of Colonialism: Fanon and Freedom," in A. Read (ed.) *The Fact of Blackness: Frantz Fanon and Visual Representation*, London: Institute of Contemporary Arts.

Part II

FANON AND/AS CULTURAL STUDIES

6

BREAKING UP FANON'S VOICE

John Mowitt

VOICING DISAGREEMENTS

The distinction between historicism and historical materialism Walter Benjamin once invited us to draw requires us to turn our attention away from the past "as it really was," and toward a temporal expanse comprising memories flashing up, as if in protest, against the oblivion to which the historical victors are on the verge of consigning them. What separates this from Foucault's "history of the present" is the theme of redemption or liberation (*die Erlösung*). That is, the notion that the present's investments in a "usable past" ought to be indexed to a political assessment of the past's immediate value in the struggle to bring about a future that – in displacing the current historical victors – would render worthwhile all that had previously been forgotten. The model of historiography that is at stake here – one, I would argue, receptive to the less exclusively temporal preoccupations of geography – is not, however, what motivates my evocation of this material. Instead, I raise the issue of historiography because, to put the matter bluntly, I want to use the occasion represented by this volume to think about Fanon as a memory, that is, as someone or something that, among many other things, obliges us to inquire after our interest in him. Why does Fanon continue to matter? Why does he matter *today*? Benjamin's formulations, of course, insist that we recognize our own as a moment of danger. Thus, if Fanon has come to matter here and now it is because he represents, from the standpoint of the historical victors, someone or something worth forgetting. For this very reason, historical materialists have an interest in, at the very least, storing the weak messianic charge borne by Fanon's memory. However, to do so they need more than Edgar Allan Poe's prototype of Big Blue. They need to articulate with some clarity the stakes, and perhaps even the repercussions, of Fanon's memory. How and where is it bound up with the agonistic vicissitudes of the present? Elsewhere, I have pursued this in relation to the struggle to theorize the conjuncture of postmodernism and postcolonialism – especially as it bears upon the politics of positionality (Mowitt 1992).

89

Here, my aim is to pursue this in terms of the cultural politics of the university, primarily – though not exclusively – in North America.

What brings Fanon's memory within the orbit of the university is not simply the fact that it is studied and debated there. More important, especially today, is the relation – evoked in the very title of this section – between his memory (or Fanon as a fragment of our memory) and the institutional innovation of cultural studies. But what precisely is to be made of this relation? Certainly, the more provocative version of the title, "Fanon and/as Cultural Studies," is the second one; the alternative that invites us to proceed as though Fanon and cultural studies were, if not one and the same, in some sense interchangeable. This is not to say, of course, that the effects of the virgule are either simple or uninteresting. But surely – precisely in order to appreciate their intricate rigor – some prior effort must be made to state what might indeed be implied by the overlap of Fanon and what Jameson has called "the desire" that is cultural studies (Jameson 1995).

Assuming that ours is indeed a state of emergency, I see no good reason not to begin by stating the obvious. Here, this would mean acknowledging that what Henry Louis Gates once referred to as "critical Fanonism," that is, the return to Fanon that so galvanized cultural political debate in the mid-1980s, coincided with the markedly heightened visibility of cultural studies initiatives within the institutions of postsecondary learning in the US (Gates 1991). Of course, such a coincidence may be nothing more than a temporal accident, and while there are indeed important theoretical possibilities packed within the concept of coincidence – one might, for example, read it as a particularly legible inscription of the work of overdetermination – delineating them would take us far afield. Thus, I will proceed by assuming something like the opposite, namely that something important indeed – perhaps even decisive – about *both* Fanon and cultural studies can be illuminated by theorizing the conjunction they at once embody and name. There are, no doubt, many ways to follow up on such a hypothesis, but since cultural studies has consistently articulated its institutional agenda in the rhetoric of resistance (if not revolt), would it not make sense to open by attempting to analyze how cultural studies might have come to recognize itself in "the voice of the African revolution"? Exactly why this evocation of "the voice" is useful can be clarified by appealing to two, comparatively recent, "critiques" (in Marx's sense) of cultural studies: one by Stuart Hall, titled "The Emergence of Cultural Studies and the Crisis of the Humanities," the other by the late Bill Readings in *The University in Ruins*.

Hall's essay was originally given as a talk at a conference in the US convened on the theme of "Technology and the Humanities." It took place at a time when the shock waves created by the neoconservative attack on humanities educators in the early 1980s were beginning to dissipate. Though focused – characteristically – on the British scene, Hall's account of the crisis is important not simply because of the way it established important political continuities between the regimes of Thatcher and Bush, but because of the way it

understood cultural studies as both a cause and an effect of this crisis. Through a recounting of the Birmingham school's now familiar "myth of origins," Hall showed that mass media technologies after World War II were perceived in Britain as effectively undermining the remaining vestiges of "traditional" working-class culture. Such an undermining was achieved neither simply nor exclusively by, as it were, crowding its expressions out of a largely state-administered public sphere, but by drowning out the voices (some traditional, some organic) that recognized and affirmed in this culture a protest against the feigned inclusivity of Arnoldian humanism. In this account, cultural studies – in the hands of Raymond Williams, Richard Hoggart and E.P. Thompson – emerges as an effort to amplify such voices, that is, as an effort to find academic and institutional shelter for the increasingly muted protest embodied in "traditional" British working-class culture.

Securing such shelter within the British university required that humanists, in particular, migrate away from their disciplinary homelands; a migration that has, as we are all well aware, rendered the entire field significantly diasporic. From Hall's vantage point, its migration westward to North America captures, in reverse, the very itinerary that brought him to Birmingham. In fact for Hall, an appropriate refashioning of the oft-cited Brixton placard might very well read: "It (cultural studies) is there (in the US), because you (the US) are every-where." In this sense cultural studies can be seen as the cause of the crisis in the humanities because, once institutionalized (however precariously), it quite literally displaced the humanities by drawing scarce talent away from already modest programs, but also by producing scholarship that established with force and credibility what was intellectually moribund and politically ineffectual about the humanities. By the same token, cultural studies is also clearly an effect of the crisis it has precipitated, because what made the humanities vulnerable to the forces of institutional innovation are developments – according to Hall, a particular intensification of the impact and scope of mass-mediated culture – whose derivation ranges well beyond the immediate infrastructure of the university (whether "public" – the former polytechnics – or "private" – "Oxbridge" and the rest).

Two observations before turning briefly to Readings who, after all (and perhaps even in spite of himself), is concerned precisely with the relation between cultural studies and the socioeconomically defined mission of the university. First, though Hall's account delineates clearly the way the cultural politics of Britain and the US converge over the status of the humanities in public life, he pointedly avoids discussing the North American reception of cultural studies. This, of course, would have required him to flesh out the fact that this took place as the proverbial sun was setting on poststructuralism and theory; a situation which has prompted numerous commentators to character-ize cultural studies as the timely return of history, agency and politics or, to restate the point in the rhetoric of nationalism: the displacement of France by Britain (and to some degree, even Germany and the US). Second, and this will

explain why I have emphasized the issue of reception, the critique of the humanities informing the reception of cultural studies in the US – where, for better *and* for worse, traditional working-class culture is even less likely to be preserved than an endangered species – is a critique informed by the poststructuralist problematization of the subject. At the heart of this critique is, among other things, an analysis of humanism that seeks to equate its ideological appeal within the humanities to its philosophical equation of the human and the voice. Of course – as Derrida never tires of saying – the voice is to be understood not as the psychophysiological capacity to produce speech, but as an unspoken and therefore powerful ideology of meaning production. That is, as a way to represent the subject's capacity to secure its prerogative in the process and medium of cultural expression. If then I emphasize these two issues, it is with an eye towards thinking about the way the "voice of the African revolution" might even assume a somewhat overdetermined status in cultural studies' encounter with the poststructuralist critique of the humanities. Thus, the crisis which spawned cultural studies is deeply informed by the encounter between what is, in effect, two critiques of the humanities, and the question then becomes: why is "Fanon" the proper name for this encounter?

Bill Readings's analysis of cultural studies takes place within Chapter 7 of *The University in Ruins*. Though the exposition of his argument is subtle and complex the thesis motivating it can be put quite simply. To wit: cultural studies is the conflicted but nevertheless persistent effort to reestablish the traditional mission of the university. To understand precisely how one is to take this rather direct contradiction of Hall, one must do more than recognize that Readings is a poststructuralist partisan. What is more helpful is knowing how Readings understands the traditional mission of the university.

As his text opens it moves to set up two models of the university (one Kantian, the other Humboltian). As these models converge during the course of the nineteenth century in Europe, the university is provided with an object – national culture – and a task – the cultural legitimation of the nation-state. As a result of this convergence, the university assumes the mission of producing cultural knowledge that bears upon, and matters to, the articulation of state power. Of course, knowledge can be both directly useful, in the sense of information mobilized either within industry or within the bureaucracy of public administration, and indirectly useful as discourses of consensus formation or legitimation. Most fundamentally, however, the mission of the university makes the study of culture into an activity that achieves its highest form of expression when it renders the university as a whole, as an institution, useful to the social order. According to Readings, this model of the university now lies in ruins; a fate visited upon it by late capitalism through the latter's abandonment of the nation-state (and therefore national culture) as the geopolitical foundation of its operations.

Thus, cultural studies – which Readings, to my mind, rightly sees as the institutional struggle to reclaim and revalidate the study of culture – is to be

understood as a rearguard action. It is committed to preserving the university's social utility at a time when the conditions for doing so have so deeply altered that culture itself – whether elite or popular – is no longer even a contested term, much less a terrain of contestation. For Readings, the lure that cultural studies has been seduced by is precisely the idea that, to use his own metaphor, "the game" is actually being played where culture is at stake.

There are, of course, legitimate objections that one might raise against such an analysis (for example, the surprising economism nestled within his concept of "the" game), but what it nevertheless prompts us to consider is that the crisis of the humanities – for which cultural studies is both effect and cause – is indissociable from the fate of the Western university; an institution poised to become a memory that may soon have to be rescued from oblivion. And, if there is indeed something interesting about the way Fanon and cultural studies can be read as interchangeable, it may well be worth trying to consider, if not establish, how Fanon belongs to or within the ruins sketched by Readings.

WHAT ISN'T IN A WORD

The typically journalistic characterization of Fanon as "the voice of the African revolution" that I have been persistently invoking may well have been inspired by the tributes printed in *Présence Africaine* immediately after his untimely death in 1962. No less a figure than Aimé Césaire wrote:

> This then is the final lesson of Fanon [that the anticolonial struggle is properly international]. There is nothing stronger than this final lesson which he wrote on his death bed. It is already a matter of a voice from beyond the grave [*d'une voix d'outre tombe*]. But, what a voice! And, it is to the Third World that it addresses itself. It is not a voice of the vanquished, a voice of the resigned. It is, at the edge of the chasm [*au bord du gouffre*], a strong "onward!," a call to invention, to creation, a leap across the chasm.
>
> (1962: 121; my translation)

Though not known for his humility or modesty, Fanon would no doubt fail to recognize himself in such an homage. Nor, for that matter, would he have referred to anyone – much less himself – as "the voice of the African revolution." However, the issue I wish to explore cuts deeper than the layer exposed by psychobiographical considerations. For if one reads what Fanon actually has to say about the relation between the voice and the African revolution, Césaire's investment – an investment which earlier in his homage prompts him to underscore the humanistic character of Fanon's revolution – in the importance of Fanon's voice is contradicted. Were it not for the fact that the disagreements between these two men – especially as concerns the cultural politics of *négritude*

– are well known, it might be worth lingering here. However, what is of perhaps more immediate interest is the way Césaire's misrecognition of Fanon might be said to cast a symptom; a symptom that has become uniquely legible in the US reception of cultural studies.

The pertinent features of Fanon's work are nowhere more evident than in his chapter, "This Is the Voice of Algeria," devoted to the use of radio during the war for Algerian independence. In the chapter preceding this discussion, Fanon puts in place the analytical narrative that organizes each of the five chapters in *A Dying Colonialism*. Beginning with a characterization of how colonial discourse provokes an antagonism that essentializes the dialectic of the master and the slave, the story then establishes how the slave strategically displaces this antagonism first by inverting it (speaking from the site of the unspeakable) and then by undermining it. In "Algeria Unveiled" this takes the form of reconstituting the veil as an oscillating value in what Ernesto Laclau might call a "chain of equivalents" (Laclau 1980: 91). In "This Is the Voice of Algeria," it is significant that this oscillation, that is, the erratic fluctuation that deprives both the master and the slave of the radio receiver, appears to shift decisively from the narrative to the thematic register; an effect whose significance I'll not have the time to ponder here.

Of course, it is precisely these theoretical maneuvers that have made Fanon's work important to Homi Bhabha. And though Bhabha has indeed been exercised by the concept of enunciation – a concept crucial to his articulation of a distinctly postcolonial politics – Fanon's remarkable discussion of the radiophonic voice of "fighting Algeria" has apparently gone through one ear and, as it were, out the other. I will address myself to the consequences of this inattention in a moment, but let us first turn to the following passages.

> Listening to the *Voice of Fighting Algeria* was motivated not just by eagerness to hear the news, but more particularly by the inner need to be at one with [*de faire corps avec*] the [N]ation in its struggle....Because of a silence on this or that fact which, if prolonged might prove upsetting and dangerous for the people's unity, the whole [N]ation would snatch fragments of sentences in the course of a broadcast and attach them to a decisive meaning. Imperfectly heard, obscured by incessant jamming [*un brouillage*], forced to change wave lengths two or three times in the course of a broadcast, the *Voice of Fighting Algeria* could hardly ever be heard from beginning to end. It was a choppy, broken voice [*une voix hachée, discontinue*]....This voice, often absent, physically inaudible, which each one felt welling up within himself [*sic*], founded on an inner perception of the Fatherland [*la Patrie*], became materialized in an irrefutable way. Every Algerian, for his [*sic*] part, broadcast and transmitted the new language. The nature [*la modalité d'existence*] of this voice recalled in more than one

94

way that of the Revolution: present "in the air" [*atmosphériquement*] in isolated pieces, but not objectively.

(1965: 86–7)

This material appears where Fanon is attempting to show how what had been perceived as a strictly "enemy object," was being reappropriated not just in the *name* of the revolution, but as a decisive condition *for* the revolution. At the core of this reappropriation is a dialectical logic whereby the more distorted, that is, less expressive the voice of the nation is rendered, the more clearly the nation's existence is, as it were, signaled. Thus, the garrulous collective interpretation of a voice acknowledged to be *fantomatique* becomes the site of free Algeria, a site which is thereby properly designated through what Fanon calls "*le vrai mensonge.*"

It is by no means insignificant that "the voice" evoked throughout these passages refers both to the psychophysiological capacity to produce speech and a rebel radio station; a situation that at times genuinely confounds Fanon's translator, who, for example, fails to retain the conspicuously cited character of Fanon's title ("*Ici la voix de l'Algérie*"). In fact, this may explain why the voice which one might otherwise have expected to ground if not support national identity, is persistently characterized as "fragmented," "hashed" (insisting here on the etymological resonances of *hacher*) and "broken" as if the systematic technological mediation of the voice would – of ontological necessity – cause it to break up. This assumes, however, that Fanon is committed to the voice dear to humanisms the world over; an assumption made implausible by his persistent critique of Europe, "where they are never done talking of Man, yet murder men wherever they find them" (Fanon 1968: 311). It seems to me that this is precisely what Césaire – concerned, as he is, with the voice's ability to project us across the chasm – fails to echo. In fact, Fanon's voice, his textual transmissions, are addressed to the third world only insofar as they are, like the broadcasts described above, rehashed out of the broken voices coming *from* worlds which – especially today – are no longer distinctly first, second, third or fourth. The chasm, as it were, is *in*, not below, his voice. If it springs it is only because it has sprung.

Ato Sekyi-Otu's rigorous discussion of this material in *Fanon's Dialectic of Experience* has underscored the way it makes language break up the dialectical impasse at the heart of colonialism. And while I appreciate the sensitivity to the "politics of the present," bespoken by such concerns, they do not yet illuminate the relation I am struggling to explore here, namely, the relation between Fanon and cultural studies. Perhaps I can, as it were, kill two birds with one stone by drawing attention to Sekyi-Otu's criticism of Bhabha's reading of Fanon (Sekyi-Otu 1996: 8–11, 44–5). Baldly stated, the problem lies with Bhabha's unabashedly poststructuralist reading of Fanon. And while there are indeed issues to be raised here, what Sekyi-Otu does not sufficiently emphasize – to my mind – is the frankly tactical character of Bhabha's reading. In short – and this is

nowhere more evident than in "The Commitment to Theory" and "Interrogating Identity" (see Bhabha 1994) – Bhabha produces a poststructuralist (or, as he would insist, a postcolonial) reading of Fanon in order to deprive those committed to an orthodox identity politics of a cherished idol. To effect this iconoclastic gesture Bhabha establishes first, that Fanon's "position" is more riven with complicities than his devotees admit, and second, that recognizing and therefore being able to capitalize upon this gives the postcolonial critic a purchase on the political that s/he had otherwise been denied.

The intricacies of Bhabha's argument do indeed repay scrutiny, but they need not detain us here. Instead, let me simply observe that Bhabha's reading – tactical though it may be – turns, as does my own, on the discovery in Fanon of a withdrawal from, if not an actual repudiation of, humanism. Though there is room here for reflection on Bhabha's reluctance to tune in to the radiophonic voice, of more immediate interest is the way his various discussions allow one to frame the terms of a response to my earlier query, namely, in what sense are Fanon and cultural studies alternative names for the same thing? If Readings is right that cultural studies, at the level of an institutional and disciplinary initiative, represents an effort to redeem the university, that is, to restore its hegemonic role in *le grand récit* of human emancipation, then what becomes legible in Bhabha's tactical return to Fanon is what might be termed a metonymic association of Fanon and cultural studies; an association organized by the way both Fanon and cultural studies (in spite of the scalar difference between them) are now caught up in the ruin of the university, or as Hall put it, the crisis of the humanities. Thus, quite apart from the matter of how Fanon might be read or reread from within a cultural studies paradigm, there is the perhaps more consequent matter of how their association prompts us to ask after the enabling political infrastructure of such a reading. Regardless of what one might turn up as a reply to such a query, it seems fair to suggest that Fanon's contemporary urgency is thoroughly bound up with the way his memory – precisely in its menaced and even contested character – represents for *us* the state of specifically cultural emergency in which we find ourselves.

Bhabha, of course, has directed our attention explicitly to the importance of rethinking the political in the wake of Fanon's ambivalent meditation on the agency of anticolonial revolt, but he has not linked this in any systematic way to a reflection on the question of political organization now confronting academic intellectuals with considerable urgency. Doing so would require one to confront Readings's analysis squarely. If, for the sake of argument, we were to say that the metonymic association of Fanon and cultural studies registers a redemptively oriented institutional strategy that has yet to pose the question of the university's mission, then what might be the consequences of posing such a question directly for both the institutional initiative of cultural studies and the retention of Fanon's memory? How are we to think about the function of a university no longer committed to securing the redemptive power of culture, which nevertheless remains a site of critical reflection – of reflection precisely on

the intellectual fallout of capitalism's abandonment of the nation-state – and radically democratic practice?

Readings and I agree that such a question is precisely what cultural studies must be striving to both pose and live up to. It may well be imponderable, and for our immediate purposes perhaps it will have been enough simply to raise it explicitly. Nevertheless, it is important to realize that the Modern Language Association[1] has, on behalf of its members, committed itself to an initiative that clearly constitutes something of a response. I am thinking, of course, of the radio programs it has commissioned for airing on National Public Radio to be broadcast under the general title, "What's the Word." Though spurred by the abuse suffered by the association at the hands of the national press, this initiative is important because of the way it attempts to address itself to, if not the crisis of the humanities per se, then certainly to the stunning lack of public credibility enjoyed by humanities educators at present. As the title of the broadcast series suggests, the very conception of "What's the Word" is humanistic, which is, after all, hardly surprising. Let me conclude however by observing that I also find it troubling. Why? Because this initiative has not yet adequately posed the question for which it is the putative response. It is clearly not asking after the conditions of possibility for the late capitalist university. Instead, it is – like the evangelical paradigm motivating the very conception of the "What's the Word" initiative – seeking to reposition, though not necessarily redeem, the university. To be sure, abandoning such a position carries with it enormous risks, and the MLA may be wise to avoid them. But if there is anything to be gleaned from what we might call "the aesthetics of bad reception" delineated by Fanon, it is the tremendous importance of listening for and aggressively reconstituting what is missing in radiophonic transmissions of the public's voice. Though at one level, drawing a parallel between the audiences of "The Voice of Algeria" and National Public Radio is at once romantic and obscene, it may also be necessary. For we are the people who will be obliged to reconstitute what will no doubt be missing from the scheduled 1998 broadcast, "The Role of Radio in an Image-Dominated Society." Though it will be tempting to do so by repeating with far greater sophistication the gesture I have struggled to make here, this is clearly inadequate. For what will be missing will not be the result of a calculated interference whose provenance will support a thorough, and therefore compelling, condemnation. Instead, it will be the effect of our confidence – no doubt largely justified – that such interference does not happen "here." But how precisely are we to interpret the threat to the funding for National Public Radio that is currently on the agendas of the appropriations committees of the US Congress? Thus, this very confidence is our chasm. It is *in* our voice because this is the chasm that structures the conditions for posing those questions academic intellectuals, at some point, should be in a position to forget.

NOTE

1 A version of this essay was first presented at the Modern Language Association Convention in Toronto, December 1997.

REFERENCES

Bhabha, H.K. (1994) *The Location of Culture*, New York: Routledge.

Césaire, A. (1962) "Untitled," *Présence Africaine* 40 (1st Trimester): 120–2.

Fanon, F. (1965) *A Dying Colonialism*, trans. H. Chevalier, New York: Grove.

—— (1968) *The Wretched of the Earth*, trans. C. Farrington, New York: Grove.

Gates, H.L., Jr. (1991) "Critical Fanonism," *Critical Inquiry* 17, 3: 457–70.

Hall, S. (1990) "The Crisis of the Humanities and the Emergence of Cultural Studies," *October* 53: 11–23.

Jameson, F. (1995) "On Cultural Studies," in J. Rajchman (ed) *The Identity in Question*, New York: Routledge.

Laclau, E. (1980) "Populist Rupture and Discourse," *Screen Education* 34: 87–93.

Mowitt, J. (1992) "Algerian Nation: Fanon's Fetish," *Cultural Critique* 22 (Fall 1992): 165–86.

Readings, B. (1996) *The University in Ruins*, Cambridge, MA: Harvard University Press.

Sekyi-Otu, A. (1996) *Fanon's Dialectic of Experience*, Cambridge, MA: Harvard University Press.

7

FANON AND THE PITFALLS OF CULTURAL STUDIES

Nigel Gibson

A society that drives its members to desperate solutions is a non-viable society, a society to be replaced…No pseudo-national mystifications can prevail against the requirement of reason.

<div align="right">Frantz Fanon</div>

After reading Edward Said's thesis in "Traveling Theory" that, taken out of their cultural contexts, theories lose some of their original power and rebelliousness, one might be led to ask what has been lost now that Fanon, removed from his own cultural context, is heard mainly in English and in the university setting.[1] Does Fanon have a relevance beyond the Anglo-American academy?

Whereas Fanon's own traveling from Martinique to France to Algeria, and abandonment of his French citizenship, were marks of his development as a revolutionary, and his trip to Washington marked his death, it is in the US that the most vocal rebirth of Fanonism is evident. Today the discussion of Fanon in the English-speaking world is in contrast to the relative lack of discussion of Fanon in French.[2] Yet, Fanon still demands an active engagement, and as Edouard Glissant put it in *Caribbean Discourse*, this is perhaps his enduring quality and challenge:

> It is difficult for a French Caribbean individual to be the brother, the friend, or simply the associate or fellow countryman of Fanon. Because, of all the French Caribbean intellectuals, he is the only one to have *acted on his ideas*…to take full responsibility for *a complete break*.
>
> <div align="right">(Glissant 1989)</div>

The different ways this responsibility has been manifested in various fields of enquiry, and the ways in which a complete break has been interpreted, are the subject of my book *Rethinking Fanon* (1999). Here I want to reconsider Said's insight above, namely how the transatlantic journey of Fanonism, shorn of its American roots in the black power movement, has fit with Fanon's

domestication within the domain of American cultural studies. By way of conclusion I will return to an engagement with Fanon, which is relevant to a politically committed cultural critique, quite different from that of mainstream American cultural studies.

I

After the African "Fanonism" of the 1960s,[3] and the American New Left and Black Panther "Fanon" of the late 1960s and early 1970s, the "Critical Fanonism" of the post-Cold War 1980s marks a crucial divide. Fanonism has shifted from radical politics to a liberal cultural studies and has become by now almost wholly institutionalized (see Gates 1991). Where should the next generation go? As Homi Bhabha, a leading Critical Fanonist, puts it, "Why invoke Frantz Fanon today, quite out of historical context? Why invoke Fanon when the ardor of emancipatory discourse has seemingly yielded to fervent, ferocious pleas for 'the end of history,' the end of struggle?" (1996: 188). Alternatively, despite Fanon's continual relevance to contemporary African politics and the continued discussion of his major works in the US, why the present invasion of a melancholic "British Fanonism" in the context of "the end of struggle"?

In the following I use Fanon to polemicize against invented "Fanons," and show how the conceptual weight of "end of struggle" informs the way Fanon is read. I am neither embarrassed at declaring my Fanon to be more authentic than others, nor concerned that "my Fanon" radically disturbs the political claims of cultural studies in the US. Fanon and the inventions of these other Fanon(s) are the subjects of this paper.

II

Fanon refuses to be claimed, declares Homi Bhabha, who has spent the last decade claiming and inventing a Fanon. Is it what refuses to be claimed that produces slippage between the titles "Fanon and/as cultural studies," and my misreading of it as "Fanon and/or Cultural Studies?"[4]

To understand such a problematic, one has to ask what is meant by the term "cultural studies." If cultural studies – crossing disciplinary boundaries, and challenging hegemonic knowledges – can mean nearly all things, then why can't Fanon be fully claimed? This paper registers a fault in Fanon studies – a field division already limiting cultural studies' cross-disciplinary claims. On one side are the social scientists, Africanists, and political theorists, writing in the 1970s – people like the Ghanaian political theorist Emmanuel Hansen; the leader of Black Consciousness in South Africa Bantu Steve Biko; the current Ugandan president Yoweri Museweni; the Africanist and world systems theorist

Immanuel Wallerstein; and African-American political and social theorists like Tony Martin and Marxist-humanists like Lou Turner. On the other side are the Critical Fanonists of the 1980s, mainly literary critics, exemplified by Bhabha's seminal essay "Remembering Fanon."

Not obeying the rules of theoretical development, I view these studies as laying side by side without mutual contact: this duality, which certainly reflects the difference between the heady days of FRELIMO (Frente de Liberta Vão Mozambique) and the Black Consciousness Movement and the retrogressive politics of today, also reflects both disciplinary divisions in the academy *as well as* real political choices inherent in the status of the question Fanon *and/or* cultural studies.

While in Britain cultural studies evolved on the margins of sociology departments, in the US such study has been prominent in literature departments. More and more ensconced within the postcolonial field, it has come to be increasingly indebted to psychoanalytic, especially Lacanian, methodologies. At least in its US domain, the division between cultural studies and postcolonial studies is not evident. In many cases postcolonialism is seen as a subfield of cultural studies. If Critical Fanonism is a weathervane, we should be wary of the way the cultural studies of Fanon have shied away from engaging politically or philosophically with Fanon as a revolutionary and political actor. Additionally, the image of the "Birmingham School" of cultural studies as rooted in Marx and Gramsci is not entirely correct. As Colin Sparks argues in his essay "Stuart Hall, Cultural Studies and Marxism," the identification of Marxism and cultural studies "lasted about four years" and was "more contingent and transitory than it once appeared to its main actors" (1996: 72, 97).

In its present-day poststructuralist phase, cultural studies finds a closer affinity with the insights from postcolonialism that have developed through a Lacanian frame than through Marxism. And, even if he wants to bring additional issues to the table, Stuart Hall (an earlier advocate of a Gramscian cultural studies) agrees with Homi Bhabha's approach to Fanon (see Hall 1996). The context of an elective affinity between cultural studies (i.e. Hall) and postcolonial theory (i.e. Bhabha) is also particularly important for any study of the recent dispersion of "Black British cultural studies" into the US academy.

Postcolonialism blossomed as a field of enquiry in the 1980s, having less to do with developments in postcolonial societies themselves than with a reflection of the restructuring of the American national cultural identity in the universities (see King 1997: 7). The new Fanon of postcoloniality, reflects, as Kobena Mercer has put it, the "fading fortunes of the independent left in the 1980s" (quoted in Hall 1996: 16). It is a Fanon which emphasizes uncertainty and fragmentation, almost replacing social analysis with psychoanalysis.

III

There is no doubt that Homi Bhabha's intervention into postcolonialism and invention of a new Fanon have revamped the status of Frantz Fanon in the academy and opened up whole new areas of study. Bhabha's reading of Fanon is exciting, suggestive, even brilliant. However, while few have extended his Lacanian insights, most have been content to rehash them. The result has been clever readings which privilege psychoanalytic moves and points of ambivalence, but which have in the main produced a very one-sided Fanon.

Fanon's *Black Skin, White Masks*, which heralds a psychoanalytic approach, also recognizes its limitations: "Only a psychoanalytical interpretation of the black problem can lay bare the anomalies of affect that are responsible for the structure of the complex." But Fanon adds, the "effective disalienation of the black man entails an immediate *recognition of social and economic realities*" (Fanon 1967a: 10–11). When speaking of Freud, Lacan, Adler, and Mannoni, Fanon insists that a preoccupation with individual neurosis is no substitute for an analysis of the social situation. In his reference to Lacan, Fanon characteristically notes that with the addition of race at the mirror stage, "historical and economic realities come into the picture" (1967a: 161). More forcefully, after citing four dream sequences analyzed by Mannoni (who greatly influenced Lacan), Fanon suggests chidingly that the dreams had nothing to do with the dependency complex: "the discoveries of Freud are of no use to us here. What must be done is to restore this dream to its proper time, and this time is the period during which eighty thousand natives were killed [in Madagascar where Mannoni was studying]" (1967a: 104). So just as Bhabha felt that he is too quick to name the Other phenomenologically, Fanon might reply that Bhabha is too quick to name the Other in Lacanian terms. Why not both, or all three?

There is no doubt that psychoanalysis is an important element of Fanon's work, but rather than taking it at face value, we need to understand its significance: the "racial drama is played out in the open," he writes, not in the unconscious (Fanon 1967a: 150). There is almost no unconscious, or the unconscious is an open secret. As Sekyi-Otu puts it in *Fanon's Dialectic of Experience*, "the neurotic alienation that defines the colonial relationship is an open secret." Thus, Sekyi-Otu continues, "the very primacy of the psychic and the psychological are put into question" in light of the "sociopolitical…'lived experience of the black'" (1996: 7–8).

Additionally, if Fanon articulated "the problem of colonial cultural alienation in the psychoanalytic *language* of demand and desire," as Bhabha claims, then what is the purpose of that language? Fanon writes that the "Negro's behavior makes him *akin* to an obsessive neurotic type" (1967a: 60). Elsewhere Fanon speaks of "psychoanalytical *descriptions*," which leads Sekyi-Otu to think that "Fanon gives psychoanalytical language no more and no less…a metaphorical

function as distinct from a foundational one" (1967a: 8). In other words, the powerful methodological process of metaphorical substitution and exchange that Bhabha employs can also be applied to the psychoanalytic viewpoint. Though this would open up to the "many Fanons thesis," my focus here is the primacy of political experience.

The medical metaphors are powerful, as we can see from Fanon's descriptions of psychiatric institutions repeated in his characterization of colonialism in chapter 1 of *The Wretched of the Earth*. This intimate relationship between the psychiatric institution and the social world of colonialism is an important one. To cite Sekyi-Otu again, "the dreams of the colonized might well be structured like the language of neurosis but they are occasioned by the language of *political experience*" (1996: 8; my emphasis). This is certainly what Fanon means in *The Wretched* when he writes of the dreams of the "native" – dreams of running and jumping, of breaking out, are an "open secret" – being dreams of freedom.

At the other extreme François Vergès, in her recent essay "Chains of Madness, Chains of Colonialism: Fanon and Freedom," virtually collapses the political into the psychoanalytic. Fanon, she maintains, applies standard psychotherapeutic practices uncritically. She insists that Fanon "fully adopted the vision of institutional therapy" and "fully embraced the approach and greatly admired one of its theorists, François Tosquelles" (1996: 57, 56). On the other hand, in his seminal *Frantz Fanon and the Psychology of Oppression*, Hussein Bulhan speaks of Fanon's "fundamental disillusionment with psychiatric hospitalization [and] his departure from Tosquellean approaches" (1985: 240). Fanon, Bulhan argues, rejected the Tosquellean distinction between the "excessive type" and the "percepto-reactive type," exactly the type of binary on which Vergès builds her criticism of Fanon's so-called application of institutional therapy. What is at stake in this disagreement is Vergès's creation of a "Fanon" who uncritically believes in the reconstitution of the "social and cultural organization of Muslim society" (1996: 59) with its strict masculine/feminine dichotomy. Vergès then employs this Fanon as a simple supporter of the orthodox narrative of Algerian decolonization, namely, "militarized virility" (65). Such a "Fanon" is a pure invention. Fanon neither uncritically advocated bringing social life into the institution, nor thought the ability of day-patients to go "home" was a cure-all. He neither uncritically supported the cultural organizations of Muslim society, nor was a supporter of "orthodox" decolonization. In fact he was its earliest and most profound critic.

IV

In many cases, the common-garden variety institutionalized Fanon of US cultural studies has become little more than a footnote to scopophilia ("Look, a Negro" fixes and objectifies the "black," not as "other" but as "an object in the

midst of other objects"). The canonization of Fanon's insight into the black's fragmentation is seen in the collection *Reading Rodney King/Reading Urban Uprising* (Gooding-Williams 1993). The LA rebellion called for an a Fanonian analysis, even if only the question of violence was tackled, yet references to Fanon turn on his insight into racist objectification and the phenomenology of The Look.

The use of Fanon in the US context is particularly interesting. What has changed from the early 1970s when Fanon was hailed by the Black Panthers, and a few insights from *Black Skin, White Masks* and from chapter 1 of *The Wretched of the Earth* were included in the bible of revolutionary quotations? Why is Fanon's rage at Sartre, for destroying "black zeal" – that moment of Fanon's embracing of négritude, which is almost too embarrassing for the racial deconstructors, who might mutter along with Sartre, "you'll see my boy black identity is only a passing stage" – not taken seriously? "The result will be individuals without an anchor, without a horizon, colorless, stateless, rootless – a race of angels," opines Fanon in *The Wretched* (1968: 218). The skepticism of the present day intellectual veers toward the same result. The critique of "race" as an empirical (ascribed) fact fails to acknowledge its continuing political relevance.

Fanon believed that such "cultural errors" as racism could be corrected because racism is not a psychological law. The psychology of racism is caused by "Negroes being exploited, enslaved, despised by colonialist capitalist society. *That is only accidentally white*" (1967a: 202). But, he also insisted that négritude's subjective dialectic, as a reaction of the black within that *accident*, has a life of its own.

Although a racial essentialism, established by Senghor – or more specifically, if we accept René Menil's argument, established by Sartre's *Orphée Noir* (Richardson and Fijalkowsi 1996: 9) – came to dominate négritude, Césaire's négritude as a form of black surrealism should not be overlooked.[5] It is a surrealism, Michael Richardson and Krzystof Fijalkowsi argue in *Refusal of the Shadow*, that is a critique of dominant cultural and social processes. Here, they add, a distinction should be made between "surrealism as living cultural praxis...and as dead cultural artifact" (1996: 11). Like Surrealism, négritude should also be seen in the context of the "lived experience of the black." During the war years, surrealism became synonymous in Martinique with the revolutionary opposition to the war. Kesteloot insists that it "was the only possible solution at the time for the cultural alienation of Martinique." "Poetry," Césaire argued, "equaled insurrection" (Kesteloot 1974: 256–60).

Césaire's poetry remained a powerful metaphoric force for Fanon, but as a political/philosophic methodology, Fanon looked elsewhere. As David Caute has put it, "Its emphasis on spontaneity and the unconscious, as well as involvement with metaphysics and the irrational, linked it to bohemian revolt rather than to any historically concrete theory of social change" (1970: 20).

V

Why has the "use" of Fanon been so patently limited? Why has the sharpness of Fanon's critique of the pitfalls of national consciousness, as well as his critique of national culture, been so absent from US cultural studies?

In their introduction to *Black British Cultural Studies*, "Representing Blackness/Representing Britain: Cultural Studies and the Politics of Knowledge," Houston Baker, Stephen Best, and Ruth H. Lindeborg point out that with the conservatism of the 1980s, which brought "dramatic intellectual retreats from any form of radical politics and the rash of academic fears," the academy was "unequivocally more tolerant of the strategies of black British cultural studies than of the roughhewn and oppositional rhetoric of Black 'mass' vernacularism in the United States" (Baker *et al.* 1996: 14). The effect was twofold. Black British cultural studies was used to dissipate the specificity of the black dimension of American culture and politics, and as a "traveling theory," black British cultural studies lost some of its original power and rebelliousness.

The racial division seen, for example, in reactions to the O.J. Simpson verdict, and in the shocking numbers of blacks incarcerated in America, continue to prove the lie of America's multiethnic democracy. When it comes to race, America's politics *are* roughhewn. Despite the growth of a black middle class, the ratio between a black man receiving a college diploma and serving a prison sentence is a staggering 100 to 1 (in 1993, 23,000 black men got diplomas while 2.3 million were incarcerated (Castells 1997: 55)).

Translating the shocking character of these figures into what Fanon called the "lived experience of the black" indicates that black life is qualitatively different from that of the white. For the black, prison operates not as a threat, or a spectacle to scare others, but as a direct reality. In these cases the state's hegemony rests not on a whole series of relations we expect in "civilized" society but on pure violence: is it surprising that black and white attitudes to the police are black and white? Fanon's description of colonial society as a world where the black masses are hemmed in, a world "strewn with prohibitions," is strangely à *propos*. A violent world which follows the "native" home, enters into every pore. A violence drummed into his head which aims to transform the native into an animal.

The differences between Afro-Caribbeans, Afro-Brazilians, Africans, and African-Americans in the US are less important than the already existing color-line in America. Rather than integration into multiethnic America, Caribbean-Americans and African-Americans, even after the development of a substantial middle class, are still *viewed* as black. In the "rough hewn" politics of America, black consciousness remains a vital force that will continue to color the important turning points of America history.

105

VI

Fanon's unique contribution to the dialectic of national liberation attempts to create meaning for lived experience in the specific context of the anti-colonial movement (it should be noted that "L'expérience vécue du Noir," chapter 5 of *Black Skin, White Masks*, is mistranslated by Charles Lamm Markmann as "the fact of blackness" and should rather more literally and philosophically be translated as the "lived experience of the Black").

Fanon's dialectic can perhaps best be understood by considering his engagement with Hegel. Axel Honneth gestures to such a reconsideration in his recent book, *The Struggle for Recognition: The Moral Grammar of Social Conflicts*. Fanon's "famous book," *The Wretched of the Earth*, he writes, is "an anti-colonialist manifesto that attempted to explicate the experience of the oppressed Black Africa by drawing directly on Hegel's doctrine of recognition" (1995: 160). Honneth grasps a truth, but in almost too simple a fashion, eliding Fanon's sharp critique of Hegel and thereby reducing Fanon's innovative recreation of the Hegelian dialectic of recognition to the phenomenological "experience of the oppressed of Africa." Instead, Fanon's argument with Hegel in *Black Skin, White Masks* is that the paradigmatic development of reciprocity that Hegel develops has to be remapped. When the slave is black the development of recognition through labor is blocked off: the black is "walled in" by color. Fanon offers another route, a dive into black consciousness.[6] This move provides an insight into Fanon's sharp critique of Sartre's collapsing race into a colorless "class" and is redeveloped in *The Wretched* as the process of national consciousness. The point is not simply a reversal of Sartre's, that class can be collapsed into race. Rather than equate reciprocity with identity, Fanon grounds mutual recognition in the moment of alterity, and calls for recognition from the other while demanding it not be a recognition that reduces it to identity. This dialectic of reciprocity is a result of the introduction of race (now made concrete in terms of a national liberation movement) as not reducible to the dialectic of labor. Fanon is not simply replacing one dialectic (i.e., the anticolonial) for another (the class struggle) but through a system of interpenetration, deepening each. The result is a much more open ended or, as Fanon would put it, "untidy" dialectic, which can be best understood in the social context:

> The consciousness of self is not the closing of the door to communication. Philosophic thought teaches us, on the contrary, that it is its guarantee. National consciousness, which is not nationalism, is the only way to give us an international dimension.
>
> (Fanon 1968: 247)

This "self," which does not close the door to communication, develops by undergoing mediation (and therefore self-negation) and thereby embraces the other in mutual recognition.

The movement of the dialectic in *The Wretched of the Earth* is first expressed by Fanon's profound retelling of the *lived experience of anticolonial political activity* – a much more profound phenomenology than Honneth's. It is an experience, Fanon concludes, that "explodes the old colonial truths and reveals unexpected facets which bring out new meanings and pinpoints the contradictions camouflaged by these facts" (1968: 147). In other words, this spontaneous activity reaches for a self-understanding based on action not hemmed in by a reaction to the "other." In fact, Fanon argues that "the rebellion gives proof of its [i.e., the rebellion's] rational basis" (1968: 146).

VII

Cultural studies should engage with Fanon's critique of national culture, because as Hall puts it,

> [the] question touches an issue of continuing controversy in post-colonial Africa and elsewhere which is probably more significant now in the wake of the crisis of the post-independence state than it was at the time of [its] writing; an issue whose surface was barely scratched by the ICA [Institute of Contemporary Arts in London] conference's focus on *Black Skin, White Masks*.
>
> (Hall 1996: 34)

If this issue is so important why has it been barely touched? Is it, like Fanon's relation to négritude, "far too convoluted to attempt to disentangle here," as Hall fittingly notes (1996: 34)? I think not. Perhaps it can only be "scratched" by a postmodern Fanon, an example of which is John Mowitt's "Algerian Nation: Fanon's Fetish." Itching not to "indulge in a denunciation of Fanon's analysis of the Algerian revolution," and so to leave that up to those who "witnessed the bureaucratization of the Algerian state" (1992: 165), Mowitt separates Fanon the revolutionary from the revolution by labeling him an outsider. He adds that this separation is something he and Fanon share! Though his essay is not without sophistication and insight, one feels that his academic "domestication" results in a "Fanon" almost like Mowitt himself, a professor of cultural studies at a leading American university. Fanon's resignation from the institutional system, his involvement in the revolution, his prescient critique of the revolution's degeneration, all tell a story which is jettisoned by Mowitt. "Made impossible" (to use Mowitt's words). Consequently, Fanon has no relevance to postcolonial Africa.

VIII

Mowitt's dilemma, which turns on the problem of who speaks for and who translates from the *position of the native*, is neither Fanon's problem nor his intention. Fanon's problem is who will *listen* to the native – a listening that involves a new kind of thinking and a new conception of theory. Rather than working through the problematic of realizing "the extent of the intellectual's estrangement from [the people]" (Fanon 1968: 226), Mowitt, throwing up his hands, turns to a critique of "authenticity." Accepting the estrangement as absolute, the intellectual can only devote energies to an "antidisciplinary struggle *within the institution*" (Mowitt 1992: 165). This might be all well and good, but where does it leave Fanon?

What is also lost in the new readings of Fanon is an understanding of the political struggles going on "behind the scenes" that will define postcoloniality. For example, Fanon advocated a non-sectarian and democratic republic and opposed a theocratic state. He was close to the authors of the Soummam declaration which was accepted by the Front de Libération Nationale (FLN) in 1956, and contained no mention of an essential Arab-Muslim nature of the future state. However, by 1961 the left wing with which Fanon was associated had become a minority, and clearly Fanon's concerns about the future of the revolution voiced in *The Wretched of the Earth* was a response to the retrogressive developments within the nationalist movement. "Critical Fanonists" leave out any narrative of the development of Fanon's thinking in relation to events. Not that thought should be hemmed in by a flaccid historicism, but one needs to understand the context in which Fanon raised, and tried to answer, important questions. For example, Fanon's elevation of the peasantry as a revolutionary force was a direct result of the fierce repression of the urban liberation movement in the fall of 1957. As François Lyotard put it, "crushed by vast police and military apparatus," the FLN turned to the countryside and the "the guerilla, peasant figure par excellence, took the lead" (Lyotard 1993: 199).

I have purposefully quoted Lyotard in contradistinction to Mowitt, who telescopes Lyotard's writing on Algeria into a proto postmodernism. Rather than comparing Lyotard's pessimism in his 1963 essay "Algeria Evacuated" with Fanon's *A Dying Colonialism*, why didn't Mowitt compare Lyotard's 1958 essay "Algerian Contradictions Exposed"? Indeed, there Lyotard makes reference to FLN articles in *El Moudjahid* (edited by Fanon), arguing that the "aggregate of ideas and forces that makes up the nationalist ideology...can only accelerate among the young peasants" (1993: 200–1). Mowitt overlooks this in his rush for a decontextualized critique of Algerian nationalism.

IX

Fanon's *Black Skin, White Masks* has canonical, almost iconical, status in cultural studies; as Stuart Hall puts it, it is "one of the most startling, staggering, important books in this field" (1992: 16). What is underscored in this canonical after-life is not only the "open-ness" of the texts to radical re-readings, but from a culturalist point of view, Fanon's insight into the attempts by the "bourgeoisie," through the symbolic, specifically scopic, economy of culture, to control anything that smacks of difference.

The reduction of Fanon's conception of culture to an insight into the phobic image of the "Negro" has to be brought into contact, even conflict, with a concept of culture defined as the ways of life and networks of meanings and the interactions of social groups in society; with the notion of cultural studies, as defined by Hall, as a place where cultural processes *anticipate social change*; and lastly, with Fanon's critique of culture, sharply etched in *The Wretched of the Earth*, which concludes that "the struggle for freedom does not give back to the national culture its former values and shapes." What is of overriding importance is how culture can anticipate and reflect social change. Fanon argues that it is in the revolution that the old culture breaks apart. This is a radical posture to those who think Fanon actually advocates upholding traditional cultures or enforcing conservative cultural relations for the sake of national unity. Yet with the benefit of hindsight, Fanon's only mistake is his failure to perceive the staying power of conservative culture (what Hall calls the "return of the repressed").

In place of a detailed analysis of actual political conflicts and actual cultural developments that compromise the new social relations in the newly independent Algeria, there is a cultural determinism. Rather than working through the point of contact of Fanon and cultural studies – that is, how cultural processes can anticipate change – culture merely becomes the deadening weight of the *past* on the future. Rather than an anticipation of the future in the present, that is, new ways of life made in and through the revolution, culture is in this view only a reactionary element, a brake on revolution, and the basis on which the return of the old ways of life is grounded. Culture becomes reified. In this view, culture acts as a barrier to change and helps found the authoritarian regime.

From a Fanonian standpoint, the problem of viewing culture outside lived experience is that such a study of culture is many times at a loss to anticipate why culture *changes*.

X

François Vergès's invention of a Fanon with a supposedly uncritical attitude to Muslim culture is constructed by imputing a mechanical conception of memory

to him: "Fanonian theory construes memory as a series of lifeless monuments, a morbid legacy, melancholic nostalgia for a past long gone. There is no place for dreams." What Fanon wanted, she adds, was "[the] revolution to be a creation unfettered by the spirits of the past...yet he did not discuss what was the *foundation* of his society" (1996: 63).

We could again enter into a battle of citation, as well as a discussion of the relation between dream and reality in the colonial and decolonizing process, but here I want to counter Vergès by considering Fanon's use of the quotation from Marx's *Eighteenth Brumaire* as the epigraph to "By Way of Conclusion" of *Black Skin, White Masks*.[7] Over twenty-five years ago Tony Martin (1970: 384–5) called this epigraph "the leitmotif of Fanon's philosophy of liberation":

> The social revolution...cannot draw its poetry from the past but only from the future. It cannot begin with itself before it has stripped itself of all its superstitions concerning the past. Earlier revolutions relied on memories out of world history in order to drug themselves against their own content. In order to find their own content, the revolutions of the nineteenth century have to let the dead bury the dead. Before the expression exceeded the content; now the content exceeds the expression.
>
> (Marx 1975, quoted in Fanon 1967a: 223)

Vergès's misunderstanding (and/or misrepresentation) of Fanon is evidenced by her reference to Toni Morrison. She contrasts Fanon to Morrison's emphasis on the process of confronting over and over again the past which keeps coming back in other forms. Yet this is exactly what Fanon saw in Marx. It is this awareness of the reappearing ghosts in postcolonialism that motivates Fanon's philosophy of revolution in permanence, and is indicated in the difference, as Marx put it, in *The Eighteenth Brumaire*, between bourgeois and proletarian revolutions, which the above quotation was referring to: "[P]roletarian revolutions, like those of the nineteenth century, criticize themselves constantly, interrupt themselves continually in their own course...until a situation has been created which makes all turning back impossible" (Marx 1975: 19). Contra Vergès, the foundation of the new society is exactly what is under discussion – the process of revolution confronting, over and over again, like a fading memory, the inert and lifeless monuments of the old colonial Manichean social relations and stripping them of their staying power. It was the inability of African independence, namely the laziness of the nationalist middle-class intelligentsia, to take part in this process that became its tragedy. As Marx put it, speaking of the state (and the few pages from chapter 7 of the *Brumaire* should be considered an influence on Fanon's chapter "The Pitfalls of National Consciousness"): "The parties that contended in turn for domination regarded the possession of this huge edifice as the principal spoils of the victor...[they] reach out for state offices as a sort of respectable alms, and provoke the creation

of state posts" (Marx 1975: 122, 129). Just as Bonaparte stole France, the new hucksтering nationalist middle-men of the postcolonial dispensation stole Africa.

XI

In Bhabha's reading, the new man and new woman, fashioned in and from the revolutionary situation, is lost, forgotten, or mocked as a utopian and uninteresting conception. All references to humanism, to revolution, to Hegel, to Marx, and to Sartre – to Fanon's "yearning" for total transformation of society – are lumped together as "banal." Despite Bhabha's own intention, as a critic within the left – at least in the "state of emergence/emergency" of the Britain mired in urban revolts of the early 1980s – to weave a new understanding of politics and agency, his privileging of the politics of subversion as being more revolutionary than the politics of revolution has resulted in a domesticated Fanon. A Fanon of "ambivalence," not "trying to transcend or sublate," proclaims Hall (1996: 27). Quite the opposite of Fanon's haunting demand for liberation "from an alienation which for centuries has made it [the colonized] the great absentee of History" (Fanon 1959: 89, quoted in Sekyi-Otu 1996: 39).

Bhabha's answer to "Why Fanon today?" centers on a rhetorical analysis of "Spontaneity: Its Strength and Weakness" in *The Wretched of the Earth*. Bhabha rightly notes how "the emergence of the (insurgent everyday)...[is] associated with political subjects who are somehow outside the 'official' discourses of the nationalist struggle" (1996: 188). Such an unofficial lived experience of the "day to day" is central to what Bhabha calls Fanon's most "fundamental" statement on ethics, namely, that "the thing which has been colonized becomes human during the same process by which it frees itself." Though Bhabha insists that we "need to grasp the dialectic in 'rapid transience' as it is forming in the process of historical becoming itself" (190), he provides no insight into such historical becoming. Instead, he asserts that we must "begin at the other end," that is, with today's postcolonial and post-Cold War "inter-ethnic unrest" (190–1). This move to the "other end" nearly elides the process of historical becoming that colored the anticolonial movements.[8] I do not mean to dismiss the problematic of today's "inter-ethnic unrest," but rather to situate it in the context of the failure of the historical becoming of African liberation. By placing the "other end" on top of the revolutionary day to day, Bhabha almost makes today's "inter-ethnic unrest" inevitable. Moreover, he doesn't follow upon the disjuncture introduced between the native's historical becoming, of the native "living inside of history," and the native as an object of ethnic cleansing. Instead, he shifts gears into a more highly theoretical discussion of Derrida's "new internationalism – in the age of migration, minorities, the diasporic, displaced 'national' populations, refugees" (191) which leaves

virtually no trace of Fanon: the mass of displaced suffering refugee humanity takes the place of the mass movement.

Bhabha celebrates spontaneity without ever engaging Fanon's critique of its weaknesses. Such an engagement at least might have led Bhabha to a critique of the Manichean ethnic politics embedded within spontaneity and help ground an analysis of inter-ethnic conflict. Such historical contextualization brings Bhabha's overly psychologized analysis into immediate relief. What he calls the "psychic *anxiety* at the heart of national-cultural identification" (1996: 191) is grounded in what Freud called the "narcissism of minor differences" and almost inevitably leads to a pessimistic politics. In reality the basis for this anxiety has more to do with postcolonial socioeconomic and political realities – informed by the World Bank, IMF, international aid communities – than with a "space informed by the unconscious" (Bhabha 1996: 192).

XII

The problems of spontaneity may appear unconnected to the question "Why invoke Fanon today?" but Fanon's answer to its weaknesses are embedded in his thinking on the organization question. Fanon saw that organization was needed to offset the dangerous "localism" of spontaneity, and responses to the dangers of a politics of immediacy. The need for organization not only criticizes the belief that victory can be won in one fell swoop but it becomes the space where the revolutionary intellectuals are put to use and help develop the natives' "force of intellect." Organization is the space where national consciousness can develop and ethnic squabbles can be confronted, precisely because the meeting place of the revolutionary intellectual and the revolutionary native is one of struggle and survival. Because this is so, the degeneration of the organization after decolonization foretells the degeneration of the nation. The very nationalist-internationalism Bhabha invokes is what is at stake, embedded not so much in "spontaneity," but in the untidy dialectic of this meeting of native and intellectual, within the dialectic of organization. It is especially evident in the necessary organizational decentralization a successful anticolonial struggle demands. Unless the nationalist organization encourages the native's expression of social and political needs, Fanon warns, factionalism will be encouraged and the nation will degenerate into racism and "tribalism." Such a retrogression is still playing out in Africa.

Resisting transcendence, Bhabha hypostatizes the ambivalent identification of black and white, which makes for a brilliant re-reading, a rich empirical account of the multiple "crossings" that undermine the strict manicheism of colonizer and colonized. Such creativity resists colonialist categories, but sadly, at the same time, refuses the possibility of a successful anticolonial revolution. A different perspective and possibility lie in following Fanon's dialectic of

organization as it develops out of the weakness of spontaneity and "the laziness" of the intellectuals.

XIII

One perhaps unintended consequence of Homi Bhabha's re-membering Fanon is, in my mind, a dis-memberment that results in a Fanon rooted in Lacan against Hegel; in a postmodernist fragmentation against Marxism; in a self-limiting revolution against "revolution in permanence." Rather than "grasping the dialectic in 'rapid transience': as it is forming in the process of historical becoming itself," as Bhabha puts it, such an unchained dialectic of historical becoming is finally elided by the Critical Fanonists as the psychoanalytic becomes the master narrative. The challenge of Fanon – that "each generation must…discover its mission, or betray it" (Fanon 1968: 206) – becomes a giddy angst about the subject position of the intellectual. "Fanon" has no resonance, no echo, no effect. In the end, cultural analyses, however nuanced, take place *against* Fanon's announced political project of *Black Skin, White Masks* and *The Wretched of the Earth*. At best Critical Fanonism becomes ideological critique. The power of ideas that Fanon found so terribly important is quite simply replaced by analysis of the power of ruling ideology. Critical Fanonism's methodology is already intimated by Fanon:

> The culture that the intellectual leans towards is often no more than a *stock of particularisms*…He wishes to attach himself to the people; but instead he only catches hold of their outer garments. And these outer garments are merely the reflection of *a hidden life*, teeming and perpetually in motion.
>
> (1968: 223–4; my emphases)

The intellectual, preoccupied with the weight of tradition and the apparent silence of the "native" "forget[s] that the forms of thought and what it feeds on…the people's intelligences and that the constant principles which acted as *safeguards during the colonial period*" can undergo extremely radical changes (1968: 225).

IN PLACE OF A CONCLUSION

> The positive balance-sheet of the year 1960 cannot make us forget the reality of the crisis in the African revolution which, far from being a mere growing-pain, is a crisis of knowledge. In several cases, the practice of the liberation struggle and its future perspectives not only lack a

theoretical basis, but are also to a greater or lesser degree remote from the concrete reality around them.

Amilcar Cabral

I

At the end of his life Fanon declared: "it is rigorously false to pretend and to believe that this decolonization is the fruit of an *objective dialectic* which more or less rapidly assumed the appearance of an absolutely inevitable mechanism" (1967b: 170). The [re]turn to Fanon in the 1990s by cultural studies brings full circle the journey of Fanonism from 1960s Afro-disillusionment to an intellectual discourse in today's American elite universities. What both standpoints share is a view of Africa mired in technological and intellectual backwardness. In contrast, Fanon's celebration of the so-called backward natives as "the truth" and as an impulse for theory was only the beginning of the intellectual's labor. He understood that the revolutionary intellectual's work was not simply to record the resistances to colonialism, not only grasp the contradictions but, as Gramsci puts it, "posit himself as an element of contradiction and elevate this element to a principle of knowledge and therefore action" (Gramsci 1971: 405). The intellectual had to enter into a battle of ideas inside the "structure of the people." Critically aware of the suppression of ideas in the name of national unity, Fanon viewed dialogue as crucial to the life of the revolutionary movement. Indeed, keeping the revolution alive, deepening it, elevating it into a new humanism, was the task set by *The Wretched of the Earth* (see Gibson 1994).

Optimism about the possibility of African freedom was a result, Fanon insisted, of subjective forces – revolutionary action a result of revolutionary consciousness. But – and here he marks a new theoretical divide in anticolonial discourse – "colonialism and its derivatives do not, as a matter of fact, constitute the present enemies of Africa." "For my part," he continued, "the deeper I enter into the culture and political circles the surer I am that the great danger that threatens Africa is the absence of ideology" (1967b: 186).

Fanon's confrontation with the problematic of the subject/object dialectic[9] depended on not imitating the European, not putting faith in mechanical development, but on the African's hand and brain. Rather than applying an *a priori*, a crucial task for the Fanonian intellectual was to confront the intellectual's internalization of colonial ideology that had become mentally debilitating. The native intellectual, therefore, does not simply uncover subjugated knowledges but has to challenge the underdeveloped[10] and Manichean ways of thinking produced by colonial rule. At the same time, "positing oneself as an element of the contradiction" also means that such rethinking has to be grounded in "the movement from practice which is itself a form of theory," as the Marxist-humanist Raya Dunayevskaya put it (1983: 1). The crisis of knowledge, as Cabral suggested, was a result of the separation of

theory and reality. The new reality engendered by the anticolonial struggle, its unchained subjectivity, which Fanon saw in the revolutionary movement, demanded new concepts. It was this unity of theory and reality that Fanon named the "future heaven." Consequently, he refused both a "return" to African essentialism and enlightenment universals. The new beginning had to be located in a different source, in the very process itself, even if the task is to transcend the realm of necessity.

II

I understand Fanon's use of the term "ideology" as a philosophy of praxis. In the African context where counter-intuitively, from a Gramscian standpoint, hegemony is far more connected to ideas than physical force (see Karp 1997), the ideas that "grab the masses" take on enormous power. Fanon is not arguing that there are no ideologies – there are plenty of "morbid symptoms" to choose from, as Gramsci put it, though all are retrogressive – the problem is the lack of a revolutionary philosophy that is grounded in the aspirations of the anticolonial social movements and which articulates a vision for the future. A philosophy of praxis is needed to counteract both the hollow rhetoric of the nationalist middle class, and the romanticizing, and potentially retrograde, nativist ideology, which in the name of traditions bolsters the status quo. The problem of the lack of ideology is expressed in the failure to convert the opening created by decolonization into a moment of change – into a genuine revolutionary moment – that becomes permanent.

III

Let us return to 1960, the transition point in African postcoloniality, and in Fanon's thought. In 1960, "Africa Year," sixteen nations became newly "independent" from Britain and France. But the duality of such a moment was plain when, backed by the West, the Katanga province broke away from the Congo just three days after it gained "independence" from Belgium. The Congo's Premier, Patrice Lumumba, who had built a truly national movement across ethnic lines, was liquidated, and with him and his movement the second landing beach of revolutionary ideas was compromised.[11] Though revolt in the Congo continued through the 1960s, the face of Africa's "future heaven" was already scarred.

The depth of that wound can be seen in a difference of emphasis between Fanon's *A Dying Colonialism* (1959) and *The Wretched of the Earth* (1961). In *A Dying Colonialism* Fanon had seen the revolution's "essential process" almost automatically reintroducing the Algerian personality into the world. He soon realized that such a project required an explicit theoretical reckoning. In a short few years between the exuberance of revolutionary Algeria in 1957, and the new dualities of 1960, Fanon plumbed the depths of the revolution's horrifying

child – the counter-revolution within the revolution – a monster that had been intimated by the murder of his friend and comrade Abane Ramdane by forces *inside* the Algerian FLN. Fanon still had Ramdane's death on his conscience when he told Simone de Beauvoir, shortly after Lumumba's murder, that he had felt responsible because he had not "forced them [Ramdane and Lumumba] to follow his advice" (Beauvoir 1992: 317). *The Wretched* – written at breakneck speed quite literally against time itself – was penned to provide the type of counsel he owed his revolutionary friends. Its central chapter, "The Pitfalls of National Consciousness," which mapped out the contradictory development of the revolutionary process, had already become the basis of a lecture series to FLN militants.

However, it would be wrong to characterize the shift in emphasis in Fanon's thought as a move toward an ontological pessimism akin to the Afro-pessimism that has infected the liberal and radical intelligentsia since the failure of the much-vaunted democracy movements of the earlier 1990s. The revolutionary pressures in Africa have not ceased. As Claude Ake has put it, "ordinary people are in revolt and demanding a second independence" (Ake 1996: 159). Fanon's point was not merely to foretell the crisis in Africa that would be affected by the degeneration of the independence movement, but to intervene and affect the process, to tap into the vast reservoir of popular resistance and to try and "put Africa in motion…behind revolutionary principles" (Ake 1996: 159). That was his self-assignment.

IV

His attempt to fill the void left by an absence of ideology gestured to an anti-Stalinist Marxian critique of the postcolonial dispensation. As he put it in his Mali Notebook: "[The] psychological explanation, which appeals to a hypothetical need for release of pent-up aggressiveness, does not satisfy us. We must once again come back to the Marxist formula" (Fanon 1967b: 187). Some may wonder why I am placing Fanon in a Marxian tradition. After all, they might say, the collapse of Communism put an end to socialism as a viable alternative in Africa. The dreams of FRELIMO and even of the ANC are long past. But I resent this kind of collapsing of what used to be called "actually existing socialism" with the liberatory idea of Marxism. Critical of both "superpowers" (the US and the Soviet Union), I place Fanon in the anti-Stalinist tradition, exemplified in Raya Dunayevskaya's Marxist-humanism, that viewed Russia as an oppressive state capitalist society and Marxism as "a theory of liberation, or nothing." This type of critical Marxism is relevant to social movements in Africa which are challenging the devastating economic and social policies of the World Bank and IMF, as is Fanon's revolutionary philosophy that attempts to overcome fragmentation and dehumanization.

Written with the effects of settler colonialism mostly in mind, Fanon's critique of the nationalist bourgeoisie (as a huckstering, greedy, useless caste) is

often associated with theories of underdevelopment. It is true that one focus of Fanon's analysis is that unequal exchange in global capitalism determines and even undermines class developments. Yet unlike the dependency theorists' preoccupation with external relations, Fanon's dialectic of revolution enabled him to discern internal social conflicts. In fact, for Fanon it was how people work, and under what conditions they worked, that became a measure of postcolonialism. The colossal efforts demanded of the masses by the nationalist leaders were criticized by Fanon. Rather than a "developed" country, he argues, such exploitation created a devolved human being, a being dehumanized because he or she is treated as such. Rather than worry about the withdrawal of capital, or primitive accumulation, Fanon voices concern in *The Wretched of the Earth* about the "very concrete question of not dragging [people] towards mutilation, of not imposing upon the brain rhythms which very quickly obliterate and wreck it" (1968: 187). Condemning forced labor in the name of the nation, Fanon insists on labor's self-determination as an important step toward its actualization. There are no stages of liberation: "It is only when men and women are included on a vast scale in enlightened and fruitful work that form and body are given to [national] consciousness" (1968: 204). Fanon's attention to the conditions of labor is reminiscent of Marx's contention that the realm of freedom is based on the transformation of alienated labor into a form of self-realization. "If conditions of work are not modified," Fanon warns, "centuries will be needed to humanize this world which has been forced down to animal level" (1968: 100)

The necessary modifications can only be effected through people making decisions, experimenting at a local level, learning by mistakes and "starting a new history" (Fanon 1968: 99, 188–9). Such a goal resides not in some utopian distance but in immediate development; thus, he speaks of the revolutionary experience as a "new beginning." Moreover, Fanon views work not as external compulsion but as an expression and act of creation of the social individual. The new social relations of work engender at the same time the reproduction of a newly created self who understands that "slavery is opposed to work, and that work presupposes liberty, responsibility, and consciousness": "In those districts where we have been able to carry out successfully these interesting experiments, where we have watched man being created by revolutionary beginnings, the peasants have very clearly caught hold of the idea that the more intelligence you bring to work, the more pleasure you have in it" (Fanon 1968: 192–3). In this context Fanon can be considered a Marxist-humanist, in the sense that he is not championing a static notion of human nature, but a human "potential" which can be "created by revolutionary beginnings,"[12] and where social relationships give meaning to life. When we get past viewing Fanon's Marxism simply in terms of class categories in the colonial context and catch his dialectical humanism, what is especially provocative is the expression of the creativity of the ideological intervention as a political act. In *The Wretched of the Earth* he calls this intervention "political education," which

he defines as "opening their [the masses'] minds, awakening them, and allowing the birth of their intelligence" (1968: 197).[13]

V

Unlike the New Left, which virtually fetishized Fanon's conception of violence, Dunayevskaya singled out an affinity with Fanon's humanism. Elsewhere, Lou Turner has considered Fanon's affinities with Dunayevskaya's Marxist-humanism (Turner 1991); here I want to pose the opposite, namely the Fanonian resonances in Dunayevskaya's Marxist-humanism.[14] Indeed, Dunayevskaya's claim that Fanon was the most acute of the post-World War II "Marxist Humanists" because he had raised the "whole question of what kind of philosophy can become *the* motivating force for all the contemporary struggle" (Dunayevskaya 1996: 100) goes beyond resonance. So powerful was Fanon's philosophic conception for Dunayevskaya that she believed a void opened with his death: "After Fanon's death there were no such affinity of ideas as we had hoped would result in *Philosophy and Revolution* (1973) being a collective work" (1983: 14).

Dunayevskaya recognized that Fanon's humanism had different origins than her own (1983: 11), but his contribution to the dialectic of revolution remained far more profound than the contribution of those in eastern Europe who did call themselves Marxist humanists. "None," she said, "looked at the African revolutions more concretely and comprehensively than did Frantz Fanon" (1989: 214). The affinity is clearly visible in chapter 7 of her *Philosophy and Revolution*, "The African Revolutions and the World Economy," which begins with epigrams from Marx and from Fanon. The epigram from Fanon, "leave this Europe where they are never done talking of Man, yet murder men everywhere they find him," intimates Dunayevskaya's cognizance of Fanon's different origins, yet she successfully joins together a Marxian conception of economics and revolution and Fanon's idea of African liberation.

Returning to the theme of subterranean connections in Dunayevskaya, Fanon's critique of the division between the leaders and the led and the consequent fetishism of technological backwardness as the central pitfall of national consciousness provides her with an analytical framework.

The Fanonian–Marxian synthesis is clear in the following explanation of the problematic of African liberation:

> 1960 was a turning point in the struggle for African freedom and at the same time a warning of impending tragedy. The greatest of these tragedies was the separation between the leaders and the led in independent Africa...without masses as reason as well as force, there is no way to escape being sucked into the world market dominated by advanced technologies.
>
> (Dunayevskaya 1989: 218)

The "tragedy of the African revolutions began so soon," she continued, "because leaders were so weighed down with consciousness of technological backwardness."

Thus in the space of a few pages Dunayevskaya redevelops Fanonian themes and weaves them into a critique of Marxists – vulgar materialists and voluntarists who are "overwhelmed by economic laws." "The greatest productive force is not the machine, but the human being," she insists, "so the human being is not only muscle, but also brain, not only energy but emotion, passion and force" (1989: 219). This was Marx's great contribution, she continues, but it is in the context of "the tragedy of the African revolutions" the creative tension of the Fanon and Marx synthesis finds new areas of expression.

VI

It would be too easy to leave things here. Yet calling attention to the centrality of labor in Fanon's conception of humanism in a postcolonial context, and the creative power of philosophic intervention, is complicated by his reluctance to embrace a philosophic "treatise on the universal"; namely an essential human nature and ethics from which Africans have been excluded, even if at the same time he calls national liberation an "original idea propounded as an absolute" (1968: 41).

Fanon's dialectic, we must remember, attempts to create meaning for lived experience in the specific context of the anticolonial movement.[15] Dunayevskaya does not ignore this. It is the African revolutions, she argues, that "opened a new page in the dialectic of thought as well as in world history" (1989: 245). Turning the European "treatise" on its head, it is now the European who must catch up with the African, as Fanon proclaims on the last line of *The Wretched of the Earth*: "For Europe, for ourselves, and for humanity, comrades, we must turn over a new leaf, we must work out new concepts, and try to set afoot a new man" (1968: 316). Dunayevskaya ends her Africa chapter in a similar vein: "[we] must instead work out a new relationship of theory to practice which arises from the practice of the masses" (1989: 245).

Dunayevskaya's re-creation of Fanon's dialectic of liberation operates at a number of levels. First, echoing Fanon's idea that the revolution creates a radical change in consciousness, Dunayevskaya opines that revolution alters human experience and opens up new human relationships. Second, instead of allowing the threat of the departure of skilled Europeans to determine policies, the revolution can become a beacon for the European left to go and help. Third, she emphasizes that "the crucial element" is "the masses' confidence." It is self-activity "and not dead things, whether machines, or lack of machines [that] shape the course of history" (1989: 237). Lastly, Dunayevskaya maintains that the African masses could strike a blow at the law of value because they felt "they were not muscle but reason, holding destiny in their own hands" (237). A full decade of dictatorships and military coups had not led Dunayevskaya to

lament the lack of mass activity and become overwhelmed by the serious retrogression that had taken place since the heady days of the late 1950s and early 1960s.[16] Like Fanon she remained an "optimist" about the African masses' own creative and transformative powers. The problem remained the theoreticians who continued to divide

> theory from practice "à la Senghor," who spoke of the Humanism of Marxism in theory but in fact followed Gaullist policies nationally and internationally. They must instead work out a new relationship of theory to practice which arises from the practice of the masses.
>
> (Dunayevskaya 1989: 245)

"The whole point," she concluded, "seems to be to hold on to the principle of creativity, and the contradictory process by which creativity develops" (1989: 246).

VII

The contradictory process reminds us of the centrality of the mental activity (the mind of the native and intellectual) that both Fanon and Dunayevskaya believe was necessary to work out new directions. The revolutionary intellectual who explicitly attempts to develop the often conflictual relationship between mental and manual labor, therefore, is grounded in two interpenetrated though different types of knowledge: the explication of subjugated knowledges and knowledges born of resistance, in their myriad (and not simply practical) forms; and what Fanon meant by working out new concepts, namely, the history of the idea of freedom. These knowledges are connected: revolutionary thought is also a conceptualization of the historical memory of struggle.

The intellectual's connection with this knowledge requires a series of estrangements. The intellectuals' cultural self-estrangement from the people during the colonial period is repeated, but now as an intellectual self-estrangement.[17] The issue is not only redeveloping a relationship to the other, qua Gramscian "man in the mass," but a working out of the relationship to the new conceptualization of freedom (a new humanism) which necessitates that the intellectual loses the Western elitist sense of intellectualism drummed into him by (neo)colonial education. The relationship to the "man in the mass" indicates the social character of the "new concept." The intellectual is a social individual; the specific ideology that fills the void is "a new humanism."

VIII

However, thirty-eight years after Fanon's *The Wretched of the Earth*, despite the constant movements for change in Africa, Afro-pessimist intellectuals bemoan the failure of democratization and lack of mass activity. The claim of engaging

in a battle of ideas outside the academy seems anathema. The "end of ideology" ideological system reins supreme. So summoning Fanon out of context – out of the context of the anticolonial movement – when "radical changes" are not taking place, when the lived experience of revolution seems a distant dream, is almost academic. But also, why domesticate the revolutionary? Why create other Fanon(s) now (to slightly adjust Hall's question)? Why now in this period of motionless equilibrium, when the subjective dialectic is compounded by a "lack of ideology," a lack of vision about reordering society? These other representations of Fanon all lack this vision. Is it simply for reasons of permanent critique within the ivory tower?

One cannot simply apply Fanon. The situations have changed, but it is Fanon's revolutionary dialectic, I believe, that remains alive. That is why Fanon's texts remain political and every engagement is always already politicized. That is why his confinement to cultural studies always already insists on removing the "dialectical scaffolding."

Against the "inventions," I claim an authentic Fanon. Like the historical Fanon, my Fanon is a revolutionary. I do not only want to defend an historical Fanon,[18] but to ask serious questions about the politics of cultural studies.

NOTES

1 Interestingly, Said takes an opposite view when he considers Fanon in "Traveling Theory Revisited" in Gibson, N. (ed.) *Rethinking Fanon*, Amherst NY: Prometheus Books 1999.

2 I should mention the four-day International Memorial for Fanon (March 31–April 3, 1982) held in Fort de France, with participants from all over the world including France, Algeria, French-speaking Africa and the Caribbean.

3 After his death Fanon was immediately part of a debate about class and revolution in the colonies (see Colloti-Pischel 1962 and Nghe 1963; see Wallerstein 1979 for an analysis of the debate about "Fanon and the revolutionary class"). Misunderstanding Fanon's argument was one thing, but the odyssey of traveling Fanon theory began as soon as he was translated into English in 1965. For example, the historian Terence Ranger argued that Africanists who had become disappointed with postcolonial Africa had employed a "Fanonesque analysis": "A wide spread belief that national independence was an episode in comedy...in which nothing had changed" (1968: xxi). Later John Lonsdale explained, "it was the radical pessimist view, *epitomized by Frantz Fanon* that decolonization was a panicky revolution in government settled round a 'green baize table,' not a social revolution" (1981: 163; my emphasis).

4 A shorter version of this paper was originally presented at the panel "Fanon and/as Cultural Studies" at the Northeast Modern Languages Association Conference, Philadelphia, April 4, 1997.

5 For René Menil, who had an important, and heretofore fairly undocumented, influence on Fanon, "it was surrealism's ideas...especially its Hegelian basis" that were particularly important (Richardson and Fijalkowski 1996: 8).

6 I much prefer to think of black consciousness as a type of Hegelian self-certainty, rather than as a "strategic essentialism," which always already knows it is *really* anti-essential. I think a more dialectical approach not only helps one understand Fanon's own intellectual context but also leads to an appreciation of his unique contribution to postwar French Hegelian thought.

7 It shouldn't be forgotten that *Black Skin, White Masks* was published one hundred years after *The Eighteenth Brumaire*, and Fanon's journey to France in 1948 coincided not only with a series of militant strikes but also with the beginnings of a series of 100-year anniversary celebrations of the 1848 Revolutions and the *Communist Manifesto*. The center of the celebrations was Lyon where the revolution began and where Fanon stayed in 1948.

8 There is another problem: what is at the other end of the "other end?" Wasn't the struggle against colonialism also inter-ethnic unrest? Is there an assumption here that anticolonial struggles were not also a form of "inter-ethnic unrest" against the European colonialists?

9 A possible relationship between the Marxist philosopher, Georg Lukács, who made a category of the subject/object dialectic in his 1919 essay "What Is Marxism," and Fanon, is discussed in Edward W. Said's *Culture and Imperialism* (1993).

10 See Paulin Hountondji (1995), who argues that there is an identity between the development of underdevelopment in economics and in knowledge production.

11 The first "landing beach," for Fanon, was, of course, Algeria. For Fanon, the failure to open up a "second front" would have a profoundly detrimental effect on the first.

12 I am using the term "potential" guardedly, but I think it gestures to a more dialectical rather than a static view of an unchanging human essence merely being uncovered by revolution. Fanon, like Marx, called his philosophy a "new humanism." In this light Tony Martin's opinion from twenty-five years ago still has validity. Martin argues that Marx's *Eighteenth Brumaire* "had a special attraction for Fanon...[and] provided him with the *leitmotif* of his philosophy." He adds that a quotation from *The Eighteenth Brumaire*, which does not appear in Fanon, sheds considerable light on his ideas, particularly his idea of history: "Men make their own history, but they do not make it just as they please; they do not make it under circumstances chosen by themselves, but under circumstances directly encountered, given and transmitted from the past." In this quotation, Martin concludes, "Marx effects a synthesis of the dialectical necessity inherent in historical development, on the one hand, and human initiative, on the other. And here Fanon follows him very closely" (Martin 1970: 382).

13 It might also be useful to consider Fanon's conception in light of the problematic of an "absence of ideology." Rather than simply "uncovering" an essential human essence, Fanon saw the need for "ideology" as a creative act, bringing "invention" into existence (as he quoted Césaire in *The Wretched of the Earth*). In other words, for the enlightenment promise to be kept, it is necessary to make a revolutionary intervention.

14 Such a resonance is, of course, more likely. Even if Fanon came across Dunayevskaya's writing in France, it is doubtful he read her *Marxism and Freedom* (1958). However, Dunayevskaya, James's co-leader in the Johnson-Forest Tendency, had presented, on the behalf of the group, their theory of Russia as a state-capitalist society, at the 1947 Fourth International conference in France. Along with attending Trotskyist meetings and workers' activities (1947 was a high point for strikes in France), we know that Fanon attended these proceedings (noted in Irene Gendzier (1985: 20)). A year earlier Dunayevskaya had published an essay in *Revue Internationale* alongside an important essay by Fanon's philosophy teacher Merleau-Ponty.

15 As much as I agree with much of Seyki-Otu's work, I would not be satisfied with labeling Fanon's dialectic dramaturgical. Certainly there is a drama in his dialectic. But I would resist this turn to performance and representation as the crucial distinguishing mark. Additionally Fanon's dialectic is not exhausted through "lived experience." That is its context. Fanon appreciates that knowledge is a product of action, but his is not a theory of practice in Bourdieu's sense. That would be one-sided. It is for this reason that I have contextualized Fanon within the Marxian

tradition of "praxis," namely theory/practice. Cognition also creates the world, as Lenin put it in his philosophical exegesis of Hegel's *Logic*.

16 For example, Dunayevskaya still considered what Sekou Touré had said on universalism and humanism "objective" despite his later degeneration into a ruthless dictator (see 1989: 214).

17 This concretization of the movement from practice as a form of theory as a reality check should be contrasted with the destructiveness of the excluded urban intellectual elites, who flee the cities and who develop their ideas of frustration about exclusion into a universal without making links with the ideas of the rural people. Willing to literally beat their ideas to death, and viewing the rural people as backward, the violence of a Pol Pot type becomes thinkable for the intellectual run amok.

18 Quentin Skinner's approach to political texts might be useful in discussing Fanon (Skinner 1988). Skinner argues that one should distinguish between two questions: first, what the text means, and second, what the author may have meant (what the author intended to mean by what is said). While it is beyond a doubt that Fanon's text has far more meaning than he imagined (and such "surpluses" of meaning are evident in the many interpretations in this book) it does seem useful to keep in mind what Fanon meant. Though such a concern puts me out of step with a dominant, and perhaps overly playful, advocation to call into question the idea of Fanon as author and the irrelevance of authorial intention, it does provide a useful structure.

REFERENCES

Ake, C. (1996) *Democracy and Development in Africa*, Washington, DC: The Brookings Institute.

Baker, H.A., Diawara, M. and Lindeborg, R.H. (eds) (1996) *Black British Cultural Studies*, Chicago: University of Chicago Press.

Beauvoir, S. de (1992) *Force of Circumstance, II*, New York: Paragon House.

Bhabha, H.K. (1986) "Remembering Fanon," introduction to the English edition of *Black Skin, White Mask*, London: Pluto, reprinted in *Rethinking Fanon*, Gibson, N. (ed.), Amherst NY: Prometheus Books, 1999.

—— (1996) "Day by Day...with Frantz Fanon," in A. Read (ed.) *The Fact of Blackness: Frantz Fanon and Visual Representation*, Seattle: Bay Press.

Bulhan, H.A. (1985) *Frantz Fanon and the Psychology of Oppression*, New York: Plenum.

Castells, M. (1997) *The Information Age: Economy, Society and Culture, Volume II: The Power of Identity*, Oxford: Blackwell.

Caute, D. (1970) *Fanon*, London: Fontana Modern Masters.

Collotti-Pischel, E. (1962) " 'Fanonismo' e 'Questione Coloniale,' " *Problemi del Socialismo* 5: 843–64.

Dunayevskaya, R. (1983) *American Civilization on Trial: Black Masses as Vanguard*, Detroit: News and Letters.

—— (1989) *Philosophy and Revolution: From Marx to Mao and from Hegel to Sartre*, New York: Columbia University Press.

—— (1996) "A Post-World War II View of Marx's Humanism, 1843–83: Marxist Humanism in the 1950s and 1980s," in *Bosnia-Herzegovina: Achilles Heel of "Western Civilization"*, Chicago: News and Letters.

Fanon, F. (1959) "The Reciprocal Basis of National Cultures and the Struggle for Liberation," *Présence Africaine* 24–25 (February–May): 82–9.

—— (1967a) *Black Skin, White Masks*, trans. C.L. Markmann, New York: Grove.

—— (1967b) *Toward the African Revolution: Political Essays*, trans. H. Chevalier, New York: Grove.

—— (1968) *The Wretched of the Earth*, trans. C. Farrington, New York: Grove.

Gates, H.L. (1991) "Critical Fanonism," *Critical Inquiry* 17, 3: 457–70.

Gendzier, I. (1985) *Frantz Fanon: A Critical Study*, New York: Grove.

Gibson, N. (1994) "Fanon's Humanism and the Second Independence in Africa," in E. McCarthy-Arnold, D.R. Penna and D.C. Sobreña (eds) *Africa, Human Rights and the Global System*, Westport, CT: Greenwood Press.

—— (1999) Introduction to *Rethinking Fanon* (ed.) Amherst NY: Prometheus Books.

Glissant, E. (1989) *Caribbean Discourse*, trans. J.M. Dash, Charlottesville: University of Virginia Press.

Gooding-Williams, R. (ed.) (1993) *Reading Rodney King/Reading Urban Uprising*, New York: Routledge.

Gramsci, A. (1971) *Selections from the Prison Notebooks*, ed. and trans. Q. Hoare and G.N. Smith, New York: International Publishers.

Hall, S. (1992) "Race, Culture and Communication: Looking Backward and Forward at Cultural Studies," *Rethinking Marxism* 5, 1: 10–18

—— (1996) "Why Fanon, Why Now, Why *Black Skin, White Masks?*," in A. Read (ed.) *The Fact of Blackness: Frantz Fanon and Visual Representation*, Seattle: Bay Press.

Honneth, A. (1995) *The Struggle for Recognition: The Moral Grammar of Social Conflicts*, trans. J. Anderson, Cambridge, MA: M.I.T. Press.

Hountondji, P. (1995) "Producing Knowledge in Africa Today," *African Studies Review* 38, 3: 1–10.

Karp, I. (1997) "Does Theory Travel? Area Studies and Cultural Studies," *Africa Today* 44, 3: 281–96.

Kesteloot, L. (1974) *Black Writers in French: A Literary History of Négritude*, Philadelphia: Temple University Press.

King, A.D. (1997) "Introduction," in A.D. King (ed.) *Culture, Globalization and the World System*, Minneapolis: University of Minnesota Press.

Lonsdale, J. (1981) "States and Social Processes in Africa: A Historical Survey," *African Studies Review* 29, 2–3: 140–225.

Lyotard, F. (1993) *Political Writings*, Minneapolis: University of Minnesota Press.

Martin, T. (1970) "Rescuing Fanon from the Critics," *African Studies Review* 13, 3: 381–99, reprinted in Gibson, N. (ed.), *Rethinking Fanon*, Amherst NY: Prometheus Books, 1999.

Marx, K. (1975) *The Eighteenth Brumaire of Louis Napoleon*, New York: International.

Mowitt, J. (1992) "Algerian Nation: Fanon's Fetish," *Cultural Critique* 22: 165–86.

Nghe, N. (1963) "Frantz Fanon et les problèmes de l'indépendance," *La Pensée* 107: 23–30

Ranger, T. (ed.) (1968) *Emerging Themes of African History*, Nairobi: East Africa Publishing House.

Richardson, M. and Fijalkowsi, K. (1996) *Refusal of the Shadow: Surrealism and the Caribbean*, London: Verso.

Said, E.W. (1993) *Culture and Imperialism*, New York: Knopf.

—— (forthcoming) "Traveling Theory Revisited," in Gibson, N. (ed.), *Rethinking Fanon*, Amherst NY: Prometheus Books, 1999.

Sekyi-Otu, A. (1996) *Frantz Fanon's Dialectic of Experience*, Cambridge, MA: Harvard University Press.

Skinner, Q. (1988) "Afterword," in J. Tully (ed.) *Meaning and Context: Quentin Skinner and His Critics*, Princeton, NJ: Princeton University Press.

Sparks, C. (1996) "Stuart Hall, Cultural Studies and Marxism," in D. Morley and K.-H. Chen (eds) *Stuart Hall: Critical Dialogues in Cultural Studies*, New York: Routledge.

Turner, L. (1991) "The Marxist Humanist Legacy of Frantz Fanon," *News and Letters* 38, 10: 4–5.

Vergès, F. (1996) "Chains of Madness, Chains of Colonialism: Fanon and Freedom," in A. Read (ed.) *The Fact of Blackness: Frantz Fanon and Visual Representation*, Seattle: Bay Press.

Wallerstein, I. (1979) "Fanon and the Revolutionary Class," in *The Capitalist World-Economy*, Cambridge: Cambridge University Press.

8

FANON: AN INTERVENTION INTO CULTURAL STUDIES

E. San Juan, Jr.

> My final prayer: O my body, make of me always a man who questions!
> Frantz Fanon, *Black Skin, White Masks*

Despite his intricately nuanced anatomy of "race" in *Black Skin, White Masks* and other works, Fanon has been somehow stereotyped as an apostle of the cult of violence. This passage from *The Wretched of the Earth* seems to have become the touchstone of classical Fanonism:

> Violence alone, violence committed by the people, violence organized and educated by its leaders, makes it possible for the masses to under-stand social truths and gives the key to them. It frees the native from his inferiority complex, and from his despair and inaction.
>
> (1963: 94)

This free-floating quote, unmoored from its determinant context, exerts a reductive and disabling force. Severed from its body, Fanon's thought can signify everything and nothing at the same time.

Claiming to rescue Fanon from this tendentious fixation as well as from the pluralism of eclectic interpretations, Henry Louis Gates offers an assessment that at first glance promises to ground Fanon in the context of the "third world." The Tunisian intellectual Albert Memmi seems to provide Gates a pretext for the revisionary intent: Memmi conjures the figure of a black Martinican torn by warring forces who, though hating France and the French, "will never return to négritude and to the West Indies" (Gates 1994: 140). But Gates unwittingly recuperates the canon by ferreting out clues of self-division in Fanon, "an agon between psychology and a politics, between ontogeny and sociogeny, between...Marx and Freud" (141). This postmortem diagnosis pronounces the demise of the author and his authority. By inscribing Fanon more steadfastly in the colonial paradigm, the "disciplinary enclave" of anti-imperialist discourse, Gates hopes to demolish the Fanon mystique. His deconstructive move may strike some as iconoclastic and others as reactionary;

Lewis R. Gordon, for example, speculates that Gates may be a surrogate for the European man in crisis (Gordon 1995). In effect, Gates disables Fanon by arguing that Fanon himself warned us of the limits of the struggle, thus presaging the virtual collapse of "the dream of decolonization."[1]

Postmodern cultural studies (inspired by the poststructuralist gurus Derrida, Foucault, and Lyotard) may have taken off from Gates's premise of skeptical individualism and neoliberal triumphalism. It has so far pursued a nihilistic agenda in rejecting "totality" (such as capitalism, nationalism, etc.), the codeword for theoretical generalizations about social relations of production and historical movements. Contemporary cultural studies celebrates heterogeneity, flux, ambiguous hybrids, indeterminacies, accidents, and lacunae inhabiting bifurcated psyches and texts. Suspicious of metanarratives (Hegel, Marx, Sartre), it repudiates utopian thought, including an alleged teleology of anticolonialism informing Fanon's texts. From this perspective, Fanon is cannibalized for academic apologetics. The version of Fanon who takes off from Hegel and Marx is rejected in favor of the Freudian disciple, thus resolving the dichotomized subject/object which postmodernist critics privileged as their point of departure.[2]

My argument here concerns the relevance of Fanon's materialist hermeneutics as an antidote to the conservative formalism of the hegemonic discipline exemplified by Gates. I hold that Fanon's central insights into sociohistorical change are pedagogically transformative and enabling in a way that locates the deconstructionist impasse in the refusal of historical determinations. David Caute perceives Fanon's serviceable legacy as inherent in his political realism, his prophetic drive to forge "new concepts" from the clash between traditional ways of thinking and novel circumstances (Caute 1970). In one of the most astute evaluations of Fanon's discourse, Stephan Feuchtwang points out that Fanon succeeded in rendering "as history the material of cultural organizations without assuming an original self for recognition," showing how contingency "is culturally organized and made" and distinguishing cultural process from its multiple determinations in economic forces, political institutions, and ideological relations. By bracketing self-consciousness as totalizing viewpoint, Feuchtwang then suggests that the fundamental questions in cultural studies raised by Fanon are, among others: What people or culture is being constructed? What "social organization of cultural difference, conceived as psycho-affective organization, enhances recognition rather than denial" and "what are the economic and political conditions in which such an organization can exist?" (1985: 473).

We need to remind ourselves that Fanon never entertained any illusion that the revolutionary struggle against colonialism would automatically realize a utopia free from the delayed effects and legacies of hundreds of years of dehumanized social relations. I contend that he was not of two minds regarding the duplicity of négritude, for example, or the perils of populist and demagogic chauvinism that swept Africa in the aftermath of formal independence (see

Fogel 1982; Gordon *et al.* 1996). The chapters on "Spontaneity: Its Strengths and Weakness" and "The Pitfalls of National Consciousness" in *The Wretched of the Earth* are lucid proofs of Fanon's circumspect and principled realism. The cogent diagnosis of deeply rooted reflexes of character and the *habitus* of groups displays his acute knowledge of historical contradictions and the variable modalities of finitude in a world of pure immanence. It is certainly an ideological move to transpose the Manichean fixation of colonialism into Fanon's psyche and infer therefrom that we cannot derive any testable methodology or working hypothesis from Fanon's *Œuvre*. That dogmatic attitude forecloses any dialogue with Fanon as alternative or oppositional to the fashionable "incredulity" at metanarratives and the ontological constitution of reality.

One lesson we can extract from the corpus of texts is precisely the avoidance of the "schism in the soul," what Spinoza calls "sadness" (1994: 188). This involves a passage from a diminished to a more heightened or enhanced capacity for action based on ideas adequately subsuming the causes and motivations of what we do. This involves all the social, economic, and political determinants that constitute the mode of cultural revolution in Algeria. To elucidate this mode, Fanon reformulates the archetypal Hegelian drama of sublation (*Aufhebung*) as "the only means of breaking this vicious circle," the battlefield within; but this drama is not a solipsistic or monadic affair. Desire involves the mutual recognition of two or more agents juxtaposed in a common enterprise: "I demand that notice be taken of my negating activity insofar as I pursue something other than life; insofar as I do battle for the creation of a human world – that is, of a world of reciprocal recognitions" (Fanon 1967a: 218). Indeed, Fanon's project goes beyond the formulaic pragmatism of psychoanalysis: "To educate man to be actional…is the prime task of him who, having taken thought, prepares to act" (1967a: 222). And this action, by risking life, enables the exercise of freedom which mediates the contingency of the present and the schematism of the future: "The Vietnamese who die before the firing squads are not hoping that their sacrifice will bring about the reappearance of a past. It is for the sake of the present and of the future that they are willing to die" (1967a: 227). This project of secular redemption reminds me of Spinoza's axiom of humanity's finite mode as distinguished by *conatus*, perseverance in striving to increase one's power through affiliation and collaboration with others (Parkinson 1975; Yovel, 1989a; De Dijn 1996; Lloyd 1996).

Fanon's idea of praxis is geared toward realizing the freedom of multitudes via programs of action. His practice-oriented sensibility registers the movement of groups and collectives of bodies interacting in solidarity. What Marx once valorized as philosophy becoming incarnate in the world, that is, the unity of theory and practice, is accomplished by Fanon in envisioning the field of discourse or signification as a range of opportunities for action. In this field, collective power and the rights of individuals associated together coalesce. We

move through and beyond the textuality of representation, the iconicity of signs, to its articulation with radical transformative practice. In inventorying the achievement of cultural studies thus far, Stuart Hall remarked how the discipline has often succumbed to "ways of constituting power as an easy floating signifier which just leaves the crude exercise and connections of power and culture altogether emptied of any signification" (1992: 286). Presciently, Fanon anticipated this fetishism of textuality in his conclusion to *The Wretched of the Earth*:

> A permanent dialogue with oneself and an increasingly obscene narcissism never ceased to prepare the way for a half delirious state, where intellectual work became suffering and the reality was not at all that of a living man, working and creating himself, but rather words, different combinations of words, and the tensions springing from the meanings contained in words.
>
> (1963: 313)

A new beginning has to be made, with a new subjectivity predicated on the bankruptcy of Eurocentric humanism and the prospect of creating a "new human being" at the conjuncture where core and periphery, center and margin, collide.

Aside from the malaise of systemic alienation fragmenting sensibilities and psyches, the reason why the discipline of cultural studies has consistently failed to confront the problem of reification is its evasion of one of the most intractable but persistent symptoms of late capitalism, racism and its articulation with sexism. It is through confronting this nexus of racism, male supremacy, and commodity-fetishism in the Manichean arena of battle that Fanon was able to grasp the subtle, compromising liaisons between culture and power, between language and value. Like Spinoza, who applied a constructive-hermeneutical method in interpreting religious texts (Yovel 1989b), Fanon used rhetorical analysis to educate the subaltern imagination and provoke a more rational stance toward everyday happenings. However, there is no unanimous agreement on Fanon's accentuation of certain aspects of "third world" reality. Renate Zahar has reservations regarding Fanon's one-sided emphasis on a psychologized notion of violence as a category of mediation, thus ignoring "violence conceived as revolutionary social work" (1974: 96). But even a trenchant critic like Jack Woddis had to admit that Fanon "yearned for an end to the old world of capitalism" (1972: 175).

The question of social determination and the directionality of change around which orthodox Marxists and the varieties of poststructuralisms have clashed hinges really on the modalities in which capital and the manifestations of its power have continued to renegotiate its recurrent crises and sustain its precarious but resilient hegemony.

CONFRONTING THE RACIAL IMAGINARY

Fanon's little-known essay "Racism and Culture" provides clues as to how Fanon will confront the impasse brought about by the institutionalization – or more precisely, the "Americanization" – of cultural studies (O'Connor 1996). For Fanon, the fact of racism cannot be divorced from the methodology and aims of any cultural inquiry: "If culture is the combination of motor and mental behavior patterns arising from the encounter of man with nature and with his fellow-man, it can be said that racism is indeed a cultural element" (1967b: 32). With the emergence of industrial and cosmopolitan societies, racism metamorphosed; its object is no longer the individual judged on the basis of genotypical or phenotypical features but "a certain form of existing" (32). Fanon mentions the antithesis between Christianity and Islam as life-forms locked in ideological combat. But what sharply influenced the change in the nature of racism as ideological/political practice, Fanon points out, is the "institution of a colonial system in the very heart of Europe" (33). Racism is part of "the systematized oppression of a people" at the heart of which is the destruction of a people's cultural values:

> For this its systems of reference have to be broken. Expropriation, spoliation, raids, objective murder, are matched by the sacking of cultural patterns, or at least condition such sacking. The social panorama is destructured; values are flaunted, crushed, emptied. The lines of force, having crumbled, no longer give direction....[The native culture] becomes closed, fixed in the colonial status, caught in the yoke of oppression....The characteristic of a culture is to be open, permeated by spontaneous, generous, fertile lines of force.
>
> (Fanon 1967b: 33–4)

This mummification of practices and the hardening of institutions once alive and changing attend the loss of the native's independence and initiative. Culture dies when it is not lived, "dynamized from within" (1967b: 34). Exoticism and other modes of objectification (for example, the varieties of Orientalism catalogued by Edward Said) accompany the colonizers' coercive program of exploitation and subjugation.

What complicates the ever-present visage of racism for Fanon is historical metamorphosis, the shifts of adaptation to evolving social relations. With the development in the techniques and means of production and its elaboration, together with "the increasingly necessary existence of collaborators," racism loses its overt virulence and camouflages itself in more subtle and stylized appearances, in seductive guises, despite the fact that "the social constellation, the cultural whole, are deeply modified by the existence of racism" (1967b: 36). But appearances are deceptive, and verbal mystification characterizes the introduction of a "democratic and humane ideology." Fanon insists: "The truth

is that the rigor of the system made the daily affirmation of a superiority superfluous" (37). Alienation worsens. In contrast to the apologists of the neoliberal "free market" system who reduce racism to a case of individual mental illness or syndrome, Fanon asserts the sociohistorical specificity of racism as institutional practice:

> Racism stares one in the face for it so happens that it belongs in a characteristic whole: that of the shameless exploitation of one group of men by another which has reached a higher stage of technical development. This is why military and economic oppression generally precedes, makes possible, and legitimizes racism....It is not possible to enslave men without logically making them inferior through and through. And racism is only the emotional, affective, sometimes intellectual explanation of this inferiorization.
>
> (1967b: 37–8, 40)

In the process of demystifying the racial imaginary that subtends Eurocentric cultural studies, Fanon traces the dialectic of alienation and assimilation binding colonial master and colonized subaltern. He recapitulates the phases of guilt and inferiority experienced by the colonized. Racism becomes normalized when it becomes a matter of personal prejudice, dissimulating the subjugation and oppression of peoples and nationalities. Subsequently, the colonized victims react to racism by revalorizing tradition. Archaic practices and their constellation of values are revived and affirmed. The goal of reconquering the geopolitical space mapped by revolutionary war orients the project of national liberation: "the plunge into the chasm of the past is the condition and the source of freedom" (1967b: 43). But this "return to the source" (to use Amilcar Cabral's metaphor) is not nativism but a passage of catharsis. What it purges is the obsession with purity, a symptom of the fetishizing drive. What Fanon emphasizes is the mixed repertoire of weapons or resources that the colonized masses bring into play – "the old and the new, his own and those of the occupant," resuscitating the "spasmed and rigid culture" so as to conduct a mutually enriching dialogue with other cultures. Here, the Manichean dilemma described in "On Violence" is resolved by the *agon* of the historical process itself. That is to say, the "universality" achieved with the recognition and acceptance of the "reciprocal relativism of different cultures" on the demise of colonialism necessarily traverses "the experienced realities of the mode of production." Fanon takes into account the improvement of technical knowledge, the perfecting of machines within "the dynamic circuit of industrial production," the frequent contacts of people "in the framework of the concentration of capital, that is to say, on the job, discovering the assembly line, the team, production 'time' " (1967b: 39). This historical materialist framework of comprehending the social formation grounds Fanon's critique of cultural

racism in the complex interaction of affects, passions, and appetites that control assemblages of bodies and govern the conduct of the whole body politic.

The theme of cultural metamorphosis broached in "Racism and Culture" is further refined and illustrated in the later essay, "On National Culture" (included in *The Wretched of the Earth*). What is new here is the inscription of culture in the *problématique* of the nation and national identity. Fanon shifts gears and plots the genesis of agency from the episodes of victimization and resistance. He underlines the process of change in the cultural responses of indigenous peoples to the violence of the European colonizer, from the poetics of négritude and the revitalization of Islam to diverse manifestations of nativism. He charts the trajectory of the organic intellectual – organic to the national-popular movement of decolonization – from the initial stage of assimilation to the reactive nativism characterized by humor and allegory to the subsequent third stage, the "fighting phase," where the artist tries to represent the advent of a new reality and a "new man." Fanon underscores how tradition changes with the unpredictable mutations of conflict, ushering in a "zone of occult instability" where "our souls are crystallized" with the people (1963: 206–48). What I would focus on here is not the ambivalence, indeterminacy, or the aura of the apocalyptic sublime, which one can extrapolate between the lines, but the *conatus* or actualization of potential inscribed in certain moments of the national liberation struggle.

Originating from the Hegelian matrix of the dialectic of master and slave, the routine approach to Fanon's thought replicates the West's "civilizing mission." In this psychodrama, the native develops and matures by undergoing the trials of self-alienation, doubt, and self-recovery; the three stages outlined in "On National Culture" reconfigure the value and function of tradition and all the properties of the indigenous life-forms in a Manichean environment. What Fanon apprehends in these life-forms is their capacity for change and infinite adaptability:

> the forms of thought and what it feeds on, together with modern techniques of information, language, and dress have dialectically reor-ganized the people's intelligences and...the constant principles which acted as safeguards during the colonial period are now undergoing ex-tremely radical changes.
>
> (1963: 225)

The affective dynamism of anticolonial struggle explodes the mystifying influence of customs, folklore, and abstract populism associated with "gratuitous actions," culminating at the stage in which time, agency, and the *habitus* of creative strategies of intervention coalesce:

> The colonized man who writes for his people ought to use the past with the intention of opening the future, as an invitation to action and

a basis for hope. But to ensure that hope and give it form, he must take part in action and throw himself body and soul into the national struggle....A national culture is the whole body of efforts made by a people in the sphere of thought to describe, justify, and praise the action through which that people has created itself and keeps itself in existence.

(Fanon 1963: 232–33)

Culture cannot be divorced from the organized forces of national liberation that "create" peoplehood and sustain its life. For this project of fashioning a life-form, the national territory serves as the concretely determinate framework for shaping that national consciousness (which for Fanon is not equivalent to European-style nationalism) that allows "the discovery and encouragement of universal values." Far from keeping aloof from other nations, therefore, it is national liberation that "leads the nation to play its part on the stage of history" (1963: 247). Fanon concludes this speech with the image of a paradoxical exfoliation of opposites: "It is at the heart of national consciousness that international consciousness lives and grows. And this two-fold emerging is ultimately only the source of all culture" (247–8).

THE ARTIFICE OF NATIONAL LIBERATION

My contention is that Fanon's idea of national liberation provides the logic of social constitution and assemblage needed for grasping the dynamics of cultural change in any geopolitical formation. By dissolving the boundaries of self and other, of nation and global ecumene, this new mode of theorizing history undercuts the fashionable postmodernist representation of the body as sheer polymorphous matter charged with desire and presumably a site of resistance against hegemonic capital. In the first place, ensembles of corporeal energies occupy a category different from the isolated, monadic physical body that postmodernists privilege. Moreover, one can argue that bodies are not simply vessels of desire but "a plane of immanence" (to use Gilles Deleuze and Felix Guattari's notion) where power and freedom born of necessity coincide (Deleuze and Guattari 1994). Fanon's theory of the praxis of multitudes not only challenges the binary opposition of bourgeois elite aesthetics and an idealized massified culture of everyday life which motivates a trendy version of cultural studies (see, for example, Fiske 1992); it also exposes its paralyzing effect on the critical sensorium of ordinary people. Without a collective *conatus* catalyzed in the ethics of decolonization, the dogma of methodological individualism will continue to vitiate the attempts of cultural studies practitioners to move beyond the limitations of Enlightenment thought (racism, patriarchy, class exploitation) and affirm identities in the interstices of difference.

One way of illustrating Fanon's singular mode of interrogating cultural practice may be sketched here in a brief commentary on his essay "Algeria Unveiled" (in *A Dying Colonialism*). A recent appraisal of Fanon by Ato Sekyi-Otu regards this text as Fanon's finest exposition of the "possibility of expressive freedom" discovered through the instrumentalization of the veil. A phenomenology of existential choice reinterprets Fanon's discourse as an allegory of Hegelian dialectics:

> The measure of freedom is the degree to which space and symbol, area of action and device of self-disclosure, are multiply configurable, open to the agent's choice of ends and means, and are thus no longer signifiers of a radically compulsory and constricted identity.
>
> (Sekyi-Otu 1996: 226)

This flexible disposition of the veil profiles, for Fanon, the eventual "transformation of the Algerian woman." It is this dialectic of experience occurring in the "public theater of revolutionary action" that, for Sekyi-Otu, embodies the resonance and efficacy of Fanon's prefigurative hermeneutics.

With the *problematique* of cultural studies as the context of exchange, my reading of Fanon's mobilization of a cultural motif is somewhat different. I consider Fanon's programmatic text as a critique of postmodernist ethnography that privileges subjective fantasies, aleatory gestures, cyborg speech, and "traveling" localizations. Fanon in fact subjects psychoanalytic speculations to the actual historic disposition of forces, using the assemblage of "composable" relationships (Hardt 1995: 28) on an immanent field of forces as a means of eliminating the need for transcendence implicit in a posited "unconscious" which perverse "Desire" supposedly inhabits. In extrapolating Fanon's unique critical stance, I deploy some concepts taken from the philosopher Benedict Spinoza in order to illuminate how the "common notion" of national liberation takes shape in the course of an uncompromisingly materialist and anti-empiricist account of the Algerian woman's role, both spontaneous and constrained, in the productive rationality of the revolution.

Fanon begins with the customary association of the veil as the synecdochic mark of Arab culture and society for the Western gaze. While the masculine garb allows a "modicum of heterogeneity," the white veil that defines Algerian female society permits no alteration or modification. In the early 1930s, French colonialism seized the initiative to abolish "forms of existence likely to evoke a national reality." Based on the premise that behind the overt patrilineal armature of Algerian society lies a "matrilineal" essence, Fanon seizes on the patriarchal animus of colonial metaphysics. He rehearses France's fabled *mission civilizatrice*: "If we want to destroy the structure of Algerian society, its capacity for resistance, we must first of all conquer the women; we must go and find them behind the veil where they hide themselves and in the houses where the men keep them out of sight" (Fanon 1965: 38). Algerian society thus stands

condemned as "sadistic and vampirish," its internal mechanics in need of revamping and overhauling.

This bureaucratic consensus to forcibly emancipate the cloistered Algerian woman became a major policy of the French colonial administration. The rationale is strategic: to overcome the Algerian male resistance to assimilation via the control of women. But up to 1959, Fanon observes, "the dream of a total domestication of Algerian society" by means of "unveiled women aiding and sheltering the occupier" continued to haunt the colonial authorities. All schemes to persuade the Algerian intellectual (not just the *fellah* or peasant) failed. Fanon sums up this attitude to the veil as symptomatic of "the simplified and pejorative way" the French regarded the "system of values" used by the colonized to resist the erasure of their "distinct identity." Identity here equals culture, and culture as shared history or cohabitation distinguishes the nation. What follows is Fanon's attempt to describe the sociopsychological causality gravitating around the penetration of indigenous society by the assimilating power. The tropes of aggressive sexuality deployed here mark the scope and latitude of the disciplinary regime France tried to impose, with the weapon of sexual seduction unfolding instead the impotence of the colonizer:

> Every rejected veil disclosed to the eyes of the colonialists horizons until then forbidden, and revealed to them, piece by piece, the flesh of Algeria laid bare....Every new Algerian woman unveiled announced to the occupier an Algerian society whose systems of defense were in the process of dislocation, open and breached. Every veil that fell, every body that became liberated from the traditional embrace of the *haik*, every face that offered itself to the bold and impatient glance of the occupier, was a negative expression of the fact that Algeria was beginning to deny herself and was accepting the rape of the colonizer.
>
> (Fanon 1965: 42)

But the impression of conquest blurs as soon as Fanon inquires into the West's cultural imaginary, with its fatal conflation of appearance and essence, phenomenon and reality, generating the Other as guarantee of the Self's mastery.

Fanon understands that for the colonizer in control of the machinery of representation, every mask or disguise assumes that a truth lurks behind it. This translates hermeneutics into technocratic subterfuge. The search for the hidden face is invested with "romantic exoticism," sexuality, and the will to possess that belies any claim to appreciate the physical beauty of Algerian women so as to share it with others. Fanon argues that the violence of revealing the Algerian woman's beauty is really directed at something else under the skin, so to speak; the quest is to bare the secret or mystery in order to break her opaque alterity, "making her available for adventure." What frustrates the European's desire to possess the Other and fulfill his dream is the *habitus* attached to the veil: "This

135

woman who sees without being seen frustrates the colonizer. There is no reciprocity....She does not yield herself, does not give herself, does not offer herself" (1965: 44). The "secret" is then immediately reduced to ugliness and deformation through a rape that evokes a deceptive sense of freedom for the conqueror, a passivity whose real cause escapes his comprehension – hence, the "sad" passions (e.g. humility, pity) shrouding the Manichean metropolis.

What is striking here in Fanon's commentary is the way the erotic affect produces a disintegration of the Western psyche. This constellation of symptoms, mapped here as "faults" and "fertile gaps," appears in dreams and criminal behavior. The rending of the veil then leads to an act of violent appropriation charged with a "para-neurotic brutality" projected onto the victimized: the "timid" woman hovering in the fantasy becomes transformed into an insatiable nymphomaniac. Fanon describes the dream narrative of the colonizer circumscribing a "field of women" (gynaeceum, harem). In the dream, the woman-victim "screams, struggles like a doe, and as she weakens and faints, is penetrated, martyrized, ripped apart" (1965: 46).

Apprehending the decomposition that afflicts the colonizer, sign of an ironic pathos in which one's capacity for grasping causality or the chain of necessity is diminished, Fanon examines next the reaction of the colonized. Initially the conduct of the occupier "determines the centers of resistance around which a people's will to survive becomes organized" (1965: 47). And so the veil, formerly an inert and undifferentiated element in quotidian existence, acquires a new significance: it becomes a taboo or cult object. Contraposed to the Western focus of pedagogical energies to destroy the veil, the Algerians weave a whole universe of affective passions (obscured causalities) around the veil to thwart the colonizer's attacks, or at least to bring about an "armed truce." The principle Fanon applies here guides his entire cognitive and didactic mapping of the alignment of political forces, a principle encapsulated in the maxim: "problems are resolved in the very movement that raises them" (1965: 48). In other words, the modes and occasions of struggle entail a whole repertoire of ethical choices and tactics. In response to the ferocity of the French settler and "his delirious attachment to the national territory" (48), the Algerian revolutionary leadership decided to mobilize women to the fullest, urging them to summon a "spirit of sacrifice" as they became part of an extended and highly differentiated revolutionary machine. This decision represents the identity of will and intellect posited by Spinoza in his *Ethics* (1994: 49), precipitating joy – passion born from the common notion, the composition of bodies in mutually useful relationships (Deleuze 1988: 54–5).

Women were then incorporated into the guerilla combat units mindful of the differential rhythm of their participation. In the process of constituting this new assemblage, the FLN (Algerian National Liberation Front) realized how the taboo or cult of the veil undermined the strategy of inventing commonalities across gender and class. Reinforcing tradition as a means of resistance led to women's loss of ease and assurance, negative affects that attenuated their

cooperation with the military forces: "Having been accustomed to confine-ment, her body did not have the normal mobility before a limitless horizon of avenues, of unfolded sidewalks, of houses, of people dodged or bumped into. This relatively cloistered life, with its known, categorized, regulated comings and goings, made any immediate revolution seem a dubious proposition" (Fanon 1965: 49). Determined by the horizon of war and death by torture, the organization of women partisans (efficient collective agency) accumulates knowledge of the microphysics of bodily motion that eventually precipitates the emergence of a new character "without the aid of the imagination," the coefficient of play and imitation in art. Before Fanon offers examples of women's creative actuality, he recapitulates the theme of culture change by acknowledging the advent of a new protagonist who will soon dismantle the Manichean theater of regimented subjects deployed in demarcated zones:

> It is an authentic birth in a pure state, without preliminary instruction. There is no character to imitate, on the contrary, there is an intense dramatization, a continuity between the woman and the revolutionary. The Algerian woman rises directly to the level of tragedy.
>
> (1965: 50)

BODIES BEARING STIGMATA

A hiatus intervenes at this juncture of the essay. Fanon evokes a scenario of passages and shifts of position, maneuvers leading to the urgent decision to involve all women gradually in the daily tasks of the revolution. Attention to the complex architectonics of space, a heuristic cartography of place and environ-ment, where state power and the subject's right (the *conatus* of persevering) confront each other, preoccupies Fanon. This allows him to trace the genealogy of freedom and grasp the coextensiveness of natural right (enjoyed by all humans) and power, in a manner close to the spirit of Spinoza's politics (Spinoza 1951: 219–20; Gildin 1973). Ideas of the play of forces replace passive affects at the mercy of illusion, notions of contingency, and irrationali-ties that pervade social existence. Freedom inhabits the space of necessity, Fanon suggests, when the mind of the revolutionary organization acquires an idea of the nature of the body politic corresponding to its essence and objective: its affirmation of life, the collective joy of shared agency. This idea becomes manifest in the Algerian masses becoming the subject of revolution in the actuality of combat, in taking political decisions and implementing them.

A geopolitical surveyor, Fanon sketches for us the stage in which the tragic mask or persona assumed by women partisans will demonstrate its irrepressible hubris. It is the revolutionary process that destroys "the protective mantle of the Kasbah," its "almost organic curtain of safety" (1965: 51). With the fragility of Manichean barriers exposed by decolonizing reason, the Algerian

woman sallies forth out of the immobilized quarters into the bare streets of the settlers' city; in doing so, she destroys the boundaries separating tradition and modernity, the self-reproducing organs of alienation and anomie, established by the colonial state. But even while new linkages are made and new channels of communication and logistics are set up by her own skills and intelligence, a recomposition of internal relations proceeds from within. We witness the shifting velocities of women's striving to increase her power/right of transforming her place in society. This is the locus where the consensus of national liberation, the power of the multitude expressed to the fullest, transpires:

> Each time [she] ventures into the European city, the Algerian woman must achieve victory over herself, over her childish fears. She must consider the image of the occupier lodged somewhere in her mind and in her body, remodel it, initiate the essential work of eroding it, make it inessential, remove something of the shame that is attached to it, devalidate it....Initially subjective, the breaches made in colonialism are the result of a victory of the colonized over their old fear and over the atmosphere of despair distilled day after day by a colonialism that has incrusted itself with the prospect of enduring forever.
>
> (Fanon 1965: 52–3)

An ethics of national liberation materializes through the vicissitudes of political antagonisms. Internal relations (compatibilities, elective affinities, disaffiliations) are rearranged on the basis of what promotes the striving for the maximum expression of the collective body's power. This involves the associative movements of love, desire, and solidarity that generate common notions, purposes, and projects giving direction to the popular struggle. With the overcoming of passions bred by the mystifications and falsehoods that comprise the oppressor's ideological apparatus, a new agency is born armed for the next phase – the counterhegemonic use of terror. This signals the phase when "the Algerian woman penetrates a little further into the flesh of the Revolution" (1965: 54), her actions transvaluing the whole Manichean asymmetry of power. This unprecedented transvaluation inverts the custom-ordained proportion of motion and rest, speed and slowness, that has characterized the position of women's bodies in urban space. The rationale of this reversal is suggested by Spinoza's proposition: "Whatsoever increases or diminishes, helps or hinders the power of activity in our body, the idea thereof increases or diminishes, helps or hinders the power of thought in our mind" (1994: 2).

The systematic adoption of political forms of terror cannot be fully understood apart from the qualitative progression of the anticolonial struggle and its corresponding tempo of change. Fanon sums up the stages of deliberation and the nuances of attitudes toward the "circuit of terrorism and counterterrorism." He reminds us that from this point on the Algerian woman

becomes inseparable from the constitutive force of the militant and conscientized (to use Paulo Freire's term) multitude. Her "speed" is now synchronized to the momentum of the national-democratic mobilization. This is also the point when Fanon warns against confusing revolutionary terrorism with the anarchist cult of violence, the fetishism of the deed, and the mystique of death.[3] Fanon almost reaches the intensity of Spinoza's intransigent affirmation of life in the course of defying tyranny, pain, fanaticism, and ignorance:

> The *fidai* [guerilla combatant] has a rendezvous with the life of the Revolution, and with his own life....To be sure, he does not shrink before the possibility of losing his life or the independence of his country, but at no moment does he choose death.
>
> (1965: 58)

The Algerian woman's spirit of sacrifice is in fact a commitment to joy identified with an enhanced, active life coincident with the nation's construction of democratic power, the vehicle for human fulfillment in the decolonized community.

In the section on the reconfiguration of the woman's body, Fanon sketches an ethics of separation and assemblage that approximates Spinoza's concept of freedom as the transition from the natural realm (the horizon of war) to civil society where, for Fanon, the nation-people functions as transformative agency. Freedom is the recognition of necessity, of the chain of causality, sparked by intellectual reflection. This passage to freedom is symbolized by the transformation of the Algerian woman's body as a relation of parts that can be decomposed and reconstituted, parts with proportions of motion and rest regulated by the variety of encounters in life.

In this context, the veil becomes the signifier that actualizes woman's power/right in a corporeal logic that breaks down the Manichean duality. In the following excerpt, we can discern the motive of Fanon's conversion of cultural-studies ethnography into an ethical–political reciprocity of body and the world marked by the varying modalities of the expression of woman's power:

> The body of the young Algerian woman, in traditional society, is revealed to her by its coming to maturity and by the veil. The veil covers the body and disciplines it, tempers it, at the very time when it experiences its phase of greatest effervescence. The veil protects, reassures, isolates....Without the veil she has an impression of her body being cut up into bits, put adrift; the limbs seem to lengthen indefinitely. When the Algerian woman has to cross a street, for a long time she commits errors of judgment as to the exact distance to be negotiated. The unveiled body seems to escape, to dissolve. She has an impression of being improperly dressed, even of being naked. She experiences a sense

of incompleteness with great intensity. She has the anxious feeling that something is unfinished, and along with this a frightful sensation of disintegrating. The absence of the veil distorts the Algerian woman's corporeal pattern. She quickly has to invent new dimensions for her body, new means of muscular control. She has to create for herself an attitude of unveiled-woman-outside. She must overcome all timidity, all awkwardness (for she must pass for a European), and at the same time be careful not to overdo it, not to attract notice to herself. The Algerian woman who walks stark naked into the European city relearns her body, re-establishes it in a totally revolutionary fashion.

(Fanon 1965: 59)

The organizing skill and resourcefulness recounted here exemplifies not individual ingenuity but the contrapuntal play of bodies and political milieu where what used to be merely accidental encounters of veiled women evolves into organized ethical striving for expression of their united power. This accords with the democratic mobilizing principle expressed by Spinoza: "If two come together and unite their strength, they have jointly more power, and consequently more right against other forces in nature, than either of them alone; and the more there be that join in alliance, the more right they will collectively possess" (1951: 194). The multitude as substrate of change now incorporates women, a major component of self-determination or national autonomy, amplifying the potential of the whole nation. Women thus epitomize the power and intelligence of the masses sprung from the inexhaustible matrix of the national-liberation struggle.

TOWARD CULTURAL REVOLUTION

The final testimony to how the necessity of revolutionary combat functions as the condition for freedom of the colonized subaltern coincides with the motion of women's bodies in the streets of Algiers. Fanon describes the way women concealed bombs and weapons, illustrating how the organizing of composable parts fused spontaneous and planned elements, integrating will and contingency. The veil's combination and permutation of opposites disrupts the conventional dichotomy of tradition and modernity. It also displaces the colonial contract, the normative codes of duty and obligation, into a field of needs and exigencies defined by the overdetermined historical situation:

Removed and reassumed again and again, the veil has been manipulated, transformed into a technique of camouflage, into a means of struggle. The virtually taboo character assumed by the veil in the colonial situation disappeared almost entirely in the course of the liberation struggle....

140

The Algerian woman's body, which in an initial phase was pared down, now swelled. Whereas in the previous period the body had to be made slim and disciplined to make it attractive and seductive, it now had to be squashed, made shapeless and even ridiculous. This, as we have seen, is the phase during which she undertook to carry bombs, grenades, machine-gun clips.

The enemy, however, was alerted, and in the streets one witnessed what became a commonplace spectacle of Algerian women glued to the wall, on whose bodies the famous magnetic detectors, the "frying pans," would be passed. Every veiled woman, every Algerian woman became suspect. There was no discrimination. This was the period during which men, women, children, the whole Algerian people, experienced at one and the same time their national vocation and the recasting of the new Algerian society.

(Fanon 1965: 61–2)

We witness in this revisiting of a phase in the national-liberation struggle the making of the Algerian masses via the composition of multiple relations between women's bodies and their circumstantial inscription. Fanon's "genealogy" is really a recording of the passage of new subjects catalyzed by the "historic dynamism of the veil." Determined by beliefs associated with tradition, the veil functioned at first as a mechanism of resistance, opposed to the occupier's design to "unveil" Algeria. This reaction entrenched passive affects sprung from uncomprehended external causes. In the second phase, Fanon summarizes, the veil was instrumentalized to solve the new problems created by the struggle. The veil refunctioned thus unfolds a horizon of composable relations bringing people together, enacting in the process the constitution of social power itself and its consensual legitimacy. Now with the power of acting determined by adequate ideas (knowledge of the nexus of causality), the theology of Manichean polarity dissolves and a new political organism is created that transforms what is "natural" into social history. The ethical striving underwritten by the anticolonial revolution charts the passage from the immobilized "natural" Manichean order of segregated habitats and locations to the free organizing of capacities, exploding the fallacies of bureaucratic representation, the reified market, and the injustice of the imperial social contract.

This Spinozistic reading of Fanon's text, arguably a hermeneutic thought-experiment never tried before, pursues the line of inquiry proposed by Antonio Negri in his book *The Savage Anomaly*. In Spinoza's political theory, we find the primacy of collective human praxis, an expression of the constitutive dynamics of the multitude as a determined being. Power is theoretically constructed out of the passage from human striving (*conatus*) through desire and imagination to the image of the power of thinking and acting as a complex productive force, generating the subject with the physical accumulation of

movements. Negri writes: "Collective human praxis, while becoming politics, supersedes and comprehends the individual virtues in a constitutive process tending toward a general condition" (1991: 188). This condition assumes the spatial form of the City (also translated as "commonwealth"), a "collective person with common body and soul...determined by the power of the multitude, which is led, as it were, by one mind (Spinoza 1951: 303). This City then subverts and displaces the Manichean terrain of exclusivity, hate, and stigmatization. Fanon anticipates the building of this City as the site of communal affections and friendships, of generosity overcoming fear and hope; a City recognized as the multifaceted protean structure that "prefigures and imitates the work of reason" (Deleuze 1992: 267).[4]

We have now arrived at the intuition of "free necessity" at the heart of the national-liberation model, the impulses of the future incarnate in everyday circumstance and regulating its course. Fanon's vision of cultural revolution implicit in *A Dying Colonialism* and *The Wretched of the Earth* testifies to what Irene Gendzier calls Fanon's conversion from the humanitarian psychiatrist to the intransigent revolutionary. The transmogrification of European humanism which Fanon witnessed in the torture of political prisoners triggered this shift. We have seen how in "Algeria Unveiled" and other essays Fanon's disruption of the separatist, apartheid logic of colonialism harmonizes with a radical transformative politics that is anathema to the ludic pluralism of mainstream cultural studies practitioners. Given this brief exploration of Fanon's insight into the productive social dynamic of the national-liberation project, one which is extremely relevant to the crisis of the South in our present globalized corporate milieu, I venture this hypothesis: Fanon's value for us today inheres in this discursive practice of a cultural politics that goes beyond the populist articulation of heterogeneous forces along a "chain of equivalence" (such equivalence already embodied as a causal motivation and impetus within the semiotics of language, rhetoric and a wide range of speech-acts replicates the structuralist "process without a subject") to advance and illuminate the ethical drama of the multitude in the actual revolutionary process. Articulation theory cannot resolve the problems of racism and sexism founded on the procedural rights of a free-market society. For Fanon, culture, not just language or discourse, is key to the revolutionary transformation of the whole communicative situation in which power (*potentia*), the capacity for joyful experience, is rooted in "adequate ideas" of our species-being as part of nature. By "adequate ideas" is meant the appreciation of the body's infinite capacities attuned to our reasoning power identical to our given natural right, our susceptibility to working with others in common, pleasure-inducing endeavors. The framework of intelligibility for Fanon is the rationality of the national-liberation agenda where the recognition of Others overcomes the seemingly permanent alienation invested in and fostered by the Manichean paradigm of subjugation, self-destructive passions, and alienating difference. In this trajectory of cultural

inquiry inspired by Fanon's example, word and deed, mind and body, become one.

NOTES

1 A similar cooptative process may be observed in Homi Bhabha's postcolonial commentary on Fanon; see my critique of Bhabha in *Beyond Postcolonial Theory* (1998). Meanwhile, Edward Said stresses Fanon's caveats on "nationalist consciousness" by aligning him with Georg Lukacs's "thesis about overcoming fragmentation by an act of will" (1994: 270), thus converting him into a voluntarist or chiliastic Marxist.

2 The psychological individualism ascribed to Fanon resembles the mistake that attributes psychological egoism to Spinoza's political thought, as evinced in many accounts (see Garrett 1996). In contrast, Bloch disagrees with the quietistic and interiorist resonance of the *scientia intuitive* by glossing the relevant portions of Spinoza's *Ethics* thus:

> It thus becomes clear that ethical freedom, as really liberating, belongs to the freedom of action....The *homo liber* of Spinoza, the man who was thoroughly theological-political, is the opposite of such privateness....Ethical freedom, where it appears, is not formed in tranquillity, but precisely as character in the river of the world. And this character forms itself in the world to the degree that it forms the world so that the *homo liber* can necessarily be preserved without constraint.
>
> (Bloch 1986: 157)

3 See Oppenheimer's remarks on the genesis of community within the guerilla ranks (1969: 49–51, 62–6). Contrary to anarchist metaphysics, Fanon believed that "Action isn't an explosion. Action is a continual creation of a human order" (quoted in Geismar 1971: 198), evidence of a Spinozistic conviction in the productive dynamic of the finite mode of extended and thinking bodies.

4 The City as allegorical figure acquires cinematic realism in Gillo Pontecorvo's now classic film on the Algerian revolution, *The Battle of Algiers* (1966). Meanwhile, in contrast to the aura and ironic mystique of vocation in Pontecorvo's characterology, Isaac Julien's rendering of Fanon's ideas in *Frantz Fanon: Black Skin, White Mask* (1995) connects Fanon with diasporic intellectuals like Stuart Hall and Françoise Vergès. The contemporarization of Fanon may occlude the Marxist–Leninist aspect of Fanon delineated in Gendzier's substantial portrait (see also Turner and Alan 1986). For the Caribbean context, C.L.R. James links Fanon with Pan-Africanists George Padmore, Marcus Garvey, and W.E.B. DuBois (James 1992).

REFERENCES

Bloch, E. (1986) *Natural Law and Human Dignity*, Cambridge, MA: MIT Press.

Caute, D. (1970) *Frantz Fanon*, New York: Viking.

De Djin, H. (1996) *Spinoza: The Way to Wisdom*, West Lafayette, IN: Purdue University Press.

Deleuze, G. (1988) *Spinoza: Practical Philosophy*, San Francisco: City Lights Books.

—— (1992) *Expressionism in Philosophy: Spinoza*, New York: Zone Books.

Deleuze, G. and Guattari, F. (1994) *What Is Philosophy?* New York: Columbia University Press.

Fanon, F. (1963) *The Wretched of the Earth*, trans. C. Farrington, New York: Grove.
—— (1965) *A Dying Colonialism*, trans. H. Chevalier, New York: Grove.
—— (1967a) *Black Skin, White Masks*, trans. C.L. Markmann, New York: Grove.
—— (1967b) *Toward the African Revolution*, trans. H. Chevalier, New York: Grove.
Feuchtwang, S. (1985) "Fanon's Politics of Culture: The Colonial Situation and its Extension," *Economy and Society* 14, 4: 450–73.
Fiske, J. (1992) "Cultural Studies and the Culture of Everyday Life," in L. Grossberg, C. Nelson, and P. Treichler (eds) *Cultural Studies*, New York: Routledge.
Fogel, D. (1982) *Africa in Struggle: National Liberation and Proletarian Revolution*, Seattle: Ism Press.
Garrett, D. (1996) "Introduction," in *The Cambridge Companion to Spinoza*, New York: Cambridge University Press.
Gates, H.L. (1994) "Critical Fanonism," in R. Con Davis and R. Schleifer (eds) *Contemporary Literary Criticism*, 3rd edition, New York: Longman.
Geismar, P. (1971) *Fanon: The Revolutionary as Prophet*, New York: Grove.
Gendzier, I. (1973) *Frantz Fanon*, New York: Grove.
Gildin, H. (1973) "Spinoza and the Political Problem," in M. Grene (ed.) *Spinoza: A Collection of Critical Essays*, New York: Anchor Books.
Gordon, L.R. (1995) *Fanon and the Crisis of European Man*, New York: Routledge.
Gordon, L.R., Sharpley-Whiting, T.D., and White, R.T. (eds) (1996) "Introduction," in *Fanon: A Critical Reader*, Cambridge, MA: Blackwell.
Hall, S. (1992) "Cultural Studies and Its Theoretical Legacies," in L. Grossberg, C. Nelson, and P. Treichler (eds) *Cultural Studies*, New York: Routledge.
Hardt, M. (1995) "Spinoza's Democracy: The Passions of Social Assemblages," in A. Callari, S. Cullenberg, and C. Biewener (eds) *Marxism in the Postmodern Age*, New York: Guilford.
James, C.L.R. (1992) *The C.L.R. James Reader*, ed. A. Grimshaw, Cambridge, MA: Blackwell.
Lloyd, G. (1996) *Spinoza and the Ethics*, New York: Routledge.
Negri, A. (1991) *The Savage Anomaly*, Minneapolis: University of Minnesota Press.
O'Connor, A. (1996) "The Problem of American Cultural Studies," in J. Storey (ed.) *What is Cultural Studies?*, London: Arnold.
Oppenheimer, M. (1969) *The Urban Guerilla*, Chicago: Quadrangle Books.
Parkinson, G.H.R. (1975) "Spinoza on the Power and Freedom of Man," in E. Freeman and M. Mandelbaum (eds) *Spinoza: Essays in Interpretation*, La Salle, IL.: Open Court.
Said, E.W. (1994) *Culture and Imperialism*, New York: Pantheon.
San Juan, E. (1998) *Beyond Postcolonial Theory*, New York: St. Martin's.
Sekyi-Otu, A. (1996) *Fanon's Dialectic of Experience*, Cambridge, MA: Harvard University Press.
Spinoza, B. de (1951) *A Theologico-Political Treatise and A Political Treatise*, trans. R.H.M. Elwes, New York: Dover.
—— (1994) *A Spinoza Reader*, ed. E. Curley, Princeton, NJ: Princeton University Press.
Turner, L. and Alan, J. (1986) *Frantz Fanon, Soweto and American Black Thought*, Chicago: News and Letters.
Woddis, J. (1972) *New Theories of Revolution*, New York: International Publishers.
Yovel, Y. (1989a) *Spinoza and Other Heretics: The Adventures of Immanence*, Princeton, NJ: Princeton University Press.

—— (1989b) *Spinoza and Other Heretics: The Marrano of Reason*, Princeton, NJ: Princeton University Press.

Zahar, R. (1974) *Frantz Fanon: Colonialism and Alienation*, New York: Monthly Review Press.

9

FANON, TRAUMA AND CINEMA

E. Ann Kaplan

I first encountered Fanon in a so-called "Marxist-Feminist Reading Group" in the early 1970s. Preoccupied as we were with questions of revolution, we read the Fanon of *The Wretched of the Earth*, especially the powerful chapter "On National Culture." We looked for parallels between Fanon's notion of "native" versus colonial cultures, and the disjunction that we were experiencing between "feminist" and dominant male cultures in the 1970s. In effect, we sought parallels between the trauma of colonialism and the trauma of gender difference.

However, framing our project through the concept of trauma had not yet occurred to us. As I re-read Fanon now, the term "trauma" leaps off the page. But this is due to my returning to Fanon in the 1990s for reasons rather different from those in the 1970s. *Black Skin, White Masks* has become a main focus, although what Fanon has to say about colonialism in his other texts now also informs theories we bring to film studies. I focus here mainly on *Black Skin* because there Fanon's personal traumas around race are most explicitly expressed, and at the same time in *Black Skin* Fanon links these traumas to cinema and popular culture more generally. It is cinema and/as trauma that I want to show Fanon implicitly theorizing, long before trauma became a humanities focus.

Why "trauma" (an old concept, long familiar in psychoanalysis, medicine, and neuropsychology) is now being taken up in literary and cultural studies is a debatable point and not my concern here.[1] What I want to discuss, rather, is not only how trauma, as a category, illuminates Fanon's comments about cinema and suggests links between *cinema* and *trauma*, as noted, but also how it reveals hitherto submerged aspects of Fanon's texts, and opens them out to diverse cultural experiences.

Trauma is characterized by the collapse of symbolizing – arguably the essentially human activity (see Lifton 1979). In Robert Jay Lifton's terms, traumas are near-death experiences – death equivalents he calls them. In such experiences, people lose touch with links to other humans, and to the sense of community or group so basic to human identity. Trauma is usually experienced in the form of images in a flashback or a nightmare, accompanied by painful

bodily sensations. The original traumatic experience is so horrifying that it cannot be grasped cognitively, and assigned meaning. Rather, it remains unprocessed – not "knowledge" in the usual sense, yet felt in the body. Neuroscientists have been able to chart which sectors of the brain are involved in trauma, and have revealed that only the sensation sector is active in trauma – the meaning-making one is shut down because the affect is too much to register cognitively (Van der Kolk and Van der Hart 1995: 158–82). The trauma keeps returning in bodily form, unwilled by the person. As Cathy Caruth puts it, in trauma "You 'see,' but you do not 'know' " (1995: 6). The event possesses the individual in ways other events do not. It is a strange kind of bodily possession, just because it has not been assimilated in the usual way to the part of the brain that deals with meaning and thus with memory as knowledge.

Fanon's oft cited experience of being hailed by the little boy, "Look, Mama, a Negro!" can now be defined as fairly classic trauma. The child's call is seen to break Fanon's links to his community, unconsciously thought of as white and French. In response to the child's hailing of Fanon as "a Negro," he tells us that

> On that day, completely dislocated, unable to be abroad with the Other, the white man, who unmercifully imprisoned me, I took myself far off from my own presence, far indeed, and made myself an object. What else could it be for me but an amputation, an excision, a hemorrhage that splattered my whole body with black blood?
>
> (Fanon 1967: 112)

A bit further on Fanon continues: "My body was given back to me sprawled out, clad in mourning on that white winter day" (113).

Interesting here is the sense of immediacy and presentness to the description of this event which occurred sometime in the past. This immediacy is a second characteristic of trauma. The very title of the chapter in which this experience is detailed, "The Fact of Blackness," echoes the phenomenological side of trauma: its "facticity," its immovable thereness, its recurring present, its not being given a meaning which would assign it a place in a person's history. Like the classic trauma victim, Fanon's language is visual, graphic, powerfully imagistic. The surgical metaphors – amputation, excision, hemorrhage – convey the immediate and painful bodily impact characteristic of traumatic episodes that recur in this apparently timeless way. They also indicate the sense of break, cutting, loss that indicates the traumatic collapse of symbolizing and community.

In this chapter, we find Fanon, the trained psychiatrist, attempting to work his trauma through by first presenting the reader with a traumatic episode in all its intensity, and then with his defense against it. Continuing his surgical metaphors, Fanon says "I felt knife blades open within me," but he counters this with: "I resolved to defend myself." He has two opposite strategies, linked to his observation that

The psychoanalysts say that nothing is more traumatizing for the young child than his encounters with what is rational. I would personally say that for a man whose only weapon is reason there is nothing more neurotic than contact with unreason.

(1967: 118)

Since specific psychoanalysts for the first statement are not named, the observation is a bit puzzling, but it becomes clear when he reports what happened in both cases.

Fanon begins with the second one: the man of reason trying to deal with "unreason" – in his case, the total unreason of racial prejudice. This strategy led only to "outrage" – something Fanon discovered he shared with the Jew. "Since no agreement was possible on the level of reason," Fanon says, "I threw myself back toward unreason. It was up to the white man to be more irrational than I" (1967: 123). But he finds that his "unreason" is "countered with reason," in the sense that the claiming of "unreason" by the poets of négritude as a higher value than the reason of white civilization is then denigrated by white reason. Whites argue that négritude is but one stage in the progress of the Negro toward the higher white culture, which has already passed through the stage of poetry (Fanon 1967: 123–33). Fanon describes a claustrophobic, traumatic impasse:

I am a master and I am advised to adopt the humility of the cripple, Yesterday, awakening to the world, I saw the sky turn upon itself utterly and wholly. I wanted to rise, but the disembowled silence fell back upon me, its wings paralyzed.

(140)

Fanon's experience epitomizes one aspect of modernity: in its broadest senses, modernity implies travel, movement, the mass, and mass culture – all propelled by industrial capitalism. In Kevin Newmark's words, in an essay discussing modernism and theories of Baudelaire and Walter Benjamin,

Assaulted on all sides by unheard of number and kinds of impressions, consciousness learns to protect itself against the injurious effects of these invasive stimuli by preventing them from ever entering into real contact with either the subject's own past or with the unified tradition in which he would otherwise find himself.

(1995: 237)

Less talked about is the specific trauma of colonialism, itself a major component of modernity. It would seem that modernity, including colonialism, is trauma.

But what I want to focus on here is the machine that is the essence of modernism, namely cinema, which I will argue is also linked to trauma. Fanon's

statements about cinema first stimulated me to think about cinema and/as trauma, in contrast to film theory's 1980s Freudian/Lacanian psychoanalytic paradigm of cinema as oedipal regression. I hope to show links between Fanon's focus on trauma as against fantasy,[2] and his theorizing cinema as trauma instead of as regression.[3]

Let me say something about what this idea of cinema as trauma might mean, as it differs from familiar psychoanalytic theories of cinema as regression. Psychoanalytic film theories of the 1970s and 1980s basically posited a late Victorian, white, middle-class spectator. We were interested in the role of cinema as a kind of psychic release for the bourgeoisie burdened by severe Victorian social, behavioral and sexual codes which repressed spontaneity, creativity, libidinal pleasures, and pushed them to a lurid underworld. The stories early twentieth-century cinema told often replicated bourgeois fantasies, wishes and forbidden desires produced by the very oppressive codes themselves. In this way, vicarious participation through cinema might have helped women endure their unconscious sufferings and experience their also unconscious wishes and desires. In this view, cinema functions like night dreams and daytime fantasies to permit regression to infantile stages inadequately worked through. It functioned as temporary wish-fulfillment the better to enable people to carry on their psychically burdened lives. In that way, it was partially like psycho-analysis: only partially, for cinema could offer no "cure" as could psychoanalysis by unlocking repressed wishes and desires. But it could offer accommodation to reality. Cinema could function like Freud's mourning process – to accommo-date people to loss of the object.

But the frame of trauma evokes very different processes: first, there are links between cinema as trauma, and the "shocks" of modernity referred to earlier. In what senses may cinema be seen as traumatic in its modernist origins? Let's recall 1895, and the crowd gathered expectantly in the Grand Café in Paris to witness a new gadget. No one was ready for what happened: as Lumière projected his three-minute film, *The Arrival of a Train at La Ciotat Station*, the crowd gasped and as one body moved violently aside to avoid the engine that seemed to be running them over. People experienced, we might say, the trauma of the moving image, the trauma of objects in the world, projected as larger than life, seeming to be "real." That is the trauma of cinema itself, as it links to what Kevin Newmark has noted about "assaults" on a pre-industrial human consciousness not yet accustomed to the new speed and technologies of industrialism, or to the larger-than-life human face and body. Cinema's modes – such as the close-up of the gun in D.W. Griffith's early films – shook people out of their ordinary sense of their bodies in space, and also of time and memory. The large screen images, soon to be accompanied by extra-diegetic as well as diegetic sound, opened up new dimensions for human consciousness.

But colonialism did this as well, in terms of imaginary extensions of Euro-pean countries that became vivid to Europeans through photographs and cinematic renderings. Tales of travel and adventure in the colonies abounded in

many forms, challenging the individual's idea of confined boundaries of race and nation. It was the combined shocks of colonialism and cinema – both products of modernity – that Fanon began to theorize in *Black Skin, White Masks*.

I am interested in how Fanon's trauma of race is worked through both in his body and his responses to American cinema in *Black Skin, White Masks*. Significantly, it is at the end of this chapter on "The Fact of Blackness" – in which Fanon's founding traumatic experience is described – that Fanon mentions the trauma of cinema: "I cannot go to a film," he says, "without seeing myself. I wait for me. The people in theater are watching me, examining me, waiting for me. A Negro groom is going to appear.[4] My heart makes my head swim" (1967: 140). In other words, the trauma of the child's call is repeated in each new instance of Fanon's body being drawn attention to (or apparently so – there is a paranoid moment here), as in this case of watching a Hollywood film with white people. As in the case of the child's call, itself a consequence of colonialism, Fanon's sense of community, his links to other humans, is radically disrupted. The sense of belonging to a group, basic to human identity, is twice lost in this cinema-experience – that is, it is lost both on and off screen. Symbolizing collapses. Fanon's panic, expressed in his phrase, "My heart makes my head swim," takes over, and cognition is impossible.

In this sense, then, cinema is trauma: for cinema's modalities elicit ambivalent bodily identification with larger-than-life bodies on the screen. Fanon unconsciously thinks of himself as white and French, only to have this basic identity wrenched away when he is forced by the presence of white spectators to identify with the larger-than-life Negro groom he fears is about to appear. Homi Bhabha points out that it is precisely the ambivalence of relations of power/knowledge that allows the critic "to calculate the traumatic impact of the return of the repressed – those terrifying stereotypes of savagery, cannibalism, lust and anarchy which are the signal points of identification and alienation" (1994: 72). Bhabha notes that for Fanon, it is "this function of the stereotype as phobia and fetish that...threatens the closure of the racial/epidermal schema for the colonial subject and opens the royal road to colonial fantasy" (72–3). An example of such colonial fantasy is the image of the black as "cripple" in Fanon's quote above: this comes from a Hollywood film Fanon has seen, *The Home of the Brave* (1947), in which the black soldier, Moss, is invited at the end to identify his blackness as equal to the white soldier's literal amputation.[5] Such a fantasy absolves white culture of its racism – blackness is simply a wound like any other – and, caught up in this ambivalent process, Moss is apparently satisfied to depart from the war as an equal to the amputated soldier. Meanwhile, the very metaphor of *amputation* (recall Fanon's earlier surgical metaphors) suggests unconscious knowledge on the part of both whites and blacks of the colonial process as causing loss or confusion of identity.

In the following chapter on "The Negro and Psychopathology," Fanon refers in a slightly different way to the trauma of cinema and popular culture for a black man being educated in a colonial system. Fanon describes how the black child's view of the world, and of the community to which he belongs, "slowly and subtly – with the help of books, newspapers, schools and their texts, advertisements, films, radio – work their way into one's mind" (1967: 152). In the Antilles, he tells us, this view "is white because no black voice exists." As late as 1940, he says, no Antillean would think of himself as Negro – something surprising, he notes, in light of the négritude movement active during Fanon's moment of writing *Black Skin*.

In a footnote, Fanon proceeds to outline the different processes of identification for the black person watching racist Hollywood films, like the *Tarzan* series, in a colonial and in a metropolitan context. In the Antilles, Fanon identifies as white, since it is as white and French that he has been educated. Watching in the Antilles then, he tells us, "the young Negro identifies himself *de facto* with Tarzan against the Negroes." In this case, the black spectators follow Hollywood's narrative and filmic codes that invite exactly this identification. However, in a European theater, when the rest of the audience is white, he says that this audience "automatically identifies him with the savages on the screen" (1967a: 153). Fanon's phrasing is interesting: he does not say that *he* identifies naturally with the Negroes (as noted above, cinematic techniques would make that difficult), but that he is aware those around him know he is black and thus force upon him *recognition of his blackness*. In the Antilles, this evidently does not happen (must the reader assume that cinema theaters in the Antilles were segregated?). In effect, Fanon *presumes* that the white Others see him as black (not likely in reality, given the darkened cinema).[6]

However this may be, Fanon argues that in Europe, the sensitized black spectator is forced to read a Tarzan film negatively against the grain, and identify with the degraded black screen figures, not the heroes, because this spectator has internalized the look of the White Other. As Mary Ann Doane puts it, "The space of the theater becomes a space of identificatory anxiety, a space where the gaze is disengaged from its 'proper' object, the screen, and redirected, effecting a confusion of the concept of spectacle" (1991: 227).

Here Fanon addresses the traumatic break with his implicit white identity and community that cinema and popular culture produce. The experience of watching a Tarzan film in Europe is, he says, a conclusive one: "The Negro learns that he is not black without problems" (1967: 153). In the case of a documentary about Bushmen and Zulus, he notes, young Antilleans laugh even more loudly than white people might. In an aside, Fanon suggests that this laughter perhaps "betrays a hint of recognition" (presumably unconscious). But in France, a Negro watching such a film "is virtually petrified. There is no more hope of flight. He is at once Antillean, Bushman, and Zulu" (153).

Film and popular culture, then – imaging forth the black man as monstrous or degraded within white institutions and discursive frames – force on the black

man a collapse of symbolizing and community characteristic of trauma. In this case, cinema as trauma is the result of the combined processes of first, filmic content – stories of white men in the African jungle exploiting its natural resources, or documents by white film makers of African tribes; second, the filmic apparatus, which entails spectators watching together in a darkened room and invited to identify in specific ways with larger-than-life figures on the screen; and, finally, the colonized black man (*sic*) identifying extra-cinematically with the look of the White Other. As Fanon puts it in concluding this cinema discussion: "The black man stops behaving as an *actional* person. The goal of his behavior will be The Other (in the guise of the white man), for The Other alone can give him worth" (1967: 154).

But from there Fanon moves in somewhat characteristic fashion to the situation of the white person who is Negrophobic. In other words, now as psychiatrist, Fanon discusses the trauma for white people of the Negro. The different mechanisms Fanon describes bear some discussion: for the Antillean, he says, "we can say that every neurosis, every abnormal manifestation, every affective erethism...is the product of his cultural situation" (1967: 152). This is a provocative statement that needs fuller treatment than I can give it here, since it would seem to deny normal oedipal neurosis for black peoples[7] – something that elsewhere in his writings Fanon does seem at least partially to accept (as for instance in his discussion of both Algerian and French patients in his "Colonial War and Mental Disorders" essay (Fanon 1963: 249–310)). However, I am arguing that Fanon's main focus on the black man's foundational racial trauma leads him away from Freudian psychoanalytic paradigms, including Oedipus.[8] So it is consistent that for the white man's Negrophobia, Fanon easily turns to more classically psychoanalytic explanations. Quoting Charles Odier, he reminds us that phobias are linked to insecurity resulting from absence of the mother somewhere in the second year of life. In phobia, "affect has a priority that defies all rational thinking....The phobic is a person who is governed by...methods of thinking that go back to the age at which he experienced the event that impaired his security" (1967: 155).

But note that when Fanon wants to move to analyzing how "In relation to the Negro, everything takes place on the genital level" (1967: 157), he turns back to the case of the white woman who, while appearing to fear the one black man in her factory, ended up being his sexual partner:[9] Fanon wonders if there was "a trauma harmful to security in the case of (this) young woman?" (157). What is not clearly said is by what mechanism a white woman's early traumatic experience of her mother's absence takes the form of fear of/desire for rape by a black man. By inference, given Fanon's prior discussion of cinema and popular culture, and the degraded images of black men, we can assume that the woman attaches her phobia to a cultural image that arouses the fear and revulsion analysts have shown to be necessary to the phobic object. In this way, cinema can produce trauma in different ways for both black and white spectators, according to Fanon. What's interesting is why such Negrophobia may not also

be seen as culturally produced while at the same time having some individual basis in terms of a mother's absence. In this view, *both* white and black people's psychic organization would be produced through a combination of family relationships *and* culture. That cultures favor white people is all important in the severity of the psychic trauma for black peoples; but the mechanisms do not have to be so widely differentiated. Fanon becomes more open to seeing parallels in mental distress and trauma when treating both the victims and the perpetrators of violence in Algeria, as described in his essay on "Colonial War and Mental Disorders."

Black Skin, White Masks contains most of Fanon's personal observations about cinema and popular culture. The only other detailed attention to any media appears in a fascinating chapter in *A Dying Colonialism*, "This Is the Voice of Algeria," where Fanon speaks in a different, now revolutionary voice. Instead of working through his own trauma *vis-à-vis* colonialism as in *Black Skin*, Fanon now uses his own experiences to empathize with the similar trauma of the Algerian people under French colonial rule.

As part of his interest in supporting the Algerian cause, Fanon discusses the changing attitudes toward the radio by Algerians. When the radio only produced the voice of French colonialism, and copied Western-style programs offensive to traditions of respectability in Algerian families, Algerians would not listen to it (1965: 70). Radio-Alger was intended to give the settlers a sense of security and serenity (71). Given the general illiteracy among Algerians, newspapers (even those offering information alternative to the French propaganda) were not any use. So word of mouth was crucial. The so-called European and the pejorative term, "The Arab Telephone," referred to this word-of-mouth method of conveying news amongst the Algerians. Fanon describes the sometimes hysterical effects of this method when individuals gave the impression of being in permanent contact with the revolutionary high command: "Individuals," Fanon says, "...would be seen dashing down a street or into an isolated farm, unarmed, or waving a miserable jagged knife, shouting 'Long live independent Algeria! We've won!' Usually, this resulted in the poor person's death from colonial officals" (78–9).

But when in 1956 Algerians managed to establish their own frequencies and speak for themselves through the "Voice of Free Algeria," suddenly the radio took on an almost fetishized importance as a powerful means of communication amongst revolutionary groups. Fanon's discussion reveals the dramatic impact of radio on the mood and behavior of the Algerians, who become nearly hysterical trying to hear what was being put over, and who created messages when they could not hear real ones because simply being in touch with ongoing battles gave the listener a sense of being part of a national community. In Fanon's words, "By its phantom-like character, the radio of the Moudjahidines, speaking in the name of Fighting Algeria, recognized as the spokesman for every Algerian, gave to the combat its maximum reality" (1965: 87). In a later passage, Fanon shows the need for the "Voice" to be so intense as to produce

hysterical imaginings of non-existent messages, in a manner very similar to that described in relation to "The Arab Telephone":

> From nine o'clock to midnight, the Algerian would listen. At the end of the evening, not hearing the *Voice*, the listener would sometimes leave the needle on a jammed wave-length or one that simply produced static, and would announce that the voice of the combatants was here. For an hour the room would be filled with the piercing, excruciating din of the jamming. Behind each modulation, each active crackling, the Algerian would imagine not only words, but concrete battles. The war of the sound waves, in the *gourbi*, re-enacts for the benefit of the citizen the armed clash of his people with colonialism.
>
> (Fanon 1965: 88)

In another interesting passage, Fanon describes the differing psychopathological phenomena the radio elicited before and after 1954. Before 1954, Algerians suffering from hallucinations described "the presence of highly aggressive and hostile radio voices" (1965: 88). But after 1954, Fanon says, "in hallucinatory psychoses...the radio voices become protective, friendly" (89). Fanon begins to theorize radio as trauma when it symbolizes the voice of the oppressor, then as producing hysterical phenomena when the voice is the people's. As in his comments on cinema, in this chapter on radio in Algeria Fanon shows his sensitivity to the psychological, ideological and metaphorical meanings of the media in the embattled colonial context.

CONCLUSION

As we see in *A Dying Colonialism*, Fanon's own traumatic experience of racial difference, described so graphically in *Black Skin, White Masks* through his reaction to being called "A Negro!" and his ensuing impossible attempts at defense, emblematizes the trauma of colonialism for himself but also for other colonized peoples: the shock of the meeting of cultures, the shock of encountering the always-already derogatory meaning pre-existing for the black man from whatever culture (1967: 134). His own meeting with racial prejudice – both in public response to his body, and in media like cinema and radio – was an experience which would define Fanon's life and work, as trauma often does, without his perhaps ever quite realizing it. Fanon's particularly revolutionary zeal – his preoccupation (as critics have pointed out[10]) with the virile, heroic, male revolutionary – may have been an unconscious effort to cancel out the trauma that marked him as a reviled object to the white child because of his black skin. Not integrated as knowledge, this shattering of his identity was something that could never be healed but which propelled Fanon on to

revolutionary zeal so as to ennoble the black man, and to reverse the pre-existing scorn of the white man.

Seeing Fanon through the lens of trauma, rather than that of fantasy or repression, helps us understand more about both the phenomena of trauma and about what are often seen as Fanon's conflicting poles – the psychiatrist and the revolutionary. Fantasy implies a psychic sphere with its own "reality": the subject invests libido in imaginary scenarios that partly bring about personal relief. Because located within trauma rather than repression, Fanon's psychic syndrome lead him to focus on institutional and social change rather than on people's internal psychic fantasy and oedipal processes that the Freudian psychoanalyst is concerned with. The characteristics of trauma episodes – their facticity, their paradoxical ever-present quality while embodying history and memory, their phenomenological aspects – urged Fanon toward implacable revolution rather than toward a politics of accommodation or reform such as a Freudian psychoanalytic theory might have encouraged. This trauma-dynamic, both Fanon's strength and his weakness, still has much to teach us today, especially in relation to cross-cultural understanding in a catastrophic age like ours, in which trauma itself may, in Cathy Caruth's words, "provide the very link between cultures: not as a simple understanding of the pasts of others but rather, within the traumas of contemporary history, as our ability to listen through the departures we have all taken from ourselves" (1995: 11).

But Fanon's trauma-dynamic also has much to teach us about media and their impacts. Fanon's contribution, we have seen, was to link psychological trauma to the impact of the media. While Fanon deals with the specificity of media as trauma within French colonial contexts, what he has to say has relevance for the impact of media in other nations, other contexts. Modernist media like cinema and radio have the potential to alter consciousness, and to dramatically change how humans conceptualize their bodies, minds, time, memory and spacial relations, as well as, more obviously, what they believe about their nation and political issues, including gender and race. Given the postmodern digital and virtual technologies that have emerged since Fanon wrote, it is our task to build on Fanon's insights and understand the different "shocks" of postmodernism and postcoloniality as these are linked to the specific traumatic impacts of the new media.

NOTES

1 I have my theories, of course, as does Michael Roth (who presented them in a talk at the Humanities Institute in November 1997). I lean toward notions of ours being an era in which the political climate enables discussion of both political/military and personal/family trauma. Roth believes the interest has to do with the failure of deconstruction and with a ready publishing market eager to lap up the newest fad.

2 Françoise Vergès has articulated what I mean here in a "Dialogue" with other Fanon scholars: "Fanon always privileged trauma over fantasy," she notes. " 'Fantasy' did not belong to his psychological vocabulary...Fanon extended the psychological

consequences of this trauma [of slavery] to the entire psychological worlds of black people" (1996: 139).

3 Readers should also consult the work of Janet Walker in the area of cinema and trauma. As I understand it, Walker deals more with issues to do with history, memory and trauma as these are worked through in cinema than with my concern with the cinematic process as miming the traumatic psychic episode as this differs from thinking about cinema as producing regression in a spectator. See Walker (1997; 1998).

4 This comment is interesting and requires more attention than I can give it here. Why does Fanon so readily identify with the "Negro groom?" Surely, such a figure is produced through the specificity of American slavery and its residues, which took a very different form in Europe. In her somewhat different analysis of Fanon's foot-note, Mary Ann Doane also notes the different mediations for Fanon and for American blacks, but she argues:

> Although the historical framework for the development of Fanon's psycho-analysis of race relations is that of colonialism, his analysis is not totally unre-lated to the representational field of a Hollywood cinema more immediately influenced by the American context of slavery, abolition and the Civil War. For the master/slave relation and that of the colonizer/colonized share a certain tropic repertoire, particularly with respect to the constructions of sexualities and the psychical configurations accruing to each.
>
> (Doane 1991: 227)

5 See my discussion of this film in Kaplan (1997): as I have suggested here, this linking reveals Hollywood's inability to confront racism for what it is – Hollywood's need to minimize racial difference as equal to losing an arm instead of as social injustice and economic opportunism. [See also Gwen Bergner's essay in this collection – Ed.]

6 The closest Fanon comes to recognizing a certain predictable and inevitable paranoid position that colonialism must create in elite blacks is his statement that "When the Negro makes contact with the white world, a certain sensitizing action takes place. If his psychic structure is weak, one observes the collapse of the ego" (1967: 154).

7 Throughout essays and dialogues in *The Fact of Blackness* (1996), this issue regarding Fanon's varying statements about black cultures and oedipal processes surfaces and is never resolved. My own opinion is that because Fanon was so enmeshed with the syndrome of trauma as basic to black peoples – a syndrome that does not involve repression or oedipal fantasies, indeed, as I'll show, does not involve fantasy at all per se – he overdetermined black peoples' psychic lives. Surely, for many people, there is a mixture of traumatic and oedipal problems, emerging in different contexts and with distinct physical and psychic phenomena.

8 On this topic, see Vergès (1996), as well as her contribution to the "Dialogues" later in the same volume.

9 There has been much important discussion of Fanon's complex gender politics, especially in essays by Lola Young, bell hooks, and Kobena Mercer in *The Fact of Blackness* (Read 1996), as well as comments made in the various "Dialogues" that follow these essays. I have been careful through most of my essay to deliberately use the pronoun "he," since most of Fanon's analyses in *Black Skin* basically assume someone like himself, an elite black male, brought up in French colonialism. The issue of cinema and/as trauma does need a gender analysis, but this is not the right place for that.

10 See, for instance, Hall (1996).

REFERENCES

Bhabha, H.K. (1994) "The Other Question: Stereotype, Discrimination and the Discourse of Colonialism," in *The Location of Culture*, New York: Routledge.

Caruth, C. (ed.) (1995) *Trauma: Explorations in Memory*, Baltimore: The Johns Hopkins University Press.

Doane, M.A. (1991) "Dark Continents: Epistemologies of Racial and Sexual Difference in Psychoanalysis and Cinema," in *Femme Fatales: Feminism, Film Theory, Psychoanalysis*, New York: Routledge.

Fanon, F. (1963) "Colonial War and Mental Disorders," in *The Wretched of the Earth*, trans. C. Farrington, New York: Grove.

—— (1965) "This Is the Voice of Algeria," in *A Dying Colonialism*, trans. H. Chevalier, New York: Grove.

—— (1967) *Black Skin, White Masks*, trans. C.L. Markmann, New York: Grove.

Kaplan, E.A. (1997) *Looking for the Other: Feminism, Film and the Imperial Gaze*, New York: Routledge.

Hall, S. (1996) "The After-Life of Frantz Fanon," in A. Read (ed.) *The Fact of Blackness: Frantz Fanon and Visual Representation*, Seattle: Bay Press.

Lifton, R.J. (1979) *The Broken Connection: On Death and the Continuity of Life*, Washington, DC: APA.

Newmark, K. (1995) "Traumatic Poetry: Charles Baudelaire and the Shock of Laughter," in C. Caruth (ed.) *Trauma: Explorations in Memory*, Baltimore: The Johns Hopkins University Press.

Read, A. (ed.) (1996) *The Fact of Blackness: Frantz Fanon and Visual Representation*, Seattle: Bay Press.

Van der Kolk, B. and Van der Hart, O. (1995) "The Intrusive Past: The Flexibility of Memory and the Engraving of Trauma," in C. Caruth (ed.) *Trauma: Explorations in Memory*, Baltimore: The Johns Hopkins University Press.

Vergès, F. (1996) "Chains of Madness, Chains of Colonialism: Fanon and Freedom," in A. Read (ed.) *The Fact of Blackness: Frantz Fanon and Visual Representation*, Seattle: Bay Press.

Walker, J. (1997) "The Traumatic Paradox: Documentary Films, Historical Fictions and Cataclysmic Past Events," *Signs: A Journal of Women in Culture and Society* 22, 4: 803–26.

—— (1998) "Captive Images: Thoughts on Traumatic Events in the Historiographic Function of the Film Western," unpublished paper presented at the Society for Cinema Studies Conference, April.

Part III

FINDING SOMETHING
DIFFERENT
Fanon and the future of cultural politics

DISAVOWING DECOLONIZATION

Fanon, nationalism, and the question of representation in postcolonial theory

Neil Lazarus

Over the course of the past fifteen years or so, and – for very obvious geopolitical reasons – especially since 1989, there has been something of an obsessive return to the subjects of nationalism and the nation-state in Western-based cultural, historical, and social scientific scholarship. The scope and suddenness of contemporary developments – the collapse of historical communism, the end of apartheid, the cataclysm in Rwanda, etc. – were nowhere predicted and tended to catch everyone unawares. Despite this – or precisely because of it, perhaps – most of the contemporary studies of nationalism have continued to be pitched quite unreflexively upon the terrain of the unambiguously First Worldist interpretation that has been predominant since at least 1918. Nationalism, that is to say, has been seen as constituting a kind of return of the repressed. The sheer destructiveness of developments in Rwanda, Liberia, Chechnya, the Caucasus, and in what only a few years ago was still Yugoslavia, has been taken to reveal a fundamental truth about nationalism in general: not merely that it is chauvinistic, but also that it only ever results in the violent intensification of already existing social divisions.

The tendency on the part of "progressive, cosmopolitan intellectuals…to insist on the near-pathological character of nationalism, its roots in fear and hatred of the Other, and its affinities with racism" (Anderson 1983: 129) receives a distinct stamp in the field of postcolonial studies. Not so long ago, in the historical context of decolonization, there seemed little reason to doubt the liberationist credentials of at least some anticolonial nationalist movements. To speak during those years of Vietnam or Cuba or Algeria or Guinea-Bissau – to evoke the names of such figures as Ché, Fidel, Ho, Amilcar Cabral, no matter how fetishistically – was to conjure up the specter of national liberation, that is, of a revolutionary decolonization capable, in Frantz Fanon's memorable phrase, of "chang[ing] the order of the world" (1968: 36). Today things are very different. It is not so much that the setbacks and defeats that have had to be endured throughout Africa and Asia and the Americas have been bitter and

severe, though this is certainly true. Rather, contemporary theorists seem increasingly given to suggesting that the national liberation movements never were what they were – that is, that they were more concerned with the consolidation of elite power than with the empowering of the powerless, with the extension of privilege than with its overthrow, and so on.

We might begin to interrogate – and, indeed, combat – these contemporary "second thoughts" about anticolonial nationalist ideology and practice by anchoring ourselves in the work of Fanon. Not only was Fanon a direct participant in the struggles of the decolonizing era, of course; his writings are today the site of major controversy and investment in the field of postcolonial studies. Readers familiar with Fanon's work will recall that in his essay on "The Pitfalls of National Consciousness" in *The Wretched of the Earth* he produced an excoriating critique of bourgeois anticolonial nationalism, an ideology aimed at the (re)attainment of nationhood through means of the capture and subsequent "occupation" of the colonial state, and which on his reading represented only the interests of the elite indigenous classes. Fanon characterized bourgeois anticolonial nationalism as "literally...good for nothing" (1968: 176). Its specific project, he wrote, was "quite simply...[to] transfer into native hands" – the hands of bourgeois nationalists – "those unfair advantages which are a legacy of the colonial period" (152). The social aspirations of the bourgeois nationalists were geared toward neocolonial class consolidation: this meant that their "historic mission" was to constitute themselves as functionaries, straddling the international division of labor between metropolitan capitalism and the subaltern classes in the peripheries. The "mission" of the national elites, Fanon argued, "has nothing to do with transforming the nation; it consists, prosaically, of being the transmission line between the nation and a capitalism, rampant though camouflaged, which today puts on the mask of neocolonialism" (152).

Some contemporary theorists of "postcoloniality" have attempted to build upon Fanon's denunciation of bourgeois nationalism. Yet Fanon's actual standpoint poses insuperable problems for them. One fundamental difficulty derives from the fact that far from representing an abstract repudiation of nationalism as such, Fanon's critique of bourgeois nationalist ideology is itself delivered from an *alternative nationalist standpoint*. To theorists whose broad commitment to poststructuralist intellectual procedures inclines them to a mistrust of what Homi Bhabha rather dismissively calls "naively liberatory" conceptions of freedom (1991: 102), this cannot but seem unassimilable.

Bhabha himself tends to "solve" this problem by, in Benita Parry's words, "annex[ing] Fanon to Bhabha's own theory" (1987: 31), maintaining, for instance, that Fanon's political vision does "not allow any national or cultural 'unisonance' in the imagined community of the future" (Bhabha 1991: 102). In truth, however, Fanon commits himself to precisely such a "unisonant" view of the decolonized state in distinguishing categorically between bourgeois nationalism and another would-be hegemonic form of national consciousness – a liberationist, anti-imperialist, nationalist internationalism,[1] represented in the

Algerian arena by the radical anticolonial resistance movement, the Front de Libération Nationale (FLN), to whose cause he devoted himself actively between 1956 and 1961, the year of his death. Of this latter, "nationalitarian" (the term is Abdel-Malek's[2]), form of consciousness, Fanon wrote that it "is not nationalism" in the narrow sense; on the contrary, it "is the only thing that will give us an international dimension...[I]t is national liberation which leads the nation to play its part on the stage of history. It is at the heart of national consciousness that international consciousness lives and grows." (1968: 247–8)

For Fanon, in short, the process of decolonization brings the future of *capitalism* radically into question. In the decolonizing context, nationhood can be secured under different auspices. If the state that emerges from colony to nation comes to be dominated by the national middle classes, capitalist social relations will be extended. This is the "neo-colonial" option: a capitalist world system made up – "after colonialism" – of nominally independent nation-states, bound together by the logic of combined and uneven development, the historical dialectic of core and periphery, development and underdevelopment. But for Fanon the *national* project also has the capacity to become the vehicle – the means of articulation – of a *social*(ist) demand which extends beyond decolonization in the merely technical sense, and which calls for a fundamental transformation rather than a mere restructuring of the prevailing social order.

Although Bhabha explicitly predicates his theory of colonial discourse upon Fanon's work, he contrives to read him "back to front," as it were – that is, from *The Wretched of the Earth* (published posthumously, but containing work produced immediately prior to Fanon's death) to *Black Skin, White Masks* (published in 1952, before Fanon had ever been to Algeria) – thereby distorting the testimony of Fanon's own evolution as a theorist. Bhabha's influential essay, "Remembering Fanon," was initially written as a foreword to a new British edition of *Black Skin, White Masks*. The subtitle of the essay, "Self, Psyche, and the Colonial Condition," does justice to the situation (the term of course is Sartre's) of that text, but not to the work of Fanon as a whole. Bhabha, however, reads *Black Skin, White Masks* not merely tendentiously but more specifically *against* Fanon's subsequent intellectual production, using it to disavow Fanon's political commitments and his theorization of "the African Revolution." The strengths of *Black Skin, White Masks* are seen by Bhabha, thus, to derive from the related facts that it "shift[s]...the focus of cultural racism from the politics of nationalism to the politics of narcissism" (Bhabha 1989: 146) and that it "rarely historicizes the colonial experience. There is no master narrative or realist perspective that provide a background of social and historical facts against which emerge the problems of the individual or collective psyche" (1989: 136).

Bhabha's "re-membering" of Fanon inverts the historical trajectory of Fanon's thought in order to propose a vision of him as preeminently a theorist of "the colonial condition," of the interpellative effectivity of colonial discourse. Fanon's "search for a dialectic of deliverance" emerges on this reading as

"desperate" and "doomed" (Bhabha 1989: 133). Bhabha concedes the existence of a revolutionary-redemptive ethic in Fanon, of course, grounded in an existentialist and dialectical Marxist humanism, but he insists that the real value of Fanon's work lies elsewhere, in a psychoanalytic interrogation of the problematics of colonial desire. Fanon's constant utilization of existentialist, dialectical and Marxist-humanist categories is therefore cast in the light of a sequence of unfortunate lapses, or as a determinate failure of vision:

> In his more analytic mode, Fanon can impede the exploration of the…ambivalent, uncertain questions of colonial desire. The state of emergency from which he writes demands more insurgent answers, more immediate identifications. At times Fanon attempts too close a correspondence between the mise-en-scène of unconscious fantasy and the phantoms of racist fear and hate that stalk the colonial scene; he turns too hastily from the ambivalences of identification to the antagonistic identities of political alienation and cultural discrimination; he is too quick to name the Other, to personalize its presence in the language of colonial racism. These attempts, in Fanon's words, to restore the dream to its proper political time and cultural space can, at times, blunt the edge of Fanon's brilliant illustrations of the complexity of psychic projections in the pathological colonial relation…Fanon sometimes forgets that paranoia never preserves its position of power, for the compulsive identification with a persecutory "They" is always an evacuation and emptying of the "I."
>
> (Bhabha 1989: 142)

Inasmuch as Bhabha wishes to construct a portrait of Fanon as a poststructuralist *avant la lettre*, his writing is full of such passages. The procedural logic of these passages is curious. Their thrust is to represent Fanon's ideas as according fundamentally with Bhabha's own epistemological and methodological program. To the extent that Fanon's explicit formulations seem to render such a construction implausible, however, they need to be reproved for preventing Fanon from saying what he would have said, had he been able – that is, had he had the right words, or the time to reflect, or the courage to follow through his best insights. For example, the real strength of Fanon's thought is said by Bhabha to consist in his attention to "[t]he *antidialectical* movement of the subaltern instance" (1990a: 198); but since it cannot be denied that his characteristic mode of conceptualization is profoundly dialectical, Fanon "must sometimes be reminded that the disavowal of the Other always exacerbates the 'edge' of identification, reveals that dangerous place where identity and aggressivity are twinned" (1989: 144). Similarly, Fanon is said by Bhabha to "warn…against the intellectual appropriation of the culture of the people (whatever they may be) within a representationalist discourse that may be fixed and reified in the annals of History" (1990b: 302); but since it has to be

admitted that Fanon's discourse is for the most part emphatically "nationalitarian," and therefore both historicist and representationalist, Bhabha bids us understand that his (Fanon's) preeminent claim to our attention is as a theorist not of decolonization or revolution, but of the "subversive slippage of identity and authority":

> Nowhere is this slippage more visible than in [Fanon's] work itself, where a range of texts and traditions – from the classical repertoire to the quotidian, conversational culture of racism – vie to utter that last word that remains unspoken. Nowhere is this slippage more significantly experienced than in the impossibility of inferring from the texts of Fanon a pacific image of "society" or the "state" as a homogeneous philosophical or representational unity. The "social" is always an unresolved ensemble of antagonistic interlocutions between positions of power and poverty, knowledge and oppression, history and fantasy, surveillance and subversion. It is for this reason – above all else – that we should turn to Fanon.
>
> (Bhabha 1989: 146–7)

And again, Fanon's thought is said by Bhabha to tend toward theoretical antihumanism; but since it has to be admitted that his language is more or less unwaveringly humanistic, Bhabha is obliged to proffer the rationalization that, for various reasons,

> Fanon is fearful of his most radical insights: that the space of the body and its identification is a representational reality; that the politics of race will not be entirely contained within the humanist myth of Man or economic necessity or historical progress, for its psychic effects question such forms of determinism; that social sovereignty and human subjectivity are only realizable in the order of Otherness.
>
> (1989: 142–3)

According to Bhabha, in short, Fanon's "deep hunger for humanism, despite [his] insight into the dark side of Man, must be an overcompensation for the closed consciousness or 'dual narcissism' to which he attributes the depersonalization of colonial man" (1989: 143)!

With the tendentiousness of Bhabha's appropriation of Fanon in mind, perhaps, other antisocialist theorists in the field of postcolonial studies have tended to respond *critically* to Fanon's palpable commitment to a would-be hegemonic national-liberationist theory and practice. Debunking Fanon's writings and political engagements, they have charged that his ideas are as authoritarian as those of his bourgeois nationalist antagonists – or, indeed, of the colonialists themselves. Perhaps the most interesting, and symptomatic, of

these repudiations is that advanced by Christopher Miller, in his book *Theories of Africans.*

Partly because Fanon addressed himself with such insistence to the question of *national* liberation, some *Marxists* have envisioned him as a nationalist – no matter how progressive – rather than as a revolutionary socialist, and have moved to criticize him on these grounds. Miller, conversely, takes Fanon's commitment to the question of national liberation to be indissolubly linked to his commitment *to* Marxism; and he attacks Fanon simultaneously for his national liberationism *and* his Marxism. Arguing in general that "the Marxist approach tends too much toward projection of a Eurocentric paradigm onto Africa, a continent in reference to which terms such as 'class struggle' and 'proletariat' need to be rethought" (1990: 32), Miller claims to find the same irreducible Eurocentrism in Fanon's use of the language of nation and national liberation:

> by placing the word at the center of his concern for evolution, without questioning the complexities of its application to different geographical and cultural environments, Fanon winds up imposing his own idea of nation in places where it may need reappraising....Far from being "natural national entities" or cohesive nation-states, the modern nations of black Africa must make do with borders created to satisfy European power brokering in the "scramble for Africa," borders that often violate rather than reinforce units of culture....In Fanon's essay on national culture, there is no analysis of what a nation might be, whether it is the same in reference to Algeria as it is in reference to Guinea, Senegal or, most notoriously, the Congo (now Zaire). The single most important fact of political existence in black Africa, the artificiality of the national borders and the consequent problem of cultural and linguistic disunity, receives no attention.
>
> (Miller 1990: 48)

Let us start by conceding the validity of some of what Miller says here. It is indeed true that Fanon fails to question the purchase of the idea of the nation on African hearts and minds. In this respect he simply takes for granted the unforgoability and even the world-historical "appropriateness" of what has been imposed upon Africa by the colonial powers. He also summarily privileges the nation as not only an "obvious" but also a *decisive* site of anti-imperialist struggle. Certainly, his commitment to internationalism is such that he does not theorize the acquisition of nationhood as a historical terminus: on the contrary, he insists that "the building of a nation is of necessity accompanied by the discovery and encouragement of universalizing values" (Fanon 1968: 247). But this is only to confirm Miller's general observation that Fanon's thinking follows the course of much post-Enlightenment social thought in subordinating "history...to History, particular to universal, local to global" (Miller 1990: 50).[3]

It is also clear that Fanon's conceptualization of the nation is often derivative of the discourse of metropolitan romantic nationalism. In an essay entitled "Nationalism: Irony and Commitment," Terry Eagleton has argued that

> [t]he metaphysics of nationalism speak of the entry into full self-realization of a unitary subject known as the people. As with all such philosophies of the subject from Hegel to the present, this monadic subject must somehow curiously preexist its own process of materialization – must be equipped, even now, with certain highly determinate needs and desires, on the model of the autonomous human personality.
>
> (Eagleton 1990: 28)

It is relatively easy to demonstrate the applicability of this formulation to Fanon's national liberationism. Fanon's discourse is full of references to the self-realization of the Algerian people-as-nation through their struggle against colonialism. And on at least one occasion, he moves explicitly to figure the relation between individuality and nationhood in an essentialist language of particular and universal:

> Individual experience, because it is national and because it is a link in the chain of national existence, ceases to be individual, limited, and shrunken and is enabled to open out into the truth of the nation and of the world. In the same way that during the period of armed struggle each fighter held the fortune of the nation in his hand, so during the period of national construction each citizen ought to continue in his real, everyday activity to associate himself with the whole of the nation, to incarnate the continuous dialectical truth of the nation and to will the triumph of man in his completeness here and now.
>
> (1968: 200)

Yet Miller's fundamental argument against Fanon is less that his discourse is Eurocentric than that it is inapposite – not to say hostile – to African realities. Pointing to numerous passages in *The Wretched of the Earth* in which Fanon speaks of the African peasantry in what Miller interprets as "massively ethnocentric" terms as being "stuck in time, outside of history, 'plunged...in the repetition *without* history of an immobile existence,' " he claims that Fanon "leaves no room for local knowledge": Fanon's national liberationist historicism commits him to viewing "precolonial history as no history at all" (1990: 50).

This reading strikes me as being deeply misconceived. In the first instance, Miller fails to acknowledge numerous passages in *The Wretched of the Earth* and elsewhere, in which – even though his focus falls fairly unremittingly on colonial culture – Fanon does quite clearly address the specificity and interior adequacy of precolonial social and cultural forms. I have always been struck, for instance, by the passage in the essay "Concerning Violence" in which Fanon celebrates as

profoundly democratic the "traditional" protocols of public culture in Africa. Referring to "the substance of village assemblies, the cohesion of people's committees, and the extraordinary fruitfulness of local meetings and group-ments," he maintains that

Self-criticism has been much talked about of late, but few people real-ize that it is an African institution. Whether in the *djemaas* of northern Africa or in the meetings of western Africa, tradition demands that the quarrels which occur in a village should be settled in public. It is communal self-criticism, of course, and with a note of humor, because everybody is relaxed, and because in the last resort we all want the same things.

(Fanon 1968: 47–8)

Similarly, in the essay "On National Culture," there is a good deal of informed and appreciative discussion of the styles, themes, tonalities, and registers of various precolonial cultural practices. Stating quite explicitly that there is "nothing to be ashamed of in the [African] past," thus, Fanon remarks that one will encounter there only "dignity, glory, and solemnity" (1968: 210). He also refers freely to the "wonderful Songhai civilization," observing, however, that no number of such references can compensate for or alter "the fact that today the Songhais are underfed and illiterate, thrown between sky and water with empty heads and empty eyes" (210). To suggest, in the face of passages such as these, that Fanon had nothing but contempt for precolonial African cultures, or that he regarded the social universe that they registered and to which they constituted a response only as "a primitive stage to be transcended, or…'liquidated,' " (Miller 1990: 49), seems indefensible. Certainly, such a reading does not in my view find much warrant in Fanon's work.

The fundamental error committed by Miller, I believe, is to (mis-)read Fanon's representation of African culture in the era of colonialism as a representation of a history-less, culture-less *pre*coloniality. Miller fails to reckon with Fanon's construction of colonialism as a total and elemental rupture within African history. Already in *Black Skin, White Masks*, Fanon had viewed colonialism in these terms:

Overnight the Negro has been given two frames of reference within which he has had to place himself. His metaphysics, or, less preten-tiously, his customs and the sources on which they were based, were wiped out because they were in conflict with a civilization that he did not know and that imposed itself on him.

(1977: 110)

We need to pay attention here to the *time frame* implicated: "[o]vernight"; and to the effect of colonialism as Fanon sees it: "customs…wiped out." Fanon

does not say that precolonial customs were *suppressed* under colonialism, or that they went into decline. On the contrary, he insists that they were *obliterated*, and that this obliteration was instantaneous. Elsewhere in *Black Skin, White Masks*, he uses this conception to ground a definition of the experience of colonization. A colonized people, he writes, is one "in whose soul an inferiority complex has been created by the *death and burial of its local cultural originality*" (1977: 18; emphasis added). Again, colonialism is phrased as utterly destructive of precolonial culture.

In *The Wretched of the Earth* – as the passage cited above on the subject of the reflexivity of public cultural fora attests – Fanon occasionally seems prepared to soften this position slightly, to allow that *in some areas* and *to a limited degree* it is meaningful to speak of precolonial cultural forms surviving into the colonial era. Yet the same general understanding as before continues to underpin his analysis of colonialism. In "Concerning Violence," thus, he argues that "[t]he appearance of the settler has meant in the terms of syncretism the death of the aboriginal society, cultural lethargy, and the petrification of individuals" (1968: 93). We come close, here, to sensing both *why* Fanon should refer to the culture of the colonized in the disparaging terms that so offend Miller, *and what is at stake for him* in doing so. Miller has it that Fanon holds African culture in contempt. The truth is quite different. For in a significant sense Fanon does not regard the culture of the colonized in Africa as "African culture" at all! On the contrary, the culture of the colonized is for him a starkly colonial projection, bespeaking a colonial logic that, from the standpoint of the colonized masses themselves, cannot be redeemed except through the destruction of colonialism itself:

> The immobility to which the native is condemned can only be called in question if the native decides to put an end to the history of coloniza-
> tion – the history of pillage – and to bring into existence the history of
> the nation – the history of decolonization.
>
> (1968: 51)

Rather like Edward Said's concept of the "oriental" or Gayatri Chakravorty Spivak's concept of the "subaltern" – figures within colonial discourse that are imposed upon and, subsequently, taken up under duress and "lived" by colonized populations – Fanon's concept of the "native" or the "Negro" is not to be thought of as merely *descriptive* of independently existing (African) subjects. This is a point absolutely insisted upon by Fanon: he notes time and again that the figure of the native is not autochthonous, but is rather a construct of colonialism – actually, of the settler: "The settler and the native are old acquaintances. In fact, the settler is right when he speaks of knowing 'them' very well. For it is the settler who has brought the native into existence and who perpetuates his existence" (1968: 36); and, elsewhere:

169

The settler makes history; his life is an epoch, an Odyssey. He is the absolute beginning: "This land was created by us"; he is the unceasing cause: "If we leave, all is lost, and the country will go back to the middle ages." Over against him torpid creatures, wasted by fevers, obsessed by ancestral customs, form an almost inorganic background for the innovating dynamism of colonial mercantilism.

(1968: 51)

In addressing himself to "native" culture, therefore, Fanon is not addressing himself to "traditional" African culture. On the contrary, he is addressing himself to a culture fabricated (almost) entirely by colonialism, a culture that positions the native as its degraded other:

The native is declared insensible to ethics; he represents not only the absence of values, but also the negation of values. He is, let us dare to admit, the enemy of values, and in this sense he is the absolute evil. He is the corrosive element, destroying all that comes near him; he is the deforming element, disfiguring all that has to do with beauty or morality; he is the depository of maleficent powers, the unconscious and irretrievable instrument of blind forces.

(Fanon 1968: 41)

Pace Miller, then, Fanon does not argue that *precolonial* African culture is "plunged...in the repetition without history of an immobile existence." This statement refers, for Fanon, to the world *of those who have been made into "natives"*; it is a *product of colonialism*. Nor is precolonial culture held to be "primitive"; rather, it is held to have been destroyed, if not totally then very nearly so. For this reason, Fanon maintains that colonialism can only be combatted on its "own terrain," as it were – that is, on the basis of the struggle for national liberation. The materiality of colonialism must be reckoned with, and cannot simply be wished away, by its antagonists. As Patrick Taylor has put it, although perhaps too much in the subject-centered vocabulary of existentialism: "[o]ne has to define oneself in terms of one's opposition to the colonial system" (1989: 60). Colonialism cannot be overturned except through anticolonial struggle; and in a world of nations, the colonial state cannot be captured and appropriated except as a nation-state. It only remains to be asked what *kind* of nation-state. Hence Fanon's critique of bourgeois nationalism, and his insistence that the anticolonial struggle has brought national liberationist consciousness into existence as a fundamental practical reality:

The Algerian people, that mass of starving illiterates, those men and women plunged for centuries in the most appalling obscurity have held out against tanks and airplanes, against napalm and "psychological services," but above all against corruption and brain-

washing, against traitors and against the "national" armies of General Bellounis. This people has held out in spite of hesitant or feeble individuals, and in spite of would-be dictators. This people has held out because for seven years its struggle has opened up for it vistas that it never dreamed existed.

(Fanon 1968: 188)

One notes some imprecision on Fanon's part as to the relationship between this decolonized world that the Algerian people are said to be bringing into existence and the precolonial social order. Fanon speaks at one point of the "*tabula rasa* which characterizes at the outset all decolonization," adding that "the proof of success lies in a whole social structure being changed from the bottom up" (1968: 35). This tells us about the relationship between the *decolonized future* and the *colonial present*, but not whether the former is to be understood as amounting in any sense to a restitution of precolonial sociality. The claim that the liberation struggle is opening up vistas that the people "never dreamed existed" suggests not, but there are other passages in *The Wretched of the Earth* – particularly those concerning national culture – that seem to encourage a different reading. We have already glanced at Fanon's affirmative characterization of such traditional legislative fora as the *djemaas* or the village assembly (with respect to southern Africa, one thinks here of institutions like the *kgotla* in Botswana), which seem to provide models for the future to emulate. And consider also the following passage, in which Fanon celebrates the emergence of new storytelling practices under the auspices of the national liberation movement, and argues that, where the colonial order had rendered oral traditions "inert" and reduced precolonial cultural forms to a state of petrification, these new practices operate in accordance with, and offer to redeem, the vibrant and communitarian cultural practices of the precolonial era:

> the oral tradition – stories, epics, and songs of the people – which formerly were [sic] filed away as set pieces are now beginning to change. The storytellers who used to relate inert episodes now bring them alive and introduce into them modifications which are increasingly fundamental. There is a tendency to bring conflicts up to date and modernize the kinds of struggle which the stories evoke, together with the names of heroes and the types of weapons. The method of allusion is more and more widely used....The contact of the people with the new movement gives rise to a new rhythm of life and to forgotten muscular tensions, and develops the imagination. Every time the storyteller relates a fresh episode to his public, he presides over a real invocation. The existence of a new type of man is revealed to the public. The present is no longer turned in upon itself but spread out for all to see. The storyteller once more gives free rein to his imagination.

> (1968: 240)

I have been arguing that Fanon's thinking about culture in the colonial era is premised upon a preliminary assumption as to the decisiveness of the transformation wrought by the colonial encounter. For him, scarcely anything of precolonial African culture is able to survive into the colonial era. Since Christopher Miller fails to recognize this initial assumption, he is obviously in no position to put pressure upon it. Yet it is precisely here, ironically – and not with respect to any supposed trivialization of precolonial African culture on his part – that Fanon's theorization is legitimately susceptible to criticism. For the plain fact is that, throughout Africa and elsewhere in the colonial world, precolonial social, cultural, and ideological forms survived the colonial era meaningfully. Indeed, they continue to survive meaningfully today, in the "postcolonial" present.

The significance of this point cannot be overestimated. However central the idea might be to his analysis, Fanon is simply incorrect when he maintains that the imposition of colonialism entails "the death of the aboriginal society, cultural lethargy, and the petrification of individuals" (1968: 93). Reports of "the death of the aboriginal society" in Fanon, one is tempted to say, are greatly exaggerated. The necessary corrective to Fanon is provided by Amilcar Cabral in an address, entitled "National Liberation and Culture," initially delivered in 1970. In this address, Cabral points out that "[w]ith certain exceptions, *the period of colonization* was not long enough, at least in Africa, for there to be a significant degree of destruction or damage of the most important facets of the culture and traditions of the subject people" (1973: 60).

At the theoretical level, Fanon's error consists in a confusion of *dominance* with *hegemony*. The distinction between these two concepts was, of course, first elaborated by Antonio Gramsci (1988, esp. 189–221, 306–7). Within postcolonial studies, a distinctly third-worldist reading of the relationship between dominance and hegemony in the context of imperialism is offered by Abdul JanMohamed in his influential article "The Economy of Manichean Allegory." Where Gramsci had articulated these concepts around the axis of class, JanMohamed suggests that they refer rather to *different historical periods*. "Dominance" is defined by him in a more or less orthodox fashion, in terms of the "exercise [of] direct and continuous bureaucratic control and military coercion of the natives" (1986: 80). However, as a mode of subjugation, dominance is historically delimited: the "dominant phase...spans the period from the earliest European conquest to the moment at which a colony is granted 'independence.' " Within this period, "the indigenous peoples are sub-jugated by colonialist material practices (population transfers, and so forth), the efficacy of which finally depends on the technological superiority of European military forces" (1986: 81). This "dominant phase" is then to be set against the "hegemonic phase," marked by the moment of independence, within which

the natives accept a version of the colonizers' entire system of values, attitudes, morality, institutions, and, more important, mode of production. This stage of imperialism does rely on the active and direct "consent" of the dominated, though, of course, the threat of military coercion is always in the background.

(1986: 81)

I do not find this conceptualization convincing, not least because it clearly has the effect of minimizing, if not of denying, the significance of class divisions among the colonized in both the "dominant" and the "hegemonic" phases.[4] While the moment of independence might be taken to mark the acceptance by the indigenous elite of "the colonizers' entire system of values," for example (although to claim even this seems to me to claim too much), it is surely implausible to argue that the lives and cultural forms of the subaltern populations of Africa in the post-independence period betoken a conversion to bourgeois ideology. Nor, it seems to me, can it be plausibly maintained that these subaltern populations have "accepted" the colonizers' "mode of production," even when cash crop farming, wage labor, land rent, etc. have been imposed upon them.

A far better theorization of the relationship between dominance and hegemony is to be found in the reconstruction of Gramsci's basic concepts in the work of Ranajit Guha. For a majority of the colonized, Guha suggests, and above all for those (mostly peasant) members of the subaltern classes living at some remove from the administrative and increasingly urban centers of colonial power, colonialism was experienced preeminently in terms of dominance, that is, along the lines of material, physical, and economic exaction: conquest, taxation, conscription, forced labor, eviction, dispossession, etc. There was comparatively little attempt on the part of the colonial establishment to seek *hegemony* among these subaltern classes, that is, to win their ideological, moral, cultural, and intellectual support for the colonial enterprise. The explicit targets of colonial hegemonization were the national or (sometimes) regional elites. One consequence of this was that although the subaltern classes could on occasion be recruited to the campaigns of the colonial government or the indigenous elites – and although the imposition and consolidation of colonial rule obviously had cumulative and long-term effects on the way in which subaltern populations lived, worked, and thought – inherited subaltern cultural forms (language, dance, music, storytelling) were able to retain both their traditionality and their autonomy from most forms of elite culture (colonial and "national"). The point is made thus by Taylor:

The colonizer's culture and his or her language, in particular, is the medium through which European values and life-style can be presented as the norm and the good, and in relation to which the colonized begin to define themselves. Still, the majority of the colonized,

unlike the colonial bourgeoisie, are able to maintain a certain distance from these norms by resisting them and recreating traditional cultural patterns.

(1989: 60)

Now it is not as though Fanon is altogether blind to this distinction between the forms of subjugation undergone by different classes among the colonized. It can certainly be argued that in *Black Skin, White Masks*, at least, he tends to generalize unwarrantedly from the ideological experience of his own class-fraction – that of the colonized intelligentsia – to the experience of the colonized population at large.[5] But even in this text, he does finally move to differentiate between the motivations that underlie "the quest for disalienation by a doctor of medicine born in Guadeloupe" and that of "the Negro laborer building the port facilities in Abidjan" (Fanon 1977: 223). In the former case, "alienation" is described as being "of an almost intellectual character"; in the latter, "it is a question of a victim of a system based on the exploitation of a given race by another, on the contempt in which a given branch of humanity is held by a form of civilization that pretends to superiority" (223–4).

Unlike Taylor, however – who concedes that in *Black Skin, White Masks*, "it is the colonized intermediary and elite classes in general whose story is told," but who argues that the text is less an analysis of colonialism as such than an impressionistic and semi-autobiographical working-through of the problematic of "racial alienation" in an attempt to "overcome" it (Taylor 1989: 44) – I do not find Fanon's formulation of the distinction between elite and masses convincing. What is at issue, for me, is not merely whether Fanon *recognizes* that what is true of the colonized elite is not necessarily true of the majority of the colonized population. Rather, it is a matter of the way in which, on the basis of this recognition, he then proceeds to think about the social existence and the forms of consciousness of this colonized majority. And here, it seems to me, Fanon's supposition that – in Taylor's words – "[i]n the creation of a colonial world, precolonial life and horizons were totally transformed and shattered" (1989: 47) begins to loom as a decisive liability. For inasmuch as he severely underestimates the resilience and vitality of inherited cultural forms and practices in the colonial era, Fanon renders himself incapable of understanding exactly what is at stake for the subaltern classes in their involvement in anticolonial nationalism.

Fanon has, in general, an insufficient grasp of what Guha, in the context of colonial India, refers to as the autonomous "politics of the people":

parallel to the domain of elite politics there existed throughout the colonial period another domain of Indian politics in which the principal actors were not the dominant groups of the indigenous society or the colonial authorities but the subaltern classes and groups constitut-

ing the mass of the laboring population and the intermediate strata in town and country – that is, the people. This was an *autonomous* domain, for it neither originated from elite politics nor did its existence depend on the latter.

(Guha 1986: 4)

In the specific case of Algeria, Fanon's failure to credit the degree to which subaltern consciousness in the colonial period is still governed by vital "traditional" protocols causes him to misread the mass recruitment of the Algerian peasantry to the FLN as testifying to their embrace of the FLN's platform. In *The Wretched of the Earth*, thus, he speaks of the "upward thrust of the people" and declares that the people have "decided, in the name of the whole continent, to weigh in strongly against the colonial regime"; and he refers to the "coordinated effort on the part of two hundred and fifty million men to triumph over stupidity, hunger, and inhumanity at the same time" (Fanon 1968: 164).

In my 1990 book, *Resistance in Postcolonial African Fiction*, I argued that this tendency on Fanon's part to project a unity and coordinated political will onto the masses of the Algerian population in the late 1950s could not withstand close historical scrutiny. For it is impossible, on Fanon's reading, to account for the wholesale demobilization and disenfranchisement of "the people" in the years immediately following the acquisition of independence in Algeria in 1962, after an anticolonial war that had lasted for eight years and claimed a million Algerian lives. Such a development cannot be reconciled with Fanon's evocation of a disciplined and progressively unified population coming closer and closer to self-knowledge as the struggle against the French colonial forces intensified. It seems inconceivable that, having been decisively and world-historically conscientized during the anticolonial struggle (as Fanon claims they had been), this population would have permitted itself to be so easily and so quickly neutralized after decolonization. The truth, rather, would seem to be that as a class the Algerian peasantry was *never* fully committed to the vision of the FLN, even when it was fighting under the FLN's leadership (Lazarus 1990: 8–17). Thus Ian Clegg, on the basis of his research into peasant politics and state formation in Algeria in the years following independence in 1962, claims that

[t]he involvement of the population of the traditional rural areas in the independence struggle must be clearly separated from their passivity in face of its revolutionary aftermath. The peasants were fighting for what they regarded as their inheritance: a heritage firmly rooted in the Arab, Berber, and Islamic past. Their consciousness was rooted in the values and traditions of this past, and their aim was its re-creation.

(Clegg 1979: 239)

Now the specific political gloss that Clegg gives to this analysis no longer seems compelling. He argues – plausibly, in my view – that while the Algerian peasantry might well have committed themselves to a struggle for the restitution of their "homeland," they lacked the ideological resources to transform this struggle into a full-fledged social revolution. But he then proceeds to follow the bad precedent of much orthodox Marxist (and, of course, liberal) theory in attributing this determinate historical limitation to the inherent fatalism of peasant consciousness. "Revolution, as a concept, is alien to the peasant consciousness, while the peasants' relationship to the environment remains one of passive endurance rather than active transformation" (Clegg 1979: 239). The credibility of this sort of reading, and above all the supposition that peasants' relationship to their world can be characterized in terms of passivity, has been demolished by ethnographic and social-historical scholarship produced since around 1980.[6] As Allen Isaacman notes, even if most of the accounts of peasant consciousness produced by scholars in recent years are still "fragmentary and largely descriptive," they "offer...ample evidence of peasant-organized social movements" (1993: 255). At the very least, he concludes, this new scholarship obliges us to reassess "the vast literature which saw peasants either as inherently conservative and bound to ingrained habits or as inevitable victims of false consciousness or ruling-class hegemony" (260).

Yet Clegg's account rings true for all this. It enables us to account both for the Algerian peasantry's *commitment* to the struggle for independence, on the one hand, and, on the other, for its lack of concerted militancy in face of the FLN's (anti-socialist) policies of the years immediately following decolonization, when "[n]either the peasantry nor the subproletariat played any other than a purely negative role in the events" (Clegg 1979: 239). The general theoretical conclusion to be drawn here has been spelled out, in a different context, by James Scott as follows:

> [Peasant] resistance...begins...close to the ground, rooted firmly in the homely but meaningful realities of daily experience....The *values* resisters are defending are equally near at hand and familiar. Their point of departure is the practices and norms that have proven effective in the past and appear to offer some promise of reducing or reversing the losses they suffer. The *goals* of resistance are as modest as its values. The poor strive to gain work, land, and income; they are not aiming at large historical abstractions such as socialism....Even when such slogans as "socialism" take hold among subordinate classes, they are likely to mean something radically different to the rank and file than to the radical intelligentsia.
>
> (Scott 1985: 348–9)

In this light, Clegg's complaint that Fanon "lacks a critical and dialectical analysis of the process of the formation of consciousness" (1979: 239) rings as

plausible and judicious. For Fanon's formulations *are* consistently intellectualist in tone, often phrasing subaltern thought and practice in the elitist–idealist vocabulary of negation, abstract totalization, and self-actualization.

It is worth noting in this respect that to the extent that Fanon's contemporary followers remain faithful to his ideas about decolonization and popular consciousness, their writing tends to echo his in its intellectualism. Consider the following two passages from Patrick Taylor's *The Narrative of Liberation*, for example. In the first, Taylor is glossing Fanon's theorization of decolonization:

> Decolonization, Fanon writes, is the process whereby "spectators crushed with their inessentiality" are transformed into "privileged actors, with the grandiose glare of history's floodlights upon them" [1968: 36]. The colonized rise above the manichaean conception of the world as a tragic drama to assume a historical conception of the world as infinite possibility. They recognize human agency and responsibility in an open and unknowable history. Fanon's notion of the entry into history must be understood, not in manichaean terms, but in terms of the stepping out of drama (mythical, tragic understanding) and the assumption of historical, national, and human responsibility.
>
> (1989: 70)

In the second passage, Taylor is referring to Fanon's theory of the role of violence in the anticolonial struggle:

> It is not the act of violent struggle that is the key to decolonization but, rather, the revolutionary leap, the "willed" entry into history, the consciousness of the categorical imperative. What moves the Hegelian dialectic from a situation of mutually exclusive protagonists to one of mutual recognition, is the recognition of the other and the recognition of oneself as an active, freely creative being.
>
> (1989: 85)

I cite these passages both because I believe that they provide a reliable (if, perhaps, one-sided) account of Fanon's own conception of decolonization, and because I believe that their weaknesses as representations of popular anticolonial struggle are very clearly marked. Concerning the subject of reliability, Taylor quite correctly reads Fanon's thought in the light of an existentialist Marxist-humanism. Thus he constructs the Fanonian distinction between national liberationist and bourgeois nationalist ideologies in terms of a distinction between "the humanistic national consciousness brought about by the revolutionary movement" and "the degenerate consciousness of a dependent bourgeoisie" (Taylor 1989: 10). He argues that "underneath the roles into which they are forced, the colonized preserve a human identity and temporal being through the recollection of the past in terms of a vision of the future"

177

(49). And he proposes that "the task" confronting radical intellectuals is "to tell the story of human freedom totalizing its situation in such a way that freedom is communicated and the oppressive situation transformed" (19). Intellectually, and in their own terms, I do not find these theorizations particularly compelling. Yet I believe that the representation they offer of *Fanon's own problematic* is considerably more accurate than that preferred by such theorists as Bhabha or Robert Young, who would claim Fanon for a distinctly contemporary poststructuralism. In his book *White Mythologies*, for example, Young attempts to distinguish between

> the Marxist-humanist attempt, by Lukács, Sartre, and others, to found a "new humanism" which would substitute, for the Enlightenment's conception of man's unchanging nature, a new "historical humanism" that would see "man as a product of himself and of his own activity in history"

and Fanon's own position, which Young characterizes as "new 'new humanism' " (1990: 121). Young maintains that Fanon (like other "non-European writers" such as Aimé Césaire) was as critical of the "historical humanism" of Lukács and Sartre as he was of Enlightenment humanism; and he claims Fanon's standpoint as a theoretical antihumanism, one rooted in "the realization of humanism's involvement in the history of colonialism, which shows that the two are not so easily separable" (122). Certainly, there is a critique of certain aspects of Sartre's philosophy in Fanon's work; but I do not accept that Sartre's *humanism* is ever the object of these critiques. I am not persuaded, in fact, that Fanon's humanism distinguishes itself in any meaningful way *as a humanism* from that of Sartre. On my reading, Fanon never places a "new 'new humanism' " on the agenda. On the contrary, the new humanism of which he speaks in concluding *The Wretched of the Earth* – "For Europe, for ourselves, and for humanity, comrades, we must turn over a new leaf, we must work out new concepts, and try to set afoot a new man" (1968: 316) – strikes me as being manifestly Sartrean, and therefore just as *Taylor* (rather than Young) represents it.

Yet the fact that Taylor "gets Fanon right" at the level of philosophy merely throws into broad relief some of the *political* liabilities of the Fanonian standpoint. (Not that Bhabha or Young have anything worthwhile to contribute in this respect, let it quickly be said.) Briefly put, the problem emerges from the fact that Fanon as radical intellectual positions subaltern thought and action as the *exact* substantification of his revolutionary theory. Theory and practice are so closely aligned that it almost seems as though the latter exists principally to confirm the former. One is reminded of those passages in the early Marx – the Marx of the *Contribution to the Critique of Hegel's Philosophy of Right* (1844) – that give the impression that the European proletariat will soon be rising up to smash private property and the capitalist

system because, as an emergent class, it represents the negation, "the *effective dissolution* of this order" (Marx 1964: 59). Seamlessly theorized in this way, how could the proletariat *fail* to overthrow capitalism, and, with it, class society as such? By the same token, Fanon (and, following him, Taylor) is often tempted to "overread" anticolonial militancy, to construct it as the objective correlative of a revolutionary philosophy.

That the masses act; that they act *against* the colonial order – that they act *under the banner of* the national liberation movement – all of these statements are true. But the interpretation of these mass actions as corresponding to "the consciousness of the categorical imperative" or to a recognition of "human agency and responsibility in an open and unknowable history" seems appropriative in its externality. One does not have to doubt the legitimacy of Fanon's authority as a spokesperson of the masses in the anticolonial struggle in Algeria to believe that a certain unwarranted "speaking for" – that is, ventriloquizing, speaking "in the place of" or "instead of" – is involved here.

It is, moreover, precisely in this context that Gayatri Chakravorty Spivak's warning about the need to "watch out for the continuing construction of the subaltern" seems especially timely (Spivak 1988: 295). One of Spivak's insistent contentions, after all, is that the "genuinely disenfranchised" among the colonized are represented as subaltern not only in the texts of empire, but also in "the great narratives of nationalism, internationalism, secularism, and culturalism" whose unfolding marks the trajectory of anticolonialism and, indeed, of capitalist modernity itself (Spivak 1990: 102). In Fanon's world, the "genuinely disenfranchised" are plainly the peasant classes, of whom he writes that they are "systematically disregarded for the most part by the propaganda put out by the nationalist parties" (1968: 61). Fanon's own work distinguishes itself sharply from bourgeois nationalist propaganda in this respect. But even in *his* representations of the Algerian peasantry as a revolutionary force, there is no sustained consideration of the ways in which the peasants' views *fail* to match those of the FLN leadership, or aim at different ends, or reflect another social logic.

Let us, in the light of these considerations, return to *Theories of Africans* and give further thought to the thrust of Christopher Miller's commentary on Fanon.[7] For Miller, as we have seen, Fanon's weakness is seen to consist not in an underestimation of the *persistence* of "traditional" political practices and forms of thought in the colonial era, but in a contempt for tradition. Miller's general suggestion is that this "contempt" is characteristic of Marxist theory, which is held to "lack...relativism." Operating with a universalizing optic, Marxism, according to Miller, is constrained to gesture conceptually toward a "totalizing unity," in the name of which it must inevitably "overlook or 'liquidate' " difference, that which it cannot assimilate or subsume (1990: 64). Marxism invariably claims "to possess the only fully integrated political...vision" (32).

With respect to Fanon, Miller advances this argument as aggressively and tendentiously as possible, even claiming at one point that Fanon's ignorance about precolonial African history is reminiscent of that of Hegel or Hugh Trevor-Roper (1990: 50)![8] Nor is this extreme statement resorted to casually. On the contrary, having introduced us to a conception of "ethnicity" – tentatively defined, following Jean-Loup Amselle and others, as "a sense of identity and difference among peoples, founded on a fiction of origin and descent and subject to forces of politics, commerce, language, and religious culture" (35) – Miller maintains that Fanon's *imposition* of the category of "nation" upon African cultures organized around "ethnic" modes of self-understanding has to be accounted an act of epistemic violence, of such colossal proportions that it invites comparison with the violence of colonial ideology itself. "What matters most, what is most impressive in reading Fanon," he writes, "is the sheer power of a theoretical truth to dictate who shall live and who shall be liquidated" (50–1). And just as colonial ideology is undergirded by the repressive power of the colonial state, so too Miller casts Fanon's discourse as the official ideology of an empowered regime. This seems implausible, since Fanon died in 1961, with the struggle for independence still to be won in Algeria. Miller, however, brushes this mere historical fact aside in constructing an image of Fanon's political philosophy fully consonant with bourgeois nightmares of Robespierre or Lenin or Mao. When, for instance, Fanon calls for the "liquidation of regionalism and of tribalism" and, addressing himself to the collaborative role played by many local rulers (the deliberate wooing of whom by colonial regimes, in an attempt to facilitate the "pacification" of local populations, is well documented), suggests that "[t]heir liquidation is the preliminary to the unification of the people" (1968: 94), Miller draws the conclusion that: "Fanon's response to local resistance is to call out the firing squad" (1990: 50). The statement *reverses* the vectors of power in the colonial context. That liberation movements should themselves have been responsible for egregious abuses is undeniable and deplorable, if scarcely surprising. But it remains the case, even so, that it was in general not the national liberation movements but *the colonial regimes* that tended to resort to the firing squad; and it was not "local resistance" but *the official suppression of local resistance* that mandated the liberation fronts' "response."

Miller then goes even further: in an extraordinarily idealist and dehistoricizing analysis, he attempts to implicate Fanon in Sékou Touré's execution of poet–politician Kéita Fodéba in Guinea in 1969. Rhetorically, his question as to whether "the fact that Sékou Touré wrapped himself in Marxist and Fanonian discourse ma[kes] Fanon responsible for the reign of terror in Guinea" is already answered in being asked. But Miller is careful to affect scrupulousness: he states that Kéita Fodéba's execution cannot be read as a "*necessary* outgrowth of either Marxism or Fanon's theories" (1990: 62; emphasis added). However, this ostentatious circumspection is surely compromised by being positioned between an earlier observation that, when alive, Fanon often cited

Sékou Touré as "a practitioner of what...[Fanon] preache[d]" (52), and the subsequent suggestion that Fanon's "discourse on liberating violence inevitably [leads] to thoughts on the violence of discourse" (63). In his analysis, Miller resolutely ignores the imperialist pressures, threats, intrigues, and exactions that – in conjunction with the long history of colonial underdevelopment – contributed decisively to the formation of Sékou Touré's regime even if they did not by any means make it inevitable. Instead, he presents the developments of the post-independence era in Guinea as corresponding to the instanciation of Fanon's anticolonialist ideology – a strikingly Hegelian understanding if ever there was one!

One notes a superficial overlap here between Miller's position and that advanced by the Moroccan writer and critic, Abdelkebir Khatibi, in his influential article, "Double Criticism." Khatibi (who is not cited in *Theories of Africans*) argues that to the extent that Marxism is a "Western system of thought," it is prone to a reductive and otherizing construction of non-Western societies even though it "presents itself as, claims to be, and is applied – in one way or another – against imperialism" (1985: 12). It thus becomes possible to "read Marx in the following manner: the murder of the tradition(s) of the other and the liquidation of its past are necessary so that the West, while seizing the world, can expand beyond its limits while remaining unchanged in the end" (12). Unlike Miller, however, Khatibi does not finally accept this reading – "which would reduce Marx's thought to a murderous ethnocentrism" (12) – as defensible. For it falls foul both of the progressive thrust of Marx's own ideas and of the historical effects of Marxism as an institutionalized politics: "Who can deny that [Marx] was against colonialism and imperialism, that his thought has helped and continues to help the Third World in overthrowing imperialism and local powers?" (12). The divergence between Miller and Khatibi here tells entirely to Miller's disadvantage, in my view, even if it also seems necessary to add that in its rather fetishistic binarization of the categories of "the West" and "the Third World," Khatibi's own position is scarcely immune from materialist critique.

In constructing Sékou Touré's Guinea as a model of Fanonism realized, Miller completely disregards a central feature of Fanon's analysis of "the pitfalls of national consciousness." In his essay of this title, Fanon had spoken with remarkable prescience of the evolution of precisely such a leader as Sékou Touré, a "man of the people" who might have had "behind him a lifetime of political action and devoted patriotism," but whose objective historical function it would become in the postcolonial era to "constitute a screen between the people and the rapacious bourgeoisie" (Fanon 1968: 167–8). No matter how progressive the role he played prior to independence might have been, Fanon argued, this populist leader, positioned between "the people" and the elite, would find himself thrust, in the postcolonial era, into the position of pacifier of "the people":

For years on end after independence has been won, we see [the leader] incapable of urging on the people to a concrete task, unable really to open the future to them or of flinging them into the path of national reconstruction, that is to say, of their own reconstruction; we see him reassessing the history of independence and recalling the sacred unity of the struggle for liberation....During the struggle for liberation the leader awakened the people and promised them a forward march, heroic and unmitigated. Today, he uses every means to put them to sleep, and three or four times a year asks them to remember the colonial period and to look back on the long way they have come since then.

(1968: 168–9)

Far from being "responsible" in any way for the direction taken by Sékou Touré as the leader of Guinea after independence, Fanon had already foreseen its likelihood and tried to warn against it. Miller points to the contradiction between Sékou Touré's "ostensibly socialist ideology" and the fact that "his Guinea was always dominated by multinational corporations," as though this tells in some way against Fanon and Fanonism (Miller 1990: 60–1). Fanon, however, does not need this lesson; before it had even entered the political vocabulary, he had already subjected "African socialism" to a blistering critique.[9]

Miller paints Fanon in the colors of despotism in order to suggest that all discourses that aspire to hegemony are effectively the same. Even those that speak in the name of emancipation are necessarily predicated upon a will to power that cannot, in ethical terms, be distinguished from the will to power exemplified by the dominant discourse itself. Fanon's radical nationalism, on this reading, exists only as a latent recapitulation of colonialism: between it and colonialism there is little to choose. A European-derived import, Fanon's nationalism is without organic roots in African soil, and can be imposed upon Africa only by force. Because it is a totalizing discourse, there can be no dialogue between it and the "local" discourses of "ethnicity."

In recoiling from Fanonism and nationalism, Miller calls for a new cultural relativism, "retooled as contemporary critical anthropology" (1990: 66). Appealing to intellectuals to unlearn their privilege, to reimagine universalizing thought as "local knowledge" (65), he goes to considerable lengths to disclaim any privilege for intellectuals, above all where the representation of subaltern populations is concerned. Indeed he joins many other contemporary critical theorists in embracing a standpoint from which the very idea of speaking for others comes to be viewed as a discredited aspiration, and secretly authoritarian.[10] What is at issue here, it seems to me, is a kind of intellectualist antiintellectualism, a premature (and unwarranted) Foucauldian disavowal of the project of representation as such.[11] It is one thing to concede, with Spivak, that unless intellectuals "watch out for the continuing construction of the subaltern," their work will tend to be "sustained" by the "assumption and construc-

tion of a consciousness or subject," and that this assumption/construction will "in the long run" assure that their work "cohere[s] with the work of imperialist subject-constitution, mingling epistemic violence with the advancement of learning and civilization" (1988: 295). It is quite another thing, however, to argue – as Trinh T. Minh-ha does, for example – that any attempt to distinguish in social terms between intellectuals (or members of social elites), on the one hand, and "the people" or "the masses," on the other, already contains an implicit justification of class-division:

> Like all stereotypical notions, the notion of the masses has both an up-grading connotation and a degrading one. One often speaks of the masses as one speaks of the people, magnifying thereby their number, their strength, their mission. One invokes them and pretends to write on their behalf when one wishes to give weight to one's undertaking or to justify it....Guilt...is always lurking below the surface. Yet to oppose the masses to the elite is already to imply that those forming the masses are regarded as an aggregate of average persons condemned by their lack of personality or by their dim individualities to stay with the herd, to be docile and anonymous....One can no longer let oneself be deceived by concepts that oppose the artist or the intellectual to the masses and deal with them as with two incompatible entities.
>
> (Trinh 1989: 12–13)

One does not want to deny, of course, that self-proclaimedly radical intellec-tualism is sometimes an exercise in bad faith, and that expressions of solidarity with "the masses" should therefore always be scrutinized carefully. One is reminded, in this context, of Adorno's devastating observation:

> In the end, glorification of splendid underdogs is nothing other than glorification of the splendid system that makes them so. The justified guilt-feelings of those exempt from physical work ought not become an excuse for the "idiocy of rural life." Intellectuals, who alone write about intellectuals and give them their bad name in that of honesty, reinforce the lie.
>
> (Adorno 1978: 28)

But in Trinh's formulation, the baby of political representation is thrown out with the bathwater of ideological appropriation or "subalternization." The proposition that intellectuals cannot talk about "the masses" without guiltily romanticizing and/or implicitly disparaging them strikes me as being empirically indefensible. I cannot accept that all of the contemporary "postcolonial" novelists, poets, and dramatists who insist on the distinction between the masses and the elite in their work do so only to sanctify their own positions, or to assuage guilt. Nor can I accept that in the writings of all of the

contemporary cultural critics, historians and political theorists who – again – locate the distinction between elite and subaltern populations as indispensable, there is at work an implication that "the masses" are herd-like, docile, or anonymous.

What Trinh says about the representation of "the masses" in the totalizing discourse of intellectuals accords precisely with Christopher Miller's view of Fanon's intellectual practice. Yet if we return to *The Wretched of the Earth*, we find Fanon reiterating, time and again, that the relationship between "the masses" and "intellectuals who are highly conscious and armed with revolutionary principles" is not to be viewed from the standpoint of elitist assumptions about leaders and led, seekers and followers, shepherds and sheep. "To educate the masses politically," Fanon writes,

> does not mean, cannot mean, making a political speech. What it means is to try, relentlessly and passionately, to teach the masses that everything depends on them; that if we stagnate it is their responsibility, and that if we go forward it is due to them too, that there is no such thing as a demiurge, that there is no famous man who will take the responsibility for everything, but that the demiurge is the people themselves and the magic hands are finally only the hands of the people. In order to put all this into practice, in order really to incarnate the people, we repeat that there must be decentralization in the extreme.
>
> (1968: 197–8)

It is easy to be cynical in face of such formulations as these. Miller sneers that "[e]veryone gives lip service to dialectics" (1990: 64). Actually, dialectical theory is almost universally *discredited* in the various subfields of cultural studies today; but even if there were something to Miller's complaint, the fact would remain that not everybody who evokes dialectics is a hypocrite, or merely giving lip service to it.[12] And in a remarkable passage in "The Pitfalls of National Consciousness," Fanon points to the implications that follow from his understanding of the relation between intellectuals and "the masses" as dialectical:

> If the building of a bridge does not enrich the awareness of those who work on it, then that bridge ought not to be built and the citizens can go on swimming across the river or going by boat. The bridge should not be "parachuted down" from above; it should not be imposed by a *deus ex machina* upon the social scene; on the contrary, it should come from the muscles and the brains of the citizens. Certainly, there may well be need of engineers and architects, sometimes completely foreign engineers and architects; but the local party leaders should be always present, so that the new techniques can make their way into the cerebral desert of the citizen, so that the bridge in whole and in part can

be taken up and conceived, and the responsibility for it assumed by the citizen. In this way, and in this way only, everything is possible.

(Fanon 1968: 200–1)

Miller (and Trinh) would, of course, seize on the characterization of the citizens' intellect in this passage as a "cerebral desert." I have tried to demonstrate above that in deploying such language, Fanon was describing colonial culture rather than "local knowledge." Taken as a whole, moreover, the passage is remarkable for its *refusal* to sanction the imposition of ideas or technologies upon people who have not first "internalized" them, who have not first made them their own. The very thing that Miller accuses Fanon of doing, in fact, turns out to be the thing that Fanon refuses above all to do! Even if the citizens' intellect does amount to a "cerebral desert," even if the citizens are – from the point of view of the cosmopolitan radical intellectual – intransigent, narrow-minded, stubborn, wrong, nothing can proceed without them. The "fighting" intellectual can "shake the people" or try to "turn...himself [*sic*] into an awakener of the people" (1968: 222–3). Ultimately, however, "he" "must realize that the truths of a nation are in the first place its realities" (225). And these realities neither necessarily follow, nor can they forcibly be made to follow, "his" script.

One finds these emphases in the work of Amilcar Cabral as well. In his essay, "National Liberation and Culture," Cabral speaks of the need for revolutionary intellectuals and leaders of the national liberation movement to live with and among "the masses" as the liberation struggle unfolds:

> The leaders of the liberation movement, drawn generally from the "petite bourgeoisie" (intellectuals, clerks) or the urban working class (workers, chauffeurs, salary-earners in general), having to live day by day with the various peasant groups in the heart of the rural populations, come to know the people better. They discover at the grass roots the richness of their cultural values (philosophic, political, artistic, social and moral), acquire a clearer understanding of the economic realities of the country, of the problems, sufferings and hopes of the popular masses. The leaders realize, not without a certain astonishment, the richness of spirit, the capacity for reasoned discussion and clear exposition of ideas, the facility for understanding and assimilating concepts on the part of population groups who yesterday were forgotten, if not despised, and who were considered incompetent by the colonizer and even by some nationals.

> (Cabral 1973: 54)

Written a decade after Fanon's death, Cabral's thought is such that one would have supposed that he could not possibly be represented as undervaluing the richness and sophistication of precolonial African sociality. After all, he refers

explicitly to the "richness of the...cultural values" of the "rural populations," and notes that "the accomplishments of the African genius in economic, political, social and cultural domains, despite the inhospitable character of the environment, are epic – comparable to the major historical examples of the greatness of man" (1973: 50). Yet in *Theories of Africans*, Miller contrives to read Cabral precisely as he reads Fanon. He quotes an observation of Cabral's, to the effect that although the peasantry – as the overwhelming majority of the population of colonial Cape Verde and Guinea Bissau – were indispensable to the armed struggle against Portuguese colonialism in those territories, the national liberation movement did not find it easy to mobilize them: "we know from experience what trouble we had convincing the peasantry to fight" (quoted in Miller 1990: 44). Miller then proceeds to gloss this observation as follows:

> Any revolution in Africa must have the support of the so-called peasants, who make up the vast majority of the population, yet the peasants do not lead but must be led....The Marxist leader must stand in a transcendent relation between the peasant and History. The peasant's destiny will be revealed to him by the leader, in a relation of active to "passive," literate to "illiterate," progress to tradition, knowledge to "ignorance."
>
> (1990: 44)

It becomes apparent that for Miller, Cabral's fault is that he sought to prevail upon the Guinean peasantry to take up arms against Portuguese colonialism. Initially encountering among the peasantry views that were dissimilar from his own, Cabral ought, it seems, as a good, respectful cultural relativist, to have accepted their legitimacy and abandoned forthwith any aspirations to struggle for the overthrow of colonial rule! Miller reads Cabral's word "convince" as meaning to "impose." The fact, therefore, that Cabral was so successful in persuading the Guinean peasantry to take up arms against their colonizers that they were able, within a space of fifteen years, to topple the colonial regime, is interpreted by Miller as revealing only the degree to which the PAIGC (*Partido Africano da Independencia da Guiné e Cabo Verde*) was able to inflict a "new" colonialism upon an already colonized people. It seems not to occur to Miller that the Guinean peasantry's struggle against the Portuguese might have reflected their own identification – however partial, mediated, uneven or belated – with the PAIGC's cause; nor, indeed, that the PAIGC's ideology might itself have been a barometer of popular aspirations.

Because it obliges us to think of national liberation as a cultural (and not merely a political) project, Cabral's theorization allows us to appreciate the vital role that "converted" intellectuals can (and must) play in its promotion. It is important to insist on this truth, in opposition to both the anti-intellectualist discourse of ultra-leftism and the theoreticist discourse currently prevailing

within the field of postcolonial studies. The work of Edward Said is a powerful resource here: for Said has for years written brilliantly about the indispensability of intellectual practice to anti-imperialist struggle. (His own political writings themselves provide an eloquent case in point, of course.) Consider, for example, the following statement, drawn from Said's essay "Figures, Configurations, Transfigurations," in which he comments on the significance of the role that literature, as one specific medium of intellectual production, has been able to play in advancing the cause of anti-imperialism throughout the twentieth century:

> in the decades-long struggle to achieve decolonization and independ-ence from European control, literature has played a crucial role in the re-establishment of a national cultural heritage, in the reinstatement of native idioms, in the re-imagining and re-figuring of local histories, geographies, communities. As such, then, literature not only mobilized active resistance to incursions from the outside, but also contributed massively as the shaper, creator, agent of illumination within the realm of the colonized.
>
> (Said 1990: 1–2)

Obviously, some writers, some intellectuals, could have "contributed mas-sively" to the decolonizing effort on the basis of their work as trade unionists or activists or coordinators of armed struggle. (One thinks for example of such figures as Sergio Ramirez or Ghassan Kanafani or Jose Luandino Vicira.) But Said's point seems to be that intellectuals have contributed most decisively to decolonization on the basis of their specific labor as intellectuals: by writing, thinking, speaking, reporting, etc. (The title of one of E. San Juan, Jr.'s, essays captures this point brilliantly: "The Responsibility to Beauty: Toward an Aesthetics of National Liberation.")[13] It is on this basis, and not on others, that they have been able to constitute themselves as "agent[s] of illumination within the realm of the colonized." Nothing, therefore, could have replaced this kind of practice, whose effects have been both unique and indispensable.

Elsewhere, Said has moved to distinguish, within the broad field of cultural production, between *artists* and *intellectuals*. "In dark times," he has written,

> an intellectual is very often looked to by members of his or her na-tionality to represent, speak out for, and testify to the sufferings of that nationality....To this terribly important task of representing the collec-tive suffering of your own people, testifying to its travails, reasserting its enduring presence, reinforcing its memory, there must be added something else, which only an intellectual, I believe, has the obligation to fulfill. After all, many novelists, painters, and poets, like Manzoni, Picasso, or Neruda, have embodied the historical experience of their people in aesthetic works, which in turn become recognized as great

masterpieces. For the intellectual the task, I believe, is explicitly to universalize the crisis, to give greater human scope to what a particular race or nation suffered, to associate that experience with the sufferings of others.

(Said 1994: 43–4)

It is true that a distinct whiff of modernist nostalgia – exilic, metropolitan, deracinated – sometimes emanates from Said's representation of intellectual practice. He is in my view considerably too much given to such pronouncements as that the intellectual life is "a lonely condition, yes, but it is always a better one than a gregarious tolerance for the way things are" (1994: xviii) – pronouncements that, in general, suggest a suspiciously self-justifying romanticization of the intellectual vocation. Despite this propensity, however, Said's formulation of the role played by intellectuals in the struggle against imperialism strikes me as being of incalculable importance. For he does not only demonstrate that what intellectuals have been able to contribute to this struggle – the opening up of horizons, the crystallizing of memories and experiences as legitimate aspects of a cultural heritage, the discursive contestation of dominating paradigms of knowledge, the production of counter-truths, etc. – could not have been provided by any other form of labor-power, by any other social practice, in any other arena. He also allows us to recognize that in its essential gesture, such intellectual practice is fundamentally *universalistic*, directed through and beyond the nodal point of the nation to a proleptic space of *internationalism*. Hence his salutary reminder that many of the radical anticolonial intellectuals and activists who are today usually thought of as nationalists – Tagore, Césaire, C.L.R. James, Fanon, Arab nationalists such as Shibley Shumayil, Rashid Rida, Abdel Rahman al-Bazzaz, Qunstantin Zurayk, and "even the resolutely Egyptian Taha Hussayn," as well as W.E.B. Du Bois – were *at the same time* stringent opponents of any narrowly nationalist vision (Said 1993: 41–2).

In these terms, Said's formulation might be said to combine the insight of Pierre Bourdieu, concerning symbolic power, with that of Samir Amin, concerning the specificity of intellectualism in the context of anti-imperialist struggle. Thus Bourdieu writes that

Cultural producers hold a specific power, the properly symbolic power of showing things and making people believe in them, of revealing, in an explicit, objectified way the more or less confused, vague, unformulated, even unformulable experiences of the natural world and the social world, and of thereby bringing them into existence. They may put this power at the service of the dominant. They may also, in the logic of their struggle within the field of power, put their power at the service of the dominated in the social field taken as a whole....The fact remains that the specific interests of cultural producers, in so far as they

are linked to fields that, by the very logic of their functioning, encourage, favor or impose the transcending of personal interest in the ordinary sense, can lead them to political or intellectual actions that can be called universal.

(Bourdieu 1990: 147)

And Amin, for his part, observes that

The intelligentsia [in the periphery] is not defined by the class origin of its members. It is defined by: (i) its anticapitalism; (ii) its openness to the universal dimension of the culture of our time and, by this means, its capacity to situate itself in this world, analyze its contradictions, understand its weak links, and so on; and (iii) its simultaneous capacity to remain in living and close communion with the popular classes, to share their history and cultural expression.

(Amin 1990: 136)

It is in this connection that I would like, in bringing this paper to a close, to suggest that it is necessary for theorists working in the field of postcolonialism to think again about the valencies of both nationalism and radical intellectualism. Of course I have in mind Lenin's assertion that "[w]ithout revolutionary theory there can be no revolutionary movement," an idea, as he put it, that "cannot be insisted upon too strongly at a time when the fashionable preaching of opportunism goes hand in hand with an infatuation for the narrowest forms of practical activity" (1969: 25). But it also seems to me that in the context of the contemporary capitalist world system, the need to construct a "counternarrative...of liberation" is especially pressing (Gates 1991: 458). Such a counternarrative would necessarily derive from the narratives of bourgeois humanism and metropolitan nationalism, with their resonant but unfounded claims to universality. But it would not need to concede the terrain of universality to these Eurocentric projections. On the contrary, where postmodern and postcolonial theory have tended to react to the perceived indefensibility of bourgeois humanism and of colonial nationalism by abandoning the very idea of totality, a *genuinely* postcolonial strategy might be to move explicitly, as Fanon already did in concluding *The Wretched of the Earth*, to proclaim a "new" humanism, predicated upon a formal repudiation of the degraded European form, and borne embryonically in the national liberation movement:

Leave this Europe where they are never done talking of Man, yet murder men everywhere they find them, at the corner of every one of their own streets, in all the corners of the globe....When I search for Man in the technique and style of Europe, I see only a succession of negations of man, and an avalanche of murders....For Europe, for ourselves, and

for humanity, comrades, we must turn over a new leaf, we must work out new concepts, and try to set afoot a new man.

(Fanon 1968: 311–12, 316)

From *this* proleptically "postcolonial" standpoint, it is vital to retain the categories of "nation" and "universality." Hence, arguably, the specific role of anti-imperialist intellectualism today: to construct a standpoint – socialist, nationalitarian, liberationist, internationalist – from which it is possible to assume the burden of speaking for all humanity.

NOTES

1 I use this phrase, "nationalist internationalism," to indicate Fanon's dual revolutionary commitments to the national liberation struggle *and* the wider struggle for socialist internationalism – both, for him, entailed in the concept of anti-imperialism. In coining the phrase, I was not initially aware that it had a history. Étienne Balibar, however, notes that it was first used by Wilhelm Reich, whose concern "was to understand the mimetic effects" both of the "paradoxical internationalism" of Marxism and of "another" paradoxical internationalism,

> which was increasingly tending to realize itself in the form of an "internationalist nationalism" just as, following the example of the "socialist homeland" and around it and beneath, the Communist parties were turning into "national parties," a development which in some cases drew upon anti-Semitism.
>
> (Balibar and Wallerstein 1991: 62–3)

Balibar uses Reich's concept to further his thesis concerning the supplementarity of racism to nationalism. Since I do not accept Balibar's thesis, my own use of the concept is rather different: for me it emphasizes the indispensability (and relative privilege) of the national liberation struggle to the wider struggle for socialism.

2 In Abdel-Malek

> [The] nationalitarian phenomenon...has as its object, beyond the clearing of the national territory, the independence and sovereignty of the national state, uprooting in depth the positions of the ex-colonial power – the reconquest of the power of decision in all domains – of national life....Historically, fundamentally, the struggle is for national liberation, the instrument of that reconquest of identity which...lies at the center of everything.
>
> (Abdel-Malek 1981: 13)

See also Amilcar Cabral: "[T]he chief goal of the liberation movement goes beyond the achievement of political independence to the superior level of complete liberation of the productive forces and the construction of economic, social and cultural progress of the people" (1973: 52).

3 Miller regards such commitments and emphases as these in Fanon's thought as crippling liabilities. I believe them, on the contrary, to be for the most part not only correct but also indispensable. On my reading, thus, the nation *is* a decisive site of anti-imperialist struggle. Similarly, it seems to me that the trajectory of modernity *does* proceed from "history...to History, particular to universal, local to global" – it is

190

precisely in this feature that the singularity and historical unprecedentedness of capitalism resides. I shall return to these points later in this essay. My intention here, however, is solely to register that in his work Fanon merely *proclaims* these commitments, rather than justifying them. Miller is right, therefore, to point out that Fanon fails to subject them to critical scrutiny.

4 In his book *Manichean Aesthetics*, JanMohamed had earlier proposed that "in the colonial situation the function of class is replaced by race" (1983: 5) – a reductive reading that works similarly to deny the pertinence of hierarchical divisions within colonized societies.

5 Cedric Robinson offers a Marxist critique of the class address of *Black Skin, White Masks* in his essay "The Appropriation of Frantz Fanon" (1993).

6 See, for example – among literally dozens of studies that could be cited – Guha (1983; 1997), Ranger (1985), Rigby (1985), and Kerkvliet (1990). See also the excellent overviews of recent scholarship on peasant consciousness and insurgency in Africa and Latin America, respectively, by Isaacman (1993) and Roseberry (1993).

7 A telling critique of Miller's reading of Fanon – one that accords strongly with the argument I am developing in the present essay – is to be found in Sekyi-Otu (1996: 31–46). I have also drawn on Brennan (1997: 53–4) and Jakubowska (1993).

8 Hegel, of course, is responsible for having written in his Introduction to *The Philosophy of History* that

> Africa proper, as far as History goes back, has remained – for all purposes of connection with the rest of the World – shut up; it is the Gold-land compressed within itself – the land of childhood, which lying beyond the day of self-conscious history, is enveloped in the dark mantle of Night...The Negro...exhibits the natural man in his completely wild and untamed state. We must lay aside all thought of reverence and morality – all that we call feeling – if we would rightly comprehend him; there is nothing harmonious with humanity to be found in this type of character.
>
> (1956: 91, 93)

Trevor-Roper, for his part, is notorious for having opened his study *The Rise of Christian Europe* with the observation that history in the non-West corresponded to little more than the "unrewarding gyrations of barbarous tribes in picturesque but irrelevant corners of the globe" (1965: 9).

9 For a critical analysis of African socialism explicitly animated by Fanon's reading, see Armah (1967).

10 Two articles that usefully assess the politics of representation in contemporary cultural studies are Alcoff (1991–92) and Shohat (1995). Alcoff observes, with particular reference to contemporary feminist theory (although the point is generalizable, it seems to me), that

> [a]s a type of discursive practice, speaking for others has come under increasing criticism, and in some communities it is being rejected. There is a strong, albeit contested, current within [critical theory] which holds that speaking for others is arrogant, vain, unethical, and politically illegitimate.
>
> (6)

11 See R. Radhakrishnan's splendid critique of Foucault's delegitimation of representation (1996: 27–61).

12 See Benita Parry, who perceptively notes that

191

[a]t a time when dialectical thinking is not the rage amongst colonial discourse theorists, it is instructive to recall how Fanon's dialogical interrogation of European power and native insurrection reconstructs a process of cultural resistance *and* cultural disruption, participates in writing a text that *can* answer colonialism back, *and* anticipates another condition beyond imperialism.

(1987: 44)

13 In this essay, San Juan offers a suggestive analysis of Roque Dalton's extraordinary essay "Poetry and Militancy in Latin America." Quoting directly from Dalton's essay, San Juan writes as follows:

Retrospectively noting the "painful scars" left by his Jesuit education, his irresponsible lifestyle nurtured in the "womb of the mean-spirited Salvadoran bourgeoisie," Dalton's career exemplifies the predicament of the Third World artist bifurcated by his "long and deep bourgeois formative period" and his "Communist militancy." His text registers the hesitancies, reservations, misgivings and scruples of this hybrid genealogy. The writer engages in self-criticism not by jettisoning the past, but by subsuming it in a dialectical mode of absorption/negation: he believes that far from exhausting its potential, the bourgeois outlook offers "creative possibilities," so by discarding its essentially negative aspects, the artist can "use it as an instrument to create ideal conditions for the new people's art that will spring up" in the process of Salvadorans fashioning a new autonomous life for themselves.

(San Juan 1988: 90)

REFERENCES

Abdel-Malek, A. (1981) *Nation and Revolution*, trans. M. Conzalez, Albany: State University of New York Press.

Adorno, T.W. (1978) *Minima Moralia: Reflections from Damaged Life*, trans. E.F.N. Jephcott, London: Verso.

Alcoff, L. (1991–92) "The Problem of Speaking for Others," *Cultural Critique*: 5–32.

Amin, S. (1990) "The Social Movements in the Periphery: An End to National Liberation?" in S. Amin, G. Arrighi, A.G. Frank, and I. Wallerstein, *Transforming the Revolution: Social Movements and the World-System*, New York: Monthly Review Press.

Anderson, B. (1983) *Imagined Communities: Reflections on the Origin and Spread of Nationalism*, London: Verso.

Armah, A.K. (1967) "African Socialism: Utopian or Scientific?" *Présence Africaine* 64, 4: 6–30.

Balibar, E. and Wallerstein, I. (1991) *Race, Nation, Class: Ambiguous Identities*, trans. (of Balibar) C. Turner, New York: Verso.

Bhabha, H.K. (1989) "Remembering Fanon: Self, Psyche, and the Colonial Condition," in B. Kruger and P. Mariani (eds) *Remaking History*, Seattle: Bay Press.

—— (1990a) "Interrogating Identity: The Postcolonial Prerogative," in D.T. Goldberg (ed.) *Anatomy of Racism*, Minneapolis: University of Minnesota Press.

—— (1990b) "DissemiNation: Time, Narrative, and the Margins of the Modem Nation," in H.K. Bhabha (ed.) *Nation and Narration*, New York: Routledge.

—— (1991) "A Question of Survival: Nations and Psychic States," in J. Donald (ed.) *Psychoanalysis and Cultural Theory: Thresholds*, New York: St. Martin's.

Bourdieu, P. (1990) *In Other Words: Essays towards a Reflexive Sociology*, trans. M. Aronson, Stanford, CA: Stanford University Press.

Brennan, T. (1997) *At Home in the World: Cosmopolitanism Now*, Cambridge, MA: Harvard University Press.

Cabral, A. (1973) *Return to the Source: Selected Speeches by Amilcar Cabral*, ed. Africa Information Service, New York: Monthly Review Press.

Clegg, I. (1979) "Workers and Managers in Algeria," in R. Cohen, P.C.W. Gutkind, and P. Brazier (eds) *Peasants and Proletarians: The Struggles of Third World Workers*, New York: Monthly Review Press.

Eagleton, T. (1990) "Nationalism: Irony and Commitment," in T. Eagleton, F. Jameson, and E.W. Said, *Nationalism, Colonialism, and Literature*, Minneapolis: University of Minnesota Press.

Fanon, F. (1968) *The Wretched of the Earth*, trans. C. Farrington, New York: Grove.

—— (1977) *Black Skin, White Masks*, trans. C.L. Markmann, New York: Grove.

Gates, H.L., Jr. (1991) "Critical Fanonism," *Critical Inquiry* 17, 3: 457–70.

Gramsci, A. (1988) *An Antonio Gramsci Reader: Selected Writings, 1916–1935*, ed. D. Forgacs, New York: Schocken.

Guha, R. (1983) *Elementary Aspects of Peasant Insurgency*, Delhi: Oxford University Press.

—— (1986) "On Some Aspects of the Historiography of Colonial India," *Subaltern Studies I: Writings on South Asian History and Society.* 1–8.

—— (1997) *Dominance without Hegemony: History and Power in Colonial India*, Cambridge, MA: Harvard University Press.

Hegel, G.W.F. (1956) *The Philosophy of History*, trans. J. Sibree, New York: Dover.

Isaacman, A.F. (1993) "Peasants and Rural Social Protest in Africa," in F. Cooper, A.F. Isaacman, F.E. Mallon, W. Roseberry, and S.J. Stern, *Confronting Historical Paradigms: Peasants, Labor, and the Capitalist World System in Africa and Latin America*, Madison: University of Wisconsin Press.

Jakubowska, T. (1993) "The Ethics of Ethnicity: A Commentary on Christopher Miller's Theories on Mediating African Literature," unpublished paper, University of Essex.

JanMohamed, A. (1983) *Manichean Aesthetics: The Politics of Literature in Colonial Africa*, Amherst: University of Massachusetts Press.

—— (1986) "The Economy of Manichean Allegory: The Function of Racial Difference in Colonialist Literature," in H.L. Gates, Jr. (ed.) *"Race," Writing, and Difference*, Chicago: University of Chicago Press.

Kerkvliet, B.J.T. (1990) *Everyday Politics in the Philippines: Class and Status Relations in a Central Luzon Village*, Berkeley: University of California Press.

Khatibi, A. (1985) "Double Criticism: The Decolonization of Arab Sociology," in H. Barakat (ed.) *Contemporary North Africa: Issues of Development and Integration*, Washington, DC: Center for Contemporary Arab Studies.

Lazarus, N. (1990) *Resistance in Postcolonial African Fiction*, New Haven, CT: Yale University Press.

Lenin, V.I. (1969) *What Is to Be Done? Burning Questions of Our Movement*, New York: International Publishers.

Marx, K. (1964) "Contribution to the Critique of Hegel's Philosophy of Right," in T.B. Bottomore (trans. and ed.) *Karl Marx: Early Writings*, New York: McGraw Hill.

Miller, C. (1990) *Theories of Africans: Francophone Literature and Anthropology in Africa*, Chicago: University of Chicago Press.

Parry, B. (1987) "Problems in Current Theories of Colonial Discourse," *Oxford Literary Review* 9, 1–2: 27–58.

Radhakrishnan, R. (1996) *Diasporic Mediations: Between Home and Location*, Minneapolis: University of Minnesota Press.

Ranger, T.O. (1985) *Peasant Consciousness and Guerrilla War in Zimbabwe*, Berkeley: University of California Press.

Rigby, P. (1985) *Persistent Pastoralists: Nomadic Societies in Transition*, London: Zed.

Robinson, C. (1993) "The Appropriation of Frantz Fanon," *Race & Class* 35, 1: 79–91.

Roseberry, William (1993) "Beyond the Agrarian Question in Latin America," in F. Cooper, A.F. Isaacman, F.E. Mallon, W. Roseberry, and S.J. Stern, *Confronting Historical Paradigms: Peasants, Labor, and the Capitalist World System in Africa and Latin America*, Madison: University of Wisconsin Press.

Said, E.W. (1990) "Figures, Configurations, Transfigurations," *Race & & Class* 32, 1: 1–16.

—— (1993) "Nationalism, Human Rights, and Interpretation," *Raritan* 12, 3: 26–51.

—— (1994) *Representations of the Intellectual: The 1993 Reith Lectures*, New York: Pantheon.

San Juan, Jr., E. (1988) *Ruptures, Schisms, Interventions: Cultural Revolution in the Third World*, Manila, Philippines: De La Salle University Press.

Scott, J.C. (1985) *Weapons of the Weak: Everyday Forms of Peasant Resistance*, New Haven, CT: Yale University Press.

Sekyi-Otu, A. (1996) *Fanon's Dialectic of Experience*, Cambridge, MA: Harvard University Press.

Shohat, E. (1995) "The Struggle Over Representation: Casting, Coalitions, and the Politics of Identification," in R. de la Campa, E.A. Kaplan, and M. Sprinker (eds) *Late Imperial Culture*, New York: Verso.

Spivak, G.C. (1988) "Can the Subaltern Speak?" in C. Nelson and L. Grossberg (eds) *Marxism and the Interpretation of Culture*, Urbana: University of Illinois Press.

—— (1990) "Practical Politics of the Open End," interview with Sarah Harasym, in *The Post-Colonial Critic: Interviews, Strategies, Dialogues*, ed. Sarah Harasym, New York: Routledge.

Taylor, P. (1989) *The Narrative of Liberation: Perspectives on Afro-Caribbean Literature, Popular Culture, and Politics*, Ithaca, NY: Cornell University Press.

Trevor-Roper, H. (1965) *The Rise of Christian Europe*, New York: Harcourt Brace Jovanovich.

Trinh T. Minh-ha (1989) *Woman, Native, Other: Writing Postcoloniality and Feminism*, Bloomington: Indiana University Press.

Young, R. (1990) *White Mythologies: Writing History and the West*, New York: Routledge.

11

BUSY IN THE RUINS OF A
WRETCHED PHANTASIA

Kobena Mercer

The power to define the other seals one's definition of oneself – who, then, in this fearful mathematics is trapped?

<div align="right">James Baldwin (1984)</div>

Keith Piper's 1983 painting, *The Body Politik*, depicts two bodies, one female and white, the other black and male, both denuded and beheaded on either side of two canvases joined by a pair of hinges. The two figures mime and mirror one another across the body of text which gives voice to mutual claims of misrecognition, "To you I was always (just) a body...I was your best fantasy and your worst fear. Everything to you but human." This early work (since lost or destroyed) can be read as embodying a matrix of concerns arising out of the visual arts sector of the postcolonial· diaspora. Its depiction of doubling across the boundaries of sex and race, the chiasmus of difference that is inscribed as a relationship of both polarity and complementarity, draws attention to the "danger zone" of psychic and social ambivalence as it is lived in the complexity and contradictions of a multicultural society. The difficulty of articulating sexual and racial difference together, as sources of social division constantly thrusting identities apart while simultaneously binding them intimately beneath the cliche that "opposites attract," pinpoints the key displacements brought about over the past decade by the hybrid interplay of postcolonial and postmodern paradigms in contemporary cultural politics.

But what strikes me as the most salient aspect of the diaspora aesthetics taking shape in a work such as *The Body Politik* is the unique way in which the fear/fantasy formulation came to be echoed and disseminated across a whole range of critical developments, for it was precisely the psychoanalytical implications of the concept of ambivalence that were being theorized in Homi Bhabha's profoundly influential text, "The Other Question," which also entered public circulation in 1983. Structured around a diacritical rereading of *Touch of Evil*, Orson Welles's film-noir classic which depicts the Mexico/US border as the narrative setting in which textual dynamics of fear and desire revolve around the mixed-race identity of its Chicano protagonist, the wealth of

<div align="center">195</div>

insights generated by Bhabha's critique can be seen to double back into the representation of interracial sexuality investigated in Piper's art: both lead us into the ambiguous realm where different differences intersect.

What is at stake is an understanding of how various critical practices helped create a shared space of mutual dialogue, through which Frantz Fanon's writings have returned in all their force and fluidity as an indispensable resource for making sense of the psycho-politics of the multicultural social body. In this sense, rather than seek out directly Fanonian "influences" amongst postcolonial artists, or set out to ascertain a didactic translation of theoretical concepts into visual arts practice, what is called for is contextual appreciation of the multiple conduits and rhizomorphic connectivity that makes diaspora a strategic site of "the dialogic imagination," in Bahktin's/Volosinov's phrase (Bahktin 1981; Volosinov 1973).

The hybrid character of this polyvocal space is nowhere more in evidence than in Mitra Tabrizian's *The Blues* (in collaboration with Andy Golding, 1987). Comprising large-scale color photographs, captioned in the manner of film stills, the work acknowledges its explicitly intertextual relationship to the highly imagistic quality of Fanon's writing in certain passages from *Black Skin, White Masks*. Just as the book begins its inquiry by looking at interracial relationships between the woman of color and the white man, and the man of color and the white woman, Tabrizian's starting point for the mise-en-scène of troubled encounters seems to concur with Fanon's point that, "if one wants to understand the racial situation psychoanalytically...considerable importance must be given to sexual phenomena" (1967: 160). Moreover, the reciprocal relation of visual arts practice to critical theory is underlined by the way Tabrizian's images have themselves been "figured" in the discourse of postcolonial intellectuals, when, for instance, Homi Bhabha writes:

> I was a wanderer in another city...I saw a black man freeze to stone, in the shadows of a woman's wide-eyed witness, the mirror turns the troubled scene around and fills the space, before and behind, with the hateful sight of questions of racist violence – interrogating identity.

As Griselda Pollock points out, the allusion here is specifically to "Out of the Past," one of the panels from *The Blues*, embedded within the reference to coercive policing practices from a publication by *Race & Class* (Pollock 1990: Appendix 1, n. 20, quoting from Bhabha 1987).

It is dialogic connections of this sort, cutting across disciplinary borders in order to forge exploratory pathways through the undergrowth of the multicultural unconscious, that set out the parameters of the projects undertaken by Sonia Boyce, Glenn Ligon, Renée Green, Marc Latime, Lyle Ashton Harris, Steve McQueen, Trevor Mathison and Edward George. Each of these artists has contributed significantly to diaspora practices of critical displacement in post-conceptual art, using a variety of materials and method-

ologies to examine and challenge the fears and fantasies that continue to enthrall us to the extent that we are each obliged to be the bearers of an ego and its fictions of identity.

If Fanon has found a new generation of readers in this context, then it is important to note how their mapping of "Fanonian spaces," in Stephan Feuchtwang's phrase (Feuchtwang 1987), delivers the spectator into a place of radical uncertainty – a place where common-sense assumptions about the nature of identity are thrown into question. As a result of epochal shifts over the past ten to fifteen years, from post-Fordism to post-Communism, there probably isn't anyone whose identity has not been touched by the bewildering uncertainties of living in a world with no stable center, and with precious few fixed points of reference besides death and taxes. These changed circumstances profoundly alter the way in which Fanon's writings speak to our contemporary crises. Whereas earlier generations prioritized the Marxist themes of Fanon's later work, above all *The Wretched of the Earth*, published in 1961 at the height of the optimism of the postwar social movements, the fading fortunes of the independent left during the 1980s provided the backdrop to renewed interest in *Black Skin, White Masks*, Fanon's first and his most explicitly psychoanalytical text. Notwithstanding the continuities underpinning Fanon's œuvre as a whole (see McCulloch 1983), it could be said that it is precisely the multi-accentual quality of Fanon's voice, which engages with négritude, Pan-Africanism and Black Atlantic traditions, as much as the European legacies of Marx, Freud, Sartre and Lacan, that encapsulates the hybrid character of the conversation which postcolonial artists have sought out in relation to his work. "O my body make of me always a man who questions" (1967: 232) writes Fanon in the last line of a book whose authorial "I" constantly oscillates between multiple points of view: autobiographical, clinical, sociological, poetical, philosophical, political. Perhaps it is this many-voicedness of Fanon's text that gives rise to the highly contested contemporary interpretation of his œuvre, as Henry Louis Gates draws out in his useful reading of the readings (Gates 1991).

From the viewpoint of visual artists, it may be said that what is equally pertinent about Fanon's multi-accentuality – a term by which Bahktin describes the presence of the body in language, the intonations, inflections and "emotive–evaluative" elements of an utterance – is the passion with which he pursues the decolonization of interior spaces, a project which postcolonial artists extend by seeking to alter the constitutive role of representations in the social construction of subjectivity. Artists working at the interface of the social and the emotional to unravel the contradictions of the "inner worlds" of migration, exile and diaspora have revitalized the way in which Fanon is read as their work itself has had a major impact on the direction of theoretical debates.

The fear/fantasy formulation signaled a decisive shift with regard to the strategies of counter-discourse performed by black artists in film, photography and fine art. Breaking through the impasse of the outmoded negative/positive images dichotomy inherited from earlier phases in struggles for

self-representation, it could be seen to punctuate what Stuart Hall propheti-
cally called "the end of the innocent notion of the essential black subject"
(1988: 27–31). If what resulted was a moment of rupture asserting the
hybridity and heterogeniety of diaspora subjects, the subsequent vicissitudes of
"black representation" serve to caution whatever celebratory tendencies remain
in a new world (dis)order of unending uncertainty and interminable anxiety.
Once we locate the transnational interventions of postcolonial artists within
the global context that differentiates their critical relationship to the visual
ecologies of race and representation in popular culture, we find that the social
field of fear and fantasy is never finally fixed. The oppressive regimes of myth
and stereotype that inform the political management of multicultural
discontent are themselves fluid, mobile and highly unpredicatable, constantly
updating themselves in the service of the changing same. The heightened
visibility of new images of "otherness" – from ragga girls and gangsta rap to
Benneton billboards and the spectacular demonization of O.J. Simpson –
demands that our attention be drawn to what film-maker Isaac Julien has
called *The Darker Side of Black* (BBC, 1994). Issues of homophobia and
misogyny have more than symptomatic meaning in current manifestations of
black expressive culture: they concentrate the mind on what could be called
the "interior limits" of decolonization.

Unhappy is the land in need of heroes, and nowhere was Brecht's maxim
more applicable than when Malcolm X returned in 1992, deified and reified, in
Spike Lee's epic biopic as hustler, prisoner, prophet and father figure –
Malcolm's mercurial identities (in the plural) made him ideal material for the
postmodern apparatus of race and representation in which the same image
satisfies competing demands. Such shifts exacerbate our need for understanding
why the specter of "race" continues to haunt the violent and sexy phantasia of
popular culture. Against the backdrop of the black gender wars symbolized by
the Anita Hill/Clarence Thomas confrontation; against the foil of neoracism
driving the escalation of racialized violence, from the LAPD attack on Rodney
King to the scores of unreported racist attacks in Fortress Europe; and against
the media-led feeding frenzy surrounding the public parade of black men in
gender trouble, from Mike Tyson and Magic Johnson, to Ice-T and Michael
Jackson: in our contemporary context we can neither ignore nor overlook the
more problematic aspects of Fanon's sexual politics.

To fashion Fanon into a "hero" is to fetishize his text as a repository of
truth. When US Black Power activist Stokely Carmichael exulted the name of
Fanon at the "Dialectics of Liberation" conference at London's Roundhouse in
1967, the sense of jubilation unleashed in the reversal of oppressor and
oppressed was no doubt felt as an authentic experience of empowerment, yet
from another point of view, such as that of Bessie Head, the Cape Colored
writer exiled in rural Botswana, how could this have been a genuine change if
victim and victimizer were merely trading places in the same binary structure of
"Manichean delirium?" All too aware of chance, history and contingency as

forces obviating manifest destiny – for Bessie Head herself was born in a psychiatric asylum – her comments in a letter to a friend in Europe spell out why contemporary artists continue to critically dialogue with the legacy of Fanon – in order to get at the things we do not yet know:

> Say, some merciful fate put me on the receiving end of brutality and ignorance, but what if I were born to mete this out to others?...This shout of rage of Mr. Stokley Carmichael is a shout from the depths of the deep, true exultant power he is receiving by being the man down there. It's a kind of power that leaps from the feet to the head in a drunken ecstasy. I feel Mr. Stokley does not know this. He might fall down on his knees and glorify his enemy. I feel these things go on in the subconscious and we give them the wrong names, and even when we try to explain them like Martin Luther, we don't reach the depths.
>
> <div align="right">(quoted in Vigne 1990; see also Rose 1994b)</div>

TASKS AND MASKS: UNDOING IDENTITIES

Identity has come to function as a sort of shorthand for the recognition of the politics of difference. However, as a static noun the term suggests a fixed category whereas the key shifts accentuated by diaspora artists over the past "critical decade" have been moving in the other direction, recognizing that the assertion of identity always depends on dynamics of differentiation, that the resulting forms of individual and collective identification are always relational and interdependent, and that the production of a differential is the mainstay of language and politics alike. While often apprehended as a shift from essentialist to constructionist conceptions of subject-formation, politically accentuated as a debate between cultural nationalisms and a postnationalist emphasis on hybridity, it is crucial to note that postcolonial artists have turned to psychoanalytically inflected notions precisely because the recognition that identities are constructed in language and representation then raises the more vexed question of how to account for the historical persistence of oppressive relations in which one's identity is continually positioned as Other in relation to someone else's construction of Self. As Mitra Tabrizian explains:

> Meaning only exists through differentiation – yet with uncertainty. In terms of power relations, white patriarchal society wants to make sure that meanings are fixed in order to maintain the status quo. But what I have been trying to do is deal with this uncertainty of meanings. As Freudian psychoanalysis bears out there is no such thing as *innate* femininity and masculinity, because we all share the same libido. Masculinity and femininity are constructed through language and culture.

In the same way there is no such thing as whiteness or blackness which pre-exists language and culture. In *The Blues* I wanted to explore these constructions.

(quoted in Noble 1989: 32)

It is from this viewpoint that black artists have wielded Fanon's insight that "the real Other for the white man is and will continue to be the black man" (1967: 161), in order to deconstruct the way in which ideologies seek to fix and eternalize differences into absolute, categorical, binary oppositions; the logic by which "the legends, stories, histories and anecdotes of a colonial culture offer the subject a primordial Either/Or" (Bhabha 1994: 61). Hence, if the task is to unfix and loosen up dichotomous codifications of difference, the terrain within which black artists intervene can no longer be adequately met by an aesthetics of realism or protest which seeks to counteract "mis-representation," but requires an acknowledgment of the emotional reality of fantasy as that domain of psychic life that is also subject to the demands of the unconscious.

Hence, various strategies in diaspora aesthetics have adapted as their point of departure the linguistic turn in poststructuralist theory, wherein the black/white metaphor of racialization is understood not as an innocent reflection or neutral correspondence with pre-existing entities, but is the imprint of an either/or logic of Self and Other in which colonial discourse brings into being the very identities that it discriminates within the optic of "racial" difference. The very concept of "race" as a natural, biological and unchangeable essence is itself a historical fetish because there is only one race, the human species. In its dominant articulation, the chromatic metaphor seeks to conceal the artificial and historically motivated character of the mythologies of racial difference it brings into effect, by naturalizing the work of representation as a mere reflection of visible difference:

In the field of fantasy the black is imagined as the Other to guarantee the status of the white man's identity. Racist stereotypical discourses reinforce power relations based on the fixation of the positions of the White/Black, Self/Other. They do this either by denigrating blacks as being completely different, a different race, blood – or by inviting them to identify, to be white, an impossible identification.

(Tabrizian, in Noble 1989: 35)

To glimpse the pivotal importance of vision and visuality in the historical sedimentation of racializing representations, consider Charles Cordier's *Aimez-vous les uns les autres* (also known as *Fraternité*) of 1867, a sculpture conceived within the era when European nations disavowed their dependence on slavery by putting forward a self-image that defined them instead as the liberators of the enslaved. The stark visual contrast between the two cherubs about to

embrace in a kiss serves to connote both formal equality and either/or difference. While it enacts the sentimental trope repeated today in the exhortation that "ebony and ivory get together in perfect harmony," the very banality of its binary model of identity and difference serves to conceal the subtle disposition whereby it is the black cherub who actively moves toward the slightly superior, upright posture of the white one, thus positioned as the universal human from which the other is differentiated. Paraphrasing Ralph Ellison, one might say that if the West had not "discovered" the Negro, then the Negro would have to be invented, for the invisibility of whiteness is thoroughly dependent on the visible difference which the black subject is made to embody as the other needed by the self for its own differentiation, yet at the same time constantly threatening the coherence of that self on account of its unassimilable otherness (this statue is discussed in Honour 1989: 251; see also Ellison 1952; 1964).

This structural interdependence is the locus of the ambivalence called forth in the fantasmatics of cultural difference, and two interrelated but distinct issues are at stake. First, it entails, on the part of the dominant culture, a fantasy based on the epistemological privilege of vision in the West. What is common to the representational forms of the three distinct modes of "othering" that often get simplified as racism, sexism and homophobia, is that in each instance the historical construction of differences of race, gender and sexuality is reduced to the perception of *visible differences* whose social meaning is taken to be obvious, immediate and intelligible to the naked eye. The dominant ordering of difference attributes the origin of discrimination in the "otherness" that is held to be bodily inscribed: in the racial difference of skin and complexion, for instance, or in the sexual difference of anatomy, or in the ocular proof of homosexuality that betrays the hidden truth of a deviant desire.

Contemporary artists have created an archeological space in which to re-view the fantasies of absolute difference at play in a work such as Cordier's. Drawing on the conventions of museum display, artists such as Fred Wilson, Danny Tisdale, Zarina Bhimji and Renée Green have sought to enter the space of the archives, and in doing so have engaged in a dialogic partnership with cultural historians such as Sander Gilman who, between them, have unearthed the fossilized coils of myth and stereotype that continue to haunt the collective imagination. The contemporary rediscovery of Sartje Bartmann, a 25-year-old African woman brought to Europe in 1815 to be displayed and exhibited as the Hottentot Venus, an object of scientific curiosity and circus-like entertainment until she died in 1824, provides a powerful instance of how black bodies were forcibly objectified under Europe's gaze to provide that foil against which discourses of physiognomy, medicine and anthropology combined to construct the visible "truth" of absolute otherness. Summarizing the views of Cuvier and Buffon, Sander Gilman demonstrates the underlying "definition by antithesis" at work in science and art alike:

> The antithesis of European sexual mores and beauty is the black, and the essential black, the lowest exemplum of mankind on the great chain of being, is the Hottentot. It is indeed in the physical appearance of the Hottentot that the central icon for sexual difference between the European and the black was found.
>
> (Gilman 1986: 83; see also Gilman 1975)

In this context, the practice of re-vision that discloses the centrality of racialized differences to modernist representations of identity – rendered, for example, by Laure, the black female maid proffering the bouquet to Manet's *Olympia* (1865) – has opened up new ways of re-entering the past. Renée Green's installation *Bequest* (1991) foregrounds citations from Melville and Poe to make visible the hidden centrality of chromatic codifications of "otherness" in US national and cultural identity: "it was the whiteness of the whale that above all things appalled me / The raven by its blackness represents the prince of darkness," in a way that remarkably complements Toni Morrison's compelling interpretation of the "Africanist" presence in American literature, in, for example, Mark Twain's *Huckleberry Finn*, who would have no identity as such if it were not for the antithetical presence of Nigger Jim (Green 1993; Morrison 1992).

Another, more immediate, point that flows from the structural interdependence of "opposites" concerns the way in which the psychic imbrication of one-in-the-reflection-of-the-other serves to complicate simplistic notions of the Other's access to self-representation. African-American art history shows the many contradictory strategies undertaken to find lines of flight out of the dilemma of how one can posit a full and sufficient black self in a culture where blackness serves as the sign of absence, negativity and lack (Gates 1988; McElroy 1989). In the Black British context, this problematic has been taken on by Sonia Boyce, in a series of self-portraits including *From Someone Else's Fear Fantasy to Metamorphosis* (1987) which features visual quotations from comic book cartoons as well as from *King Kong*, a film whose "sex-race" unconscious was brilliantly brought to light by James Snead, just as Lola Young has investigated the way in which black women are constructed as exotic others mirroring (white) male fears and fantasies in contemporary films such as Neil Jordan's *Mona Lisa* (1986) (Snead 1994; Young 1990).

Whereas the realist refutation of racist stereotypes often ended up with an idealized view of a black identity untouched by degrading images of otherness, one strand in the postmodern repertoire of hybrid appropriation and parodic repetition among black visual artists has been to suggest that such stereotypes, however disavowed, may nevertheless act as "internal foreign objects" around which self-perception is always "alienated" by the way in which one is perceived by others as *the* Other. This dilemma is at the heart of Fanon's analysis of racializing interpellation: being objectified under the imperial gaze – "Look, a Negro!" – to the point where the black self's own body is fragmented,

dismembered and thrown back as "an object in the midst of other objects" (1967: 109). Unlike the infant in front of the mirror for whom the specular reflection returns as the basis of the body-image, when blacks are made to bear the repressed fantasies of the imperial master they are denied entry into the alterity which Lacan sees as grounding the necessary fiction of the unified self. For Fanon, this is because "the white man is not only The Other but also the master" (1967: 138). The implications of Fanon's conclusion, that the colonized is "forever in combat with his own image" (1967: 194), have been explored by black visual artists for whom self-portraiture in its received sense is a structurally impossible genre for the black artist to occupy.

Carrie Mae Weems's *Mirror, Mirror* (1986–87) signifies on the (de)formative experience of the black subject's mirror phrase by captioning the non-reflective surface of the specular other with a parody of the nursery rhyme: "Looking into the mirror, the black woman asked, 'Mirror, mirror on the wall, who's the finest of them all?' The mirror says, 'Snow White, you black bitch, and don't you forget it!!!' " Relatedly, in key works by Adrian Piper, from pictorial collage such as *I Embody* (1975) and *Vanilla Nightmares #8* (1986), to her performance pieces in the character of "Mythic Being" who appears in whiteface, the use of mimicry and masquerade subverts the cultural narcissism inherent in white supremacy's arrogation of otherness to itself alone (thereby condemning the black to stand-in for, and re-present, the mirror-image which the white ego props itself upon). Piper thus problematizes the issue of self-representation in order to enact a practice of non-self-representation which makes whiteness visible as a historically constructed identity dependent upon antinomies of white/not-white, male/not-male, I/not-I.

Similarly subversive strategies were at work in mixed-media bricolage such as Bettye Saar's *The Liberation of Aunt Jemima* (1972), which used counter-appropriation to acknowledge the psychic reality of what could be called "the stereotypical sublime," so low you can't get under it and so high you can't get over it, which thus showed how alternative meanings can be made by passing through it, repeating the Mammy stereotype with a critical, signifying difference: this time, she's got a gun. It strikes me that the deployment of such techniques in black women's art practices of the 1970s, in the name of transforming "Object into Subject," as Michelle Cliff put it, predated the "crisis of authority" that Craig Owens subsequently identified in the forms of critical postmodernism (Cliff 1987; Owens 1992; on Weems and Piper see Lippard 1990).

The vertiginous sea-changes associated with the advent of postmodernity brought about a crisis of representation whereby subjects hitherto invisible sought to assert their presence in and through practices of critical displacement that made visible for the first time the historical identity of liberal, humanist, universal Man. However, to the extent that straight, white males may have been derisorily demonized as an Other for our times (as if straight, white, males themselves do not feel burdened by the impossible task of having to represent

the entire human race), what has resulted is a double-edged situation. While the recognition of multiple identities has helped skewer the double-binds of minority/majority discourse, thereby unpacking the black artist's burden of having to be a representative – a process which has brought to light the sheer diversity of black identities previously repressed in cultural nationalisms – the flip-side to the new pluralism has been a kind of identitarian closure. Indeed, the term identity often preempts understanding of subjectivity as constituted by alterity, and thus often results in new modes of policing access to self-representation, as Sonia Boyce has pointed out:

> Whatever we black people do, it's is said to be about identity, first and foremost. It becomes a blanket term for everything we do, regardless of what we're doing....I don't say it should be abandoned, [but] am I only able to talk about who I am? Of course, who I am changes as I get older: it can be a lifelong enquiry. But why should I only be allowed to talk about race, gender, sexuality, class? Are we only able to say who we are, and not able to say anything else? If I speak, I speak "as a" black woman artist or "as a" black woman or "as a" black person. I always have to name who I am: I'm constantly being put in that position, required to talk in that place...never allowed to speak because I speak.
>
> (quoted in Diawara 1992: 194–5)

To the extent that diaspora artists have sought to escape the tyrannical demands of identitarian fixity, from whatever source they come, Glenn Ligon's self-fashioning in the series of lithographic prints entitled *Slave Narratives* (1993) offers a cutting "read" on modernism's efforts to make sure the black artist knows its place: "RAN AWAY, Glenn, a black male, 5′ 8″, very short cut hair, nearly completely shaved, stocky build, 155–156 lbs, medium complexion (not 'light skinned,' not 'dark skinned,' slightly orange)." A case, perhaps, of postmodern drapetomania, the nineteenth-century slaveholder's psychiatric label for the slave's "irrational" desire to run away.

Running alongside the artwork of Lorna Simpson, Lorraine O'Grady, Roshini Kempadoo and others, whose deconstructions of self–other polarities have been examined by Kellie Jones (see Jones 1992; O'Grady 1992), the concept of "intersectionality" has been put forward in critical theory to offer a spatial framework for examining the structural interdependence of differential elements in the social text, as an alternative to the temporal fixity sought by micro-narratives proclaiming innate hierarchies of oppression. As Val Smith has stated: "Rather than attempting to determine the primacy of race or class or gender, we ought to search for ways of articulating how these various categories of experience inflect and interrogate each other and how we as social subjects are constituted" (Smith 1990: 285; see also Crenshaw 1989).

In the work of artists such as Lyle Ashton Harris, Marlon Riggs, Rotimi Fani-Kayode and Isaac Julien, unprecedented insights into Fanon's premise that Self and Other are always mutually implicated in ties of identification and desire have arisen precisely at the intersections of diverse artistic traditions. Rather than the reflection of a "black gay aesthetic" as such, the key feature of black lesbian and gay cultural production of the past decade has been its emphasis on the constitutive hybridity of the postcolonial subject, which dislodges the authoritarian demand for authenticity and purity. Querying the way in which exclusionary notions of belonging have been replicated in the legacy of the postwar "liberation" movements, black lesbian, gay and bisexual interventions have contributed creatively to a postnationalist politics of difference which seeks to bring new forms of "imagined community" into being.

This post-essentialist conception of black selfhood has nowhere been more graphically displayed than in Lyle Harris's photographs – including *Constructs* (1989), *Americas* (1988–89), and *Secret Life of a Snow Queen* (1990) – in which the artist theatrically stages a self whose authentic identity gives way to the artifice of the mask, an iconic element of diaspora aesthetics. Making literal Fanon's metaphor of black skin/white masks, Harris performs a version of black masculinity that signifies upon the grotesque pathos of the minstrel mask in white popular culture (sambo as sign of entertainment and enjoyment), and does so in such a way as to simultaneously evoke the masquerade of femininity as spectacle. Something vital differentiates the subversive ambiguity of Harris's critically parodic literalization from the mere illustration of the Fanonian metaphor, to be found, for instance, on the cover of Chinwezu's book, *Decolonizing the African Mind* (1987).

I think it is because the Snow Queen snaps pointedly, signifying on the worst fears and fantasies of a model of black masculinity in which the racial and sexual ambivalence of the mask provokes the mortal anguish of inauthenticity that remains unsaid and unspeakable in the discourse of black nationalism. Am I not a man and an other?

After the innocence, modernist movements came to grief at the crossroads of difference. In traffic management, crashes are most likely to occur at junctions or intersections, which is one way of looking at how the race, class, gender contingent got caught up in the mimetic loop whereby the very binary structures of Self and Other underpinning the hubris of the Western fantasy of sovereign identity were ceaselessly repeated in narratives which sought to deliver the wretched and unloved into the utopian spaces of "total" liberation, but which got stuck instead on the road to nowhere: or is it the road to hell? When Isaac Julien states, "I want to raise ambivalent questions about the sexual and racial violence that stems from the repressed desires of the other within ourselves" (1992: 260), he indicates the ruined scene that Fanon ghosts today, the incomplete project of decolonization pervaded by what Trevor Mathison and Eddie George call "the smell of disappointment."

AGONIES OF THE EMOTIONAL TIE OR, OH
BONDAGE! UP YOURS

The dream is real my friend, the failure to make it work is the unreality.
Toni Cade Bambara, *The Salt Eaters* (1980)

Black Skin, White Masks begins with the question of desire: "What does a man want? What does a black man want?" (1967: 8), and questions of sexuality are located at key points in the structure of the book. Chapters 2 and 3 are structured around interracial sexual relationships, and chapters 5 and 6, "The Fact of Blackness" and "The Negro and Psychopathology," investigate a wide range of materials (children's comics, Hollywood "race-problem" films of the 1940s, the novels of Richard Wright and Chester Himes, and the psychiatric testimony of "some 500 members of the white race" (166)) to arrive at psychoanalytic interpretations of the neurotic and pathological significance of such symptomatic representations of colonial psychosexuality.

Reading Fanon today, however, a whole generation after "external" decolonization began, there is a pervasive sense that the forward march of liberation came to a halt precisely around the "interior" spaces of sexuality – it is as if sexual politics has been the Achilles heel of black liberation. What happens to a dream deferred? It might explode in your face. It was not just that the psychosexual scripts Fanon diagnosed in the 1940s and 1950s came to be reenacted in the highly sexualized "clenched-fist" aesthetics of the Black Power movement, as an embodiment of political self-empowerment. Nor was it simply that the fears and fantasies so adroitly mobilized in the confrontational visibility of the Black Panther Party, for example, also had the effect of provoking the worst fears and fantasies of the paranoid racist state, whose conspiracy theories laid waste to the lives of activists, and set off the moral panics that demarcated the post-permissive era of neoconservative hegemony. The tragedy is that the dream of "total" liberation became a nightmare of unending antagonisms, spilling over dichotomies of inside and outside, left and right, margin and center, to become the shifting ground of the provisional and positional spaces which contemporary artists seek to keep open for debate and critical enquiry.

"At the risk of arousing the resentment of my colored brothers, I will say that the black man is not a man...I propose nothing short of the liberation of the man of color from himself" (Fanon 1967: 9). Reading these lines today, announcing Fanon's radical humanist vision of self-liberation, what one hears is the sound of transcendental Man shattered on the grounds of gender antagonism, for the vision of universal brotherhood has given way to the fratricidal realities of life and death for young black men in the late modern underclass, ravaged by the escalation of suicide and homicide, scapegoated as the personification of drugs, disease and crime. In the bloody interregnum in which the beautiful ones are not yet born, "fear and fantasy came home to

roost," as Keith Piper put it in *Go West Young Man* (1988). Turning to psychoanalytically inflected concepts of ambivalent identifications across the visible boundaries of racial and sexual difference, postcolonial artists have returned to the scene of colonial psychosexuality which Fanon revealed with such clarity of insight. But this time, the psychic knots of sex and violence roiling through the ugly expression of misogyny and homophobia from within the broken heart of what Nelson George calls a "post-soul" culture (George 1992) demand that an unflinching gaze be directed to examine the way the emotional tie of identification often turns up on the "wrong" side, where it is least expected.

As bell hooks has shown, underlying the racialized dualities of black nationalist discourses was a phallocentric identification with the other that found expression in a range of sexualized metaphors and equations acted out around the ultimate either/or of the symbolic realm – having the phallus or losing it in castration:

> The discourse of black resistance has almost always equated freedom with manhood, the economic and material domination of black men with castration, emasculation. Accepting these sexual metaphors forged a bond between oppressed black men and their white male oppressors. They shared the patriarchal belief that revolutionary struggle was really about the erect phallus.
>
> (hooks 1990: 66–7; see also hooks 1992)

Overdetermined from the outset, the symbolic all-too-symbolic visibility of the black male body has become a central arena in which multiple crises of social chaos and political uncertainty have found expression in hyberbolic images of phallic black masculinity as embodying the ultimate Other – I am the nigger you love to hate, as Ice Cube succinctly said, laughing all the way to the bank.

Rather than the functionalist circularity of "internalization," it is the thin line between love and hate that complicates the oedipal coding of desire and identification. Just as the commercial success of black rap performers who brag, "it's a black thing, you wouldn't understand," depends on the mostly white, male, suburban youth who buy their records to get a bit of the other, so the panics played out when George Bush used an image of an escaped convict, Willie Horton, in the 1988 presidential election to amplify the me/not-me dichotomy of ethnic absolutism have recurred with new symbolic substitutes in the role of sacrificial scapegoat. The media parading of black males as public enemies numbers one, two, three and four – from Ice-T in Cop-Killer drag; to the de-racialization and re-racialization of Clarence Thomas, first as race-blind NeoCon Negro, then as victim of a "high-tech lynching"; or the blurring of persona and performance in court cases involving rappers Tupac Shakur and Snoop Doggy Dog – has taken place in a political context where fundamentalist fixations on rigid gender roles now provide unanticipated alliances across ethnic

lines as a result of the instrumentalization of homophobia in political life.

A key example of this sort of "unthinkable" political alignment occurred in the US presidential election of 1991 when populist right-wing columnist Pat Buchanan brazenly appropriated a clip from Marlon Riggs's film *Tongues Untied* (1989) to tendentiously suggest that George Bush was squandering tax-payers' money on the public funding of what the wretched right, nowadays, are happy to call "victim art." Picking up the embers of the panic ignited by Jesse Helms's attack on the National Endowment for the Arts, played out on the body of Robert Mapplethorpe's photography, what was most bizarre about the fantasmatics of Buchanan being threatened by black gay art was that the clip he used did not feature any of the images of black men loving black men which many others found too hot to handle, but images of white gay leather-queens in San Francisco's annual Folsom Street fair, chosen by Riggs to depict the absence of blacks in the predominantly white gay "community." Projective identification is the mainstay of paranoid defenses that reverse positions of object and subject, such that what is coming from me is felt to be coming towards me. In Buchanan's construction of Riggs as folk devil, his me/not-me boundary effectively edited a metonymic displacement such that the black gay body became all the more threatening for *not* being seen.

While the concept of homophobia risks psychic reductionism if it is isolated from the underlying sexual economy of compulsory heterosexuality, it has symptomatic status in contemporary black vernacular and intellectual culture alike. At issue is a logic of mimetic replication (doing to others what's been done to you) which Marlon Riggs discerned in the search for "the other within": "What strikes me as most insidious, and paradoxical, is the degree to which African-American depictions of us as black gay men so keenly resonate majority American depictions of us, as black people" (1991: 255). The desperate refrain of ragga star Buju Banton's "Boom bye bye ina de batty man head," in 1992, may thus be juxtaposed to what can only be described as "homosexual panic" in an important exchange of responses to Isaac Julien's film *Looking for Langston*, which took place at the conference on "Black Popular Culture," where a series of ambiguous undercurrents gave rise to Houston Baker's opening remarks, "I am not gay, but ..." (1992: 132; see also Gates 1992).

Because we are dealing not with persons, but with the imaginary and symbolic positions through which the contingent, historical and psychic construction of personhood is spoken, it is important to recognize that there is no question of assigning fault. One of the virtues of psychoanalytic theory, based on the interpretation of the transference in the "talking cure," is that it brackets the issue of culpability, and thus hears "it" rather than "I" speaking in the discourse of the symptom. If the differentiation of self and other depends on repression that splits ego from unconscious, then the ambivalence of identification can be seen to arise from the effects of unconscious phantasy in which the self oscillates between positions of subject, object or spectator to the

scene. Because libido and the drives are highly mobile, object-choice and identification are rarely finally fixed; thus in the realm of cultural representation we access the ambivalence whereby ego and alter may trade places at any one time. If empathy depends on being able to put oneself in the other's place, other structures of feeling also arise which generate intolerable anxieties (does this feeling belong to you or me?) which may find expression through mechanisms such as splitting and denial at the level of the object (the realm of not-me), or at the level of the ego ("identification with the aggressor," for example).

My point is that Fanon returns as our contemporary precisely because "his" problems, with psychosexuality, are also "our" problems. I want to briefly touch upon some of the key moments where homosexuality makes an appearance in *Black Skin, White Masks* because contributions to the re-reading of Fanon put forward by contemporary lesbian and gay cultural theorists offer compelling reasons "why there can be no facile equation of racist and sexual discrimination via the appeal to Fanon," which is precisely on account of "the place of sexuality, especially homosexuality, in his writing," as Jonathan Dollimore has argued (Dollimore 1991: 344–5).

Against the background of Fanon's analysis of negrophobia, defined as "a neurosis characterized by the anxious fear of an object" (1967: 154), lie the dread historical realities of white supremacist terror, which often culminated in literal acts of castration, torture and dismemberment for colonized and enslaved women and men alike. From word-associations in which "*Negro* brought forth biology, penis, strong, athletic, potent, boxer, Joe Louis, Senegalese troops, savage, animal, devil, sin" (1967: 166), Fanon filters a wide range of pathological evidence through a subtle comparison with the phobic logic of anti-Semitism in order to differentiate the violent "sexualization" of the black body under the scopic drive of the Other who is also the Master. He concludes: "The Negro symbolizes the biological" (167), "For the majority of white men the Negro represents the sexual instinct" (177), "The Negro is the genital" (180), and when "the Negro is castrated...it is in his corporeality that the Negro is attacked...that he is his lynched" (162, 163). It is in the context of his clinical interpretation of psychic structures giving rise to such symptoms that Fanon asserts: "the Negrophobic woman is in fact nothing but a putative sexual partner – just as the Negrophobic man is a repressed homosexual" (156). As Dollimore notes, these stark remarks arise from the interpretation of sadomasochistic fantasies in which punishment is sought to alleviate the guilt involved in the wish to destroy the phobic object: "There are...men who go to 'houses' in order to be beaten by Negroes: passive homosexuals who insist upon black partners" (Fanon 1967: 177). While evoking the variations of active/passive and observing positions which Freud showed in his analysis of the fantasy, "a child is being beaten," Fanon draws out the mobility and reversibility of libidinal drives; yet there is an element of explanatory confusion underlying his highly judgmental reading of female masochism in the colonial fantasy denoted

as "a Negro is raping me": "whilst...repressed homosexuality is construed as a *cause* of a violent and neurotic racism, elsewhere Fanon regards *manifest* homosexuality as an *effect* of the same neurotic racism, though now in a *masochistic*, rather than a *sadistic* form" (Dollimore 1991: 344–5).

Drawing attention to such difficulties, Diana Fuss (1994) and Lee Edelman (1994) have further delineated Fanon's preoccupation with the binary distinction of active and passive sexual aims. This illuminates the phobic logic of black nationalism whereby homosexuality is equated with whiteness as something inherently alien to African eroticism, something foisted and imposed by the European colonizer – that it is a "white man's disease." Insofar as the psychoanalytical account of sexual difference assumes the Oedipus complex as a primordial either/or in which the boy's assumption of active, phallic, masculinity depends on the repudiation and casting out of passive, thereby "feminine," erotic aims, then the demonization of homosexuality in the black nationalist imaginary must require the expulsion of the feminine within the man, for him to be a "real" black man.

On this view, black and gay are mutually exclusive terms for an empowered black male identity because the establishment of proud, upright, phallic manhood for black heterosexual men depends on self-definition against an active/passive equation in which "white racists (literally) *castrate others* while homosexuals (figuratively) *are castrated themselves*" (Edelman 1994: 56). Hence, it is difficult not to hear a certain castration anxiety voiced in the self-canceling logic that punctuates another key instance in which Fanon discusses homosexuality:

> Let me observe at once that I had no opportunity to establish the overt presence of homosexuality in Martinique. This must be viewed as the result of the absence of the Oedipus complex in the Antilles. The schema of homosexuality is well enough known. We should not over-look, however, the existence of what are called there "men dressed like women" or "god-mothers." Generally they wear shirts and skirts. But I am convinced that they lead normal sex lives. They can take a punch like any "he-man" and they are not impervious to the allures of women – fish and vegetable merchants. In Europe, on the other hand, I have known several Martinicans who became homosexuals, always passive. But this was by no means a neurotic homosexuality: For them it was a means to a livelihood, as pimping is for others.
>
> (1967: 180 n. 44)

Quoted in full what becomes all too visible are a series of denials, negations and repudiations. First there are no homosexuals in Martinique, then it is acknowledged that cross-dressed men exist, although such "he-men" are attracted to women, and then, third, it is claimed that Caribbean migrants in Europe "*became* homosexuals, always passive," merely as a means of economic

survival. Surely something must be going on? And what is one to make of Fanon's denial of an Antillean Oedipus, when the Oedipus complex lies at the foundation of psychoanalytic thought? The problem is how Fanon problematically enacts the psychic mechanisms which he analyses, and in a third instance, we see how his own definition of phobia – "It must arouse...both fear and revulsion" (1967: 154) – comes to be auto-inscribed when he later says:

> I have never been able, without revulsion, to hear a man say of another man: "He is so sensual!" I do not know what the sensuality of a man is. Imagine a woman saying of another woman: "She's so terribly desirable – she's darling ...".
>
> (201)

Fanon's resistance to the dehumanization effected when racism equates blacks with all that is bodily seems to take expression in homophobic form as a psychic defense against the terror of the very real threat of castration. Moreover, the preoccupation with passivity as "unthinkable" seems to form a sexualized counterpoint to the dilemma of the "actional man" (1967: 222) whom, having been acted upon by forces of history, is envisioned as rising out of the experience of colonial "alienation" in the transcendental moment of mutual recognition. Finally, if what we are addressing is inferential, as much as overt, homophobia as a significant element in black psychosexuality, then the proximity between the replication of phobic mechanisms in Fanon's own text, and the utterance of some of his most profound philosophical insights, cannot be disavowed: "Fault, Guilt, refusal of guilt, paranoia – one is back in homosexual territory...Good–Evil, Beauty–Ugliness, White–Black, such are the characteristic pairings of the phenomenon that...we shall call 'manicheism delirium' " (1967: 183). Too close for comfort, in my view, especially when such proximity appears reiterated in the double-edged ambiguity to be heard in Toni Morrison's testimony of affection of James Baldwin:

> I had been thinking his thoughts for so long I thought they were mine...There was a kind of courage in him that I have not seen duplicated elsewhere. Part of it is to do with homosexuality, with the willingness to be *penetrated by the enemy.*
>
> (quoted in Gilroy 1993: 180; emphasis added)

Contemporary black gay scholars such as Daerick Scott have questioned the psychic syntax implicit in the phrase "sleeping with the enemy" when used as a highly charged danger-sign in the black nationalist imaginary to ward off anxieties around interracial sexuality (Scott 1994). The fact that black gay men may themselves demonize each other when racial preference in erotic life is raised to the level of object-choice serves to question the certainties of the identity police who cling to essentialist notions of desire. It also shows why we

need access to the speculative thinking of post-Freudian theory, even while the eurocentric limits of the psychoanalytic institution are recognized, as Fanon himself articulated it in a double-voiced discourse that always operated in-and-against the forms of knowledge to which he contributed as he criticized.

HYBRID WORLDING: TWO SORTS OF SUTURE

> Hybridity…is the name for the strategic reversal of the process of domination through disavowal.…It unsettles the mimetic or narcissistic demands of colonial power but reimplicates its identifications in strategies of subversion that turn the gaze of the discriminated back upon the eye of power.
>
> (Bhabha 1994: 112)

Bhabha's insight finds a stunning constellation in postcolonial visual art-forms as diverse as Isaac Julien's *Looking for Langston*, wherein the subject looks back and reimplicates the gaze in transgressive visual pleasures, and in the meta-primitivist masks of Jean-Michel Basquiat's paintings, which also return the gaze, as Dick Hebdige suggests, to "smite" the eye of power (Hebdige 1992; see also Arroyo 1991). That such art practices confirm the subversive potential of hybridity, in a world where neonationalisms of whatever stripe continue to demand purity and authenticity, is to recognize the way critically multicultural practices have enriched the legacies of the political and artistic avant-gardes which, for their own purist sins, have more or less disappeared into the museum's ruins.

On this view, two overlapping issues emerge, concerning the psychic dimensions of history and geography. While the concept of hybridity enables the recognition of "new ethnicities," and hence the formative and not merely reflective role of representation in the cultural construction of transindividual affinities, the word comes with the baggage of biologism associated with the old racism of genetics and breeding, an inheritance heard in the circulation of the word "half-caste" as a label for flesh and blood hybrids, which Saldaan suggests be recoded to "double-caste" if it is have any referential bite (McClintock 1992). Images of interraciality are so overdetermined by inchoate fears and fantasies, of mixing as a threat to purity, that its cultural representation rarely escapes the codification of a "problem-oriented" discourse, as seen in the films of Fanon's era in the 1940s such as *Lost Boundaries, Islands in the Sun*, or *The World, the Flesh and the Devil*. Yet in the postwar treatment of miscegenation in the movies, in the transition from, say, *Guess Who's Coming to Dinner* (1967) to Spike Lee's *Jungle Fever* (1991), the narrative shift from white patriarch to black patriarch merely reveals an implicit continuum in which interracial relationships are rarely portrayed for what they are, that is,

relationships, but for what they are made to mean as a token of one's "true" loyalties, affiliations and identifications.

Ngozi Onwura's early films, *Coffee Colored Children* (1989) and *The Body Beautiful* (1990), turned away from this "duty" to explain oneself, shifting the axis of the gaze and the tone of voice to sketch the relational space of relationships, such as that between daughter and mother, in all their fractured intimacy. The family is (always) a key site of representation for ideology, and yet even though actual spaces for independent practice have been remarginalized, one reaches for a word like "oppositional" to describe the critical, signifying, difference from Spike Lee's plea to restore the authority of the patriarch (even if it entails the murderous rage of an Oedipus in reverse: the father kills the bad son, whom the good son failed to protect because of his desire for the other), to be found in the experimental cinema of Camille Billops and James Hatch's *Finding Christa* (1991), a fraught reconciliation between a mother and the daughter she put up for adoption; Marco Williams's autobiographical quest *In Search of Our Fathers* (1991); or Tony Cokes's *The Book of Love* (1993), a video-interview with the artist's mother, in which narrative presence is constantly interrupted by doubts, questions, memory and silences.

Developing from black avant-garde work of the 1980s, this strand of hybrid cinema seeks a third way between the stratifications of individualist self-expression and mass market popularity, and the work of the Black Audio Film Collective in particular has continued to cross-fertilize various local–global idioms. Their body of work has influenced African and Caribbean film-makers such as Raol Peck, whose *Lumumba: Death of a Prophet* (1992), like David Aschar's *Allah Tontu* (1992), follows the journey through the "war zone of memories" in which John Akomfrah tracked the memory-traces of the dream of liberation amidst the ruins of the derailed project of decolonization, in the Ghanaian setting of *Testament* (1989). There, the exiled Abena returns to find there is no "home" to go to: the utopian desires of her past, as a recruit at Kwame Nkrumah's Ideological Training Institute, are given over to loss and ruination, a creolized verb used by Michelle Cliff in her novel of return to Jamaica, *No Telephone to Heaven* (1990). If the films ask whether the "post" in postcolonial really does mean that colonialism belongs to the past (or whether the exigencies of unending neocolonialisms merely demand a structural adjustment program of the soul), there is no final answer-word. Instead, as Abena enters a state of mourning for an unsymbolizable loss, the hybrid soundscapes, designed by Eddie George and Trevor Mathison, induce an aesthetic effect that feels like "melancholia in revolt" (Bhabha 1992: 65).

Zarina Bhimji's major installation work *I Will Always Be Here* (1991) further evokes such melancholic structures of feeling, of survival in the face of losses that can never be repaired but only endured, in part, through the labor of symbolization. If Bhimji's powerful evocation of an unnameable and unknown trauma brings the question of affect back into the struggle for signification (the glass boxes containing various part-objects are modeled on the artist's use of

shoe-boxes as improvised play-toys during her childhood in Uganda, which was interrupted by the expulsion of settled Asian communities during the 1960s (Bhimji 1992), then the implicitly psychoanalytical dimension of Bhimji's practice perhaps lies in the way it returns to the question of psychic pain at the very heart of psychoanalytic practice as a healing art. bell hooks, too, has pushed the uses of psychoanalysis in this direction, in her book *Sisters of the Yam* for instance, starting from the view that the vitality of the pleasure principle in African-American expressive culture cannot be separated from the sheer prevalence of psychic pain in subaltern life, which it seeks to answer (hooks 1994)

In this broader view of psyche in history, artists of the postcolonial diaspora inscribe a wide range of points of entry and departure within the Fanonian text as their various practices refuse to flinch from the difficulties of difference, constantly tarrying the negative in critical dialogues operating on a number of fronts, or as Glenn Ligon has it: "What do black audiences not want to hear?" (1994: 226). I think this commitment to difficulty differentiates the practice of critical hybridity, especially when the contested character of the term threatens to install it as merely a new orthodoxy for multicultural micro-management. Far from submission to a new master, diaspora artists actively use Fanon as a resource for deepening the understanding of unconscious phantasy as the psychic binding of social life, and in this sense hybrid work arising from the interstices of difference makes contact with the diversity of psychoanalytic schools of thought, including object-relations theory, which has to an extent been minimized by the dazzling fascination exerted by Lacan as "absolute master" (Borsh-Jacobson 1993; see also Klein 1964). While the insights of postcolonial theory arose from what could be called an anaclitic relationship to the 1970s feminist turn to psychoanalysis, for the purposes of thinking why it is that social relations are so resistant to progressive political change, there seems to be a paucity of acknowledgment of the genuine process of hybridization whereby diaspora practitioners have re-accentuated the dialogue which previous generations sought in the hyphenation of Freudo-Marxism (a word which today reeks of the funky, musty smell of hippy kinship arrangements).

The fear/fantasy formulation probably had no one single origin, but I think it is crucial to acknowledge the importance of dialogic practitioners such as Laura Mulvey, whose "Fears, Fantasies and the Male Unconscious" was first published in 1972. In her retrospective glance, Mulvey situates the kind of suture or joining sought across theory and practice to create a critical space able to account for the ideological wiring of the pleasure principle as a conduit of power and subjection by which subjects appear to consent to their oppression, and the creation of new possibilities for "other" pleasures, which her films with Peter Wollen, such as *Riddles of the Sphinx* (1977), sought to bring into being (Mulvey 1989). This doubled-vision of pleasure as ultimately a political problem inseparable from the lived experience of psychic pain is something I see being reworked, renewed, in the film practices of an artist such as Julie Dash,

whose *Daughters of the Dust* (1991) offers untold pleasures as it remembers and puts back together memories of a past that never passed. As Mary Ann Doane notes (1991), alongside *Riddles*, other key films from the British independent sector of the past, the Berwick Street Collective's *Nightcleaners* (1975), and Sally Potter's *Thriller* (1979), each depicted black women as central narrative actants, even if the black figure was more in-itself than for-itself: contemporary hybridity, differentiated by the vocal and visible presence of others, enriches such inheritance to seek new forms of dialogic detente in an age of post-imperial perestrioka.

What differentiates the hybrid turn to the primal scene of difference, staged in all its horror and wonder in Onwura's *Body Beautiful* where siblings struggle over the mother's body, is its recognition of psychic negativity as constitutive of subjectivity. In the ruins of the utopian fantasies that sought to "liberate" the transgressive potential of the id, there is an altogether more sorry storying of the postcolonial self which recognizes how love's body is also a festival of hate. This alters the dialogue between politics and psychoanalysis, for as Jacqueline Rose describes it:

> Instead of the unconscious as the site of emancipatory pleasures, we find something negative, unavailable for celebration of release. One could argue that it has been too easy to politicize psychoanalysis as long as the structuring opposition has been situated between an over-controlling, self-deluded ego and the disruptive force of desire; that this opposition has veiled the more difficult antagonism between super-ego and unconscious, where what is hidden is aggression as much as sexuality, and the agent of repression is as ferocious as what it is trying to control.
>
> (1994a: 143–4)

When Rose argues that, "By seeing the unconscious as the site of sexual or verbal free fall, the humanities have aestheticized psychoanalysis" (1994a: 144), an important caveat follows for postcolonial practices, namely the risk that hybridity might be recolonized by the apparatus of power as either compensation for our losses, or as the velvet glove of enjoyment that goes hand in hand with the iron fist of exclusion. Perhaps such risks will be mitigated by the construction of new kinds of pleasures, available to anyone who travels the dark side of the postimperial city at night, which multiply the zones of engagement for critical dialogue. Beyond the field of vision alone, the diasporic sensorium whereby artists as diverse as Keith Khan and Sonia Boyce both use materials such as hair to touch on the tactile dimensions of everyday fear and fantasy in the proxemics of multicultural social space – do you want to touch? – provides a point of access to the "dark continents" of intersectionality that remain as yet unexplored. Or, to plug into another orifice of the multi-culti social body, the mixing-desks which Mathison and George use to hollow out the ear of the

other offer the prospect of exploring the joyful soundings of the black voice as it constitutes identity in the acoustic mirror of desire. "As soon as I *desire* I am asking to be considered" (1967: 218), said Fanon, in a dubwise echo acknowledging the intersection of desire and recognition that goes back to Hegel and came out of the mouth of Marvin Gaye: I want you, *and I want you to want me too.*

History has not been kind to hybrids. The reason why Bessie Head was born in the Pietermartizburg Mental Hospital in South Africa "was that my mother was white, and she had acquired me from a black man. She was judged insane, and committed to the mental hospital while pregnant" (Head 1982: 34). The remaking of our mongrel selves means more than a desire to heal the wounds of power's pathologies; it risks movement along the jagged edge of the borderlines that continue to define the policing of difference, as Chicana poet Gloria Andzaldua fiercely recognizes:

> Borders are set up to define the places that are safe and unsafe, to distinguish *us* from *them*. A border is a dividing line, a narrow strip along a steep edge. A borderland is a vague and undetermined place created by the emotional residue of an unnatural boundary. It is in a constant state of transition. The prohibited and forbidden are its inhabitants. *Los atravesados* live here: the squint-eyed, the perverse, the queer, the troublesome, the mongrel, the mulato, the half-breed, the half-dead; in short, those who cross over, pass over, or go through the confines of the "normal."
>
> (Anzaldua 1987: 3)

NOTE

This essay is dedicated with love to the memory of Mark Finch, 1962–1995.
My thanks to David A. Bailey, Isaac Julien and Catherine Ugwu for materials, suggestions and critical encouragement.

REFERENCES

Anzaldua, G. (1987) *Borderlands/La Frontera: The New Mestiza*, San Francisco: Aunt Lute.

Arroyo, J. (1991) "Look Back and Talk Back: The Films of Isaac Julien in Postmodern Britain," *Jumpcut* 36.

Baker, H.A. (1992) "You Cain't Trus' It: Experts Witnessing in the Case of Rap," in G. Dent (ed.) *Black Popular Culture*, Seattle: Bay Press.

Bahktin, M. (1981) *The Dialogic Imagination*, Austin: University of Texas Press.

Baldwin, J. (1984) *Just Above My Head*, New York: Dell.

Bambara, T.C. (1980) *The Salt Eaters*, New York: Random House.

Bhabha, H.K. (1983) "The Other Question: The Stereotype and Colonial Discourse," *Screen* 24, 4.

—— (1987) "Interrogating Identity," in *Identity*, London: ICA Documents 6.

—— (1992) "Postmodern Authority and Postcolonial Guilt," in L. Grossberg, C. Nelson, and P. Triechler (eds) *Cultural Studies*, New York: Routledge.

—— (1994) *The Location of Culture*, New York: Routledge.

Bhimji, Z. (1992) *I Will Always Be Here*, exhibition catalogue, Birmingham, England: Ikon Gallery.

Borsh-Jacobson, M. (1993) *Lacan: The Absolute Master*, Stanford, CA: Stanford University Press.

Chinwezu (1987) *Decolonizing the African Mind*, Lagos: Pero Press.

Cliff, M. (1987) "From Object to Subject: Some Thoughts on the Work of Black Women Artists," in H. Robinson (ed.) *Visibly Female*, London: Camden Press.

Crenshaw, K. (1989) "Demarginalizing the Intersection of Race and Sex: A Black Feminist Critique of Antidiscrimination Doctrine, Feminist Theory and Antiracist Politics," *University of Chicago Legal Forum*.

Diawara, M. (1992) "The Art of Identity," *Transition* 55.

Doane, M.A. (1991) *Femmes Fatales*, Bloomington: Indiana University Press.

Dollimore, J. (1991) *Sexual Dissidence: Augustine to Wilde, Freud to Foucault*, New York: Oxford University Press.

Edelman L. (1994) "The Part for the (W)Hole: Baldwin, Homophobia, and the Fantasmatics of 'Race,' " in *Homographesis: Essays in Gay Literary and Cultural Theory*, New York: Routledge.

Ellison, R. (1952) *Invisible Man*, Harmondsworth, England: Penguin

—— (1964) *Shadow and Act*, New York: Vintage.

Fanon, F. (1967) *Black Skin, White Masks*, trans. C.L. Markmann, New York: Grove.

Feuchtwang, S. (1987) "Fanonian Spaces," *New Formations* 1.

Fuss, D. (1994) "Interior Colonies: Frantz Fanon and the Politics of Identification," *diacritics* 24, 2–3: 215–27.

Gates, H.L. Jr. (1988) "The Trope of a New Negro and the Reconstruction of the Image of the Black," *Representations* 24, 129–55.

—— (1991) "Critical Fanonism," *Critical Inquiry* 19, 1, 457–70.

—— (1992) "The Black Man's Burden," in G. Dent (ed.) *Black Popular Culture*, Seattle: Bay Press.

George, N. (1992) *Buppies, B-Boys, Bohos and Baps*, New York: Random House.

Gilman, S. (1975) "The Figure of the Black in German Aesthetic Theory," *Eighteenth Century Studies* 8, 4, 373–91.

—— (1986) *Difference and Pathology: Stereotypes of Sexuality, Race and Madness*, Ithaca, NY: Cornell University Press.

Gilroy, P. (1993) "Living Memory: A Meeting with Toni Morrison," in *Small Acts*, London: Serpent's Tail.

Green, R. (1993) *World Tour*, Los Angeles: Museum of Contemporary Art.

Hall, S. (1988) "New Ethnicities," in *Black Film/British Cinema*, London: ICA Documents 7.

Head, B. (1982) *Notes from a Quiet Backwater*, London: Heinemann.

—— (1990) *A Woman Alone: Autobiographical Writings*, London: Heinemann.

Hebdige, D. (1992) "Welcome to the Terrordome," in *Jean-Michel Basquiat*, New York: Whitney Museum.

Honour, H. (1989) *The Image of the Black in Western Art*, Cambridge, MA: Menil Foundation/Harvard University Press.

hooks, b. (1990) "Reflections on Race and Sex," in *Yearnings: Race, Gender and Cultural Politics*, Boston: South End.

—— (1992) "Reconstructing Black Masculinity," in *Black Looks: Race and Representation*, Boston: South End.

—— (1994) *Sisters of the Yam: Black Women and Self-Recovery*, Boston: South End.

Jones, K. (1992) "Re-creation," *Critical Decade, Ten 8*, 2, 3.

Julien, I. (1992) "Black Is...Black Ain't: Notes on De-Essentializing Black Identities," in G. Dent (ed.) *Black Popular Culture*, Seattle: Bay Press.

Klein, M. (1964) "Some Theoretical Conclusions Regarding the Emotional Life of the Infant," in *Envy and Gratitude and Other Works*, London: Hogarth Press.

Ligon, G. (1994) *Print Collector's Newsletter* XXIV, 6 (January–February).

Lippard, L. (1990) *Mixed Blessings: Art in a Multicultural America*, New York: Pantheon.

McClintock, D. (1992) "Color: Skin I'm In," *Critical Decade, Ten 8*, 2, 3.

McCulloch, J. (1983) *Black Soul White Artifact*, Cambridge: Cambridge University Press.

McElroy, G. (1989) *Facing History*, Brooklyn: Museum of Art, 1989.

Morrison, T. (1992) *Playing in the Dark: Whiteness and the Literary Imagination*, Cambridge, MA: Harvard University Press.

Mulvey, L. (1989) "Introduction," in *Visual and Other Pleasures*, London: Macmillan.

Noble, A. (1989) "The Blues: An Interview," *Ten 8* 1, 25.

O'Grady, L. (1992) "Olympia's Maid: Reclaiming Black Female Subjectivity," *Afterimage*, 20, 1.

Owens, C. (1992) "Feminism and the Discourse of Others," in *Beyond Recognition: Representation, Power, and Culture*, Minneapolis: University of Minnesota.

Pollock, G. (1990) "Veils, Masks and Mirrors," in M. Tabrizian (ed.) *Correct Distance*, Manchester, England: Cornerhouse.

Riggs, M. (1991) "Black Macho Revisited: Reflections of a SNAP! Queen," in E. Hemphill (ed.) *Brother to Brother: New Writings by Black Gay Men*, Boston: Alyson.

Rose, J. (1994a) "Negativity in the Work of Melanie Klein," in *Why War?: Psychoanalysis, Politics, and the Return to Melanie Klein*, Oxford: Blackwell.

—— (1994b) "On the 'Universality' of Madness: Bessie Head's *A Question of Power*," *Critical Inquiry* 20, 3, 401–18.

Scott, D. (1994) "Jungle Fever? Black Gay Identity Politics, White Dick, and the Utopian Bedroom," *GLQ*, 1, 3, 299–321.

Smith, V. (1990) "Split Affinities: The Case of Interracial Rape," in M. Hirsh and E. Fox Keller (eds) *Conflicts in Feminism*, New York: Routledge.

Snead, J. (1994) "Spectatorship and Capture in *King Kong*: The Guilty Look," in *White Screens/Black Images*, New York: Routledge

Vigne, R. (ed.) (1990) *A Gesture of Belonging: Letters from Bessie Head, 1965–1979*, London: Heinemann.

Volosinov, V.N. (1973) *Marxism and the Philosophy of Language*, Cambridge, MA: Harvard University Press.

Young, L. (1990) "A Nasty Piece of Work: A Psychoanalytic Reading of *Mona Lisa*," in J. Rutherford (ed.) *Identity*, London: Lawrence & Wishart.

12

POLITICS AND PATHOLOGIES

On the subject of race in psychoanalysis

Gwen Bergner

SUBJECT, RACE, AND NATION

In the final chapter of *The Wretched of the Earth*, Frantz Fanon outlines the psychiatric disorders that colonial violence produces in both Algerians and their French colonizers. After a brief but peremptory statement about the pathology of "reactionary psychoses" that stem from colonial conflict, Fanon describes four case studies. This chapter, "Colonial War and Mental Disorders," follows the text's more famous sections on violence and national consciousness that, no doubt, earned it the reputation of revolutionary handbook (the Grove edition bears the bold subtitle "handbook for the black revolution"). Fanon himself notes the incongruity of the subject matter: "Perhaps these notes on psychiatry will be found ill-timed and singularly out of place in such a book" (1991b: 249). Though he does not head off this anticipated challenge (he gives it a characteristic dismissal: "...but we can do nothing about that"), we might ask what this somewhat fragmented and unframed collection of colonial mental disorders is doing in a political manifesto. What does the juxtaposition suggest about the relationship between the subject and the nation? About the relationship between discourses of the psychological and the political? In the first half of this essay, I address these questions by discussing some of the disciplinary and theoretical tensions among discourses of race, nation, and subject. In the second half, I examine the Hollywood film *Home of the Brave* (1949) in an attempt to use those tensions productively for theorizing the politics of racial subjectivity.

The location of "Colonial War and Mental Disorders" at the end of the text could be seen as a displacement of psychoanalysis from the center of Fanon's critical approach – where it is in his earlier work *Black Skin, White Masks* – in favor of theories of nationalism and Marxism. This development in Fanon's writing has sometimes been cast as a progressive evolution from an apolitical to a political stance. Proponents of this teleological outlook object to the recent

219

resurgence of interest in *Black Skin, White Masks*. As an example of this position, Stuart Hall paraphrases Cedric Robinson's claim

> that to privilege *Black Skin, White Masks* over *The Wretched of the Earth* is a motivated political strategy which, perversely, reads Fanon backwards, from his "immersion in the revolutionary consciousness of the Algerian peasantry" to the "petit-bourgeois stink" of the former text.
>
> (Hall 1996: 15)

Certainly, between the writing of *Black Skin, White Masks* and *The Wretched of the Earth* Fanon did become more politically active, abandoning the French colonial machinery that had brought him to Algeria and participating in the Algerian revolution. Moreover, *Black Skin, White Masks* is not the call to revolution that is *The Wretched of the Earth*. Nonetheless, Fanon's return to the psyche toward the end of *The Wretched of the Earth* signals his continuing demand that we explore the interdependence of nation and subject.[1] Fanon describes how colonial occupation entails a process of dehumanization which causes a crisis of identity in the colonized: "Because it is a systematic negation of the other person and a furious determination to deny the other person all attributes of humanity, colonialism forces the people it dominates to ask themselves the question constantly: 'In reality, who am I?' " (1991b: 250). Thus, for Fanon, "[i]ndividual alienation and political alienation are related; both are the product of social, political, and cultural conditions that must be transformed" (Vergès 1996: 49). The structure of Fanon's text – the truncated discussion of the psychiatric cases tacked onto the call for national consciousness – models both the difficulty and the necessity of conjoining the discourses of political and psychic identities.

The theoretical ambivalence that relegates "Colonial War and Mental Disorders" to an appendix-like form has been amplified by much contemporary antiracist discourse which exhibits a disjunction between the psychic and the political. Until the last decade, Fanonian critics and activists enacted the disjunction between Marxism and psychoanalysis by passing over *Black Skin, White Masks* in favor of Fanon's later work (Hall 1996: 14). More recently, *Black Skin, White Masks* has enjoyed a renaissance in postcolonial theory, not least because of Homi Bhabha's treatments; they renewed our sense that psychoanalytic concepts work in colonial contexts (Bhabha 1983; 1989; 1990). Colonial power and native resistance operate through (among other things) desire, language, subjectivity, and masquerade – staples of psychoanalytic thought. By contrast to postcolonial theory, African-American literary and cultural theory has shown less interest in critical discourses of the subject, including psychoanalysis; "race has been most thoroughly examined in terms of domination and agency rather than subjectivity" (Abel *et al.* 1997: 5). In general, recent work in African-American and poststructuralist theories has exposed the ideological and discursive processes that produce the conceptual category "race," but has paid far less attention to the processes through which

the subject internalizes these cultural determinations.[2] So, although W.E.B. Du Bois's term "double consciousness" has become standard shorthand to describe African-American subjectivity, the condition of double consciousness remains relatively undertheorized (Du Bois 1994: 2). This neglect is due, in part, to the assumed incongruity between psychoanalysis and the politics of racial difference which, in turn, is part of a broader skepticism about the relevance and propriety of poststructuralist theory for African-American studies.

What accounts for this reticence toward psychoanalytic and other poststructuralist discourses? Some critics argue that poststructuralism represents the Western critical tradition that long excluded the literature of African-Americans, women, and other minorities. Barbara Christian's well-known essay "The Race for Theory," first published in 1988, exemplifies this position; invoking terms of cultural imperialism to describe the rise of poststructuralism in the academy, Christian writes, "[T]here has been a takeover in the literary world by Western philosophers from the old literary elite, the neutral humanists" (1990: 37). Critics such as Christian privilege methodologies grounded in African-American cultural specificity. That African-American critics have devised culturally attuned critical frameworks is suggested by Henry Louis Gates's somewhat tentative acknowledgment, in his state-of-the-field essay "Criticism in the Jungle," that he has ventured further afield:

> I have been concerned…with that complex relationship between what is useful to call 'the representative' in black letters and its modes of 'representation,' of mimesis. To explore this relation, moreover, I have attempted…to 'read' the black tradition closely, drawing eclectically on the activity of reading as practiced by those outside the black literary traditions.
>
> (1984: 4–5)[3]

Another criticism of poststructuralism is that, in attempting to deconstruct identity, it potentially elides the history and experience of African-Americans who have been subjected to intransigent racial categories regardless of their fictive nature. Toni Morrison explains:

> For three hundred years black Americans insisted that "race" was no usefully distinguishing factor in human relationships. During those same three centuries every academic discipline, including theology, history, and natural science, insisted "race" was *the* determining factor in human development. When blacks discovered they had shaped or become a culturally formed race, and that it had specific and revered difference, suddenly they were told there is no such thing as "race," biological or cultural, that matters and that genuinely intellectual exchange cannot accommodate it.
>
> (Morrison 1994: 370)

As Morrison suggests, the political effect of deconstructing race is contingent on who is doing it when, where, and for what purpose. Despite various calls to bridge the gap, the critical tension between recognizing African-American cultural specificity, on the one hand, and deconstructing race, on the other, remains.[4]

The roots of psychoanalysis also lie far from the African-American context. Psychoanalysis's modernist, bourgeois, European origins have made it seem irrelevant, at best, to African-American culture and experience. Admittedly, classic psychoanalysis emphasizes gender and sexuality as the determining factors of social organization and subjectivity, neglecting racial difference altogether. Furthermore, psychoanalytic theory has tended to describe psychology in terms of universal frameworks that ignore cultural and historical specificity. Although feminist psychoanalytic and film theories have revised psychoanalysis substantially, in part, by reading its gender bias as symptomatic rather than normative, these discourses have famously ignored the dimension of race in processes of subject formation. Jane Gaines and bell hooks have eloquently leveled this charge against feminist theorists; Gaines, for example, writes that conventional feminist film theory, "based on the psychoanalytic concept of sexual difference, is unequipped to deal with a film which is about racial difference and sexuality" (1986: 61).[5] Thus, psychoanalytic theory needs substantial reworking to better account for racial subjectivity. We need to address psychoanalysis's historic inattention to race, to extend it beyond the scope of its early twentieth-century origins, and to ground analysis of subjectivity in a material, social context.[6] More than any other text, Fanon's *Black Skin, White Masks* has inaugurated a discourse of race and psychoanalysis by grounding a psychoanalytic study of the colonial dynamic in a sociopolitical context.

To say that critics generally consider psychoanalysis and the politics of racial difference incompatible is not to say that we lack a large body of complex and eclectic African-American literary and cultural theory. Nor is it to say that even most critics in the field today are skeptical of poststructuralism. Rather, I would argue that the politics of disciplinary traditions and the biased omissions of psychoanalytic theory have contributed toward a significant and persistent divergence between psychoanalytic and African-American discourses. Although feminist and African-American theorists have been calling attention to feminism's bias in favor of white, middle-class women – a bias that has operated in feminist psychoanalytic theory also – for at least a decade, we have not yet satisfactorily refitted psychoanalysis for exploring how race operates as a factor in subject formation. The experiences of the editors of a recent anthology on race, psychoanalysis, and feminism, *Female Subjects in Black and White*, illustrate the persistent divide. They discovered that their contributors were less interested in revamping psychoanalysis to better account for racial subjectivity than in "questioning the languages available for representing unconscious processes, modes of healing, and the social formation of the female subject"

(Abel *et al.* 1997: 5). Even the editors themselves disagreed over the collection's purpose; the two white editors, Elizabeth Abel and Helene Moglen, had envisioned "a revised psychoanalytic discourse [that] could provide a common set of terms for coordinating race, gender, and subjectivity" (5). Barbara Christian, the lone black editor, remained concerned about representing the critical methodologies "that had been suppressed or denigrated by the academy" (4). They ultimately "came to envisage this collection as a series of dialogues, rather than reconciliations, between feminist psychoanalysis and African American representations of female subjectivity" (1).[7]

Although I have briefly outlined the conflict between psychoanalytic and African-American critical discourses, I expect neither to resolve the differences nor to examine fully the claims of each side in this essay. I do, however, want to argue for the necessity of examining racial subjectivity – valid criticisms of the academy and discourses of psychoanalysis notwithstanding. How else can we engage with popular and political discourses that are rife with assumptions about racial psychology? For although academics and activists on the political left, in general, are reluctant to discuss the psychic effects of racism for those who experience discrimination, the political right shows no such reticence. Conservative rhetoric links psychological attributes to racial identity; assumptions about the psychology of race are implicit in popular and political rhetoric about the laziness of welfare mothers and the burdens of self-doubt imposed on minorities by affirmative action programs. Too often, politicians and analysts use unacknowledged assumptions about the psychological effects of a "culture of poverty" that militates against "personal responsibility" to blame the economically disadvantaged for their lack of upward social mobility.[8] By ignoring the larger social context, pundits and politicians can blame social problems on the individual failure of will they suggest is endemic to a race. We are challenged to find a productive way to talk about the psychological effects of the historical trauma of American racist practices. The difficulty is to recognize the psychic damage caused by racism without representing oppressed minority subject positions as essentially compromised.[9]

No doubt the greatest danger in discussing the psychic effects of racism is the potential to pathologize blackness. There is a long record of such pathologizing from both conservative and liberal quarters. Historically, the psychiatric profession justified discrimination and reinforced myths of racial difference by marshaling scientific "evidence" to prove that blacks were intellectually inferior and tended to abnormal personalities.[10] From Dr. Samuel G. Morton's craniometric mismeasurings in 1840, to Arthur R. Jensen's assertion in the *Harvard Educational Review* (1969) that genetics plays a part in differences of IQ between whites and blacks, to Herrnstein and Murray's infamous *The Bell Curve* (1994), notions of black genetic inferiority will not die. Clinicians, politicians, and others have attributed to psychological deviance African-Americans' challenges to the racist status quo. A particularly ludicrous example of such rationalizing is that of Samuel Cartwright, an ante-bellum

doctor who diagnosed runaway slaves as suffering from "*drapetomania*," the flight-from-home sickness, and who characterized unsubmissive slaves as exhibiting *dysaesethesia Aethiopica*, or "insensibility of nerves" and "hebetude of mind" (quoted in Thomas and Sillen 1972: 2). Though Dr. Cartwright's claims seem incredible to us now, we cannot easily dismiss such faulty logic as a thing of the distant past.

Even advocates for racial equality sometimes invoke clinical terms to pathologize and thereby neutralize radical political protest. In order to whitewash the actual conditions of life for African-Americans, a 1947 *Ebony* editorial derides the disaffected protagonist of Chester Himes's novel *Lonely Crusade* by accusing both the character and Himes of being "infected with a psychosis that distorts their thinking and influences their every action in life" (*Ebony* 1947: 44). The *Ebony* editorial extends the mental illness metaphor with now-familiar cliches, writing that this "psychosis"

> is a mental condition that is a biological but not common sense response to the crimes committed by whites against Negroes....It answers white hate with Negro hate, substitutes emotions for intelligence, dictates thinking with the skin rather than the brains. Its outer symptoms are constant breast beating about the terrible misfortune of being a Negro. Usually this develops into a persecution complex that results in chip-on-the-shoulder resentment of all whites.
>
> (1947: 44)

The editorial goes on to minimize America's systemic racism: "Yes, the Negro is deprived of his vote and sometimes of his life in many Southern states but where else in the world can a person yell as loud and long about it except in America?" (44). The infamous "Moynihan report," *The Negro Family: The Case for National Action* (1965), is a particularly notorious example of how even liberal social scientists have located the source of socioeconomic disparities in the black psyche, family, and community, rather than in the American sociopolitical system. The report attributes the problems of poor African-Americans to the "matriarchal" structure of the black family – a structure which, the report claims, deviates from the patriarchal norm exhibited by white families. In turn, children – especially boys – raised within the matriarchal family structure suffer personality disturbances. Although the report notes historical conditions that gave rise to the alleged matriarchal family structure, it nonetheless regards perceived differences as deviant rather than adaptive, and as a cause rather than an effect of current social ills.

Despite discourses of racial pathology, arguments about the psychic effects of racism sometimes further civil rights. Policies for educational reforms involving multiculturalism, ebonics, all-black schools, and ethnicity-oriented dormitories depend, to a large extent, on the notion that self-esteem and emotional environment affect measurable educational outcomes for black students.[11] In

the landmark *Brown v. Board of Education* decision (1954), the Supreme Court struck down school desegregation on the grounds that to separate children solely on the basis of race "generates a feeling of inferiority as to their status in the community that may affect their hearts and mind in a way unlikely ever to be undone" (Bell 1980: 112).[12] The *Brown* decision broke with jurisprudential conventions because it weighed intangible factors of the psychological effects of racism to overturn the longstanding policy of segregation set by *Plessy v. Ferguson* in 1896. The *Plessy* Court had dismissed Plessy's assertion that segregation institutionalized the racial inferiority of blacks, claiming that blacks only *imagined* this was so:

> We consider the underlying fallacy of the plaintiff's argument to consist in the assumption that enforced separation of the two races stamps the colored race with a badge of inferiority. If this be so, it is not by reason of anything found in the act, but solely because the colored race chooses to put that construction on it.
>
> (Bell 1980: 70–1)

In order to overturn *Plessy*, the *Brown* Court needed to demonstrate that separation on the basis of race was inherently discriminatory, regardless of physical facilities; it did that by acknowledging the symbolic message of segregation, its real psychological effects, and the consequences for educational opportunity: "Whatever may have been the extent of psychological knowledge at the time of *Plessy v. Ferguson*, this finding [that segregation imparts a message of inferiority to blacks] is amply supported by modern authority" (Bell 1980: 112). Clearly, arguments about the psychology of race can be used for or against the cause of racial justice.

HOME OF THE BRAVE

In the second half of this essay, I want to consider how conceptions of racial subjectivity intersect with national ideology by way of the Hollywood film *Home of the Brave* (1949).[13] I am drawn to film, and this film in particular, as a specimen case for exploring the interdependence of nation and raced subject for several reasons. First, as Michael Rogin writes, "Hollywood's importance in making Americans, in giving those from diverse points of class, ethnic, and geographic origin, a common imagined community, is by now commonplace" (1996: 18). Moreover, Hollywood films have typically constituted an imagined community for white immigrant workers by offering them an American identity defined against subjugated African-American and Native American populations (Rogin 1996: 14). Rogin argues that we can track the development of American film through four pivotal movies about race: *Uncle Tom's Cabin* (1902), *Birth of a Nation* (1915), *The Jazz Singer* (1927), and *Gone With The*

Wind (1939). These films, which trade in racial stereotypes that grow out of the minstrel tradition, "provide the scaffolding for American film history. They instantiate the transformative moments in American film – combining box office success, critical recognition of revolutionary significance, formal innovations, and shifts in the cinematic mode of production" (1996: 18). Although Hollywood might be criticized more obviously for ignoring African-Americans, its landmark films have returned to the repressed origins of American freedom in slavery. Films about race are, then, central rather than incidental to Hollywood's discourse on national identity and its rise as a cultural institution. After World War II, Hollywood films such as *Home of the Brave* began to attack the casual, yet purposeful, race prejudice that characterizes these four seminal films. But, as Rogin notes, these later films "bore an unacknowledged indebtedness to the tradition they wanted to repudiate" (1996: 22).

A second attraction to film is that it provides a nexus of Fanonian and psychoanalytic theory. In *Black Skin, White Masks*, Fanon emphasizes a schema of the scopic regime that constitutes racial difference; this attention to "looking relations" coincides with the vocabulary and preoccupations of feminist film theory which has focused on the role of the gaze in constructing femininity.[14] If racial and gender difference are constructed through scopic regimes that align blacks and women with the body and with sexuality, then this common ground might provide a site for reconfiguring psychoanalytic theory.

Third, *Home of the Brave* represents psychoanalysis diegetically, that is, on the level of plot. It is a story about a black soldier during World War II who suffers a sort of shell shock and must be cured through psychoanalytic therapy. In the course of the therapy, the psychiatrist "discovers" that the soldier's symptoms stem from a racial inferiority complex rather than the horrors of war. The doctor attempts to "cure" the soldier of *his* race complex, thereby locating the problem of American racism in the African-American subject. This filmic representation provides us with an opportunity not only to use psychoanalytic theory to explore the film's construction of racial identity, but also to examine its explicit representation of psychoanalysis as a mechanism of assimilation and suppression.

Fourth, *Home of the Brave* belongs to a string of post-World War II films preoccupied with redefining American masculinity in the wake of the historical trauma of the war. In fact, the film represents at least three aspects of its historical moment. Its rhetoric about the nature of bravery, masculinity, and sacrifice indicates its location in a discursive field in which, as Kaja Silverman argues, America was attempting to reconsolidate an ideology of masculinity and citizenship in the wake of the disillusionment caused by World War II. Its representation of psychiatry indicates that notions of psychology had disseminated sufficiently to be invoked by various popular and civic discourses. Its attempt to foster racial tolerance marks new sensitivity to national prejudice. I want to consider these themes of masculinity, race, and psychoanalysis, in the

context of a recent critical text that brings together theories of ideology and psychoanalysis, namely, Silverman's *Male Subjectivity at the Margins*. This context will provide me with a theoretical framework for analyzing the relationship between masculinity, psychoanalysis, and national ideology; but because Silverman does not consider race as an aspect of male subjectivity, it also provides me with an opportunity to contribute to revising feminist psychoanalytic theory to account for race. I argue that psychoanalytic theory can productively explore the relationship between male subjectivity and national ideologies of race (as long as we account for its past omissions of race as a factor of identity-formation), but that *Home of the Brave* instead invokes a popular version of the talking cure in order to unhinge politics and identity.

In *Male Subjectivity at the Margins*, Silverman explores a series of films made in Hollywood between 1944 and 1947 that, she argues, attest to the "crisis of male subjectivity" brought about by World War II. In films such as *The Guilt of Janet Ames* and *The Best Years of Our Lives*, the hero returns from the war "with a physical or psychic wound which marks him as somehow deficient" (1992: 53). These post-World War II films depart from popular culture's traditional representation of a sufficient masculinity by revealing rather than concealing the male subject's castration. By "attest[ing] with unusual candor to the castrations through which the male subject is constituted," these films indicate that the "historical trauma" of World War II disrupts a collective ideological belief in the "dominant fiction" of normative masculinity. This moment of "ideological fatigue" – as Silverman terms it – illustrates that America's national ideology is closely tied to the terms of normative masculinity which, by aligning penis and phallus, "solicits our faith above all else in the unity of the family and the adequacy of the male subject" (1992: 15–16). Ideologies of class, race, ethnicity, and nation "articulat[e] themselves in relation" to these privileged terms of the family and the phallus. Masculinity is thus "a crucial site" for renegotiating the set of images that constitutes our ideological reality (1992: 2).

Silverman's claim that national ideology and masculine subjectivity are mutually constitutive marries Althusserian theories of ideological interpellation to psychoanalytic theories of subjectivity. In other words, she links historical materialism and psychoanalysis. I am particularly interested in this approach because it engages psychoanalytic theory for political and historically contextualized analysis. According to this model, masculine sufficiency – though sanctioned by the symbolic order – is continually besieged by material and political conditions such as sexual, economic, and racial oppression, as well as by traumatic historical events such as World War II (1992: 52). Silverman discusses the implications of this post-World War II failure of belief in phallic sufficiency for ideologies of gender and the family, but does not probe its implications for ideologies of race. Though classic masculinity covers over lack in the male by equating the penis with the phallus and, usually, by projecting lack onto the female – as indeed other film theorists such as Laura Mulvey have also argued – surely this sufficient masculinity is reserved for white males.

Moreover, our culture's valorization of whiteness endows it with compensatory capabilities similar to those of the penis so that the white subject – whether masculine or feminine – can lay claim to fictions of racial superiority and actual benefits of racial privilege to cover over subjective lack. In this sense, whiteness is aligned with the phallus as the symbolic sign of plenitude. Thus, while all subjects are constituted by primary lack, white subjects nevertheless possess social power that blacks and other minorities do not. My question is, how is this moment of "ideological fatigue," or loss of collective belief in phallic suffi-ciency, represented in relation to racial difference?

Set in the South Pacific during World War II, *Home of the Brave* (based on a play by Arthur Laurents and directed by Mark Robson, in consultation with Stanley Kramer) focuses on the sacrifices made by five American soldiers – four white and one black – who execute a dangerous reconnaissance mission. The white soldiers in *Home of the Brave* incur emasculating wounds as a direct result of the war: one is killed; one loses his right arm and his wife. But the wounds of the lone black soldier in the film are *psychosomatic*. His ostensible war injuries – partial paralysis and amnesia – turn out to be hysterical expressions of his own pathological psyche that became diseased with a racial inferiority complex long before the war. Private Peter Moss, or "Mossy" (the black soldier, played by James Edwards), volunteers for a dangerous mission to map an island occupied by the Japanese. Three white soldiers reluctantly volunteer to perform the mission with Mossy and their commanding officer; these include an old high-school pal of Mossy's named "Finch," played by Lloyd Bridges; T.J. Everitt, a racial bigot who taunts Mossy throughout; and Mingo, whose character remains emotionally detached until near the end. Though Mossy dispatches Japanese attackers with aplomb, he is easily shaken by every one of T.J.'s slurs. Bridges's character, Finch, repeatedly comes to his rescue, acting in an almost paternal role. He tells T.J. to shut up and soothes Mossy's hurt feelings. But then, in the heat of battle, Finch lets slip a racial epithet. Actually, he calls Mossy a "yellow-bellied ni...t-wit." But both Mossy and the audience know that he had started to say "yellow-bellied nigger." Mossy feels betrayed and responds with anger, but Bridges's character is almost immediately shot by a Japanese soldier and Mossy must leave him behind in order to save the maps. Unable to help Finch, Mossy is wracked with guilt and a sense of impotence as he hears Finch scream, presumably while being tortured by the Japanese. Finch eventually crawls back to camp, only to die in Mossy's arms. At this moment, Mossy develops paralysis from the waist down and amnesia.

Once rescued from the island and returned to the South Pacific army base from which the group started, Mossy undergoes a drug-enhanced course of psychotherapy – termed "narcosynthesis" – that is administered by an army psychiatrist known only as "the Doc." The drug, a Hollywood device akin to truth serum, makes Mossy relive the events leading up to the traumatic shock that caused his paralysis and amnesia. In the psychiatrist's words, he must "return to the scene of the crime." If there is any doubt that – narcosynthesis

injections not withstanding – the Doc is practicing psychoanalysis, we can consider that he is coded Jewish and that Mossy says to his fellow soldiers that the injections gave way to treatment sessions in which he and the Doc "only talked." Even the Doc's repeated lamentations that he wished he and Mossy had more time to continue the talking treatment signal that the Doc is administering "the talking cure."

Though Mossy relives the primal scene of his friend's death and the onset of his own paralysis, he is "cured" only when the psychiatrist interprets the remembered events for him. The Doc explains that Mossy's symptoms stem not simply from guilt over leaving Finch behind, as Mossy suspects, but rather from a sense of shame that his leaving Finch and the relief he feels for surviving the mission confirm his racial difference. In other words, Mossy believes – or so the Doc tells him – that a white soldier wouldn't have reacted similarly, wouldn't have felt relieved, as Mossy was, that his own life had been spared. The psychiatrist relieves Mossy of this emotional burden by insisting that every man is glad he isn't the one to die, and so Mossy is no different from any other soldier – that is, no different from white soldiers. When Mossy persists in saying that he is different from the other men because he's black, referring more to his experience of racism than to any essential difference, the Doc says: "There, that sensitivity, that's the disease you have." He proceeds to explain that Mossy needs to be cured of *his* racial sensitivities, his inability to judge men in a color-blind fashion, or "this could happen again, or something worse." Although the film suggests that American society bears some responsibility for Mossy's psychic wounds, the denouement ultimately locates the problem of racism within the black, male psyche itself. *Home of the Brave* uses the scene of psychoanalytic therapy not for understanding the unconscious of an African-American man, but for projecting white society's fantasies onto the black man via the paternalistically benign voice of medical authority.

The film's proclaimed antiracist message that all men are equal – or, as the "cured" Mossy says at the end, "We're all different, but underneath we're all guys" – aligns it with other Hollywood films of the era (such as *Imitation of Life*) that profess to challenge racist assumptions only to reinscribe them. The black man's justifiably angry response to racism is, in this film, contained by representing it as a self-destructive, even auto-immune, disease that leaves him in infantile and impotent confusion (Mossy's expressions throughout the film are pretty much limited to facial twitches that indicate his overwrought nervous frustration and grateful, puppy-dog gazes toward his white protectors: Finch, the Doc, and a third soldier, Mingo). The film suggests repeatedly that it is not a lack of educational, employment, and social opportunities that circumscribes Mossy's life (Mossy and Finch attended an integrated high school; the psychiatrist suggests that racism is limited to attitudes and doesn't affect policies; Mingo promises to open a bar and restaurant with Mossy as co-owner), but rather the deplorable fact that he feels interpellated by name-calling bigots like T.J. By scapegoating T.J. as the racist, the film says, in effect, sure there are

a few bigots, but we know they're wrong, so don't let them bother you. In accordance with America's ideology of individualism, the film acknowledges the existence of racist individuals, but not the systemic racism of American society.

The unsettling end of the scene of psychoanalysis between Peter Moss and the psychiatrist illustrates one way that the film unravels its own rhetoric of equality and self-esteem for blacks. Though Mossy (now called by his first name, Peter) accepts on an intellectual level the Doc's word that he is equal to whites, he says he does not know it in his heart. Thus, he is not cured of his lack of self-esteem, and he continues to believe that he cannot walk. In a last ditch effort to effect a cure, the Doc calls him a "yellow-bellied nigger." This so enrages Mossy that he staggers out of bed in order to attack the doctor. When he reaches the Doc, he realizes he is cured and sinks gratefully into the Doc's arms. The Doc's final clinical technique (shouting racial epithets) undercuts his previous exhortations that Peter must cease to heed name-calling racists. Yet, in the film's terms, the Doc resorts to enacting this very dynamic, to playing the part of the racist, for Mossy's own good. The trick of calling Mossy by the n-word in order to rouse his wilted manhood wouldn't have worked if Mossy did not still feel interpellated by the label and its ideological implications. He can be cured of his psychosomatic injuries, as long as he accepts his place of lack or castration within the social order.

How does the black soldier's disfigurement in *Home of the Brave* compare with the white veteran's symbolic castration? To answer this question I would like to consider a character I have left aside until now. The fifth man on the mission (in addition to Mossy, Finch, T.J., and the Major) is Mingo, coded a "non-racist" like Finch, who gets shot in the right arm. In addition to losing his arm, which is amputated when the party returns to base, Mingo has already lost his wife, who left him while he was serving overseas. In the off-camera character of Mingo's wife – she sends him poems testifying to her fidelity and then leaves him with a "Dear John" letter – we see the fulfillment of Silverman's observation that these post-World War II films often attribute "male insufficiency not only to the war, but to the collapse of traditional gender divisions in the home…a collapse for which it holds the female subject responsible" (1992: 53). The wife is a hypocrite who, as Mingo says, doesn't live up to the promise of her own poems. By the film's end, Mossy will take up the wife's position in relation to Mingo in an interracial, homoerotic suturing of the wounds of war.

The film's final scene brings together – and draws parallels between – the physically damaged Mingo and Mossy, now cured of paralysis and amnesia, but not of being black. In this scene, Mossy and Mingo await the transport that will begin their journey back to the States. T.J. manages to make one more unthinking, egregious racial slur and to remind Mossy that he left Finch behind. At this, Mossy begins to unravel; he buries his head in his hands and moans over and over, "I'm just like the others; I'm just like the others." Mingo steps in to assume Finch's position as Mossy's protector. He sends T.J. away, offers to go into business with Mossy stateside, just as Finch had, and plays

Finch's part in an inside joke he and Mossy had shared. Mossy first remains skeptical of Mingo's sincerity, but is finally won over when Mingo compares his armless, wifeless state to Mossy's condition as a black man. They resolve to do well despite their disabilities: Mingo says he won't let his arm go down the drain for nothing; Mossy replies, "I ain't gonna let me go for nothing." The white man may have been symbolically castrated in the war, but black masculinity is inherently lacking. As they leave the barracks, Mingo has trouble hoisting his duffel bag over his shoulder with one arm. Mossy offers help by quoting a line from Mingo's wife's poem, a poem that Mingo had earlier recited for Mossy. He says, "Hey coward, take my coward's hand." Because Mossy offers help not from a position of masculine sufficiency superior to Mingo's, but rather from the castrated, feminized position of the black man masquerading as the white woman, Mingo can accept assistance without losing face. Mingo accepts help from Mossy although he had previously rejected T.J.'s offer to light a cigarette for him, because T.J. had assumed an air of smug superiority and pity.

The film gestures toward an acknowledgment of the psychologically debilitating effects of material and ideological discrimination, but winds up mainly pathologizing the victim. If this is yet another example of how popular discourses cast African-American responses to racism as pathological, what have we learned about the relationship between racial subjects and national ideology, or the relationship between race and psychoanalytic theory? We can modify Silverman's thesis that many post-World War II films highlight rather than conceal the male subject's castration, and so demonstrate a loss of collective belief in phallic sufficiency. Although the white male subject in *Home of the Brave* suffers unrecoverable loss during the war, he nevertheless remains recognizably "masculine" in relation to the black man. Though he is not a romantic war hero, Mingo possesses a stoicism and emotional toughness that Mossy lacks. In effect, Mingo has been castrated by the war, while Mossy is always-already castrated. Mingo's racial superiority compensates for his – and the audience's – loss of belief in masculine sufficiency. Mingo's protective chaperoning of Mossy's return to the States suggests that the white man may not be omnipotent, but he can still take care of the women, children, and blacks. In this way, the film simultaneously acknowledges and sutures over the historic traumas of World War II and of America's legacy of slavery – segregation. Normative masculinity, and the national ideology which depends on it, cannot be deconstructed apart from factors of racial difference.

NOTES

1 Stuart Hall also disagrees that Fanon's work becomes progressively more political as it moves away from psychoanalysis (1996: 17). For an early defense of why Fanon included the psychiatric case studies in *The Wretched of the Earth*, see Gendzier (1974: 102–9).

2 Interestingly, theorists writing on the construction of whiteness (primarily in relation to blackness) draw on the psychoanalytic registers of desire and identification even if they do not place themselves explicitly within a psychoanalytic tradition. See for example Lott (1993) and Rogin (1992).

3 Diana Fuss credits Gates with having "done the most to open the flood-gates for poststructuralist Afro-American literary theory" (1989: 81).

4 R. Radhakrishnan makes an appeal for the conjoining of ethnic specificity and poststructuralism; focusing on either, he argues, creates an untenable political position:

> The constituency of "the ethnic" occupies quite literally a "pre-post"-erous space where it has to actualize, enfranchise, and empower its own "identity" and coextensively engage in the deconstruction of the very logic of "identity" and its binary and exclusionary politics. Failure to achieve this doubleness can only result in the formation of ethnicity as yet another "identical" and hegemonic structure. The difficult task is to achieve an axial connection between the historico-semantic specificity of "ethnicity" and the "post-historical" politics of racial indeterminacy.
>
> (Radhakrishnan 1990: 50)

5 See also hooks (1992). E. Ann Kaplan thoroughly summarizes this critique of feminist film theory and articulates the stakes for a psychoanalytic analysis of race in *Looking for the Other* (1997, especially 99–130).

6 I have argued elsewhere that in *Black Skin, White Masks* Fanon demonstrates how to ground psychoanalytic theory in a specific socioeconomic location: see Bergner (1995). I have also made a case at greater length for the relevance of psychoanalytic theory to African-American theory in Bergner (1998).

7 Despite the continuing difficulties of generating dialogue among theorists working in different critical traditions, a number of American theorists of race *are* reconfiguring psychoanalytic theory to interrogate racial subjectivity and a racist social order; Hortense Spillers, Jane Gaines, Stuart Hall, and Claudia Tate are among the most influential.

8 Although we associate the notion of a "culture of poverty" with conservative anti-welfare, anti-affirmative action positions, it actually originated from liberal social scientists who wanted to oppose claims of inborn group inferiority (Thomas and Sillen 1972: 68).

9 In an article that expresses her intellectual and emotional debt to Fanon, bell hooks suggests that it can be enabling rather than debilitating to recognize, on an intrapsychic level, the harm caused by oppression:

> I was given by this intellectual parent [Fanon] paradigms that enabled me to understand the many ways in which systems of domination damage the colonized. More than any other thinker, he provided me with a model for insurgent black intellectual life that has shaped my work.
>
> (1996: 85)

In fact, hooks laments that Fanon does not put more emphasis on interrogating the individual's personal past; "It is here," she writes, "that his paradigms for healing fall short" (85).

10 For an account of recent developments in "transcultural psychiatry" that attempt both to eliminate racial bias and account for multicultural perspectives, see Kaplan (1997: 104–5).

11 See, for example, a *Washington Post* article on responses to Brown University's dormitory dedicated to "students who identify with their African descent, speak an African language, or major solely in Pan-African studies" (Jordan 1995: 395).

12 The *Brown* Court cited studies by child psychologist Kenneth Clark as evidence for the psychological damage inflicted by segregation, thus inaugurating a debate about the self-esteem of black children which has not yet subsided. See Abdullah (1988), Gopaul-McNicol (1988), McMillan (1988), Powell-Hopson and Hopson (1988), and Whaley (1993). Clark's famous "doll tests" are, today, generally discredited on statistical grounds (for citation information on the studies that disproved Clark's findings, see Whaley 1993: 408). But debates still rage over whether all-black or integrated schools are most conducive to black children's education and self-esteem.

13 For another discussion of *Home of the Brave*, see Kaplan (1997: 106–9).

14 For discussions of Fanon's and film theory's focus on scopic regimes that constitute difference, see Bhabha (1983), Gaines (1986), Bergner (1995), Hall (1996) and Kaplan (1997).

REFERENCES

Abdullah, S.B. (1988) "The Media and the Doll Studies," *Journal of Black Psychology* 14, 2: 75–7.

Abel, E., Christian, B. and Moglen, H. (eds) (1997) *Female Subjects in Black and White*, Berkeley: University of California Press.

Bell, D.A. (ed.) (1980) *Civil Rights: Leading Cases*, Boston: Little, Brown.

Bergner, G. (1995) "Who Is That Masked Woman? Or, The Role of Gender in Fanon's *Black Skin, White Masks*," *PMLA* 110, 1: 75–88.

—— (1998) "Myths of the Masculine Subject: The Oedipus Complex and Douglass's 1845 *Narrative*," in C. Lane (ed.) *The Psychoanalysis of Race*, New York: Columbia University Press.

Bhabha, H.K. (1983) "The Other Question: Difference, Discrimination and the Discourse of Colonialism," in F. Barker *et al.* (eds) *Literature, Politics and Theory: Papers from the Essex Conference 1976–1984*, Colchester: University of Essex Press.

—— (1989) "Remembering Fanon: Self, Psyche, and the Colonial Condition," in B. Kruger and P. Mariani (eds) *Remaking History*, Seattle: Bay Press.

—— (1990) "Interrogating Identity: The Postcolonial Prerogative," in D.T. Goldberg (ed.) *Anatomy of Racism*, Minneapolis: University of Minnesota Press.

Christian, B. (1990) "The Race for Theory," in A.R. JanMohamed and D. Lloyd (eds) *The Nature and Context of Minority Discourse*, New York: Oxford University Press.

Du Bois, W.E.B. (1994) *The Souls of Black Folk*, New York: Dover.

Ebony (1947) "Time to Count Our Blessings," editorial (November): 44.

Fanon, F. (1991a) *Black Skin, White Masks*, trans. C.L. Markmann, New York: Grove.

—— (1991b) *The Wretched of the Earth*, trans. C. Farrington, New York: Grove.

Fuss, D. (1989) *Essentially Speaking*, New York: Routledge.

Gaines, J. (1986) "White Privilege and Looking Relations: Race and Gender in Feminist Film Theory," *Cultural Critique* 4: 59–79.

Gates, H.L., Jr. (1984) "Criticism in the Jungle," in H.L. Gates, Jr. (ed.) *Black Literature and Literary Theory*, New York: Routledge.

Gendzier, I.L. (1974) *Frantz Fanon*, New York: Vintage.

Gopaul-McNicol, S. (1988) "Racial Identification and Racial Preference of Black Preschool Children in New York and Trinidad," *Journal of Black Psychology* 14, 2: 65–8.

Hall, S. (1996) "The After-Life of Frantz Fanon: Why Fanon? Why Now? Why *Black Skin, White Masks?*" in A. Read (ed.) *The Fact of Blackness: Frantz Fanon and Visual Representation*, Seattle: Bay Press.

Herrnstein, R.J. and Murray, C. (1994) *The Bell Curve: Intelligence and Class Structure in American Life*, New York: Free Press.

hooks, b. (1992) *Black Looks: Race and Representation*, Boston: South End.

—— (1996) "Feminism as a Persistent Critique of History: What's Love Got to Do with It?" in A. Read (ed.) *The Fact of Blackness: Frantz Fanon and Visual Representation*, Seattle: Bay Press.

Jensen, A.R. (1969) "How Much Can We Boost IQ and Scholastic Achievement?" *Harvard Educational Review* 39: 1–123.

Jordan, M. (1995) "Separate by Choice," in R. Atwan (ed.) *Our Times*, Boston: Bedford.

Kaplan, E.A. (1997) *Looking for the Other: Feminism, Film, and the Imperial Gaze*, New York: Routledge.

Lott, E. (1993) *Love and Theft: Blackface Minstrelsy and the American Working Class*, New York: Oxford University Press.

McMillan, M. (1988) "The Doll Test Studies: From Cabbage Patch to Self-Concept," *Journal of Black Psychology* 14, 2: 69–72.

Morrison, T. (1994) "Unspeakable Things Unspoken: The Afro-American Presence in American Literature," in A. Mitchell (ed.) *Within the Circle*, Durham, NC: Duke University Press.

Moynihan, D.P. (1967) *The Negro Family: The Case for National Action*, in L. Rainwater and W.L. Yancey (eds) *The Moynihan Report and the Politics of Controversy*, Boston: MIT Press.

Powell-Hopson, D. and Hopson, D.S. (1988) "Implications of Doll Color Preferences Among Black Preschool Children and White Preschool Children," *Journal of Black Psychology* 14, 2: 57–63.

Radhakrishnan, R. (1990) "Ethnic Identity and Post-Structuralist Difference," in A.R. JanMohamed and D. Lloyd (eds) *The Nature and Context of Minority Discourse*, New York: Oxford University Press.

Rogin, M. (1992) "Blackface, White Noise: The Jewish Jazz Singer Finds His Voice," *Critical Inquiry* 18: 417–53.

—— (1996) "The Two Declarations of American Independence," *Representations* 55: 13–30.

Silverman, K. (1992) *Male Subjectivity at the Margins*, New York: Routledge.

Thomas, A. and Sillen, S. (1972) *Racism and Psychiatry*, New York: Bruner, Mazel.

Vergès, F. (1996) "Chains of Madness, Chains of Colonialism: Fanon and Freedom," in A. Read (ed.) *The Fact of Blackness: Frantz Fanon and Visual Representation*, Seattle: Bay Press.

Whaley, A.L. (1993) "Self-Esteem, Cultural Identity, and Psychosocial Adjustment in African-American Children," *Journal of Black Psychology* 19, 4: 406–22.

TERRORISTS AND VAMPIRES

Fanon's spectral violence of decolonization

Samira Kawash

As cosmopolitan intellectuals, as observers, interpreters, and critics of global movements and historical events, Fanon seems to press on us the necessity to take sides: for violence or against. Among Fanon's contemporaries, perhaps the most celebrated parties to the debate surrounding Fanon's stance on violence were Jean-Paul Sartre and Hannah Arendt. In Sartre's Preface to *The Wretched of the Earth*, he suggests that the asymmetry of violence through which the colonizing European upholds an exclusive claim to "humanity" can be righted only by violence from the other side; that the Hegelian struggle for recognition is achieved when the formerly colonized turn violence back on their European masters. Sartre's celebration of this violence in the service of history is matched in vehemence only by Arendt's disgust. In "On Violence," she suggests that "the new undeniable glorification of violence by the student movement [of the late 1960s]" can only be explained by "the ignorance and nobility of sentiment of people exposed to unprecedented events and developments without any means of handling them mentally" (Arendt 1972: 122). Fanon, in Arendt's view, is largely to blame, for although she qualifies her condemnation by suggesting that Fanon's text might contain a more complex and qualified assessment of violence, her continual evocation of Fanon as the exemplary influence promoting the new glorification of violence would imply that such complexities are ultimately of little matter. Does revolutionary violence liberate its agents to a new level of humanity? or does it further enslave its agents in animalistic passions which can never contribute to history or be historical? Is such violence a historical necessity for humanity or a corruption of humanity? For Sartre, violence is the only means of historical change. For Arendt, violence is mere animalistic behavior that cannot change anything; change will only come through positive human action.

It is not difficult to see why Fanon would provoke such a debate. For example, in the essay titled "Algeria Unveiled," Fanon takes a stand for terrorism in the context of anticolonial struggle in a way that would be all but impossible today. Terrorist violence is described as a necessary counterforce to the more pervasive and ongoing terror instilled in the Algerian populace by the colonizing French: "the revolutionary leadership found that if it wanted to

prevent the people from being gripped by terror it had no choice but to adopt forms of terror which it had until then rejected" (Fanon 1965: 55). Fanon insists that the terrorism of the colonized is only a weapon of last resort. Fanon's distinction, between on one hand the ongoing terror of the colonizing force and on the other the strategic resort to terrorism as a weapon in the revolutionary struggle, maintains a commitment to an empirical definition of terrorism. That is, his description of the revolutionary fighter's use of terrorist tactics is contextualized by insisting that these tactics be understood as a strategic response to the far more violent and ubiquitous terrorism of the colonial regime. In this case, Fanon would seem to suggest that the task of the critic is not to condemn terrorism, but rather to call all violence by its proper name and to place the terrorism of the colonized in relation to the unnamed terrorism of the colonizer.

In vivid contrast to Fanon's careful specification and delimitation of particular acts of violence within particular circumstances is the popular consensus regarding terrorism today. Terrorism is typically characterized in the media and by politicians and experts as opposing everything "we" stand for and believe in. Terrorism is represented as a pure unmotivated attack that threatens the West, modernity, Judeo-Christianity, democracy, civilization itself. Terrorism is thus positioned as the evil to our good, the expression of the irrational, the anti-modern, the tribal, the fundamentalist, everything which must be excluded to make way for the progress of enlightenment. And invariably, the response to terrorism is more security and more control to better preserve and defend everything that is good, modern, valuable, and decent. This reframing of terrorist violence is characteristic of what Joseba Zulaika and William Douglass call "terrorism discourse":

> Characteristically, terrorism discourse singles out and removes from the larger historical and political context a psychological trait (terror), an organizational structure (the terrorist network), and a category (terrorism) in order to invent an autonomous and aberrant realm of gratuitous evil that defies any understanding.
>
> (1996: 22)

What Fanon describes in "Algeria Unveiled" as a strategic and instrumental act is, within terrorism discourse, "gratuitous evil." Fanon understands revolutionary acts within the context of their ends; terrorism discourse insists that these acts "defy understanding," that they are outside the realm of instrumental reason, that the violence of terrorism is a means divorced from an end.

But can these competing definitions or explanations be reconciled? Is there some empirical fact that would decide the truth of terrorism? The incoherence and inconsistency of definitions of terrorism in the media and in the writings of "terrorism experts" have been extensively documented.[1] But the complexity of the meaning of "terrorism" is not simply a matter of politicized or biased

applications of a label. For even if a particular revolutionary act may be described in some empirical sense as a form of terrorism, terrorism as it reappears in "terrorism discourse" becomes detached from specific actions or specific ends, and becomes a sort of free-floating menace. Where terrorism understood as a revolutionary act is contained by the implicit instrumental relation between violence and its ends, in terrorism discourse terrorism appears as pure means, a violence without any instrumental logic. The distance between terrorism as instrumental violence and terrorism as absolute violence is not a matter of competing interpretations of some empirical and determinable event. Although in "Algeria Unveiled" Fanon is careful to contain terrorism within the bounds of instrumental – and thereby explicable – violence, there is elsewhere in Fanon's text a resurgence of just the sort of excessive violence that seems to be named by the "terrorism" of terrorism discourse.

The absence of a singular determination of violence in Fanon's text belies the terms of a debate that would fix violence as an object to be embraced or condemned. Thus, I want to suggest in this essay an altogether different possibility: that Fanon makes it impossible to choose, for violence or against. Because although violence is at some moments in Fanon's text a particular object or act that would be amenable to judgment or evaluation, elsewhere what appears as violence would seem to be precisely that which would render such judgment impossible. Fanon's violence of decolonization, I want to argue, is always in excess and elsewhere to the instrumental violence of the colonized in struggle. And it is this excess – which is not reducible to or identifiable as particular violent acts – that portends the decolonization that will be a rupture with, rather than a re-formation of, the colonial past.

In *The Wretched of the Earth* Fanon refers to the violence of decolonization as "a program of complete disorder," "absolute violence" (Fanon 1963: 36, 37). This violence of decolonization, a violence that destroys the colonial world to make way for a new humanity, cannot be comprehended in terms of quantities of instrumental violence. In relation to the instrumental violence whereby the colonized opposes the rule of the colonizer, the violence of decolonization appears as another order of violence altogether. These are not two different kinds of violence, if by kinds of violence we mean classes of empirical acts that could be categorized or distinguished. Rather, instrumental violence and absolute violence are two ways in which violence emerges into and operates on a reality that is always constituted and conceived discursively. It is characteristic of Fanon's text that every scene of violence oscillates between these two discursive attractors, the instrumental and the absolute. Instrumental violence in Fanon's text is the violence of revolt and of reversal, the violence whereby the colonized challenge and attempt to upend the domination that has oppressed them. At the same time, another violence (perhaps alongside or unleashed by instrumental acts of violence) emerges as the world-shattering violence of decolonization. Decolonization destroys both colonizer and colonized; in its wake, something altogether different and unknown, a "new

humanity," will rise up. Thus, this absolute violence cannot be simply a means or instrument that the colonized may wield in order to depose the colonizer. As irruption and interruption, it is neither means to something else nor a condition for its own sake; outside means and ends, this violence shatters the very world that has determined the value and distinction of means and ends.

It is in relation to this non-instrumental violence of decolonization that "terrorism" as it appears in terrorism discourse must be understood. For if decolonization is the liberation of the world for and to a new humanity, "terrorism" might be seen as the face of decolonization from the perspective of the interests and entities that decolonization threatens. Thirty-five years after Sartre's apocalyptic fantasy as described in his Preface to *The Wretched of the Earth*, the West is no longer threatened by the specter of the former colonies rising up as a mass in a raging torrent of murderous violence. Today, the perception of such a threat has been condensed and focused into a single figure: "the terrorist." Terrorism in its contemporary incarnation appears uniquely linked to antagonisms formed in the aftermath of colonialism; the particular acts of violence labeled "terrorist" are typically the violence of formerly colonized groups against neocolonial or state oppressors. From the perspective of anticolonial sympathizers, such terrorism is a guerrilla tactic, one element in a larger struggle for liberation. But if a particular style of terrorism became a familiar revolutionary tactic in the anticolonial wars of the 1950s and 1960s, the "terrorist threat" as it appears in terrorism discourse today is no longer geographically localizable, nor does it any longer seem to be an expression of particular or local struggles. In its postcolonial incarnation in the 1980s and 1990s, "terrorism" stands as the violence of decolonization gone global.

The threat of decolonization as Fanon describes it is the threat of the end of this world, a destruction necessary to clear the way for a new birth. It is the profundity of this threat that I think is signaled by the panic-stricken tone of terrorism discourse. From the perspective of a hegemonic "new world order" in thrall to the continual threat of terrorism, there is a profound asymmetry between the actual incidence of terrorism and the power and force brought to bear against terrorism; an asymmetry between the actual threat and the fear. One cannot help but notice that no matter how many arrests, how many security measures, how many instances of "no negotiation," the terrorist somehow always returns. The threat of violence unleashed in relation to the terrorist is always more than the terrorist, always in excess. And in turn, the discursive ubiquity of the figure of "the terrorist," evidenced in its power to motivate huge expenditures to "eradicate terrorism," far exceeds the actual incidence of what is represented as terrorism. In this sense, terrorism is a specter that haunts social order and public safety; in so far as terrorism threatens to erupt at any moment against any "innocent" target, terrorism is ubiquitous and constant. The danger of terrorism, the violence of terrorism, is thus in excess of the effects of any particular "terrorist acts." This is what we might call a "spectral violence," the measure of a violence that is never fully materialized,

that is always in excess of its apparent material effects and that is neither containable, specifiable, nor localizable.

Thus, I would argue that the perception of ubiquitous "terrorism" today is not simply ideological illusion fueled by right-wing propaganda. If this were the case, it would be sufficient to reveal the distortions of terrorism discourse with data and facts. But the "terrorism" of terrorism discourse cannot be dispelled like a fog under the light of science, any more than it can be contained by the military and police arts. Rather, this terrorism, in all its ubiquity and uncontrollability, is as a discursive phenomenon entirely real. As a ubiquitous form of spectral violence, the threat of terrorism is simultaneously omnipresent and yet never quite materializes. The terrorist is, in this sense, structurally similar to the ghosts and vampires of the Victorian imagination, exemplary figures of the Freudian uncanny. As is well known, for Freud the uncanny (*unheimlich*) marked the moment when what was most familiar became most alien and threatening; the uncanny signals the undecidability between the inside of home (*heimlich*) and the alien outside of not-home (*unheimlich*). The Lacanian translation of uncanny as *extimité* emphasizes the workings of the uncanny as a disturbance to the bordering functions that separate inside and outside. Mladen Dolar explains: "the dimension of *extimité*…is located there where the most intimate interiority coincides with the exterior and becomes threatening, provoking horror and anxiety. The extimate is simultaneously the intimate kernel and the foreign body" (Dolar 1991: 6). We might recall that the response to the terrorist threat is, invariably, security: to improve and enforce the barriers protecting the "inside" from dangers coming from "outside." Security is thus understood as the successful separation of interior from exterior, the successful maintenance and protection of the boundary between interior and exterior. But if terrorism is *extimate* to security, then terrorism is not only a particular act of violence that penetrates the barrier from the outside; terrorism in its uncanny, excessive incarnation exposes security to its constitutive failure, for the outside that terrorizes is always already at the heart of the inside that demands to be secured. It is for this reason that terrorism appears at the limit as the threat of total destruction: if terrorism exposes the impossibility of separating inside from outside, it equally points to the fictiveness of any separation or distinction between inside and outside, and thus threatens the claim to difference that guarantees the identity of the inside as such. From the psychoanalytic perspective of the extimate, one might conclude that claims such as "terrorism threatens the West" or "terrorists seek to destroy the West" are not so much exaggerations as they are disavowed acknowledgments of the very non-existence of some securable or isolatable entity such as "the West" or "Western civilization."

Fanon's absolute violence of decolonization is akin to this discursive "terrorism." It is an uncanny violence in excess of any instrumentally conceived ends, a violence that cannot be contained or comprehended within social reality. The absolute violence of decolonization is outside agency or representation;

rather, it interrupts and erupts into history and wrests history open to the possibility of a justice radically foreclosed by the colonial order of reality. Fanon suggests that there is on the other side of this irruption the possibility of a "new humanity." This transformation of humanity might suggest that there is a dialectic of history at work in Fanon's account of decolonization. But I will argue that it is not the Hegelian dialectic of progress; rather it is something closer to Walter Benjamin's redemptive dialectic of revolution in which the "now" is not subordinated to any conception of "progress" but rather "blast[s] open the continuum of history"; in this dialectic, the present is not a transition to the future, but rather a "leap into the open air of history" without any way to know where the leap will land (Benjamin 1985: 262, 261). The "terror" of decolonization is the terror of radical possibility generated from within the scene of colonization. Decolonization promises (threatens) the total destruction of law and right and the beings that come into existence in relation to law and right, and the opening onto a future that cannot be known, that has not been given in advance by the narrative trajectory of history. And, I would suggest, this terror of decolonization is equally the terror that reappears today in the form of the "terrorist" who confronts Western hegemony with the threat of a total destruction that – because it has been produced in and by Western hegemony – can never be contained or controlled.

REVOLUTION, DECOLONIZATION, AND THE "ZONE OF NONBEING"

Fanon's account of revolutionary violence is most frequently interpreted as describing moments in a dialectic; first the reversal of black and white in the violent upheaval of revolution, then decolonization as the historic development now made possible for the previously colonized. For example, Lewis Gordon identifies in Fanon a

> two-stage theory of liberatory mediation. The oppressed, [Fanon] claims, achieve psychological liberation, or cleansing, by violating the oppressor. They are then free to go on with the more organized forms of violence (praxis), that are necessary for the building of a new, liberated society.
>
> (1996: 298–9)[2]

Yet what would be the basis for such a dialectic of development? For the "Manichean world" of colonialism is not a metaphor; it is rather a literal description of the new reality, simultaneously ideological and material, engendered by the colonial project. This Manichean world is one of absolute separation and opposition. Colonizer and colonized cannot enter into a dialectical process because they are absolutely opposed and mutually exclusive.

As Fanon specifies, "the two zones are opposed, but not in the service of a higher unity" (1963: 38). In contrast to the reading of Fanon as enacting a dialectic of revolution, Ato Sekyi-Otu has argued that the upsurge of violence into the scene of colonialism is described in *The Wretched of the Earth* as absolutely antidialectic; Fanon's "revolutionary catastrophism," Sekyi-Otu writes, "is a result of this refusal of a dialectical understanding of colonial history" (1996: 50). "Revolutionary catastrophism" indicates a rupture, a radical discontinuity, between the universe of colonialism on one side and a "new humanity" on the other.

In the place of a dialectical historical process in which violence appears in two stages, we might consider the violence that ruptures colonialism as appearing in two discrete forms: at once, *reversal*, the instrumentally violent wresting of power from the colonizer; and also, *authentic upheaval*, the violent crucible that creates a "new humanity." I want to suggest that we consider these two forms of violence in Fanon's text through the lens of Benjamin's efforts to distinguish between "mythical violence" and "divine violence" in his 1921 essay, "Toward a Critique of Violence." The originality of Benjamin's "Critique" lies in its attempt to rethink the relation between violence and instrumentality, to ask whether all violence is necessarily a tool in the service of some end (see Hanssen 1997). What Benjamin calls "mythical violence" is just such a tool, the violence that serves an end determined in relation to law. Thus, both the violence that founds an order of law and the violence that serves and preserves an order of law once founded are forms of mythical violence. But Benjamin insists that there is also some other violence that cannot be reduced to the working of law. The possibility of a non-instrumental violence, a sovereign violence that operates outside the means–ends relation, is the most controversial and disturbing aspect of Benjamin's analysis. In the name of this "divine violence," Benjamin would appear to unleash and glorify the most horrifying scenes of human cruelty and destruction imaginable. Yet Benjamin insists that this "divine violence" is bloodless and may not even be recognizable as violence: "For only mythical violence, not divine, will be recognizable as such with certainty, unless it be in its incomparable effects, because the expiatory power of violence is not visible to men." Divine violence is not destruction but rupture, the revolutionary violence that founds "a new historical epoch" (Benjamin 1986: 300). In Fanon's account of the violence of decolonization, violence oscillates between these two forms: a mythical violence that would found a new arrangement of rule within the flow of history (this new arrangement might be called "postcolonialism" or "neocolonialism"), and a divine violence that would herald the blasting open of history to an order not after but on the other side of colonialism.

What Fanon calls the violence of reversal is explicitly instrumental. It re- claims everything that has been denied to the colonized, and ousts the colonizer from every position of power: "decolonization is quite simply the replacing of a certain 'species' of men by another 'species' of men" (1963: 35).

Yet this reversal is not in itself decolonization, for as the subsequent critique of the rule of the "nationalist bourgeoisie" makes clear, the revolution against the settler, if it leaves the systemic structure of colonial relations intact, will in fact be no revolution at all. In the name of "national consciousness," the inauthentic revolution led by the nascent national bourgeoisie replaces foreign rule with native rule, yet takes this replacement to mean simply "the transfer into native hands of those unfair advantages which are the legacy of the colonial period" (1963: 152). The violence of reversal is thus the violence of one form of rule supplanting another form of rule, a violence commensurable with what Benjamin calls the "dialectical rising and falling in the lawmaking and law-preserving formations of violence" (1986: 300). The violence of reversal is violence in the service of law, a form of mythical violence that founds and sustains a particular reality. It may have as its end the substitution of a new rule of law for an old rule, but this substitution remains within the same order of history, the same "universe" defined by colonialism.

While the violence of reversal replaces the rule of the colonizer with the rule of the colonized, something much more is at stake in the violence of authentic decolonization: the very constitution of the being of native and settler, colonized and colonizer, blackness and whiteness. As Fanon insists, the colonial relation is historically generative: "For it is the settler who has brought the native into existence and who perpetuates his existence. [And in turn] the settler owes the fact of his very existence, that is to say, his property, to the colonial system" (1963: 36). The destruction of the colonizer is thus also necessarily the destruction of the colonized who exists as such only within the colonial system and only as the opposite term to the colonizer. For this reason, true decolonization is something much more radical that the reversal of position and the replacement of rulers; decolonization is the uprooting of the system as a whole, the supplanting of the political, existential, and corporeal reality created by colonization: "decolonization is the veritable creation of new men" (36). This is Fanon's "new humanism," one that would seek to replace the rule of European humanism – a false humanism that depends on subordination of its "others" – with a new and genuine humanism. Yet the "new man" Fanon promises is not a return to some precolonial human essence that has been until now distorted by European dominance. Rather, it is something unknown, something that is always emerging in decolonization and therefore always coming from the future.[3]

The violence of decolonization is thus the "divine" counterpart to the mythical violence of reversal. As divine violence, decolonization is an opening onto the radical alterity of the future accompanied by the emergence of beings who are not already determined by the colonial past but rather made possible only by a rupture with that past. It is from this perspective that we might understand Fanon's more explicit suggestion in *Black Skin, White Masks* that it is at the level of the "universe" that the rupture of decolonization must occur. Fanon argues that the "black man," constituted as object (not-man) within the

colonial system, is "rooted at the core of a universe from which he must be extricated" (1967: 8). Hence, this "extrication" will not simply be a challenge to the meaning of blackness as blackness, but will demand the collapse of the very universe in which blackness has been relegated to the status of object. The radical violence of an authentic decolonization is therefore at the level of the system as a whole; it destroys not only the relations of oppression or exploitation characteristic of the colonial system but also the very entities constituted by the colonial system, both "the settler" and its counterpart "the native," both black (not-man) and (white) man. It is from this perspective that Fanon's claim that decolonization is a program of "complete disorder" and "absolute violence" might be understood as something other than a description of social anarchy. For the violence and disorder are defined in terms of and from the perspective of the colonial order they challenge. "Complete disorder" is not the physical destruction wrought by instrumental violence (although instrumental violence may unleash or open the possibility of this complete disorder); rather, the complete disorder of decolonization points toward the collapse of an entire "universe," the "reality" of colonialism.

If decolonization is a violent upheaval that is beyond the law of colonial reality, then decolonization is not an event or a project that can be delimited or fixed. Rather than saying, in a historical mode, that decolonization initiates a process of historical transformation, it would be more appropriate to say that decolonization wrests open a gap which may (or may not) make possible some sort of historical rupture. In contrast, the instrumental violence of reversal is a violence of discrete acts and events, representable in terms of agents and ends. The violence of decolonization accompanies and is initiated by the violence of reversal; but the violence of decolonization immediately exceeds this instrumental violence. By initiating a violent struggle against the colonizer, the colonized open the space of decolonization. But decolonization is not the violence of the colonized that threatens bodies or properties; decolonization is rather the excessive violence that threatens reality as a whole. While the violence of reversal can be identified in terms of its material manifestations, the absolute violence of decolonization can only be "symbolic violence," violence that threatens the symbolic order, violence that bursts through history.

Like Benjamin's vision of a "pure violence" without end, Fanon's "absolute violence" is irreducible to the instrumental violence that enacts reversal. Absolute violence is recognizable not in violence as such (in its instrumental appearance) but rather in its epochal or world-shattering effects. It is thus a violence against violence, Benjamin's divine violence that breaks through and destroys the cycle of mythical violence, the "cycle maintained by mythical forms of law" (Benjamin 1986: 300). Benjamin suggests that, against the mythical cycle of law that posits or imposes order, divine violence only interrupts, only "deposes." The deposing of divine violence must be understood outside the traditional framework of means and ends. And as Werner Hamacher has argued,

deposing must also therefore be suspended outside the time of representation and the determinations of agency:

> Deposing for Benjamin is a historical event; yet it is one that puts an end to the cyclical history of legal institutions and that is not thoroughly determined by this history....Deposing requires an agent, yet this agent can neither have the constitution of a collective or individual legal subject, nor be conceived of as an agent at all, that is, as a subject of positings. Deposing must be an event, but not an event whose content or object could be positively determined....Deposing could not be the means to an end, yet it would be nothing but means. It would be violence, and pure violence, but therefore entirely non-violent.
>
> (1994: 115–16)[4]

Where the violence of reversal imposes a new rule in the place of the old, the violence of decolonization "deposes" all rule. The violence of decolonization "deposes" the system that has brought settler and native into being. It is a violence that must come not from native or settler, but from what might be termed an "elsewhere" and an "otherwise." Thus, while the events, stages, and methods of anticolonial struggle may be specified and described, the absolute violence of decolonization – what is for Benjamin the true revolutionary violence – is outside representation.

In Fanon's text, we might locate the non-narrativizable scene of deposing in what Fanon calls a "zone of nonbeing, an extraordinarily sterile and arid region, an utterly naked declivity where an authentic upheaval can be born" (1967: 8). While "sterile and arid," this "zone of nonbeing" nonetheless is (it is a zone, it is a region); if it cannot be represented positively, it nonetheless cannot be separated from its implicit counterpart, the unnamed "zone of being." But if there is a "zone of nonbeing," then the zone of being – the Manichean world divided among and inhabited by colonizer and colonized – is not everything. For although the reality of the colonial system, divided into Manichean opposites, would appear to provide an exhaustive and totalizing account of what is, this reality (like every construction of reality) is necessarily not real, that is to say, this reality can only be ideological.

By ideology, I do not mean a false representation or illusion that masks the true nature of social relations. Rather, ideology is the very condition of social relations, the necessary discursive or imaginary mediation between the real (what we might provisionally imagine as the chaos of sensory experience which has no subject) and the possibility of rendering experience intelligible, meaningful, or communicable by or to a subject. Thus, there is no opposition between reality and ideology; reality (in so far as it is meaningful or intelligible) can only exist as ideology. This reality, as Slavoj Žižek has emphasized in his writings on ideology, can never fully account for the real:

(what we experience as) reality is not the "thing itself," it is always-already symbolized, constituted, structured by symbolic mechanisms – and the problem resides in the fact that symbolization ultimately always fails, that it never succeeds in fully "covering" the real, that it always involves some unsettled, unredeemed symbolic debt. *This real (the part of reality that remains non-symbolized) returns in the guise of spectral apparitions.*

<div align="right">(1994: 21)</div>

Žižek suggests that this gap between reality and the real is the constitutive condition of reality, and thus every reality is sutured by the "spectral apparitions" that seem to fill the gap in reality. For Žižek, these are, in a sense, friendly ghosts that make it possible to experience reality as indeed real, even when we know that it is not. Such spectral apparitions complete the illusion that reality is whole, but they are not a part of reality. From the perspective of reality as ideology, Fanon's violence of decolonization – a violence that threatens reality itself – is similar to Žižek's spectral apparitions insofar as it is not symbolizable, but marks the very limits of the symbolic order. It has effects on reality and yet cannot be represented within reality. But perhaps, despite Žižek's attempts at domestication, the specter points to a truly disruptive danger. For while it seems necessary that, if there is to be meaning or intelligibility or consciousness, there be *some* reality (ideology), it is not necessary that it be *this* reality (ideology). The violence of decolonization is outside reality; but, rather than holding reality together (as Žižek might have it), it threatens to explode through reality and to force reality to give way to something altogether new.

Fanon says nothing more about that "zone of nonbeing" that heralds an authentic upheaval. But perhaps we might consider the zone of nonbeing as the space of a real that cannot appear within representation but that can only be marked by the persistence of a spectral haunting that is neither present nor absent. Fanon is not interested in the uncanny or in ghosts or phantoms, yet there is one spectral figure that haunts the margin of Fanon's text. It is a vampire, dreamed up by one of his patients who fears the vampire's predations. In the following section, I want to probe the spaces of this vampire. For the vampire signals, I will argue, an opening onto the "zone of nonbeing," the not-all of colonial reality. The terror of the vampire marks the violence of "deposing," a violence that cannot be represented within the normal modes of representation but which nonetheless signals a dangerous gap in reality, that is to say, a gap dangerous to the continuing existence of colonial reality.

VAMPIRE DREAMS

Through his psychiatric practice in Algeria, Fanon came to recognize the existence of a peculiar class of psychological disorders arising from what he calls

the "colonized personality." For Fanon, the colonized is rendered static, hemmed in both corporeally and existentially. Thus fixed, deprived of both spatial reach and by implication deprived of temporality or historicity, the colonized become, at the limit, but another element of the landscape:

> a colonized people is not only simply a dominated people....In Algeria there is not simply the domination but the decision to the letter not to occupy anything more than the sum total of the land. The Algerians, the veiled women, the palm trees and the camels make up the land-scape, the *natural* background to the human presence of the French....Railways across the bush, the draining of swamps and a na-tive population which is non-existent politically and economically are in fact one and the same thing.
>
> (1963: 250)

In light of the ordering principles of the colonial relation, which presume the non-existence of the colonized, the "mass attack on the ego" that Fanon associates with colonized personality disorders is not surprising; the colonized (non-)self is only repeating what the colonial situation assumes, his non-existence: "Because it is a systematic negation of the other person and a furious determination to deny the other person all attributes of humanity, colonialism forces the people it dominates to ask themselves the question constantly: 'In reality, who am I?' " (1963: 250).

This question, "In reality, who am I?," foregrounds the complexity of the relation between the reality of the colonial situation on the one hand and the subjectification of the colonized on the other. For if the colonial system positions the colonized as "non-existent," the reality of that system is challenged by the very form of a question, "who am I?," a question that expresses the disjunction between a reality that demands non-existence and a corporeal and psychical presence that exists, even if only in the negative mode of non-existence. The problem Fanon identifies as the "negation of the other person" is constitutive of the "psychopathology" that renders the colonized personality definitionally abnormal: defined as non-existent, the colonized can only be neurotic.

How can one live as non-existent? One of Fanon's patients literalizes this contradiction by invoking the topos of the vampire, the being who is not living but who exists nevertheless.[5] This patient is wrought by a nightmare of his blood spilling out:

> the patient talked of his blood being spilt, of his arteries which were being emptied and of his heart which kept missing a beat. He implored us to stop the hemorrhage and not to let him be "sucked by a vam-pire" within the very precincts of the hospital. Sometimes he could not

speak any more, and asked us for a pencil. Wrote: "I have lost my voice; my whole life is ebbing away."

(1963: 262)

Fanon describes this condition as a "living depersonalization." Yet the distinctiveness of this patient's fantasy must not be overlooked: the mass attack on the ego has become, in this patient's fantasy, a mass attack on the body. The hemorrhaging seems interminable, a perpetual blood-letting which can be neither staunched nor completed. Yet despite the massive blood loss, the patient continues to live. The patient's body – now suspended between life and death – becomes the effect of a reality that simultaneously denies, defines, and contains the colonized. If living depersonalization names the attack on the ego characteristic of life under colonialism, then the corresponding name for its corporeal manifestation might be *living death*.

A question immediately arises, for Fanon as analyst and for the reader: who is the vampire? For if the patient imagines a vampire stalking him, preparing to suck his blood, vampire myth would suggest that the patient himself risks becoming a vampire in turn. Fanon's therapeutic intervention will require the identification of this vampire, an attempt to translate the vampire into the patient's psychosocial history and thus free the patient from his tormenting fantasy. Yet the vampire, as a figure of contagion and multiplication, signals in advance the point that Fanon will suggest with this case history: in the case of the colonized, neither pathology nor cure can be isolated in the individual. The vampire haunts not only this individual patient, but also the colonial reality that constitutes the colonized as such. It is this reality that has conjured the vampire; and in turn, the only escape from the threat of the vampire is to destroy the reality that has conjured it: "I will tell him, 'The environment, society are responsible for your delusion.' Once that has been said, the rest will follow of itself, and what that is we know. The end of the world" (Fanon 1967: 216).

Continuing on the trail of the vampire, we might turn to political economy to supply one of the missing terms; for is not the colonizer but another version of Marx's capital: "dead labor which, vampire-like, lives only by sucking living labor, and lives the more, the more labor it sucks" (Marx 1977: 342)? Like the political economies of imperialism and capitalism, the vampire's excessive and insatiable appetite demands a constant stream of new conquests; and through each act of consumption, the vampire's strength grows. But political economy is only one aspect of the vampiric metaphor; the threat of the vampire permeates colonial reality. The vampire does not simply consume his victim. Rather, the vampire transforms his living victim into an animate corpse, one who walks and breathes, but whose life has "ebbed away." Thus, in his fantasy of the vampire, the patient repeats the image of colonized non-existence which Fanon characterizes as the existential dilemma of the colonized; the vampire is a literal figure for this condition of non-existence, a non-existence which is not

247

death but which is rather the undeath of the vampire, walking among the living and yet drained of life and of self.

In the patient's account of his nightmare, the vampire gradually gives way to a woman who comes at night to persecute him. Initially, Fanon interprets this woman to be the patient's mother. Thus, the preliminary diagnosis is that the nightmare reflects an "unconscious guilt complex following on the death of the mother." Yet as the patient reveals more, it becomes clear that this woman is not the patient's mother, but rather a settler woman whom the patient himself has killed. The patient's mother, it is true, is also dead, but it is not the patient who has killed her. Rather, it is a French soldier who "killed point blank" the patient's mother. On the other hand, the patient has killed a woman, but it is not his mother; rather, it is a settler woman, the wife of an "active colonialist." In the narrative shift between the mother's death at the hands of a French soldier, and the patient's stabbing of a French settler, the oedipal circuit between mother and son is interrupted and crossed by another circuit between settler and native. These two narratives of murder and guilt are, from the point of view of the personages involved, incommensurable. Yet they become, in the patient's dream, the same. The interpenetration of the Oedipal scene of individual psychogenesis (mother and son) and a more complex and politicized scene of sociogenesis (settler and native) is effected at the narrative level by the complex circulation of blood and blame.

The patient's narrative unfolds along a circuit of blood, tracing a path between the mother's lost blood at the hands of the French, the disemboweled French woman, and the patient's conviction that it is his own blood which is being drained. The vampire who threatens to suck his blood gradually metamorphoses into the woman he has killed: "This woman started coming every night and asking for my blood. But my mother's blood – where's that?" The mother's blood is irretrievably lost. Yet in the murdered woman's demand for blood is a displaced accounting: the patient will have to pay for the loss of his mother's blood with his own blood, despite his effort to extract the price of his mother's murder from the settler woman. The organizing principle of this economy is not Oedipal guilt that demands that the son pay for the death of the mother because he unconsciously wished it; rather, this is a colonial economy in which the currency is coined of the native's flesh, while the asymmetry of colonial power guarantees that whatever the sin or crime, only the native will pay.

In the patient's nightmare, the dead woman multiplies into a "manifold repetition of the same woman" who, in multiple form, "invades his room"; these women are "bloodless, pale, and terribly thin"; they insist "that he should give them back their spilt blood" (Fanon 1963: 264). It is the patient's blood these tormentors claim; but it is also his mother's blood that must somehow be repaid, as well as the murdered woman's blood that the patient has spilt. If the blood that the phantomal women demand is somehow the women's own blood, then the patient's blood, the blood that drains from his body to fill their

bodies, is already not properly his, but guiltily stolen at the scene of revenge for the loss of the mother's blood. Whose blood is it, then? The blood in this narrative is a currency to which continuous claims of ownership are made; and yet as currency the blood must continually circulate between the soldier, the settlers, and the soldier's mother. This promiscuous flow of blood stages a collapse of proper corporeal boundaries, threatening the solidity of body with a blood that will not stay in place.

It is with some trepidation that I pursue the path of the patient's blood. For the signal importance of blood in the crossing discourses of race and sexuality indicates a somewhat overwhelming complexity of possible interpretations. One might emphasize here the relation between metaphors of blood and race, and the way in which the interflow of blood establishes a scene of racial contamination and interpenetration. One might also consider the manner in which colonial extraction of value is sexualized, such that the colonized's virility is drained by the colonizer's demands (where the colonizer appears as castrating woman). However, I want to leave aside these alternative interpretive strategies in order to emphasize a particular aspect of this bloody scene which connects it to Fanon's "zone of nonbeing." As I suggested in the previous section of this essay, the "zone of nonbeing" holds a particular place of importance in Fanon's thought of revolution. Obviously, the vampire itself is a kind of "non-being." But what is more interesting is that, in the blood economy of the patient's dream, all bodies become "non-beings" figured as suspended between life and death.

The vampiric threat that inaugurates the story of the patient's nightmare begins as a specified figure but quickly begins to metamorphose and multiply. The threat of the vampire thus cannot be isolated to a single figure or position; rather, this threat permeates the entire scene. The blood that flows through all bodies but belongs to no body, the blood that is continually drained but never depleted, enacts a disruption of bodily boundaries and thus of stable identities, and imposes a condition of indeterminacy on the distinction between living and dead. Thus, it would be a mistake to conclude that the vampire simply stands as a metaphor for the colonizer, such that the pathological terror of the patient can be understood as an extreme version of the "normal" relation between colonizer and colonized. And although the vampire threatens contagion, such that to be bitten by a vampire is to become a vampire, the colonized does not unequivocally take up the position of the vampire. In sum, one cannot simply identify the figure of the vampire with either the colonizer or the colonized; the threat of the vampire is equivocal, identified more properly with the entire scene of colonial non-existence. The vampire is simultaneously the force that threatens to drain the life from the colonized, and the condition of the colonized as living dead.

Thus, the vampire is both in-between and outside of the Manichean opposition of native and settler. Where the colonial system claims to be "all," the persistence of the vampire exposes this "all" to something else, a being neither

living (as the colonizer) nor dead (as the landscape or the colonized bodies filling that landscape). The vampire marks the "not-all" of colonial reality.

KANT AND THE VAMPIRE

The vampire, and related specters of the living dead, are recurrent figures in Žižek's Lacanian account of the ideological constitution of reality and the haunting persistence of the unrepresentable real (see especially Žižek 1993: 108–14; 1991: 219–22). It is (at least in Žižek's reading) Immanuel Kant who is the first to locate a certain "vampiricity" in any attempt to construct a rational account for the world or reality. Žižek suggests that Kant's every effort to institute a domain of pure reason which would render the world totally transparent to knowledge is haunted by a philosophically "monstrous apparition," a Thing that exists for reason only in the form of non-existing, a vampiric "living dead." This haunting apparition is the mark of the necessary foreclosure whereby there may be any reason – and any reality – at all.

While Žižek does not flesh out the historical or political resonances of Kantian vampiricity, I would suggest that by pursuing the trail of Fanon's vampire back through Kant's *Critique of Pure Reason*, we might gain a richer understanding of the relation between Enlightenment reason and colonial reality. Reason, for Kant, must be understood in terms of the non-coincidence between objects as representations for us (the phenomenal) and objects as things in themselves (the noumenal). Kant argues that we can only know the world insofar as it is an object of our representation. It is because there is representation that there is experience, knowledge, and reason. But when Kant insists that "we can never transcend the limits of experience" to reach the things in themselves, he is both describing the condition of reason, and marking a necessary but unspoken prohibition (1965: B xx). For if the limits of experience are transcended, if reason could somehow come into contact with the thing in itself, reason would no longer be reason. There is always this danger lurking at the limits of reason: that the boundary that institutes reason as the separation from the thing in itself might fail to hold. The "scientific" practice of Kant's *Critique* thus shifts from a description of reason to a proscription to protect reason: "we must never venture with speculative reason beyond the limits of experience" because any such venture beyond proper limits "threaten[s] to make the bounds of sensibility coextensive with the real" (1965: B xxv). Most simply put, if reason's domain were coextensive with the real, if reason were no longer separated from the noumenal, there would be no more representation, and thus no more reason. Thus, the limits on speculative reason have "a positive and very important use": to protect reason and rescue it from that which "threatens to destroy it" (B xxv).

The *Critique of Pure Reason* emphasizes the necessity of limits to the determination and securing of a proper domain for reason. It is this limiting,

bounding, or excluding gesture that more generally characterizes the "scientific reason" of Enlightenment thought. But the exclusions of Enlightenment thought are not simply speculative; they are equally material and historical, whence the by now familiar critique of the collusion between European enlightenment and European imperial and colonial domination. For if "Man" is to know and to govern the world through the exercise of reason, then the distinction between Man and World, between human and non-human, is already implicit. As Robert Young points out, "humanist is itself already anti-humanist. That is the problem. It necessarily produces the non-human in setting up its problematic boundaries" (1990: 125). Yet the boundary-drawing operation that guarantees the domain of the human may not so simply result in the binary opposition between human and non-human. From Kantian philosophy (and its imaginative correlative, Gothic fiction) to the contemporary political ideal of a posthistorical global order, we witness the repeated scene of an uncanny threat that emerges as the shadowy counterpart to the ordering divisions that uphold knowledge and rule. Kant's speculative reason is haunted by the persistence of the thing in itself that threatens to destroy reason; the transcendental Subject is haunted by an uncanny double that evades and challenges the subject's claim to total knowledge; the colonial scene, whose stability is governed by the colonizer's knowledge of and power over the colonized, is haunted by a spectral "vampire"; the total security of a new, neocolonial Western hegemony is haunted by a ubiquitous and uncontrollable "terrorist."

If the scene of haunting signals the foreclosure necessary to institute the foundational limits of reason, then it should not be surprising that uncanny figures of spectrality should emerge in Kant's text at precisely those moments when the limits of reason are most at stake. It is what Kant calls the "antinomies of pure reason" that simultaneously raise and mark the limits of reason. For while reason is limited in its knowledge to the phenomenal appearance of things, yet insofar as it is reason, it speculates about what is beyond the phenomenal appearances. It is in this speculation that reason encounters antinomies, the apparent contradiction of an "idea that can never be reconciled with appearances" (Kant 1965: A 408/B 435). The antinomy marks the suspension of reason between the prohibition against coming too near the thing in itself, and the compulsion that drives reason to seek knowledge of that very thing that would destroy it.

As Kant is aware, the impasse of the antinomies is not a contingent mark of reason's failure, but rather the very condition of reason. It is the foundational separation from the thing in itself – and thus the possibility of representation – that institutes reason; the thing is thus not external to reason but its very center. In Lacanian terms, the thing in itself is *extimate* to reason. If the *Critique of Pure Reason* seeks to set reason on a firm footing, its strategy is to remove the danger to reason by transforming the *extimate* relation between reason and the thing into a more manageable exteriority. One particular management

technique for rationalizing and controlling the extimacy that structures the relation between reason and the thing is what Kant calls "indefinite judgment." Indefinite judgment aims to definitively re-mark the exclusion of the thing from reason's domain even when reason approaches it most nearly.

The mechanism of indefinite judgment – to specify the thing only in terms of what it is not – is explicitly a boundary-drawing operation. Indefinite judgment takes the following form: because we cannot (must not) know the thing in itself, the only positive statement we can make about it is that it is non-phenomenal. As Žižek puts it, in describing the (noumenal) thing in itself,

> all our (finite) thought can do is to draw a certain limit, restrict the field of our knowledge, without making any positive statements about its Beyond....By saying 'the Thing *is* non-phenomenal'...we do not make any positive claim about it, we only draw a certain limit and lo-cate the Thing in the wholly nonspecified void beyond it.
>
> (1993: 111)

Indefinite judgment specifies a positive knowledge of what cannot be known by emphasizing the boundedness of what can be known. Indefinite judgment thus falls precisely at the border that excludes from the domain of reason what cannot – what must not – be experienced. Yet as Kant's example of indefinite judgment suggests, this prophylaxis is never entirely successful. For even if reason can, through indefinite judgment, exclude the thing in itself from the limits of reason, the thing nevertheless persists in spectral form:

> If I should say of the soul, "It is not mortal," by this negative judg-ment I should at least have warded off error. Now by the [indefinite] proposition, "The soul is non-mortal," I have, so far as the logical form is concerned, really made an affirmation. I locate the soul in the unlimited sphere of non-mortal beings.
>
> (1965: A 72/B 97)

In Kant's fortuitous choice of examples, he indicates reason's approach to its limits as an approach of the uncanny. To foreclose what reason cannot know is always also to expose reason to this uncanny return. In the case of Kant's example of the soul, it would seem that because we cannot know the soul, we necessarily know the soul in the uncanny form of non-mortal, as *simultaneously* what is most familiar (mortal) and what is most alien (not mortal). The object of knowledge that cannot be an object of knowledge takes on the aspect of a ghost: the soul is not living but neither is it dead. The soul has become one of those phantomal living dead, of which the vampire is but one manifestation.

Kant's uncanny void of the "unlimited sphere of non-mortal beings" is repeated, I would suggest, in the scene of Fanon's description of the colonial landscape. The settler's view of the native as part of the landscape (the native

does not exist) is haunted by the persistence of the native as living being (the native exists) who nonetheless cannot appear as such. Hence, the native can only exist as non-existent. The "empty" landscape perceived by the colonizer is shadowed by an uncanny double, a landscape traversed by the "non-existent" colonized. Thus, while the colonizer would exclude the colonized from the realm of "mortal beings," the colonized returns in the form of a "non-mortal being," non-existent, a ghostly double that exceeds the delimitation whereby the colonizer has determined the colonized as object. The thing that has been excluded as the condition for the colonizer's view of the "empty landscape" – the existence of the native – returns as a monstrous apparition that threatens the order of the landscape and the colonizer who rules it.

The uncanny non-existence (that of the undead) that disturbs the opposition between existing and its simple negation ("not existing") suggests how we might understand Fanon's "Manichean world" as anti-dialectical without concluding that the static opposition between colonizer and colonized is therefore immutable and non-historical. This opposition is, for Fanon, the opposition of Aristotelian contraries: "the two zones are opposed, but not in the service of a higher unity. Obedient to the rules of pure Aristotelian logic, they both follow the principle of reciprocal exclusivity" (1963: 38–9). Within this Aristotelian logic, the native's claim to exist, to be human, cannot be comprehended at the same time as the settler's claim that the landscape is empty, that the only one there is the settler. If the settler is human, the native is not human. Yet while the two terms are "reciprocally exclusive," there persists an uncanny excess indicated by the indefinite form that disturbs the categorical opposition. If the settler's own determination as human depends on the exclusion of the native from the realm of the human, this exclusion is radically unstable. The impossibility of such exclusion becomes manifest in the haunting persistence of the native as non-human, an indefinite form that troubles the boundaries of the human. Where the settler seeks to determine the native as dead, inert matter, the persistence of a spectral remainder of undead disturbs this static division between settler and native. Beyond the living subject of the settler and the dead object of the native is this void which is not-empty, a no-place and a no-thing which cannot appear as positive being but which nonetheless interrupts the reality of the colonial landscape. This disturbance is what I am calling the vampire, not-living and not-dead, not-settler and not-native.

The vampire thus simultaneously exceeds and interrupts the opposition between the living being of the settler and the dead matter of the native. The vampire is not the native; but the vampire comes from the native in a certain sense, insofar as it figures the living being of the native which cannot appear in colonial reality, and which therefore re-emerges in spectral form. Colonial reality is haunted by the real of the native that cannot be recognized as living being: "spectral apparitions emerge in this very gap that forever separates reality from the real, and on account of which reality has the character of a (symbolic)

fiction: the specter gives body to that which escapes (the symbolically structured) reality" (Žižek 1994: 21). The spectral supplement of the vampire is the haunting remainder that insists that the ideological reality of the colonial universe, the Manichean division of settler and native, is not real, that the totalizing opposition between settler and native is "not-all." This means that within colonial reality, there is no escape from the vampire. The vampire is a constant threat, an inescapable haunting. The vampire is an inextricable element of the relation that brings settler and native into being. It is in this sense that we might conclude that the vampire terrorizes reality; the vampire is a terrorist.

VAMPIRE, TERRORIST

The spectral terrorist of terrorism discourse, like Fanon's vampire, signals the possibility and the immanence of an epochal collapse of the law that constitutes this history and this reality, and an opening onto some otherwise and elsewhere. This is not to advocate a practice of terrorism as a means of achieving a more authentic revolution. For the threat to reality that is signaled by terrorism in its most powerful discursive formations has little to do with the practical acts of violence that are described as terrorism. On the contrary, terrorism, conceivable from within the law only as a violence that is absolutely beyond the law, is dangerous precisely because it holds the seed and secret of the bursting forth of another, unknown future.

If Fanon seems on a superficial reading to be "for violence," a more complex consideration of the multivocity of violence in Fanon's text suggests that Fanon is neither celebrating nor justifying the violence of the colonized; rather he is indicating the complexity of the relation between reality and violence. The violence of decolonization is constitutively doubled: it is at once the violence of the colonized that can be represented within the symbolic order, and another violence, alongside or in excess of this first instrumental violence, that exceeds the possibility of representation. It is in this sense that the violence of decolonization is spectralized, appearing once as instrumental violence and then reverberating uncontrollably in the spectral form of a violence that cannot be represented but nonetheless disturbs the conditions of representation. From this perspective, what I earlier described as "terrorism discourse" appears as simultaneously absolutely true and absolutely false. Terrorism discourse indicates the opening of decolonization as an endless violence that threatens the very constitution of reality. Yet terrorism discourse can only narrate this violence by returning it to the instrumental framework of means and ends, inventing a "terrorist" or a "terrorist network" which might explain, and thereby control, a violence that threatens the foundations of reality.

Although it is the psychoanalytic account of the uncanny that exposes the paradoxical extimacy of "terrorism" to the very order it appears to threaten, there is also in psychoanalysis a conservative tendency that works to domesti-

cate the "terrorist threat" and defuse its most destructive or revolutionary impulses. In particular, when the uncanny is universalized as the condition of subjectivity and social reality, then no specific site or instance of the uncanny is understood to bear any particular historical or material significance. Thus, Žižek insists that the specter – as some incursion into reality of the Real that has been foreclosed to achieve reality – demands nothing; the specter is but a sign of the inherently, necessarily incomplete character of any social reality. Žižek concludes that "our primary duty is not toward the specter, whatever form it assumes" (1994: 27). But "social reality" is not neutral or universal, any more than the "subject" of modernity or the "subject" of psychoanalysis is neutral or universal, whatever its pretensions to the contrary. Žižek's insistence that the specter demands nothing might be taken as a form of disavowal of the ideological privilege of a certain subject position. That is, viewing the specter as a "friendly ghost" that sutures reality in order that the subject might comfortably experience reality as real implies a certain harmony between the subject and reality. Yet colonial reality might only or primarily be comfortable, one would suppose, for the colonizer.

In contrast, to allow the possibility that the specter that sutures reality might also terrorize that reality suggests not only that reality is "not-all," but that the way in which reality is not all is invested in particular ways. If we recognize the specter as a "terrorist," then the question of our duty toward the specter becomes more complex than Žižek supposes. I have suggested that the spectral violence of terrorism is a threat to reality itself. "Terrorism" is therefore figured discursively as the site of a radical alterity – "pure evil" – that must be absolutely excluded in order to guarantee the security of social order. Thus, the "terrorist threat" is typically met with the purely conservative duty of security. Fanon, however, would suggest that we view this security otherwise, as the securing of a particular colonial order against the disruptive force of the violence of decolonization. From this perspective, the "terrorist threat" is indeed a demand. It is, we might say, a demand emanating from the "not-all" of reality, a demand that reality be otherwise.

While Žižek insists that the specter demands nothing, Derrida has argued that the specter does indeed demand something: justice. Justice is, for Derrida, the absolute converse of security. For while security preserves and perpetuates the rule of law, justice must be that which exceeds the law, that which exceeds in particular the calculability given by the law. Thus, while security is always more of the same, justice for Derrida can never be known in advance:

> Justice remains, is yet, to come, *à venir*, it has an, it is *à-venir*, the very dimension of events irreducibly to come. It will always have it, this *à-venir*, and always has. Perhaps it is for this reason that justice, insofar as it is not only a juridical or political concept, opens up for *l'avenir* the transformation, the recasting or refounding of law and politics.
>
> (1992: 27)[6]

255

How might such a justice answer to the demand of "terrorism"? This justice to come is a justice discontinuous with the present; justice to come indicates a futurity not of progress, but of rupture. It is, for Fanon, the violence of decolonization that makes possible such a rupture into history. And likewise, it is the violence of decolonization that wrests open a space from which will emerge the "new human" to supplant the exclusions of European humanism. But Fanon's gesture toward the "new human" that emerges out of the space of decolonization is neither a correction of a bad old humanism nor a prescription for a new and better humanism. Rather, this "new human" is something that cannot be known or predicted, that cannot be foretold or produced, but that simply comes. If the spectral violence of "terrorism" that pervades contemporary life is, as I have argued, the violence of decolonization from the other side, then it is altogether misleading to speak of the postcolonial. For Fanon shows us that decolonization is not an event that happens in history; it is rather the shattering of that history and the opening to an otherwise that cannot be given in advance, but that is always, like justice, to come.

NOTES

1 In addition to the analysis of terrorism discourse in Zulaika and Douglass (1996), see the collected essays and discussions in Brown and Merrill (1993).
2 Gordon cites as additional authorities for this reading E. Hansen (1976) and L.A. Jinadu (1986).
3 More detailed accounts of Fanon's humanism which seek to distinguish it from a return to Enlightenment universals can be found in Alessandrini (forthcoming) and Robert Bernasconi (1996).
4 My thinking on violence in Benjamin has also benefited from the analyses of Hanssen (1997) and Derrida (1992).
5 The case appears in the final chapter of *The Wretched of the Earth*, "Colonial War and Mental Disorders," Series A, Case no. 3: "Marked anxiety psychosis of the depersonalization type after the murder of a woman while temporarily insane" (1963: 261–4).
6 On justice and the specter, see also Derrida 1994, especially pp. 10–37.

REFERENCES

Alessandrini, A. (forthcoming) "Humanism in Question: Fanon and Said," in S. Ray and H. Schwartz (eds) *A Companion to Postcolonial Studies*, Cambridge, MA: Blackwell.
Arendt, H. (1972) "On Violence," in *Crises of the Republic*, New York: Harvest/HBJ.
Benjamin, W. (1985) "Theses on the Philosophy of History," in *Illuminations*, trans. H. Zohn, New York: Schocken.
—— (1986) "Critique of Violence," in *Reflections: Essays, Aphorisms, Autobiographical Writings*, trans. E. Jephcott, New York: Schocken.
Bernasconi, R. (1996) "Casting the Slough: Fanon's New Humanism for a New Humanity," in L.R. Gordon, T.D. Sharpley-Whiting, and R.T. White (eds) *Fanon: A Critical Reader*, Cambridge, MA: Blackwell.
Brown, D.J. and Merrill, R. (eds) (1993) *Violent Persuasions: The Politics and Imagery of Terrorism*, Seattle: Bay Press.

Derrida, J. (1992) "Force of Law: The 'Mystical Foundation of Authority,' " in D. Cornell, M. Rosenfeld, and D.G. Carlson (eds) *Deconstruction and the Possibility of Justice*, New York: Routledge.

—— (1994) *Spectres of Marx: The State of the Debt, the Work of Mourning, and the New International*, trans. P. Kamuf, New York: Routledge.

Dolar, M. (1991) " 'I Shall Be with You on Your Wedding-Night': Lacan and the Uncanny," *October* 58: 5–24.

Fanon, F. (1963) *The Wretched of the Earth*, trans. C. Farrington, with a preface by J-P Sartre, New York: Grove.

—— (1965) "Algeria Unveiled," in *A Dying Colonialism*, trans. H. Chevalier, New York: Grove.

—— (1967) *Black Skin, White Masks*, trans. C.L. Markmann, New York: Grove.

Gordon, L.R. (1996) "Fanon's Tragic Revolutionary Violence," in L.R. Gordon, T.D. Sharpley-Whiting, and R.T. White (eds), *Fanon: A Critical Reader*, Cambridge, MA: Blackwell.

Hamacher, W. (1994) "Afformative, Strike: Benjamin's 'Critique of Violence,' " trans. D. Holander, in A. Benjamin and P. Osborne (eds) *Walter Benjamin's Philosophy: Destruction and Experience*, New York: Routledge.

Hansen, E. (1976) *Frantz Fanon: Social and Political Thought*, Columbus: Ohio State University Press.

Hanssen, B. (1997) "On the Politics of Pure Means: Benjamin, Arendt, Foucault," in H. de Vries and S. Weber (eds) *Violence, Identity, and Self-Determination*, Stanford, CA: Stanford University Press.

Jinadu, L.A. (1986) *Fanon: In Search of the African Revolution*, London: KPI.

Kant, I. (1965) *Critique of Pure Reason*, trans. N.K. Smith, New York: St. Martin's.

Marx, K. (1977) *Capital, Volume I*, trans. B. Fowkes, New York: Vintage.

Sekyi-Otu, A. (1996) *Fanon's Dialectic of Experience*, Cambridge, MA: Harvard University Press.

Young, R. (1990) *White Mythologies: Writing History and the West*, New York: Routledge.

Žižek, S. (1991) *For They Know Not What They Do: Enjoyment as a Political Factor*, New York: Verso.

—— (1993) *Tarrying with the Negative: Kant, Hegel, and the Critique of Ideology*, Durham, NC: Duke University Press.

—— (1994) "The Spectre of Ideology," in S. Žižek (ed.) *Mapping Ideology*, New York: Verso.

Zulaika, J. and Douglass, W.A. (1996) *Terror and Taboo: The Follies, Fables, and Faces of Terrorism*, New York: Routledge.

14

"I AM NOT THE SLAVE OF SLAVERY"

The politics of reparation in (French) postslavery communities

Françoise Vergès

On May 23, 1998, for the first time in France, more than 20,000 Antilleans, Guyanese and Réunionnais demonstrated in the streets of Paris as *Negroes*.[1] They marched silently from République to Nation, two of the city places whose names are associated with left and revolutionary politics, in honor of their foremothers and forefathers who died victims of slavery. It was an unprecedented event. Intellectuals, workers and artists claimed their filiation with their *enslaved* ancestors and demanded the recognition of slavery as a crime against humanity. The demonstration was the expression of a will – to be present as descendants of slaves and colonized in the heart of France – and a response to the revisionist discourse of the French government. Indeed, the French government has chosen to commemorate the 150-year anniversary of the abolition of slavery in the French colonies[2] with a discourse of racial reconciliation whose effect has been to reduce the responsibility of the French state in the history of slavery and the role of the slaves' revolts in its abolition.

The government seemed embarrassed, as if it wished that the role and function of slavery in the making of France would wither away. Few French know that their country was among the great slave traders, that the economy of slavery organized the lives and work of thousands of people in the *métropole* and the French colonies, and that today among the citizens of the French nation there are descendants of slaves. The discourse that constructs France as synonymous with liberty, that presents its philosophers as the advocates of equality and rights, and that associates the end of slavery with the goodwill of the republicans reinforces among the French the conviction that slavery belonged to a foregone past. The fact of blackness remains ignored and the experience of Martinicans, Guadeloupeans, Guyanese and Réunionnais as *descendants of slaves* continues to be marginalized. They are French citizens, they carry a European passport but experience discriminations which are not analyzed as such. The message is thus: since they are French and since the Republic cannot *par essence* discriminate, they have no grounds upon which

258

they can make their claims. On Saturday May 23, the demonstrators challenged the "absurd catalog of official history"[3] and demanded the revision of a rhetoric that continues to deny their existence and their role in the history of democracy and citizenship.

The issue of reparation – symbolic and material – has been raised. What reparation are the descendants of slaves entitled to demand of the French State? What constitutes reparation? Connected with this reflection, the following question has re-emerged: What constitutes the experience of being black and a citizen of a country that resists confronting its responsibilities in the slave trade and colonial racism and claims that its democratic and republican foundations share no complicity with these facts? What constitutes the fact of blackness, the *expérience vécue du noir*, in France? The question has been tackled by black intellectuals for some time. In the 1920s, they affirmed the existence of precolonial African civilizations and cultures. They debated whether *métissage* was the answer to a Europe fascinated by the politics of blood and purity or another form of erasure within the empire. In the 1950s, Frantz Fanon argued in *Black Skin, White Masks* that a politics of reparation should be based on the defeat of the colonial power. A new humanism signified transcending the classification of black/white and for the black to become a "man among other men." To Fanon, the past was a burden and to be free meant first to relieve oneself of that burden. Today, young Martinicans, Guadeloupeans and Réunionnais wish to carry that burden, to awaken the past and walk through the streets of Paris as *Negroes*. In 1952, Fanon claimed: "I am not the slave of slavery." On Saturday May 23, we said: "Honor and Respect to the memory of our parents who died in deportation and slavery." In this essay, I wish to analyze the politics of forgetfulness and reparation from the 1920s to today among the Creole communities born of slavery and colonialism.[4] First, I retrace the responses of the black diaspora of the 1930s. Then, I examine Fanon's politics of reparation. Finally, I turn to the politics of reparation which are being elaborated today.

ABOLITIONISM, COLONIALISM AND REVISIONISM

It could be useful to present the contemporary context of the re-emergence of the issues around historical crimes and political reparations. When on April 27, 1848 the Second Republic abolished slavery in its colonies, 250,000 persons were freed in Martinique, Guadeloupe, Guyana and Réunion. The commemoration of the 150-year anniversary of the event constituted an opportunity to revise memories of the trade and of slavery. To the French government, it signified celebrating the role of the Republic while paying a formal homage to the creativity of Creole communities. Through its *Chargé de mission*, the Guadeloupean writer Daniel Maximin, the French government has affirmed its

will to celebrate fully this "essential act of freedom," declaring that the "struggle for the abolition of slavery is *identical to the struggle with the Republic.*"[5] In the official discourse, the association of slavery with the *Ancien Régime* and its abolition with the Republic obliterates how servitude and racism were reconfigured, how new forms of discipline emerged, and how abolitionism and colonialism were complementary ideologies. In postslavery societies, the plantation remained the unit of production; racism organized social and cultural relations; democracy was limited and the colonial status reinforced the dependence of the colonies upon France. In 1848, the abstract vocabulary of rights hid new relationships of domination and exploitation. In 1998, the abstract vocabulary of republican reconciliation hides the ways in which Creole minorities are still excluded from equality and autonomy.

For the descendants of slaves, the notion of reconciliation, the 1998 program of "*Doudous* and dancing Negroes," is an insulting denial. "Tous nés en 1848" ("All of us were born in 1848"), the motto of the government's program, masks the permanence of racial injustice and gives the Republic a maternal role and function, repressing the figure of the black father and mother and of the role of the Haitian revolution which gave birth to a *free* black citizen outside of Africa. From the descendants of slaves, the issue of reparation has been raised. The *devoir de mémoire* (duty of memory) has become an imperative. This duty, this obligation, is not about a politics of resentment but about a politics of reparation. Reparation refers to the act of mending or restoring a damaged object as well as to the act of making amends, giving satisfaction for a wrong. The French State has proved its resistance to making amends for a crime against humanity. Slavery, its Minister of Cooperation has argued, does not fit with the definition of "crime against humanity." True, the French government admits that slavery constituted a terrible wrong, but the responsibility of the French State is not addressed, nor the issue of reparation. In the French government's document which announced the commemoration of the 150th anniversary, the Minister of Culture and the Minister of the Overseas Territories wrote: "The combatant of liberty like the maroon in the colonies and the European abolitionist, can each adopt as its own Fanon's declaration: 'I am not the slave of Slavery that dehumanized my ancestors' [Fanon 1967: 230]." The myth of natural solidarity between the maroon and the abolitionist deflects the political and ethical accountability of the French State. French identity was also built upon the exclusion of the black from what defines French citizenship: equality, liberty, fraternity. The *Code noir* (France was the first power to issue a code of laws that regulated the working conditions, sexuality, life, modes of filiation of the persons it enslaved) clearly delimited the boundaries of French whiteness: liberty was associated with whiteness, bondage with blackness. The abolitionism of 1848 did not question the assumption. It rested upon a Christian vision of brotherhood and was unable to imagine the "liberty" of French colonialism and capitalism to invent new forms of servitude and bondage. Abolitionists described the world of the

plantation in order to awaken a moral condemnation among their readers. Their narratives brought tears to Europeans; the rhetorical devices of good and evil supported a theory of reconciliation rather than struggle. Slavery, they said, was a corruptive force; it corrupted the masters like the slaves. The colony was the reverse image of the *métropole*: the former was dissolute, idle, violent, the latter sought justice and harmony. The abolitionists of 1848 were sincere republicans and thus convinced of French superiority. They bequeathed a burden to the emancipated slaves: to be worthy of the freedom "given" to them by France, *La Mère-Patrie*. Emancipated slaves had a debt and they could repay the debt by becoming dutifully colonized. The abolitionist discourse of 1848 reduced the free person to a debtor and bonded laborer. In the same move, the abolitionists of the Second Republic Solidarity put an end to an extreme form of servitude and announced republican colonialism. Liberating those enslaved by the "barbarians" would justify the colonization of Algeria and Madagascar.[6] Solidarity was not (and can never be) natural: it was and is a politically constructed act. In 1848, the task of reconciliation fell upon the emancipated. The masters received financial compensation for their "loss." The emancipated had to prove that they deserved the bonded freedom bestowed upon them by the colonial power. In 1998, the task of reconciliation still falls upon the descendants of slaves. France is not ready to take into account an "alterity which is constitutive but which, for the most part, it denies" (Balibar 1998: 74).

The perverted use and abuse of Fanon's words demonstrates the will of the French government and its allies to speak for the descendants of slaves. Fanon defended a *devoir de mémoire* which implied defeating racism and moving forward away from a celebration of the past that was defeating. How do we construct the duty of memory? Why do we have this duty? Fanon feared that this duty would be a burden. Today, young Antilleans claim that this burden is their duty. What is the cultural and political project which this duty inspires? What constitutes the "reparation" of slavery, an appropriate sanction for such a loss?

NEGRESSES AND NEGROES IN 1930S PARIS

Colonial soldiers of the French empire and African-Americans soldiers had fought in World War I. Tens of thousands of them stayed in France after the armistice. They constituted the first important black community living in France, nearly 30,000 individuals. Their encounter transformed their consciousness and brought a new alterity to the *métropole*. Senegalese, Malagasy, Antilleans, Cameroonians, Moroccans, Réunionnais, Vietnamese met each other and all met African-Americans. The colonized, the descendants of slaves, the black diaspora had finally come together. Journals and reviews were published; some of them would last many years, others would disappear after

one issue, but their sheer existence, the diversity of the themes they tackled, the polemics that took place, testified to the emergence on the cultural and political scene of a new group which saw its role as a relentless critic of racism and colonialism as well as the creator of a new culture. The diaspora reflected on the ideology of fascism and its relation with colonial racism in the French empire. Black intellectuals, artists and workers invented a *Paris noir*[7] in which they asserted their emerging autonomy through a process of "deterritorialization" – the process whereby there is a subversion of discourse conventions that wrench the hegemonic language from the possession of its cultural overlords. There was a radicalization of the attacks against colonialism. Reparation was about denouncing racism, the hypocrisy of French republicanism, challenging the alleged superiority of European civilization and affirming the existence of precolonial African civilizations and cultures.

Few among the African-Americans were aware of colonial crimes and of the terrible working and living conditions of the 200,000 workers brought from the empire to work in French factories. Though there were no Jim Crow laws in France, colonized populations were subjected to discriminatory policies, forced labor and racism. There had been slavery in the old colonies and France had participated in the slave trade. It was the republic which had launched the enterprise of colonization. Colonial intellectuals often shared the vision of France as the country of liberty. They promoted the idea that there were "two" Frances. They would claim republican France as their motherland and reject colonial France. Maran wrote thus: "Colonial France is in constant and basic opposition with France" (Maran 1923; quoted in Dewitte 1985: 83). The majority of colonized peoples saw no contradiction in this notion of "two" separate and opposed Frances, as if republican and revolutionary France had not engendered colonial France.

The same French government which condemned the American armed forces' racism did not hesitate to enforce a discriminatory policy against its colonial soldiers. The latter could not be high-ranking officers and they did not receive the same pay as the French soldiers. Colonial soldiers had, however, claimed their love of France. In the first autobiographical novel written in French by an African, *Force bonté* (1916), the author Bakary Diallo described them as men "ready to answer the call of their adoptive fatherland, France". After the war, colonial soldiers demanded full recognition of their right in the name of *la dette de sang*, the debt of the blood they had lost in the French killing fields.

Massacres and arbitrary rule were denounced. Colonial administrators and governors were seen as the remnants of the aristocratic class which had been destroyed in Europe. To colonial intellectuals, the benefits of the French Revolution needed to be expanded to the colonies. But assimilation did not mean losing one's culture. In their research about the fact of blackness, colonial intellectuals benefited from the contributions of African-American intellectuals and activists. In 1919, the first Pan-African Congress was held in Paris. It was

the result of a meeting of W.E.B. Du Bois, the African-American leader of the NAACP, with the Senegalese Blaise Diagne and the Martinican Gratien Candace. Fifty delegates coming from the French and British Caribbean islands, the United States, Haiti, Liberia, Egypt, Saint-Domingue, French and British Africa, Portuguese and Spanish Africa, Congo and South Africa met in Paris. The Congress condemned the American segregationist policy but congratulated France for its colonial policy. The delegates concluded that black peoples around the world shared a common oppression and were all victims of racism. In the following Congress, held concurrently in London, Brussels and Paris, on September 27, 1921, the delegates took a more radical position. Diagne, the assimilated Senegalese, wanted to defend French colonial policy, whereas Du Bois was more interested in the unity of black peoples and in the denunciation of the abuses of colonization in Africa. The Congress sided with Du Bois and the delegates affirmed that the "Black race has a civilization" while condemning racial segregation. Yet the Congress did not question the principle of colonization and still spoke of the "backward populations" of Africa.

René Maran, a colonial administrator from Martinique who won the Goncourt Price in 1921 with his novel *Batouala* (the first black man to receive the prestigious literary award), embodied the ambivalence of the 1920s. In his preface to the novel, he wrote:

> Civilization, civilization, pride of Europe. Charnel house of innocents, one day, in Tokyo, the Hindu poet, Rabindranath Tagore, described what you were!
>
> You built your kingdom on corpses. Despite your claims, you lie. One sees you and cries tears of grief and shouts with fear. To you, might is right. You are not a torch but a blaze. Everything you touch is destroyed.
>
> (Maran 1921; quoted in Dewitte 1985: 87)

This attack preceded a prayer to France: "Honor to the country which gave me everything, my French brothers, I call upon you because I have faith in your generosity." But Maran, who lost his job after the publication of this novel, was deeply concerned with defining black identity. His encounter with Kojo Tovalou-Houenou, a prince from Dahomey who had come to France before World War I, gave him the opportunity to develop his ideas. In 1923, an incident had made Tovalou famous. While he was having a drink in a bar at Montparnasse, he was attacked by white American tourists offended by the presence of a black man in a café. They beat him and threw him out of the bar. It was a scandal. The French press and the French government condemned the white Americans and declared that American racism and segregationist policies had no place in France. In April 1924 Maran and Tovalou-Houenou began to publish a bimonthly entitled *Les Continents* and founded *La Ligue Universelle de Défense de la Race Noire* (the Universal League of Defense of the Black

Race). In *Les Continents*, Maran, Tovalou and their friends, Jean Ralaimongo, Jean Fangeat, and Ravoahangy, fought for the end of forced labor and the status of *indigénat* – which denied equal political rights to colonized people. *Les Continents* was also a review which promoted black culture: articles on jazz, African civilization, African religious beliefs, the psychology of African peoples, and Negro culture appeared regularly in a rubric ironically called "*La Case de l'Oncle Tom*" ("Uncle Tom's Cabin"). Poems by the writers of the Harlem Renaissance, like Langston Hughes, were published, as well as news about black artists and musicians of the United States. It was in *Les Continents* that information about Marcus Garvey and his Universal Negro Improvement Association first appeared. Tovalou was fascinated by Garvey's personality and ideology and he went to the United States in 1924 hoping to meet the black leader. He talked at one of Garvey's meetings, complimenting the leader with these words: "Your association represents the Zionism of the black race." But if the editors of *Les Continents* were proud that such a movement existed, they were more diffident towards Garvey's condemnation of *métissage* and rejection of the struggle for social equality. Garvey had written:

> I believe in a pure black race in the same manner that a white man who out of respect for himself believes in a pure white race....Instead of en-couraging a general degeneration of the race through miscegenation, we think that we must, right now, create a pure racial model which cannot be blamed later for being degenerate.
>
> (quoted in Dewitte 1985: 83)

La Race nègre took the debate about black identity and culture where *Les Continents* had left it. The editors sought to create a space for black intellectuals whether they were from Africa, the Caribbean, the Indian Ocean or the United States. For the first time, a review published a text which reproduced faithfully the vocabulary and ways of speaking of black African soldiers. Its editor, Baba Diarra, violently denounced the living conditions of the colonial soldiers in a style that mocked and at the same time subverted what was called "*petit nègre*" by the French: the French spoken by Senegalese soldiers. The French language had gone through a process of creolization, becoming a new language which affirmed a new identity, neither French nor assimilated.

In 1923, the poet of the Harlem Renaissance, Claude McKay, arrived in Paris, followed a year later by Langston Hughes. McKay would later say that "the cream of Harlem was in Paris" in these years. Hughes, who was 22 when he arrived, described his first encounter with Paris thus:

> I recognized the Champs Elysées, and the great Arc de Triomphe in the distance through the snow. Boy, I was thrilled! I was torn between walking up the Champs Elysées or down along the Seine, past the Tuileries. Finally, I took the river, hoping to see the bookstalls and

Notre Dame. But I ended up in the Louvre instead, looking at Venus. It was warmer in the Louvre than in the street, and the Greek statues were calm and friendly. I said to the statues: "If you can stay in Paris as long as you've been here and still look O.K., I guess I can stay a while with seven dollars and make a go at it."

<div align="right">(Hughes 1979: 144–5)</div>

Hughes found a room in Montmartre, which was called the "Harlem of Paris" because so many African-Americans had established themselves in the working-class neighborhood. Some of the most famous nightclubs owned by African-Americans were in Montmartre, hiring then-compatriots as busboys, waiters, cooks, and musicians, as jazz was the rage in Paris. McKay's experience in Paris was quite different from Hughes's. In the city, McKay said, "radicals, esthetes, painters and writers, pseudo-artists, bohemian tourists – all mixed congenially enough together." He declared later:

I never thought that there was anything worthwhile for me in the bohemian glamor of Montparnasse. The sidewalk cafés of Montmartre held no special attraction for me. Attractive as Paris is, I have never stayed there for a considerable length of time....I appreciated, but was not specially enamored of Paris....If I had to live in France, I would prefer life among the fisherfolk of Douarnenez, or in the city of Strasbourg, or in sinister Marseilles.

<div align="right">(quoted in Cooper 1987: 120)</div>

At the end of 1923, McKay left Paris and spent a year in La Ciotat, a fishing village located midway between Toulon and Marseilles, where he befriended sailors and fishermen. He returned to Paris in the middle of 1924 with his first novel, *Banjo*. McKay met Jane, Paulette and Andrée Nardal, Martinican sisters who saw their role as disseminating the ideas of the Harlem Renaissance and facilitating relations between black Americans and black French. They opened a salon, on the model of the intellectual and cultural salon of the eighteenth century, which they wished to be the center of the intellectual life of *Paris Noir*. As Léopold Senghor would later note, "It was during the years of 1929–1934 that we made contact with American Negroes through the intermediary of Mademoiselle Andrée Nardal who...held a literary salon where African Negroes, West Indians, and American Negroes could meet". The Nardal sisters actively supported the idea that French-speaking black Africans and West Indians had to rediscover their folk cultures and affirm their intrinsic human values. In the Nardals' salon, Langston Hughes, Countee Cullen and Jean Toomer met with Léopold Sédar Senghor and Aimé Césaire.

The intellectuals of *Paris Noir* defended the idea that black culture and black civilization were an important contribution to humanity. They reacted against the discourse which posited Africa as a blank page, a continent without a

civilization populated by childish, backward groups. One of their arguments was that black peoples had an innate instinct for creativity because they had remained close to nature and were free of the limitations which industrialization and progress had brought upon the Europeans. The argument, which was essentialist, nonetheless opened the way for a debate about specificity and diversity. In one of her articles, Jane Nardal celebrated black internationalism thus: "Black peoples of different traditions, religions, countries, know that they nevertheless belong to the same race". Paulette and Jane thought that the black individual was spontaneously an artist, a creator, anticipating one of the fundamental claims of négritude. "In art, in music, the whites copy us," an editor of *La Race nègre* wrote in 1935. "Our race is the leader of a new humanity. We represent fraternity against the ferocious individualism of the Europeans. We represent diversity against white uniformity, which engenders apathy". In his novel *Karim* published in 1935, the Senegalese writer Ousmane Socé had attacked the racist discourse of national-socialism and its rejection of cultural and biological *métissage*. Socé's answer appeared idealistic to black intellectuals who believed that European racism foreclosed the consequences of miscegenation. The rise of Nazism and fascism, the colonial massacres, the celebration of the glories of the empire constituted the background of the debates around blackness, politics and culture. Slavery as such was not directly evoked. Aimé Césaire would first speak of the event which had given birth to the diaspora: "How much blood in my memory, how many lagoons! They are covered with death's heads. They are not covered with water-lilies /.../ My memory is circled with blood. My remembrance is girdled with corpses!" (1971: 90). Reparation was about demanding that the colonial power make amends, bow its arrogant head and ask for forgiveness.

A SONG OF FREEDOM

Frantz Fanon adopted Césaire's tone but carried it further. *Black Skin, White Masks* was his magnificent song to the despised and rejected black man. At the end of a journey during which he has experienced contempt, paternalism, abject curiosity, exclusion, he reaffirmed his solitude and fortitude. He was alone but free, a "man among other men." Fanon's cries and rage find an echo among us, for whom the experience of solitude and rejection contain a dimension of the sublime.[8] Looking at Fanon's modalities of reparation, we may be able to discover what constitutes the strength and attraction of his discourse. Fanon wished to be his "own foundation," a non-divided (*indivis*) person. This was – and still is – the seductive dimension of Fanon's vision, a vision deeply inspired by Western theology. It met with the human wish to be responsible for one's own origin, the fantasy of being born adult.[9] No strings attached. We were and are fascinated by Fanon's affirmation because it finds an echo in us: it speaks to the intimate place which aspires to be unburdened of any connection – no

father, no mother, no lover, no others. At the end of *Black Skin*, Fanon seemed to remember the sermons of his youth to find the words of his "final prayer: O my body, make of me always a man who questions!" (1967: 232). The question comes from a self, not from interaction with others. It suggests that there exists a self which is not caught in the web of relations, desires and fantasies. Fanon's prayer resumes a division between body and soul. The body as the site of contradictions does not, however, challenge the notion of the pure self. Fanon's mastery of the self was a response to a discourse which had fostered a spirit of servitude in which the self sought to please the master in an endless game of mutation and humiliation. Fanonian reparation was about getting access to a site of freedom in which the body and the self are in conversation, a site free of the specters and ghosts of the past. Fanon tried to kill the specter which Maurice Blanchot (1986) says is the return of that which cannot return, the return of an absence, in this case, the return of the slave, absent from history and present in history.

Slavery appears in Fanon's work at the end of *Black Skin, White Masks*, in the pages about "The Negro and Hegel." Fanon describes the impossibility for the "French Negro" to be free despite the abolition of slavery; he "knows nothing of the cost of freedom, for he has not fought for it." Even when he fought for "Liberty and Justice," "these were always white liberty and justice; that is, values secreted by his masters" (1967: 221). The abolition of slavery in the French colonies was not the result of a struggle but of the whim of a "good white master who had influence [and] said to his friends, 'Let's be nice to the niggers' " (220). Hence, the French Negro remained forever "the slave of the past." Since the chains of slavery were not symbolically broken, freedom was elusive and the master's power was not challenged. African-Americans, on the other hand, who had fought for their freedom, escaped the Antilleans' destiny, for whom the inheritance of the fathers could only be symbolic bondage. The French Negro is doomed to be chained to the past of slavery; and yet, he still may free himself from his ancestors' legacy. Freedom from the past is possible if one breaks with its heritage. To repair past wrongs is to engage in the political struggle of liberation. To repair oneself, burdened with an identity that has been constructed (in proslavery language, black = "slave"), is to *dis-identify* with it. Identification, we are told, is the "psychological process whereby the subject assimilates an aspect, property or attribute of the other and is transformed, wholly or partially, after the model the other provides" (Laplanche and Pontalis 1973: 205–8). It is about taking oneself for another. Identification belongs to the realm of the Imaginary, Lacan wrote. It is an unconscious process, which is made conscious *only through dis-identification*. In other words, I have no way of knowing that I am identifying with the other as long as I have not brought to consciousness the unconscious imitation. Octave Mannoni compares the Ego to an onion: layers of successive identifications (and therefore of successive dis-identifications) are like the skins of the onion (Mannoni 1985). If the facility to identify expresses a weakness of the Ego, the facility to dis-identify is a strength.

The mask cannot represent identification, which is about "being like" someone rather than "looking like" someone, but mimicking is a form of dis-identification. One does not experience the need to justify this process, Freud said. It is necessary to find the *how* rather than the *why* of identification. Fanon refused to be haunted by a creature of racism, the slave. For dis-identification to occur, he had first to be conscious that blackness (as understood by Europe) was an imposition and that his identification with it constituted an obstacle to his freedom. Reparation was also about repairing oneself, in a move that belied a prescribed destiny. It was not only about asking the other to recognize his fault, for him to ask for forgiveness, to pay a compensation, but also for oneself about finding another access to recognition, which was through knowledge. It signified becoming an intellectual and a psychiatrist. Yet, in Fanon, the figure of the *léttré*, of the intellectual, seemed to be in conflict with the figure of the soldier. The brotherhood of arms fascinated Fanon, even though he had chosen the world of social-institutionalized psychiatry, in which the relationship is above all a relationship of trust and negotiation in which the other is not an enemy but a suffering person.[10] There was a tension between dis-identification with a prescribed identity (slave) and identification with a masculine identity expressed through force and violence (soldier). The Fanonian politics of reparation did not address the modalities of the *devoir de mémoire*, of making amends for past wrongs. The defeat of the oppressor and the birth of a new society were the revenge for a present of denial. In the same move, Fanon engaged a process of dis-identification and identified with an idealized and romantic figure: the excluded, the rejected, the despised who is willing to die for the "sake of the present and of the future" (1967: 227).

Fanon, who wanted to have "another purpose on earth" than "to avenge the Negro of the seventeenth century," sought to liberate the French black, prisoner of the signifier "slave," prisoner of the master's gaze (1967: 228). It was a rejection of the historical and social injunction of being true to one's ancestors, of the imposed inheritance of the father onto the son. Fanon's move of *disavowal*, his wish to get rid of the past and his desire to be his "own foundation," denied the inevitability of the subject's dependency (see Vergès 1996b; 1997). The Fanonian individual seems to have no childhood. How is the sign "slave" identified, recognized by the Antillean black child? In Fanonian psychology, language is transparent, the polymorphous figure of alterity absent. "I" (black male) is the Other, and blackness circumscribes alterity.[11] The Fanonian subject is not inscribed in a network of symbolic debts. The process of reinscription of the French black happens in the temporal break with the past. The signifier "slave" is not constituent of the subject "Fanon," a subject who must free himself of symbolic overdetermination. Identification with the enslaved ancestors would hold the individual captive of the other's sadistic desire to destroy and possess. Whites wish to destroy and possess something that they see blacks as having. They enslaved Fanon's ancestors to capture that "thing" and would like him to bear the symbolic chains of slavery. Fanon

refuses. The Fanonian process of (dis-)identification signifies freeing oneself of what had been imposed by the other, but in the same move to reconstruct a mythic self free of limitations. "The Negro," Fanon wrote, "however sincere, is the slave of the past" (1967: 225). Fanon turned to the vocabulary of political militancy and historical rupture in order to reconcile his past with his future. Political militancy may constitute the need for transcendence. It is a form of sublimation and reparation activity which Fanon adopted.[12] Fanon dreamed of a moment of pure rupture, of a revolution which would cleanse the colonial world of its corruption. Yet "revolution may be necessary for taking a society out of an intractable stretch of quagmire but it does not confer freedom, and may indeed hinder it" (Achebe 1987: 90). The revolutionary moment in postslavery societies like Martinique after World War II could only disappoint Fanon: the descendants of slaves were asking for political integration! He felt confirmed that they were not ready to die for freedom. Fanon could not suspect that suffering could be "passed on as education, upbringing or development" (Nandy 1983: 57). Today, young Martinicans, Guadeloupeans, Réunionnais and Guyanese turn to that past to claim that they are "Negroes."

NEGROES AND THE POLITICS OF REPARATION AT THE END OF THE CENTURY

"*Devoir de mémoire*" is the title of an interview with Primo Levi, conducted in 1982, published in 1989 in *Rassegna Mensile di Israel* and translated into French in 1996. It was part of a series about the "memory of deportation." Levi, a "saved" from Auschwitz, warned us against a memory which runs adrift and reorganizes the past to fit our present.[13] Yet, there is also the issue of a disaster, of an irrevocable wrong whose existence raises the question of its writing, of its symbolization. The disaster, Blanchot writes, is "related to forgetfulness – forgetfulness without memory, the motionless retreat of what has not been treated – the immemorial perhaps" (1986: 3). Silence and forgetfulness are other means of expressing the disaster. Charlotte Delbo, a survivor of Auschwitz, wrote in one of her remarkable books about being asked what it meant to be in a camp:

> As to questions, they stopped quickly because I never answered any. I hear their voices coming from a great distance. When they entered my room, my eyes clouded over. Their thickness intercepted the light. Through this veil, I saw them give me an encouraging smile, but I failed to understand their smile, their attitude, their kindness – later I assumed it was kindness. It was almost impossible, later, *to explain with words what was happening in that period of time when there were no words*.
>
> (Delbo 1995: 237)

Survivors of camps have tried to find the language in which the crimes of Nazism and its paranoid world of blood purity would be told beyond mere denunciation. In the case of slavery in the French colonies, few direct testimonies exist. The voices of the slaves are found in the police and justice archives, in the testaments of the masters, in the songs, proverbs and oral poetry of the Creole peoples. However, the transmission from generation to generation has been problematic.

"Why did they [our grandparents, our parents] remain silent" about slavery, the Guadeloupean psychotherapist Viviane Romana asked during the "Day of Reflection on the *Devoir de mémoire* among the Antillean, Guyanese and Réunionnais Communities."[14] To Romana, it is wrong to talk of collective amnesia among postslavery communities, for amnesia must be preceded by knowledge. There has been no teaching about slavery in French schools, and therefore no shared, symbolized, historical knowledge. Slavery remained the *secret de famille*, whose existence, like any other family secret, operates as a ghost, a skeleton in the cupboard. Romana argues that our parents kept silent for three reasons. To begin with, victims of trauma prefer not to speak about it; they experience it through nightmares which they do not talk about. Then, the technique of *de-fabrication* – the technique of dehumanization whereby isolation, dispersal, torture, violence, the proximity of death are the structures of life – entails a strategy of survival which is invented and transmitted. It is *survival* which is taught rather than the causes of what brought survival. Finally, our parents kept silent because they did not want to be burdened so that we could move forward. As Blanchot has written, "to forget is not simply a weakness, a failing, an absence or void" (1986: 85). Thus, we might say that for our generation, Fanon acted as a father. Silence protects a wounded self. During the "Day of Reflection," Patrick Chamoiseau, the Martinican writer of Créolité, spoke of the "medicine of silence." Silence, he claimed, is the foundation of the *devoir de mémoire* and the *droit à la mémoire*. Forgetting is the "sculptor of memory." One must abandon a *mémoire obscure* – a form of memory which expresses itself through hallucinations – and move to a *mémoire consciente* which "works against *and* with forgetfulness." To preserve memory from oblivion constitutes the motive of Creole postcolonial critics today. There is a shift from the Fanonian position: the tension between forgetfulness and memory is acknowledged and memory is no longer simply a burden. Freedom, for which Fanon fought at great cost, is still being sought as a "matter of the inner economy of the individual."

It is through a process of repetition, I argue, a repetition which may appear monotonous or neurotic, that the memory of a crime against one's people is finally absorbed, finally transformed into experience, into metaphors. Repetition is a means by which I can say that what happens to me belongs to an order of things that have bearing on the history of humanity. Slavery was not an accident, the result of a moment of madness, but a signifying act of human beings. Africans were not enslaved because Europeans were mad or were the

embodiment of evil; neither was it because Africans were said to belong to another order of the living (neither totally beasts nor totally humans).[15] Repetition metamorphoses the hallucinations of the *mémoire obscure* into symbolic inscriptions. It is a way of carrying out revenge: "In the silence of abjection, when the only sounds to be heard are the chains of the slave and the voice of the informer...this is when the historian appears, charged with avenging the people" (Chateaubriand, quoted in Lyotard 1988: 27). The task of revenge given here to the historian may be carried out by the poet, the writer, the revolutionary crowd: it is about saying what remained unsaid, about making visible what is hidden, about rendering conscious what is on the margins of perception.

At a seminar on "Race and Identity in Africa,"[16] the discussion around crimes (of slavery, colonialism, apartheid, ethnic genocide, tyranny) brought forth the difficulties of thinking about what constitutes reparation. Is the generation which did not commit the crime responsible for reparation? Is not the notion of "collective responsibility" another trick to disculpate individuals? Is the State the institution to which one group must turn to ask for reparation? What constitutes reparation: financial compensations? symbolic recognition? What is our debt to the past? A single response could not exhaust all the possibilities. The singularity of suffering seemed to resist any generality. The human tendency to think that one's experience cannot be compared, that the "truth was always more atrocious, more tragic than what will be said about it," that words are missing to express the atrocity, compounded the difficulty. How could one explain the atrocity, the crime, the torturer? How do we accomplish reparation when the torturer lives among us (as in Argentina, Chile, Rwanda, South Africa...)? Why does it seem that human beings do not "learn," that the motto "Never again" looks like empty rhetoric? Is not revenge a form of reparation? The philosopher Fabien Eboussi-Boulaga proposed an "ethical identity" whereby the sufferings of the ancestors are incorporated into one's construction of identity. It is not about carrying a moral burden, making one's own the crimes or sins of the ancestors, but recognizing one's debts. Moral discourse does not explain humanity's malice, it transforms it into a projective *thing*. What must be understood is that one remains subject to an order which one cannot entirely master, that personal power is limited. The philosopher François Flahault suggests that the "seed of hatred and malice is present in each of us; it is the expression of a rebellion against the limitations imposed by the existence of others" (1998: 17). Reparation, Melanie Klein and Donald Winnicott have said, is about the integration of the bad and good object within us. The work engaged by Creole postcolonial critics speaks of the integration of the obscure memory of our worlds. The passivity of the slaves, the resistance of the slaves, their silence, their words, their melancholia, their creativity constitutes their legacy, the bad and the good.

At the end of the twentieth century, the descendants of slaves in the French postcolonies are reappropriating their history. Their sense of dislocation –

arising from the fact that, for the most part, they were born in faraway territories, in former colonies, and yet are said to be "French" – provides the grounds for subverting the French definition of Frenchness. For British or American audiences, this may seem a very late awakening, but the notion of race and its close relationship with slavery and colonialism has still not been fully analyzed in France. There is an important resistance because of the intimate relationship between the Republic and a colonizing ideology. French people do not like to think of themselves as accomplices and perpetrators of colonial crimes.[17] The discourse about race remains moralistic, which means that the terms "racism" and "antiracism" delimit the field of the debate. The fact that "race" does not exist as a scientific concept is used to mask the "materiality" of the term.

"What I seek in speech," Lacan argued,

> is the response of the other. What constitutes me as subject is my question. In order to be recognized by the other, I utter what was only in view of what will be. In order to find him, I *call him by a name that he must assume or refuse* in order to reply to me.

(1977: 86)

The question is: "Is not slavery a crime against humanity?" Slavery constituted the grounds of the fact of blackness in France and its colonies. Revising its history would redistribute the roles and functions of the slave, the colonized, the citizen. In the 1930s, the Nardal sisters and their friends reinscribed the voices of the black diaspora in a Paris which saw itself as the capital of an empire in which the French republicans were the leaders of this French paradoxical "unequal fraternity." The titles of their reviews bespoke their will to reaffirm the fact of blackness, the existence of black internationalism. In the 1950s, Fanon wished to establish a new humanism in which the Wretched of the Earth would get their revenge and would fulfill the biblical prophecy: "The first shall be the last and the last shall be the first." Fanon was born in the same year as my father. Both grew up men of color in a French colony. Both joined the Free French Army to fight Nazism in Europe. Both then joined anticolonialist movements and became committed anticolonialists. Fanon would be 73 this year, and yet he remained forever young, like we wish our revolutionary dreams to be. He entered our pantheon of revolutionary heroes, forever untouched by age, limitations, compromises. We salute his courage, physical and moral, a virtue that is not remembered today as it should be. We admire his commitment to political struggle. He reminds us that politics is about conflict in a time when the discourse of consensus seeks to erase the division between the oppressors and the oppressed. Yet, if we agree with Fanon's attack on consensus, we depart from his idealization of the notion of historical rupture. We try to make ours James Baldwin's words: "One cannot claim the birthright without accepting the inheritance" (1955: xii).

NOTES

1 The demonstration was organized by the *Comité pour une commémoration unitaire de l'abolition de l'esclavage des Nègres dans les colonies françaises*. The organizers insisted on the use of the term "*Nègre*" (Negro). The committee, created on January 23, 1998, mobilized more than 300 associations throughout France. A member of the committee myself, I participated in events whose goal was to explain why it was important to march through Paris.

2 On April 27, 1848 the Provisory Government of the Second Republic issued a decree abolishing slavery in the French colonies and the infamous *Code noir* that for 150 years had regulated the lives of slaves. Two hundred and fifty thousand slaves – women, men, and children – were freed and became French citizens.

3 This is Edouard Glissant's expression.

4 I am speaking of Martinique, Guadeloupe, Réunion and Guyana. These territories, which belonged to the pre-revolutionary French empire, experienced slavery and colonialism. Known as the *Vieilles Colonies* (Old Colonies) in the French empire, they became French Overseas Departments in 1946. Their economies today are heavily dependent on France; there is a high level of unemployment.

5 Press conference of the Minister of Culture and Minister of the Overseas Territories, April 7, 1998; my emphasis.

6 In 1846, Victor Schoelcher, the "hero" of abolitionism, launched a campaign against slavery in Algeria where a bloody colonial war was underway since 1830. The image of the "Muslim" as slave trader was used in French abolitionist propaganda: if the Muslim, who was a barbarian, enslaved people, the European should embrace the abolitionist cause. See Arzalier (1995: 301–8).

7 This is the title of Tyler Stovall's book (1996); see also Dewitte (1985).

8 On the figure of the despised and rejected as the figure of the sublime, see the remarkable study by François Flahault (1998).

9 This wish is not universal. It was inspired by the European approach to the self. If we were looking at African or Asian approaches to the self, we would find that there are other conceptions of the self.

10 On institutionalized psychiatry, its revolutionary method and theory, see Vergès 1996a; 1996b.

11 I disagree with the commentators on Fanon who present him as a theorist of post-Manichean politics. Fanon, who was a political activist besides a psychiatrist, knew the importance of constructing the most powerful force in a political struggle. He believed in the necessity of maintaining a division of society into two antagonistic forces in order to clarify the distinction between friends and enemies. This law of politics has too often become buried under theories of hybridity and creolization, and yet one still has to choose, once in a while, on which side of the barricade one wants to be.

12 On political activity as a form of reparation, see Langer (1989).

13 Levi wrote:

> I might be alive in the place of another, at the expense of another; I might have usurped, that is, in fact, killed. The "saved" of the Lager were not the best, those predestined to do good, the bearers of a message: what I have seen and lived through proved the exact contrary....The worst survived, that is, the fittest; the best all died.
>
> (1989: 82)

14 The "Day of Reflection" was organized by the *Comité pour une commémoration unitaire de cent cinquantenaire de l'abolition de l'esclavage des Nègres dans les colonies*

français on Saturday May 2, 1998, in Paris. The *Comité*, as of this writing, is planning a demonstration through the streets of Paris on May 23, 1998.

15 As Florence Burgat has said: "If ontologically, the slave is made closer to the state of animality than to the state of humanity, the ethical and theological problems inherent to its subjugation are ignored" (1998: 19).

16 The seminar, organized by the Gorde Institute and CODESRIA – respectively represented by Breyten Breytenbach and Achille Mbembe – was held at Zanzibar, May 11–13, 1998, and brought together twelve scholars whose work and research are related to postcolonial Africa and its diaspora.

17 Witness the difficulty of integrating the Algerian war in the national debate despite books, films and conferences. Slavery is still deeply marginalized in history, literary, cultural and philosophical studies. The majority of schoolbooks do not address the issue of slavery. See *Autrement*, "*Oublier nos crimes. L'Amnésie nationale: une spécificité française?*" (144, April 1994); *Lignes*, "*Algérie–France: Regards coisés*" (February 30, 1997); *Dédale*, "Postcolonialism," (5–6, Spring 1997); Balibar (1998).

REFERENCES

Achebe, C. (1987) *Anthills of the Savannah*, New York: Anchor.

Arzalier, F. (1995) "Les Mutations de l'idéologie coloniale en France avant 1848: De l'esclavagisme à l'abolitionnisme," in *Les Abolitions de l'esclavage de L.F. Sonthonoax à V. Schoelcher*, Paris : Presses Universitaires de Vincennes/Éditions UNESCO.

Baldwin, J. (1955) *Notes of a Native Son*, Boston: Beacon.

Balibar, E. (1998) "Algérie, France: Une ou deux nations?" in *Droit de cité: Culture et politique en démocratie*, Paris: Éditions de l'Aube.

Blanchot, M. (1986) *The Writing of the Disaster*, trans. A. Smock, Lincoln: University of Nebraska Press.

Burgat, F. (1998) "Esclave et propriété," *L'Homme* 145 (January–March): 11–30.

Césaire, A. (1971) *Return to My Native Land*, Paris: Présence Africaine.

Cooper, W. (1987) *Claude McKay: Rebel Sojourner in the Harlem Renaissance*, New York: Random House.

Delbo, C. (1995) *The Measure of Our Days*, trans. R.C. Lamont, New Haven, CT: Yale University Press.

Dewitte, P. (1985) *Les Mouvements nègres en France, 1919–1939*, Paris: L'Harmattan.

Diallo, B. (1973) *Force bonté*, Nendeln: Klaus Reprint.

Fanon, F. (1967) *Black Skin, White Masks*, trans. C.L. Markmann, New York: Grove.

Flahault, F. (1998) *La Méchanceté*, Paris: Descartes & & Cie.

Hughes, L. (1979) *The Big Sea*, New York: Hill & Wang.

Lacan, J. (1977) *Écrits: A Selection*, trans. A. Sheridan, New York: Norton.

Langer, M. (1989) *From Vienna to Managua: Journey of a Psychoanalyst*, trans. M. Hooks, London: Free Association Books.

Laplanche, J. and Pontalis, J.-B. (1973) *The Language of Psychoanalysis*, trans. D. Nicholson-Smith, New York: Norton.

Levi, P. (1989) *The Drowned and the Saved*, New York: Vintage.

Lyotard, J.-F. (1988) *The Differend: Phrases in Dispute*, Minneapolis: University of Minnesota Press.

Mannoni, O. (1985) "La Désidentification," in M. Mannoni (ed.) *Le Moi et l'Autre*, Paris: Denoel.

Maran, R. (1921) *Batouala, véritable roman nègre*, Paris: Alban Michel.

—— (1923) "La France et ses Nègres," *L'Action coloniale* 90 (September 25).

Nandy, A. (1983) *The Intimate Enemy: Loss and Recovery of Self Under Colonialism*, Delhi: Oxford University Press.

Stovall, T. (1996) *Paris Noir: African Americans in the City of Light*, New York: Houghton Mifflin.

Vergès, F. (1996a) "Chains of Madness, Chains of Colonialism: Fanon and Freedom," in A. Read (ed.) *The Fact of Blackness: Frantz Fanon and Visual Representation*, London: Institute of Contemporary Arts.

—— (1996b) "To Cure and to Free: The Fanonian Project of 'Decolonized Psychiatry,' " in L.R. Gordon, T.D. Sharpley-Whiting, and R.T. White (eds) *Fanon: A Critical Reader*, Oxford: Blackwell.

—— (1997) "Creole Skin, Black Mask: Fanon and Disavowal," *Critical Inquiry* 23, 3: 578–96.

BIBLIOGRAPHY

WORKS BY FRANTZ FANON

Books

(1952) *Peau noire, masques blancs*, Paris: Éditions du Seuil; trans. C.L. Markmann as *Black Skin, White Masks*, New York: Grove, 1991; London: Pluto (with an introduction by H.K. Bhabha), 1986.

(1959) *L'An V de la révolution algérienne*, Paris: François Maspero; trans. H. Chevalier as *A Dying Colonialism*, New York: Grove, 1967.

(1961) *Les Damnées de la Terre*, preface by J.-P. Sartre, Paris: François Maspero; trans. C. Farrington as *The Wretched of the Earth*, New York: Grove, 1991.

(1969) *Pour la révolution africaine: Écrits politiques*, Paris: François Maspero; trans. H. Chevalier as *Toward the African Revolution*, New York: Grove, 1988.

Articles

(1951) "L'Expérience vécue du Noir," *L'Esprit* (May).

(1955) "Antillais et Africains," *L'Esprit* (February).

(1955) "Réflexions sur la ethnopsychiatrie," *Conscience Maghrebine* 3.

(1956) "Racisme et culture," presented at the First Congress of Black Writers and Artists, Paris, September.

(1957) "Le Phénomène de l'agitation en milieu psychiatriqtie. Considérations générales – signification psychopathologique," *Maroc Médical* (January).

(1957) "Déceptions et illusions du colonialisme français," *El Moudjahid* 10 (September).

(1957) "L'Algérie face aux tortionnaires français," *El Moudjahid* 10 (September).

(1957) "A propos d'un plaidoyer," *El Moudjahid* 12 (November).

(1957) "Les Intellectuels et des démocrates français devant la révolution algérienne," *El Moudjahid* 15 (December).

(1958) "Aux Antilles, naissance d'une nation?" *El Moudjahid* 21 (January).

(1958) "La Farce qui change de camp," *El Moudjahid* 21 (April).

(1958) "Décolonisation et indépendance," *El Moudjahid* 23 (May).

(1958) "Une crise continuée," *El Moudjahid* 24 (May).

(1958) "Vérités orenuères à propos du problème colonial," *El Moudjahid* 24 (July).

(1958) "Appel aux Africains," *El Moudjahid* 28 (August).

(1958) "La Leçon de Cotonou," *El Moudjahid* 28 (August).

(1958) "Lendemains d'un plébisite en Afrique," *El Moudjahid* 30 (October).

(1958) "La Guerre d'Algérie et la liberation des hommes," *El Moudjahid* 31 (November).

(1958) "Accra: L'Afrique affirme son unité et définit sa stratégie," *El Moudjahid* 34 (December).

(1958) "L'Algérie et Accra," *El Moudjahid* 34 (December).

(1959) "Fureur raciste en France," *El Moudjahid* 42 (May).

(1960) "Le Sang coule aux Antilles sous domination française," *El Moudjahid* 58 (January).

(1960) "Unité et solidarité effective sont les conditions de la libération africaine," *El Moudjahid* 58 (January).

(1960) Address to the Afro-Asian Conference in Conakry, April. Abridged version in *El Moudjahid* 63 (April).

(1960) "Cette Afrique à venir," Conference for Peace and Security in Africa, Accra, April. Abridged version in *El Moudjahid* 63 (April).

(1960) "The Stages of Imperialism," *Provisional Government of the Algerian Republic: Mission in Ghana* 1, 6 (December).

(1961) "La Mort de Lumumba: Pouvions-nous faire autrement?" *Afrique Action* 19 (February).

Co-authored articles

Fanon, F. and Toquelles, F. (1953) "Indication de thérapeutique de Bini dans le cadre des thérapeutiques institutionelles," Congrès des médicins aliénistes et neurologues de France et des pays de langue française, 5lst session, Pau, July 20–26.

Fanon, F. and Tosquelles, F. (1953) "Sur quelques cas traités par la méthode de Bini," Congrès des médicins aliénistes et neurologues de France et des pays de langue française, 5lst session, Pau, July 20–26.

Fanon, F. and Tosquelles, F. (1953) "Sur un essai de réadaptation chez une malade avec épilepsie morphéique et troubles de caractère grave," Congrès des médicins aliénistes et neurologues de France et des pays de langue française, 5lst session, Pau, July 20–26.

Fanon, F. and Despinoy, M. (1953) "A propos de syndrome de Cotard avec balancement psychosomatique," *Les Annales médico-psychologiques* 2.

Fanon, F., Despinoy, M. and Zenner, W. (1953) "Note sur les techniques de cures de sommeil avec conditionnement et contrôle électroencéphalographiquie," Congrès des médicins aliénistes et neurologues de France et des pays de langue française, 5lst session, Pau, July 20–26.

Fanon, F. and Azoulay, J. (1954) "La Socialthérapie dans un service d'hommes musulmans: Difficultés méthodologiques," *L'Information psychiatrique* 30, 9.

Fanon, F., Azoulay, J. and Sanchez, F. (1954/55) "*Introduction aux troubles de la sexualité chez les nord Africains,*" unpublished manuscript.

Fanon, F. and Lacaton, R. (1955) "Conduites d'aveu en Afrique du nord," Congréès des médicins aliénistes et neurologues de France et des pays de langue française, 53rd session, Nice, September 5–11.

Fanon, F., Dequeker, J., Lacaton, R., Micucci, M., and Ramee, F. (1955) "Aspects actuels de l'assistance mental en Algérie," *L'Information psychiatrique* 31, l.

Fanon, F. and Geromini, C. (1956) "Le T.A.T. chez la femme musulmane:. Sociologie de la perceptions et de l'imagination,," Congrès des médicins aliénistes et neurologues de France et des pays de langue française, 54th session, Bordeaux, August 30 – September 4.

Fanon, F. and Sanchez, F. (1956) "Attitude de Musulman Maghrebin devant la folie," *Revue pratique de psychologie de la vie sociale et d'hygiène mentale* 1.

Fanon, F. and Levy, L. (1958) "A propos d'un cas de spasme de torsion," *La Tunisie médicale* 36, 9.

Fanon, F. and Geromini, C. (1959) "L'Hospitalisation de jour en psychiatrice:, Valeur et limites," *La Tunisie Mmédicale* 37, 10.

Fanon, F. and Levy, L. (1959) "Premiers essais de méprobamate injectable dans les états hypocondriaque," *La Tunisie médicale* 37, 10.

Other work by Fanon

(1949) *Tam Tam*, February 21 (edited by Fanon).

(1949–50) *Les Mains parallèles, L'Œil se noye; La Conspiration* (unpublished plays).

(1951–52) "Troubles mentaux et syndromes psychiatriques dans hérédo-dégénération-spino-cérébelleuse: Un cas de maladie de Friedrich avec délire de possession" (dissertation, University of Lyon).

(1955) "Conférence sur les catégories de l'humanisme moderne," unpublished lecture delivered at Blida.

(1959–60) *Rencontre de la soci*été *et de la psychiatrie: Notes de cours Tunis 1959–69*, Tunis: University of Oran.

SECONDARY SOURCES ON FANON

Biographical information

Beauvoir, S. de (1992) *Force of Circumstance*, trans. R. Howard, New York: Paragon House.

Bouvier, P. (1971) *Fanon*, Paris: Éditions Universitaires.

Caute, D. (1970) *Frantz Fanon*, New York: Viking.

Fanon, J. (1982) "Pour Frantz, pour notre mère," *Sans frontière* (February): 5–11.

Frantz Fanon (1975), Panaf Great Lives, London: Panaf Books.

Geismar, P. (1971) *Fanon: The Revolutionary as Prophet*, New York: Grove.

Gendzier, I.L. (1973) *Frantz Fanon: A Critical Study*, New York: Grove.

Gibson, N. (1998) *Frantz Fanon*, Cambridge, MA: Polity Press.

Julien, I. (1995) *Frantz Fanon: Black Skin, White Mask*, Normal Film.

Macey, D. (1997) "Fort-de-France," *Granta* 59 (*France: The Outsider*): 61–76.

—— (1998) *Frantz Fanon*, London: Granta Books.

Perinbam, M. (1982) *The Revolutionary Thought of Frantz Fanon: An Intellectual Biography*, Washington, DC: Three Continents Press.

Wyrick, D.B. (1998) *Fanon for Beginners*, New York: Writers and Readers.

Full-length studies and essay collections

Alekseevna, L.A. (1979) *Ideino-Teoreticheskie Vzgliady Frantsa Fanona*, Moscow: Izd-Vo Moskovskogo Universiteta.

Aruffo, A. and Pirelli, G. (1994) *Frantz Fanon, o, l'eversione anticoloniale*, Rome: Erre Emme.

Bulhan, H.A. (1985) *Frantz Fanon and the Psychology of Oppression*, New York: Plenum.

Clemente, P. (1971) *Frantz Fanon, Tra Esistenzialism e Rivoluzione*, Bari: Casa Editrice Guis.

Dacy, E. (ed.) (1986) *L'Actualité de Frantz Fanon: Actes du colloque de Brazzaville*, Paris: Karthala.

Fernandez-Pardo, C.A. (1971) *Frantz Fanon*, Buenos Aires: Editorial Galerna.

Fontenot, C.J. (1979) *Frantz Fanon: Language as the God Gone Astray in the Flesh*, Lincoln: University of Nebraska Press.

Gibson, N. (ed.) (1999) *Fanon and Fanonism*, Atlantic Highlands, NJ: Humanities Press.

Gordon, L.R. (1995b) *Fanon and the Crisis of European Man: An Essay on Philosophy and the Human Sciences*, New York: Routledge.

Gordon, L.R., Sharpley-Whiting, T.D., and White, R.T. (eds) (1996) *Fanon: A Critical Reader*, Cambridge, MA: Blackwell.

Hansen, E. (1976) *Frantz Fanon: Social and Political Thought*, Columbus: Ohio State University Press.

Jinadu, L.A. (1986) *Fanon: In Search of the African Revolution*, London: KPI.

Lucas, P. (1971) *Sociologie de Frantz Fanon*, Algiers: SNED.

McCulloch, J. (1983) *Black Soul White Artifact: Fanon's Clinical Psychology and Social Theory*, New York: Cambridge University Press.

Mémorial international Frantz Fanon (1984), Paris: Présence Africaine.

Onwuanibe, R.C. (1983) *A Critique of Revolutionary Humanism: Frantz Fanon*, St. Louis, MO: W.H. Green.

Read, A. (ed.) *The Fact of Blackness: Frantz Fanon and Visual Representation*, Seattle: Bay Press; London: Institute for Contemporary Arts.

Sekyi-Otu, A. (1996) *Fanon's Dialectic of Experience*, Cambridge, MA: Harvard University Press.

Sharpley-Whiting, T.D. (1998) *Frantz Fanon: Conflicts and Feminisms*, Lanham, MD: Rowman & Littlefield.

Turner, L. and Alan, J. (1986) *Frantz Fanon, Soweto and American Black Thought*, Chicago: News and Letters.

Wallerstein, I.M. (1970) *Frantz Fanon: Reason and Violence*, New York: Institute of African Studies.

Zahar, R. (1974) *Frantz Fanon: Colonialism and Alienation*, trans. W.F. Feuser, New York: Monthly Review Press.

Articles and book chapters

Note: This section does not include individual contributions to the essay collections cited above.

Adam, H.M. (1993) "Frantz Fanon as a Democratic Theorist," *African Affairs* 92: 499–518.

Adams, P. (1970) "The Social Psychiatry of Frantz Fanon," *American Journal of Psychiatry* 127: 109–14.

Alessandrini, A.C. (1997a) "Fanon and the Post-Colonial Future," *Jouvert* 1, 2.

—— (1997b) "Whose Fanon?," *The C.L.R. James Journal* 5, 1: 136–52; revised version in *Minnesota Review* 48 (1998).

—— (1998) "Humanism in Question: Fanon and Said," in S. Ray and H. Schwartz (eds) *A Companion to Postcolonial Studies*, Cambridge, MA: Blackwell.

Andrade, S. (1993) "The Nigger of the Narcissist: History, Sexuality, and Intertextuality in Maryse Condé's *Heremakhonon*," *Callaloo* 16, 1: 219–31.

Arendt, H. (1969) *On Violence,* New York: Harcourt Brace Jovanovich.

Armah, A.K. (1967) "African Socialism: Utopian or Scientific?" *Présence Africaine* 64, 4: 6–30.

—— (1969) "Fanon: The Awakener," *Negro Digest* , 18, 12: 4–9.

Azar, M. (1995) "Fanon, Hegel och Motståndets Problematik," preface to the Swedish edition of *Black Skin, White Masks*, (*Svart Hud, Vita Masker*), Götesborg: Daidalos.

—— (1997) "Albert Camus och l'Algérie française," *Ord* & *Bild* (Uddevalla) (June).

Beckett, P.A. (1973) "Algeria vs. Fanon: The Theory of Revolutionary Decolonization and the Algerian Experience," *Western Political Quarterly* 26, 1: 5–27.

Ben Bella, A. (1972) "La Mémoire de Frantz Fanon," *Le Monde* 27 December: 4.

Bennoune, M. (1988) *The Making of Contemporary Algeria, 1830–1987*, New York: Cambridge University Press.

Berger, R.A. (1990) "Contemporary Anglophone Literary Theory: The Return of Fanon," *Research in African Literatures* 21, 1: 141–51.

Bergner, G. (1995) "Who Is That Masked Woman? or, The Role of Gender in Fanon's *Black Skin, White Masks*," *PMLA* 110, 1: 75–88.

Bhabha, H.K. (1983) "Difference, Discrimination, and the Discourse of Colonialism," in F. Barker (ed.) *The Politics of Theory*, London: Colchester.

—— (1986) "Remembering Fanon: Self, Psyche and the Colonial Condition," preface to *Black Skin, White Masks*, London: Pluto; reprinted in B. Kruger and P. Mariani (eds) *Remaking History*, Seattle: Bay Press, 1989; and in P. Williams and L. Chrisman (eds) *Colonial Discourse and Post-Colonial Theory: A Reader*, New York: Columbia University Press.

—— (1994) "Interrogating Identity: Frantz Fanon and the Postcolonial Prerogative" and "The Other Question: Stereotype, Discrimination, and the Discourse of Colonialism," in *The Location of Culture*, New York: Routledge.

Blackey, R. (1974) "Fanon and Cabral: A Contrast in Theories of Revolution for Africa," *Journal of Modern African Studies* 12, 2: 191–209.

Boucebci, M. (1990) "Aspects actuels de la psychiatrie en Algérie," *L'Information psychiatrique* 10, 66 (December).

Bouillon, A. (1981) *Madagascar, le colonisé et son âme: Essai sur le discours psychologique colonial*, Paris: Éditions l'Harmattan.

Bulhan, H. (1985) "Frantz Fanon: The Revolutionary Psychiatrist," *Race and Class* 21, 3: 251–71.

Butler, J. (1993) "Endangered/Endangering: Schematic Racism and White Paranoia," in R. Gooding-Williams (ed.) *Reading Rodney King/Reading Urban Uprising*, New York: Routledge.

Césaire, A. (1962) "Homages à Frantz Fanon," *Présence Africaine* 40 (lst Trimester): 120–2.

Cherif, M. (1966) "Frantz Fanon: La science au service de la révolution," *Jeune Afrique* 295 (4 September).

Cheyette, B. (1997) "White Skin, Black Masks," in K.A. Pearson, B. Parry, and J. Squires (eds) *Cultural Readings of Imperialism: Edward Said and the Gravity of History*, New York: St. Martin's.

Clegg, I. (1979) "Workers and Managers in Algeria," in R. Cohen, P.C.W. Gutkind, and P. Brazier (eds) *Peasants and Proletarians: The Struggles of Third World Workers*, New York: Monthly Review Press.

Collotti-Pischel, E. (1962) " 'Fanonismo' e 'Questione Coloniale,' " *Problemi del socialism* 5: 843–64.

Condé, M. (ed.) (1992) *L'Héritage de Caliban*, Paris: Édition Jasor.

Condé, M. and Cottenet-Hage, M. (eds) (1995) *Penser la Créolité*, Paris: Éditions Karthala.

Coser, L. (1970) "Fanon and Debray: Theorists after the Third World," in I. Howe (ed.) *Beyond the New Left*, New York: McCall.

Dane, R. (1994) "When Mirror Turns Lamp: Frantz Fanon as Cultural Visionary," *Africa Today* 41, 2: 70–9.

Davis, H. (1978) *Toward a Marxist Theory of Nationalism*, New York: Monthly Review.

Decker, J.L. (1990) "Terrorism (Un)Veiled: Frantz Fanon and the Women of Algeria," *Cultural Critique* 17: 177–98.

Doane, M.A. (1991) "Dark Continents: Epistemologies of Racial and Sexual Difference in Psychoanalysis and the Cinema," in *Femmes Fatales: Feminism, Film Theory, Psychoanalysis*, New York: Routledge.

Dollimore, J. (1991) *Sexual Dissidence: Augustine to Wilde, Freud to Foucault*, New York: Oxford University Press.

Duster, T. and Wellman, D. (1988) "La Fantôme de Frantz Fanon," *Actes de la recherche en sciences sociales* 71–72: 135–6.

Edelman L. (1994) "The Part for the (W)Hole: Baldwin, Homophobia, and the Fantasmatics of 'Race,' " in *Homographesis: Essays in Gay Literary and Cultural Theory*, New York: Routledge.

Esebe, P.O. (1994) *Pan-Africanism: The Idea and the Movement, 1776–1991*, 2nd edition, Washington, DC: Howard University Press.

Esonwanne, U. (1993) "The Nation as Contested Referent," *Research in African Literatures* 24, 4: 49–62.

Fairchild, H.H. (1994) "Frantz Fanon's *The Wretched of the Earth* in Contemporary Perspective," *Journal of Black Studies* 25, 2: 191–9.

Farber, S. (1981) "Violence and Material Class Interests: Fanon and Gandhi," *Journal of Asian and African Studies* 16, 3–4: 196–211.

Farr, R. (ed.) (1995) *Mirage: Enigmas of Race, Difference and Desire*, London: Institute of Contemporary Arts.

Fashina, O. (1989) "Frantz Fanon and the Ethical Justification of Anti-Colonial Violence," *Social Theory and Practice* 15, 2: 179–212.

Faulkner, R.A. (1996) "Assia Djebar, Frantz Fanon, Women, Veils, and Land," *World Literature Today* 70, 4: 847–55.

Feuchtwang, S. (1985) "Fanon's Politics of Culture: The Colonial Situation and its Extension," *Economy and Society* 14, 4: 450–73.

—— (1987) "Fanonian Spaces," *New Formations* 1.

Fogel, D. (1982) *Africa in Struggle: National Liberation and Proletarian Revolution*, Seattle: Ism Press.

Fuss, D. (1994) "Interior Colonies: Frantz Fanon and the Politics of Identification," *diacritics* 24, 2–3: 215–27; reprinted in *Identification Papers*, New York: Routledge, 1995.

Garcia Passalacqua, J.M. (1983) *Two Caribbean World Views: Fanon and Naipaul*, Washington, DC: Wilson Center.

Gates, H.L. (ed.) (1989) *"Race," Writing, and Difference*, Chicago: University of Chicago Press.

—— (1991) "Critical Fanonism," *Critical Inquiry* 17, 3: 457–70; reprinted in R. Con Davis and R. Schleifer (eds) *Contemporary Literary Criticism*, 3rd edition, New York: Longman, 1994.

Gendzier, I.L. (1969) "Reflections on Fanon and the Jewish Question," *New Outlook* 12: 13–20.

Gibson, N. (1989) "Three Books on Frantz Fanon," *Africa Today* 36, 2: 49–53.

—— (1994) "Fanon's Humanism and the Second Independence in Africa," in E. McCarthy-Arnold, D.R. Penna, and D.C. Sobreña (eds) *Africa, Human Rights and the Global System*, Westport, CT: Greenwood Press.

Gilmore, R.W. (1993) "Terror Austerity Race Gender Excess Theater," in R. Gooding-Williams (ed.) *Reading Rodney King/Reading Urban Uprising*, New York: Routledge.

Glissant, E. (1989) *Caribbean Discourse*, trans. J.M. Dash, Charlottesville: University of Virginia Press.

Goldberg, D.T. (ed.) (1990) *Anatomy of Racism*, Minneapolis: University of Minnesota Press.

Gooding-Williams, R. (1993) " 'Look, a Negro!' " in R. Gooding-Williams (ed.) *Reading Rodney King/Reading Urban Uprising*, New York: Routledge.

Gordon, L.R. (1995a) *Bad Faith and Anti-Black Racism*, Atlantic Highlands, NJ: Humanities Press.

—— (1996a) "Black Skins Masked: Finding Fanon in Isaac Julien's *Frantz Fanon: Black Skin, White Mask*, *differences* 8, 3: 148–58.

—— (1996b) "Introduction: Black Existentialist Philosophy," in L.R. Gordon (ed.) *Existence in Black*, New York: Routledge.

—— (1997) "Fanon, Philosophy, and Racism," in *Her Majesty's Other Children: Sketches of Racism from a Neocolonial Age*, Lanham, MD: Rowman & Littlefield.

Graham, J. (1972) "Political Ideologies in Contemporary Africa," *Centennial Review* 16, 1: 23–40.

Gubar, S. (1997) *Racechanges: White Skin, Black Face in American Culture*, New York: Oxford University Press.

Hall, S. (1990) "Cultural Identity and Diaspora," in J. Rutherford (ed.) *Identity: Community, Culture, Difference*, London: Lawrence & Wishart.

—— (1995) "Negotiating Caribbean Identities," *New Left Review* 209: 3–14.

Hansen, W.H. (1997) "Another Side of Frantz Fanon: Reflections on Socialism and Democracy," *New Political Science* 40: 89–104.

Harbi, M. (1980) *Le FLN: Mirage et réalité*, Paris: Éditions Jeune Afrique.

Henry, P. (1996) "African and Afro-Caribbean Existentialism," in L.R. Gordon (ed.) *Existence in Black*, New York: Routledge.

Henry, P. and Buhle, P. (1992) "Caliban as Deconstructionist: C.L.R. James and Post-Colonial Discourse," in P. Henry and P. Buhle (eds) *C.L.R. James' Caribbean*, Durham, NC: Duke University Press.

Honneth, A. (1995) *The Struggle for Recognition: The Moral Grammar of Social Conflicts*, trans. J. Anderson, Cambridge, MA: Polity.

Hopton, J. (1995) "The Application of the Ideas of Frantz Fanon to the Practice of Mental Health Nursing," *Journal of Advanced Nursing* 21, 4: 723–8.

Hountondji, P. (1983) *African Philosophy: Myth and Reality*, Bloomington: Indiana University Press.

—— (1995) "Producing Knowledge in Africa Today," *African Studies Review* 38, 3: 1–10.

Irele, A. (1971) *Literature and Ideology in Martinique: René Maran, Aimé Césaire, Frantz Fanon*, Buffalo: Council on International Studies, State University of New York.

Ismail, Q. (1991) "Boys Will Be Boys: Gender and National Agency in Frantz Fanon and the Liberation Tigers of Tamil Eelam," *South Asia Bulletin* 11, 1: 79–83.

JanMohamed, A. (1983) *Manichean Aesthetics: The Politics of Literature in Colonial Africa*, Amherst: University of Massachusetts Press.

Jha, B.K. (1988) "Fanon's Theory of Violence: A Critique," *Indian Journal of Political Science* 49, 3: 359–69.

Julien, I. and Mercer, K. (1989) "Race, Sexual Politics and Black Masculinity: A Dossier," in R. Chapman and J. Rutherford (eds) *Male Order: Unwrapping Masculinity*, London: Lawrence & Wishart.

Kaplan, E.A. (1997) *Looking for the Other: Feminism, Film, and the Imperial Gaze*, New York: Routledge.

Kedourie, E. (1968) "Revolutionary Nationalism in Asia and Africa," *Government and Opposition* 3, 4: 453–64.

LaGuerre, J.G. (1984) *Enemies of Empire*, St. Augustine: University of the West Indies.

Lazarus, N. (1990) *Resistance in Postcolonial African Fiction*, New Haven, CT: Yale University Press.

Lazreg, M. (1990) "Feminism and Difference: The Perils of Writing as a Woman on Women in Algeria," in M. Hirsch and E.F. Keller (eds) *Conflicts in Feminism*, New York: Routledge.

Lemelle, S.J. (1993) "The Politics of Cultural Existence: Pan-Africanism, Historical Materialism, and Afrocentricity," *Race and Class* 35, 93–112.

Long, K. (1995) "Marx, Fanon, Nkrumah, and the Intersection of Socialism and Radical Feminism," *Rethinking Marxism* 8, 4: 89–103.

Maldonado-Denis, M. (1978) *Marti y Fanon*, Mexico City: Universidad Nacional Autónoma de México.

Martin, G. (1974) "Fanon's Relevance to Contemporary African Political Thought," *Ufahamu* 4: 11–34.

Martin, T. (1970) "Rescuing Fanon from the Critics," *African Studies Review* 13, 3: 381–99.

Marton, I. (1969) *Tereszmek a Hardmadik Vilagban: Leopold Sedar Senghor, Aimé Césaire es Frantz Fanon*, Budapest: Kossuth Konyvkiado.

Mazrui, A. (1993) "Language and the Quest for Liberation in Africa: The Legacy of Frantz Fanon," *Third World Quarterly* 14, 2: 351–64.

Mazrui, A. and Mphande, L. (1993) "Orality and the Literature of Combat: Ngugi and the Legacy of Fanon," *Paintbrush* 20, 39: 159–84.

McGann, J. (1989) "The Third World of Criticism," in M. Levinson *et al.* (eds) *Rethinking Historicism: Critical Readings in Romantic History*, New York: Blackwell.

Memmi, A. (1965) *The Colonizer and the Colonized*, trans. H. Greenfield, New York: Grove.

—— (1968) "Frantz Fanon and the Notion of 'Deficiency,' " trans. E. Levieux, in *Dominated Man: Notes towards a Portrait*, New York: Orion.

—— (1971a) "La Vie impossible de Frantz Fanon," *L'Esprit* (September): 248–73.

—— (1971b) Review of P. Geismar, *Fanon*, and D. Caute, *Frantz Fanon*, *New York Times Book Review*, 14 March: 5.

Miller, C. (1990) "Ethnicity and Ethics," in *Theories of Africans: Francophone Literature and Anthropology in Africa*, Chicago: University of Chicago Press.

Moi, T. (1994) *Simone de Beauvoir: The Making of an Intellectual Woman*, Cambridge, MA: Blackwell.

Moore-Gilbert, B. (1996) "Frantz Fanon: En-gendering Nationalist Discourse," *Women: A Cultural Review* 7, 2: 125–35.

—— (1997) *Postcolonial Theory: Contexts, Practices, Politics*, New York: Verso.

Mostern, K. (1994) "Decolonization as Learning: Practice and Pedagogy in Frantz Fanon's Revolutionary Narrative," in H. Giroux and P. McLaren (eds) *Between Borders: Pedagogy and the Politics of Cultural Studies*, New York: Routledge.

Mowitt, J. (1992) "Algerian Nation: Fanon's Fetish," *Cultural Critique* 22: 165–86.

Neill, M. (1982) "Guerillas and Gangs: Frantz Fanon and V.S. Naipaul," *Ariel* 13, 4, 21–62.

Nghe, N. (1963) "Frantz Fanon et le problème de l'indépendance," *La Pensée* 107: 23–36.

Ngugi wa Thiong'o (1993) *Moving the Center: The Struggle for Cultural Freedoms*, Portsmouth, NH: Heinemann.

Nursey-Bray, P. (1972) "Marxism and Existentialism in the Thought of Frantz Fanon," *Political Studies* 20: 152–68.

Nwafor, A. (1973) "Liberation and Pan-Africanism," *Monthly Review* 26, 6: 12–28.

Parry, B. (1987) "Problems in Current Theories of Colonial Discourse," *Oxford Literary Review* 9, 1–2: 27–58.

—— (1994) "Resistance Theory/Theorizing Resistance, or Two Cheers for Nativism," in F. Barker, P. Hulme, and M. Iversen (eds) *Colonial Discourse/Postcolonial Theory*, Manchester, England: Manchester University Press.

Perez, A. (1989) "Sartre, Memmi et Fanon," *Présence francophone* 35.

Perinbam, M. (1973) "Fanon and the Revolutionary Peasantry: The Algerian Case," *Journal of Modern African Studies* 11, 3: 440–2.

Posnock, R. (1997) "How It Feels to Be a Problem: DuBois, Fanon and the 'Impossible' Life of the Black Intellectual," *Critical Inquiry* 23, 2: 323–49.

Postel, J. and Quetel, C. (eds) (1994) *Nouvelle histoire de la psychiatrie*, Paris: Dunod.

Prasad, M. (1992) "The 'Other' Worldliness of Postcolonial Discourse: A Critique," *Critical Quarterly* 34, 3, 74–95.

Rangua, T. (1986) "Frantz Fanon and Black Consciousness in Anzania (South Africa)," *Phylon* 47, 3: 182–91.

Robinson, C. (1983) *Black Marxism: The Making of the Black Radical Tradition*, London: Zed.

—— (1993) "The Appropriation of Frantz Fanon," *Race & Class* 35, 1: 79–91.

Said, E.W. (1989) "Representing the Colonized: Anthropology's Interlocutors," *Critical Inquiry* 15, 2: 205–27.

—— (1990) "Figures, Configurations, Transfigurations," *Race & Class* 32, 1: 1–16.

—— (1994) "Resistance and Opposition," in *Culture and Imperialism*, New York: Pantheon.

—— (1999) "Traveling Theory Revisited," in N. Gibson (ed.) *Fanon and Fanonism*, Englewood Cliffs, NJ: Humanities Press.

Samuel, J.J. (1997) "Ignoring the Role of Violence in Fanon: Playing with the Bones of a Hero," *Fuse Magazine* (May), 63–4.

Sandoval, C. (1997) "Theorizing White Consciousness for a Post-Empire World: Barthes, Fanon, and the Rhetoric of Love," in R. Frankenberg (ed.) *Displacing Whiteness: Essays in Social and Cultural Criticism*, Durham, NC: Duke University Press.

San Juan, E. (1979) "Literature and Revolution in the Third World," *Social Praxis* 6, 1–2: 19–34.

—— (1998) *Beyond Postcolonial Theory*, New York: St. Martin's.

Schwartz, S. (1995) "Fanon's Revolutionary Women," *UTS Review* 1, 2: 197–201.

Scott, D. (1994) "Jungle Fever? Black Gay Identity Politics, White Dick, and the Utopian Bedroom," *GLQ* 1: 299–321.

Sekyi-Otu, A. (1975) "Form and Metaphor in Fanon's Critique of Racial and Colonial Domination," in A. Kontos (ed.) *Domination*, Toronto: University of Toronto Press.

Serequeberhan, T. (ed.) (1991) *African Philosophy: The Essential Writings*, New York: Paragon House.

—— (1994) *The Hermeneutics of African Philosophy*, New York: Routledge.

Shohat, E.H. (1997) "Framing Post-Third-Worldist Culture: Gender and Nation in Middle Eastern/North African Film," *Jouvert* 1, 1 (online).

Sirinielli, J.-P. and Rioux, J.-P. (1991) *La Guerre d'Algérie et les intellectuels français*, Paris: Éditions Complexe.

Spillers, H. (1987) "Mama's Baby, Papa's Maybe: An American Grammar Book," *diacritics* 17, 2, 65–82.

—— (1996) " 'All the Things You Could Be by Now If Sigmund Freud's Wife Was Your Mother': Psychoanalysis and Race," *Critical Inquiry* 22, 4: 710–34; *Boundary 2* 23, 3: 75–142.

Staniland, M. (1969) "Frantz Fanon and the African Political Class," *African Affairs* 68, 270: 4–25.

Sutton, H. (1971) "Fanon," *Saturday Review of Literature* (17 July): 16–19, 59–61.

Taylor, C. (1994) "The Politics of Recognition," in D.T. Goldberg (ed.) *Multiculturalism: A Critical Reader*, Cambridge, MA: Blackwell.

Taylor, P. (1989) "Frantz Fanon and the Narrative of Liberation," in *The Narrative of Liberation: Perspectives on Afro-Caribbean-Literature, Popular Culture, and Politics*, Ithaca, NY: Cornell University Press.

Todorov, T. (1993) *On Human Diversity: Nationalism, Racism, and Exoticism in French Thought*, trans. C. Porter, Cambridge, MA: Harvard University Press.

Turner, L. (1989) "The Marxist Humanist Legacy of Frantz Fanon," *News and Letters* 38, 10: 4–5.

Vergès, F. (1996) "The Heritage of Frantz Fanon," *European Legacy* 1, 3: 994–8.

—— (1997) "Creole Skin, Black Mask: Fanon and Disavowal," *Critical Inquiry* 23, 3: 578–95.

Verharen, C.C. (1995) "History and Self-Knowledge: Fanon and Afrocentrism," *The Philosophical Forum* 26, 4: 294–314.

Wallerstein, I.M. (1979) "Fanon and the Revolutionary Class," in *The Capitalist World-Economy*, New York: Cambridge University Press.

Welsh-Asante, K. (1990) "Philosophy and Dance in Africa: The Views of Cabral and Fanon," *Journal of Black Studies* 21, 2: 224–32.

White, J.S. and Parham, T.A. (1984) *The Psychology of Blacks: An African-American Perspective*, 2nd edition, Englewood Cliffs, NJ: Prentice-Hall.

Woddis, J. (1972) "Fanon and Classes in Africa," in *New Theories of Revolution*, New York: International Publishers.

Worsley, P. (1972) "Fanon and the 'Lumpenproletariat,' " in R. Miliband and J. Savile (eds) *Socialist Register*, London: Merlin Press.

Wright, C. (1992) "National Liberation, Consciousness, Freedom, and Frantz Fanon," *History of European Ideas* 15, 1: 427–36.

Wright, D. (1986) "Fanon and Africa: A Retrospect," *Journal of Modern African Studies* 24, 4: 679–89.

—— (1994) "Breaking the Cycle: Fanonian Patterns in West African Writing," *Literary Half-Yearly* 35, 1: 64–77.

Young, R. (1990) "Disorienting Orientalism" and "The Ambivalence of Bhabha," in *White Mythologies: Writing History and the West*, New York: Routledge.

Zack, N. (1993) *Race and Mixed-Race*, Philadelphia: Temple University Press.

Zimra, C. (1978) "A Woman's Place: Cross-Sexual Perceptions in Race Relations: The Case of Mayotte Capécia and Abdoulaye Sadji," *Folio* (August): 174–92.

—— (1990) "Righting the Calabash: Writing History in the Female Francophone Narrative," in C.B. Davies and E.S. Fido (eds) *Out of the Kumbla: Caribbean Women and Literature*, Trenton, NJ: Africa World Press.

Zolberg, A.R. (1970) "Frantz Fanon," in *The New Left: Six Critical Essays*, New York: Library Press.

Zolberg, A.R. and Zolberg, V.B. (1966) "The Americanization of Frantz Fanon," *Public Interest* 9, 49–63.

INDEX